Trauma and Media

Routledge Research in Cultural and Media Studies

1. Video, War and the Diasporic Imagination
Dona Kolar-Panov

2. Reporting the Israeli-Arab Conflict
How Hegemony Works
Tamar Liebes

3. Karaoke Around the World
Global Technology, Local Singing
Edited by Toru Mitsui and
Shuhei Hosokawa

4. News of the World
World Cultures Look at Television News
Edited by Klaus Bruhn Jensen

5. From Satellite to Single Market
New Communication Technology and
European Public Service Television
Richard Collins

6. The Nationwide Television Studies
David Morley and Charlotte Bronsdon

7. The New Communications Landscape
Demystifying Media Globalization
Edited by Georgette Wang

8. Media and Migration
Edited by Russel King and
Nancy Wood

9. Media Reform
Edited by Beata Rozumilowicz and
Monroe E. Price

10. Political Communication in a New Era
Edited by Gadi Wolfsfeld and
Philippe Maarek

11. Writers' Houses and the Making of Memory
Edited by Harald Hendrix

12. Autism and Representation
Edited by Mark Osteen

13. American Icons
The Genesis of a National
Visual Language
Benedikt Feldges

14. The Practice of Public Art
Edited by Cameron Cartiere and
Shelly Willis

15. Film and Television After DVD
Edited by James Bennett and
Tom Brown

16. The Places and Spaces of Fashion, 1800–2007
Edited by John Potvin

17. Communicating in the Third Space
Edited by Karin Ikas and
Gerhard Wagner

18. Deconstruction After 9/11
Martin McQuillan

19. The Contemporary Comic Book Superhero
Edited by Angela Ndalianis

20. Mobile Technologies
From Telecommunications to Media
Edited by Gerard Goggin and
Larissa Hjorth

21. Dynamics and Performativity of Imagination
The Image between the Visible
and the Invisible
Edited by Bernd Huppauf and
Christoph Wulf

22. Cities, Citizens, and Technologies
Urban Life and Postmodernity
Paula Geyh

23. Trauma and Media
Theories, Histories, and Images
Allen Meek

Trauma and Media

Theories, Histories, and Images

Allen Meek

Routledge
Taylor & Francis Group
New York London

First published 2010
by Routledge
711 Third Avenue, New York, NY 10017, USA

Simultaneously published in the UK
by Routledge
2 Park Square, Milton Park, Abingdon, Oxon OX14 4RN

Routledge is an imprint of the Taylor & Francis Group, an informa business

© 2010 Taylor & Francis

Typeset in Sabon by IBT Global.

Library of Congress Cataloging in Publication Data
Meek, Allen, 1961–
 Trauma and media : theories, histories, and images / by Allen Meek.
 p. cm.—(Routledge research in cultural and media studies ; 23)
 Includes bibliographical references and index.
 1. Psychic trauma and mass media. 2. Collective memory. 3. Mass media—
Psychological aspects. I. Title.
 P96.P73M44 2009
 302.23—dc22
 2009025263

ISBN13: 978-0-415-80123-2 (hbk)
ISBN13: 978-1-138-77487-2 (pbk)

Contents

Introduction 1

1 Theories, Histories and Images 18

2 Photography and Unconscious Optics 47

3 Critical Theory, Mass Culture and Film 73

4 Barthes: The Traumatic Image and the Media Code 107

5 After Auschwitz: A Community of Witness 133

6 Virtual Trauma: After 9/11 171

Notes 197
Bibliography 203
Index 215

Introduction

Trauma and Media argues that theoretical and cultural discourses of trauma and witnessing, which have achieved such prominence in recent research in the humanities, have often tended to reinforce rather than interrogate the assumption that certain events are inherently traumatic for large collectives, such as nations or specific ethnic groups. Recent trauma theory wants to bear witness to authentic forms of testimony that directly transmit experience outside the codes and conventions of mainstream media. Against this transmission model, this book argues for an understanding of historical trauma as an open-ended, experimental approach to engaging with the violent and catastrophic legacies of the past. I understand historical trauma not only in terms of bearing witness to specific events and experiences, but also as an ongoing struggle over representations of the past. The conceptualization of trauma plays an important part in that struggle.

In the following chapters I present a critique of contemporary trauma theory and develop an alternative account of historical trauma. Against theoretical constructions of traumatic memory as a literal trace of an external reality, or the testimony of a traumatized subject as the living embodiment of historical truth, *Trauma and Media* understands historical trauma as only revealed through intertextual constructions whose methodological precedents include Freudian psychoanalysis, Walter Benjamin's "dialectical images" and Theodor Adorno's "micrologies." Historical trauma is not grounded in memory traces but in the interpretation of what may be "forgotten" in the texts of mass media, academic criticism, psychoanalysis and critical theory itself. Historical traumas are constructions of collective memories that cannot be verified through empirical research, or by ascribing an indexical relation between the image and the real. Instead the following chapters situate trauma in different constellations of theories, histories and images in order to reveal what is at stake politically in these traumatic identifications. Sometimes this requires reading texts against the grain in order to elaborate the historical contexts and political implications of trauma's role in modern media criticism.

This book also stresses analysis of the unconscious structures of political identity rather than identification with, or empathy for, the victim/

survivor of trauma. In the face of the community of witness and the politics of collective grieving, I develop a critical theory of historical trauma which allows us to understand human life subject to biopolitical power. Giorgio Agamben has been seen by several critics[1] as making claims regarding the impossibility of accurately representing trauma and for the ethical status of the survivor-witness that are consistent with trauma theory as developed by Cathy Caruth and others. However, in the following chapters I read Agamben, along with the critical theories of Benjamin and Adorno, as providing an important account of power and sovereignty that has not often formed a significant feature of contemporary trauma theory. In the figure of *homo sacer* we are confronted with an image of the death, or mere survival, of an individual without political rights. This throws into question some of the legitimizing narratives of nation building and liberal democracy that dominate both mass media representations and certain theorizations of trauma and media.

Today's trauma theory emerged from a conjunction of research into Post Traumatic Stress Disorder with a critique of representation. However, trauma is not only a psychological condition extended into the domain of literary and media texts. It has always formed a central part of psychoanalytic theories of culture. Freud himself extended the concept of trauma beyond the individual to include social collectives at least as early as *Totem and Taboo* (1913). Benjamin and Adorno employed Freud in their critical theory in the 1920s and '30s. For Benjamin and Adorno the then new media of photography and film presented images of a mass culture shaped, on one hand, by a history of revolution and terror and, on the other, by practices of industrial production and consumption. The Freudian account of both individual and collective trauma enabled these critics to develop a critical account of violence, shock and propaganda in mass mediated societies.

In the late 1930s, facing the deepening crisis that would result in World War II and the Holocaust, Freud, Benjamin and Adorno all developed somewhat different theories of historical trauma. In *Moses and Monotheism* (1939) Freud attempted to explain Jewish identity with reference to the collective trauma of the murder of the primal father and the psychic impact of monotheistic faith. Benjamin made Freud's theory of shock (as outlined in *Beyond the Pleasure Principle* [1920]) part of his own account of modern urban experience and photography. Adorno devised a critique of Wagner's music using psychoanalytic terms, including traumatic memory and compulsive repetition, that he would later extend in his critique of mass culture. After the war Adorno, following Benjamin's theses on history as catastrophe, proposed that Auschwitz constituted a trauma for philosophical thought. In the postwar period Roland Barthes also returned to the problem of trauma in his various essays on photography. Many of these texts serve as an ongoing reference for more recent work in trauma studies. However, recent research on trauma and media is concerned primarily with visual evidence, testimony and commemoration. What these

earlier texts provide are more comprehensive philosophical and historical accounts of the relation between political violence, modern media and collective identity.

While I do not claim that these critics present us with models that can simply be "applied" to today's culture, I propose that they offer important precedents for a theory of historical trauma that addresses today's culture of mediated violence and terror. In order to extend their contemporary relevance I read their writings with reference to Agamben's biopolitical theory of sovereignty. By showing that these founding texts of trauma theory are preoccupied with what Agamben calls "bare life" (the reduction of the human individual to mere biological existence), I demonstrate how trauma is embedded in larger ideological formations. Identification and/or empathy with the victim often assumes a progressive liberal account of social relations. The Freudian concept of trauma, however, reveals repressed violence to be the basis of both individual and group identity. The question of political violence and sovereign power are also central to Benjamin's and Adorno's uses of Freud. Today we need to extend the insights of these earlier thinkers and pursue a geopolitical analysis of the ways trauma discourse may participate in structures of power and exclusion.

I pursue these issues further in a series of readings of these theorists and in discussions of two iconic traumas of modern media: the Holocaust and the events of September 11, 2001. Numerous studies of the limits and ethics of Holocaust representation have cited Adorno's proposition that "To write poetry after Auschwitz is barbaric" (*Prisms* 34) without seeking any further engagement with Adorno's work. Yet Adorno made psychoanalytic theory part of his critique of fascism, both before and after Auschwitz. In *Minima Moralia* (1951) Adorno wrote that "the nullity demonstrated to subjects by the concentration camp is already overtaking the form of subjectivity itself" (16), anticipating Agamben's argument that the camp is the archetypal political space of modernity (*Homo Sacer* 166). Debates about Holocaust representation have sometimes missed the larger stakes of Adorno's and Agamben's propositions: that the radical reduction of individual freedom and agency is intrinsic to the biopolitical regimes of the modern state and capitalist economy. Trauma discourse itself participates in a therapeutic understanding of experience that forms part of medical and managerial modes of surveillance and control. The relation between trauma and bare life is explicit in the experience of the Holocaust, but may seem less obvious in the case of 9/11. Both media professionals and academic critics responded to the 9/11 attacks by claiming a "traumatic" status for those events. In this way trauma discourse did more to reconstitute national identity than to consider the larger significance of the annihilation of civilian populations through terrorist violence.

Whereas trauma studies is mostly preoccupied with testimonial texts and documentary images, it remains haunted by the presence of a more general media culture. At least since the publication of Shoshana Felman's

and Dori Laub's *Testimony* (1992), contemporary trauma studies has included analyses of film and video texts along with works of literature. But the testimony of Holocaust survivors discussed in Felman's and Laub's book were exceptional cases. *Testimony* appeared to assume the common criticism that news and entertainment media commodify human suffering and transform viewers into indifferent voyeurs. Then the events of September 11, 2001, brought the representation of traumatic experience right to the center of contemporary media culture in new and dramatic ways. After 9/11 the experience of collective trauma was extended in more direct ways to media viewers. Researchers attempted to find evidence of psychological disturbance among those who had seen the terrorist attacks and their aftermath on television (Young 28–33; Furedi 12–16). More importantly, the mass media itself almost immediately spoke of the events as traumatic for both Americans and the Western world in general (Sreberny 223). Cultural critics and academic theorists gave added weight to this interpretation by applying the terms of already established discourses of trauma and witnessing to account for the impact of the shocking events.

9/11 presented itself instantaneously as a paradigmatic case for media studies. The rapid transmission of the catastrophe to a global audience via "live" television and the Internet, along with the spectacular nature of the collapse of the twin towers, gave the events iconic status among media representations of actual occurrences. However, as commentators in the media and academia were quick to point out, the events bore an uncanny resemblance to numerous Hollywood disaster movies and apocalyptic fantasies. Those who interpreted 9/11 in terms of its traumatic impact stressed the gap between the immediacy of the media images and the ability of the public to make sense of the events, or even to believe what they were seeing. However, the sense that the events had somehow already been visualized before they happened suggested the appropriateness of an approach that drew from Freud, who had emphasized the role of fantasy and desire in the construction of events as traumatic. Such interpretations were readily offered by cultural theorists such as Jean Baudrillard, Paul Virilio and Slavoj Žižek. The tension between these two approaches to trauma and representation, which came into such high relief after 9/11, is one of the ongoing concerns of this book.

The 9/11 attacks also gave rise to a new rhetoric of good versus evil, civilization versus barbarism, and 'us' versus 'them.' The former terms in this series of binaries could be once again openly applied to America and first-world countries and the second terms in the series to its strategic enemies. Islamic fundamentalism was portrayed as the nemesis of liberal democracy and human progress. Reeling in shock from an unexpected violation of their apparent immunity from violent destruction, many Western intellectuals missed an important opportunity to engage in a critique of global power and inequality. As Jacques Derrida commented, the rapidity with which 9/11 was spoken of as a "traumatic event" effectively negated a deeper reflection

on and more gradual working-through of its political significance (Borradori 93). The communities of grieving and mourning that quickly formed through the aid of news media and other information networks tended to put aside political analysis in response to a perceived need for empathy and human solidarity. How should we understand the responsibility of critical intellectuals in such a dramatic situation? A sense of national identity, or identification with the West, emerged strongly in many intellectuals' responses to 9/11, including those involved in contemporary trauma studies. 9/11 was certainly, in Benjamin's memorable phrase, a "moment of danger" in which the "true image of the past" must be seized from uncritical narratives of progress and homogeneous constructions of historical time (4: 391–395). The moment of danger is also a moment of possibility—potentially enabling new insights into the past and new projects for different futures.

TRAUMA AND MEDIA

Psychological theories of trauma have explained how the experience of physical harm or life-threatening situations can cause individuals to suffer behavioral and memory disorders over extended periods of time. Today film, television and the Internet regularly show violence and catastrophe in the most vivid ways. Whereas the impact of these representations has been an ongoing concern in media research it would appear most people have learned to live with representations of extreme violence without suffering obvious psychological effects. Exposure to media alone is not a sufficient cause of traumatization. Nevertheless, the price of this exposure may be an emotional and intellectual disengagement with the wider world and even a "psychic numbing" that is itself listed as a symptom of Post Traumatic Stress Disorder. However interesting the question of the psychic impact of media may be, recent research on trauma and representation has tended to pursue different directions. Contemporary trauma theory, as developed by critics such as Felman and Caruth, is concerned with the paradoxical nature of traumatic memory and the crises it poses for conventional understandings of historical narrative, truth and representation. Drawing from both the psychiatric category of PTSD and Freudian psychoanalysis, trauma theory explores the ways that trauma's temporality constitutes an event that is always displaced in space and time. Trauma may not be consciously registered at the time of its occurrence but it returns in the form of intrusive memories, nightmares, compulsive acting-out and flash-backs. Caruth has called trauma a "symptom of history" ("Introduction" 5), suggesting both a direct, yet often inaccessible, link with the past. In contemporary Western culture images of violence and catastrophe are consumed as part of normal everyday life. So when academic critics make the representation of trauma an index of historical truth and authenticity we need to situate such claims in broader cultural contexts.

Beyond the initial question of the possibly traumatic effects of media, contemporary trauma studies addresses the specific communities that are created through the collective experience of, or collective relation to, traumatic events. Film theorist E. Ann Kaplan proposes that "trauma produces new subjects" (Kaplan 1); that is, it produces new forms of political identification based in different experiences of victimhood, shared suffering and witnessing. This interest in trauma as the basis of shared identity is also characteristic of broader cultural trends outside the academy. Despite the proliferation of images of war, torture, genocide and natural disaster in Western news media, certain events, such as the Holocaust or 9/11, have become iconic cultural traumas—relived and retold in numerous documentaries and dramatizations. Commentators suggest we are living in a "trauma culture" in which "extremity and survival are privileged markers of identity" (Luckhurst 2).[2] The application of psychoanalytic concepts and methods to the study of modern media has a long and complex history, and it is not surprising that recent research into trauma and testimony has quickly become part of the study of film, television and photojournalism. World War II, the Holocaust and the Vietnam War have been common subjects for popular film, whereas more recent events, such as the September 11 attacks or the death of Lady Diana Spencer, have been rapidly translated into film and television dramas. While some critics describe these representations of human suffering as kitsch, others argue that they constitute popular and influential representations of history. These debates have carried over to trauma theory. Critics such as Felman and Caruth stress the impossibility of adequately representing traumatic experience. For this they have been accused of making trauma the experience of only particular groups or granting trauma a quasi-religious status. In contrast film scholars E. Ann Kaplan and Ban Wang argue that a choice must be made "between inadequate telling and the relegating of trauma to a mystified silence" (Kaplan and Wang 12). They propose, instead, a range of different positions for relating to traumatic experience in film, including vicarious traumatization, voyeurism and empathetic identification (9–11).

Insofar as traumatic experience becomes the measure by which we attempt to evaluate media representations we may neglect to consider the larger questions that underline our understanding of trauma and memory, such as the shifting historical relations between technology and optical experience. Ever since photographs were first used to document the physical states of hysterics in Jean Martin Charcot's clinic or the horrific deaths and injuries suffered in World War I, the literal representation of traumatic experience has always been only one side of the relation between trauma and media. Benjamin compared photography to the ways that human consciousness attempts to deflect potentially traumatic shock and emphasized the ways media technologies served to attune experience to new rhythms and speeds of modernity. Photography, he argued, is the mnemonic device that has replaced the long memory characteristic of more stable societies, localized communities and

traditional cultures. Trauma and shock became important new conceptions of memory in the writings of Freud and Benjamin because they marked an historical break with the past experienced as long memory. When Freud first advanced his theories concerning the sexual abuse of children in the bourgeois family he scandalized the public. When Benjamin drew on Freud's theory of trauma to develop his own analysis of urban industrial culture as based in the experience of shock, he emphasized the destruction of earlier forms of communal memory and individual interiority.

Yet today our understanding of trauma has almost undergone a reversal of Freud's and Benjamin's earlier articulations: trauma often appears to serve as our only remaining guarantee of the reality of the past in a new era of technologically mediated memory. As critics such as Andreas Huyssen and Thomas Elsaesser have observed, it is as if the idea of trauma has assumed a place that is somehow commensurate with the proliferation of visual media in our lives. For not only is our understanding of traumatic experiences and events often complicated by their visual mediation, but traumatic memory and modern visual media have also both been theorized as registering, repeating and re-playing events in ways that exceed conscious perception and understanding. Should we speak today of a collective desire *for* trauma? We need to ask why so much research is focused on the representation of trauma when so much earlier theory struggled to account for the inter-relatedness of consciousness and media effects. Psychoanalysis, particularly given Jacques Lacan's influence on film theory, has been used to argue that subjectivity is structured within the formal codes, visual fields and shifting perspectives purveyed by the cinematic apparatus. Such critical positions formed a central part of the intellectual culture of "theory" that impacted research in the humanities from the event of structuralism, through deconstruction and the debates about postmodernism. The emphasis on semiotic meaning, discursive power and rhetorical tropes that influenced so much research during this period was consistently criticized for failing to adequately address the question of history, which appeared to remain suspended due to the ultimate impossibility of grounding linguistic reference in any empirical reality. Into this space emerged trauma studies, with its claims for trauma as the return of history as a symptom or trace of past events.

Trauma theory has drawn its authority from both neurobiological research and survivor testimony in order to align the experience of trauma with privileged notions of historical truth. In the introduction to her 1995 collection *Trauma: Explorations in Memory*, Caruth noted the landmark decision of the American Psychiatric Association in 1980 to officially recognize the psychological condition of Post Traumatic Stress Disorder. On one hand, commented Caruth, PTSD serves as a catch-all for the psychological fall-out from a range of violent or otherwise disturbing experiences. On the other hand, the concept of trauma brings with it a number of new challenges to defining pathology. In traumatic memory as theorized

by Caruth the past intrudes directly and unexpectedly in the present with-
out being situated in a linear narrative in conscious memory. Drawing on
psychotherapeutic research, Caruth claimed that to the extent that trauma
remains unassimilated into the narrative fabric of everyday memory its
return in the form of nightmares, flashbacks or compulsive behavior car-
ries both *"the truth of an event* and *the truth of its incomprehensibil-
ity"* (153). These propositions have led Dominick LaCapra and others to
warn of a potential mystification and sacralization of trauma. Against
such a tendency LaCapra emphasizes the importance of an ongoing pro-
cess of working-through in which traumatic experience can assume mean-
ing within a symbolic or narrative context (*History in Transit* 119–121).
These debates have tended to move from specific psychotherapeutic studies
(for example, on veterans of the Vietnam War or Holocaust survivors) to
textual forms such as historical analyses, oral and written testimonies or
fictionalized narratives. Whereas these critics have produced close read-
ings of films such as Claude Lanzmann's *Shoah* or Alain Resnais' *Hiro-
shima Mon Amour,*[3] there has been little discussion by influential figures
like Caruth and LaCapra of the wider role of visual media in shaping
contemporary forms of history and memory.

In contrast to these theorists I argue that a collective identification with
trauma is a feature of a society in which visual media define much of our
relation to the past. To the extent that trauma theory seeks to establish
some privileged or exceptional link between the image, testimony, witness-
ing and traumatic event, it participates in forms of political identification
that are often already constituted through media representations. Beyond
debates about the limits of representing traumatic experience we need to
ask how modern cultural forms, especially those of modern visual media,
have helped to create conditions in which trauma has assumed such signifi-
cance. Such questions were central to Benjamin's research, which moved
beyond the sphere of psychoanalysis and individual therapy to consider a
situation in which "exposure to shock has become the norm" (4: 318). He
argued that the disruption of long-enduring, pre-modern forms of expe-
rience and memory by rapid social change, technological innovation and
the mass availability of information created a cultural shift in which pho-
tography performed important new mnemonic functions (337). Thus, for
Benjamin, photography provides "coverage" for a traumatic loss. In the
face of postwar consumer culture, Barthes's prognosis was less optimistic
than Benjamin's. For Barthes, too, the photograph was inseparable from
traumatic experience. In his essay "The Photographic Message," Barthes
proposed the possibility of a traumatic image that would suspend language
and block signification (*Image* 30). For Barthes trauma became a form of
resistance to mass media. This notion was further developed in his last
essay on photography, *Camera Lucida* (1980), in which he withheld from
publication the photograph of his mother as a young girl, which for him
most poignantly signified the trauma of her loss. Barthes refused to let the

image of his mother enter the modes of circulation and re-production by which the dominant media code absorbs and redirects shock.

This book argues that whereas visual media have multiplied and extended our means of recording and thereby remembering events, trauma increasingly serves as a model for deep memory in a mass mediated culture. For Caruth, the intensity of the traumatic memory defies understanding and assimilation into narrative. Such an attempt to be faithful to the alterity of traumatic experience runs the risk of withdrawing historical experience from critical engagement with the present. Whereas Caruth's emphasis on the ways that traumatic experience eludes representation would appear to function as the antithesis of proliferating media images of human suffering and catastrophe, her accompanying insistence on the *literal* nature of the traumatic memory trace recalls some of Benjamin's and Barthes's earlier propositions about photography. Benjamin argued that the "aura"—the web of associations that cluster around an object of perception, including its value as cult or art object—was shattered by industrial reproduction of the image. The post-auratic image was defined instead by its status as the trace of a physical reality and by its technological reproducibility. For Barthes the photographic image is inherently traumatic as far as its "thereness," its denotative force, represents an historic rupture and mutation in the history of image-making. Between Benjamin's and Barthes's different formulations, trauma begins to constitute a unique and authentic experience *even as it bears witness to the radical destabilizing of human perception* and offers a substitute for the lost aura of the object/image.

This connection between trauma, the media image and deep memory is made explicit in recent studies of Holocaust representation. For example, film scholar Joshua Hirsch writes that if photography, as Benjamin proposed, shattered the aura of the art work and gave rise to a new politics of the image, "then one of the effects of this new politics is the potentially endless reproduction and dissemination of trauma" (Hirsch, *Afterimage* 14). Hirsch understands this reproduction and dissemination as the literal transmission of traumatic experience. But we can also see preoccupation with trauma as part of an ongoing search for a substitute for the lost aura and the loss of shared traditions and social narratives. The idea that photographs and films disseminate trauma—Hirsch's example is the Holocaust film—is premised on an act of identification with the victim (Hirsch declares his own identification with Holocaust victims at the beginning of his book). Interpretation of images as embodying traumatic experience is thrown into question if we understand the "traumatic" image or film as a projection of value based on an identification with specific instances of collective suffering.

Rather than providing an authentic link with the past, images of violence and catastrophe often function as "screen savers" for group identity: they both memorialize suffering and deflect its emotional impact. Benjamin explained this function with respect to the need for modern urban dwellers

to develop a protective shield against perceptual overload. By understanding the photograph as a way of screening out potentially traumatic experience, Benjamin anticipated the increasingly important role that modern media would play as a shock-absorber. However, the immediacy of audio-visual communication in "real time" further compounds this problem in ways Benjamin could not have anticipated. How should we understand the prominence of trauma as an interpretive paradigm in an age of "live" transmission and digital information networks? There have been some provocative responses to this. Huyssen argues that trauma theory is a response to the ever-increasing speeds of human mobility and technological communication, whereas Elsaesser notes the structural parallels of traumatic experience with media effects themselves. For Huyssen, trauma has been enlisted in the quest for authentic experience and historical anchorage in an age of spatio-temporal dislocation, and has thereby become a pervasive metaphor in poststructuralist theory and postmodern culture. For Elsaesser, however, it is the groundless, placeless media image that gives contemporary experience a traumatic "turn," as a compulsive repetition of the image that cannot be located in established historical narratives.

Trauma theory often constitutes an attempt to rescue historical experience from standardized and globalized forms by refashioning the media image as a traumatic memory. Huyssen proposes that the basis of contemporary Western culture's obsession with memory (in both its traumatic and nostalgic forms) is a "crisis of temporality in our lives" ("Trauma" 21) caused by rapid technological change and the global mobility of people and capital. The crisis of the nation state has undermined the stabilizing grounding of collective identity and memory. Trauma provides a substitute for earlier forms of community by way of collective identification with the victim. But Huyssen rejects trauma as the basis for identity politics. He believes this fails to support any viable alternative to the flux of consumerist postmodernity and spatio-temporal displacement. Whereas earlier theorists such as Freud and Benjamin sought to shatter bourgeois repression and historicism, Huyssen sees contemporary trauma theory as manifesting a conservative postmodern impulse.

However, there may be greater potential for a traumatic relation to history than Huyssen allows. Some possibilities are suggested by Elsaesser in an important essay that has not attracted the attention it deserves. In "Postmodernism As Mourning Work," Elsaesser asks how the temporality of traumatic memory, the belated impact of remembered experience and its return in the form of compulsively repeated behaviors and symptoms, interacts with the ways that media repeat and reiterate events. Thus Elsaesser asks whether media should be understood as "traumatizing" audiences in order to draw them into a particular discursive mediation of historical experience ("Postmodernism" 197). Elsaesser sites examples of such mediation in television talk shows, multi media and cinematic dramatizations of history, and digital manipulations of the image. In these terms trauma theory

would be an attempt to understand the relation of subjectivity to history through the process of narration: "To the degree that culture is generating and circulating new forms of media memory, the subject 'invents' or invokes temporal and spatial markers. . . . for her/his own memory, body-based and somatic, which is to say, she/he fantasizes history in the form of trauma" ("Postmodernism" 198). The breakdown of earlier spatial and temporal structures, as film and television representations increasingly replace earlier forms of historical narrative and commemoration, gives trauma a conceptual "fit" with the articulation of contemporary experience. The proliferation of narratives and mediated histories available in contemporary culture creates a new field of possible identifications from which the individual can choose. Film embodies these paradoxes of traumatic memory and representation, argues Elsaesser, in its ability to represent everyday experience with great immediacy and power while at the same time simulating traumatic effects and thereby placing their authenticity in question.

Elsaesser develops explicit parallels between the structure of traumatic memory and the media image that remain implicit in Caruth. Because the experience of trauma is delayed and displaced, the location of trauma as a physical event is complicated by its repetition and rearticulating as a psychic event. This problem of where trauma is located is also endemic to various visual media, which represent and reconstitute events in contexts that are always removed in space and time, yet often experienced with a powerful sense of immediacy and involvement. Just as trauma is transmitted without reference to a clearly situated memory, media representations can become events in their own right, displacing access to any original context. The spectacular imagescapes of the cinema, "live" television transmission and digital interactivity may all be considered in terms of this logic of displacement and simulation. Elsaesser's propositions can be seen to follow a precedent established by Benjamin's analysis, whereby both trauma theory and technological media can be understood in terms of their historical relation to new forms of experience in modernity and postmodernity. The wider implications of these arguments would seem to be that traumatic experience does not so much offer an authentic counterpoint to visual mediation as much as allow us to understand how and why trauma has become such a central preoccupation in contemporary culture.

These different arguments about the relation of trauma and media make any simple application of theory to visual example problematic. It was Benjamin who first grasped that the unassimilated past is only perceived via transformations of the technological apparatus. Yet these problems have not always been taken up directly in recent research. In their anthology *Trauma and Cinema* (2004), Kaplan and Wang argue against what they see as, on one hand, the impasse presented by Caruth's insistence on the unreproducible nature of trauma, and on the other by the critique of the culture industries and the proliferation of spectacle and simulation. Kaplan and Wang address the Disneyfication of history by corporate media which

present the past as a consumable commodity and source of distraction and self-gratification (1–2). They are also alert to the dangers of deconstruction undermining claims of realist historical representation. Both tendencies in contemporary culture run the risk of disallowing critical engagement with historical representation. In contrast to what they see as these unsatisfactory alternatives, their notion of "traumatic history" (8) supports an ongoing critical analysis of narrative and representational forms through which traumatic events are mediated. Kaplan and Wang propose an understanding of historical trauma that moves beyond an empirical model of collective psychological suffering. Rather they consider the ways that traumatic events leave traces that are registered in cultural representations and argue that through acts of testimony, witnessing and mourning, traumatic events of the past can be worked-through and give rise to new forms of political agency. Their account, however, continues to assume the exteriority of a traumatic event to processes of mediation.

Kaplan and Wang propose to examine "how traces of traumatic events leave their mark on cultures" (16). Following LaCapra, they argue that the possibility of "inadequate telling" is preferable to an insistence on traumatic experience as impossible to represent. However, this argument is complicated by the multiple roles of media representations:

> The visual media do not just mirror those experiences; in their courting and staging of violence they are themselves the breeding ground of trauma, as well as the matrix of understanding and experiencing of a world out of joint. The visual media have become a cultural institution in which the traumatic experience of modernity can be recognized, negotiated, and reconfigured. (Kaplan and Wang 17)

Elsaesser further complicates the relation between trauma and media by proposing that the media image provides a site through which one's position in history is imagined as traumatic. Traumatic narratives allow positions of identification without requiring any referential relation to actual traumatic experiences. In this sense modern artists such as Baudelaire (in Benjamin's analysis) and Holocaust survivors both constitute a vanguard in a culture in which traumatic experience becomes the basis for collective identification in response to the waning of earlier articulations of national and ethnic identity. Historical reference has given way to the simulation of shared experience. For example, whereas catastrophic events such as 9/11 are doubtless traumatic for many who experienced them directly or as part of a family, personal relationship or community, the mediated nature of such events has allowed the notion of trauma to be generalized in new ways. Earlier precedents are found in the televised funerals of John F. Kennedy and Lady Diana Spencer, or in the coverage of the Vietnam War. Although these events can be inserted into narratives of national identity they also support new globalized forms of imagined community.

Just as traumatic experience is unable to be assimilated into consciousness at the moment of its occurrence and can only be experienced belatedly, the media image is always both displaced in relation to the event it records *and* its literal trace. So when history is imagined by the subject of contemporary media culture the past is mapped onto images that give a "traumatic" turn to both individual and collective memory. If this is the case then it is not a question of choice between, on one hand a traumatic memory that remains beyond representation and, on the other, imperfect or inadequate representations of traumatic experience. Rather, according to Elsaesser's argument, in contemporary media culture there is often a double displacement in which history is fantasized in terms of the trauma-like temporality of the media image.

Fantasizing history as trauma both reveals and obscures what is at stake in contemporary articulations of identity. On one hand it reveals the distance of the individual from a collective located in tradition or by national territories. On the other hand it obscures geopolitical realities with forms of emotional and moral self-gratification. We can understand Elsaesser's account of the postmodern subject's traumatic relation to history as an ideological formation that mirrors and thereby inverts the harsher forms of biopower which populations can be subjected to. Mediated trauma does not so much carry the traces of the traumatic past as dramatize and act out a crisis of subjective agency. In the following chapters I propose that we understand theories of historical trauma as an attempt to articulate the crisis of the political subject which Agamben has identified as "bare life." Modern visual media constitute a crucial dimension of this crisis because they increasingly provide the images through which contemporary identity is negotiated. The understanding of photographic or film images as an indexical trace of the historical real has supported a fusion with theories of traumatic memory. We need now to situate these images in terms of larger structures of power and subjectivity if we are to understand how trauma theory articulates in important ways (sometimes in spite of its intentions) our relation to history.

ORGANIZATION

In the following chapters I explore the shifting articulations of the question of trauma and media in modern theory and criticism. By reading a series of influential texts I show how critical discourses use the concept of trauma both to address and to evade the historical crises and transformations from which they emerge. Chapter 1 provides a brief account of the historical relation between contemporary trauma studies and earlier uses of Freud in the cultural criticism of Benjamin and Adorno. I also propose three different models for approaching the relation of trauma and media: the traumatic image, structural trauma and historical trauma. Of the three I argue that

historical trauma suggests the most valuable avenues for further research. The historical trauma model presumes that no event or image is traumatic by nature, but only becomes traumatic for a specific individual or group. And whereas traumatic memory may have a specific structure, this structure can only be transferred to the media image in ways that are so highly generalized that they tell us little or nothing about specific examples. Only a theory of historical trauma which incorporates both significant events and psychic structures can support interpretive strategies that are potentially adequate to account for our complex relation to the past.

Chapter 2 considers Freud's occasional references to photography as a metaphor for unconscious mental processes along with his actual avoidance of the new medium in the practice of psychoanalysis. I employ Benjamin's term "unconscious optics" to explore how Freud engaged, directly and indirectly, with the historical crises of war and denationalization. I then compare the political influences on Freud's changing concepts of trauma with Benjamin's study of the optical unconscious in photography. Benjamin perceives a shift in early photography from representations of the classic liberal individual to the new collective subject of mass politics. In this way Benjamin's approach to photography reveals social and political transformations that Freud's theory of trauma cannot.

Chapter 3 discusses Benjamin's and Adorno's different uses of Freudian theory in their respective studies of Baudelaire and Wagner. In a manner analogous to the experimental constructions of psychoanalysis, Benjamin and Adorno construct traumatic histories, including those of revolutionary and colonial violence, from the disparate sources of modernist art and mass culture. Benjamin's closeness to Freud can be seen in his interest in unconscious memories rising to the surface of consciousness and allowing a momentary "flash" of insight. For Benjamin these images have the potential to recover realms of experience lost under the conditions of modern urban life. One of these images is the crowd. In the earlier version of the two Baudelaire essays "The Paris of the Second Empire in Baudelaire," Benjamin examines the historical image of the crowd in detail. Benjamin shows how in the works of several nineteenth-century French writers, the city is imagined by way of Fennimore Cooper's landscapes of the American frontier. I argue that the image of the Mohican should also be read with reference to an historical trauma which remains unacknowledged by Benjamin: the catastrophe of colonial genocide. The popular sovereignty of the people is evoked in literature as the fear of the crowd as savages, replicating the structures of European imperialism. Adorno would later comment that in Cooper "one finds in rudimentary form the whole pattern of Hollywood" (*Minima Moralia* 147). The Mohican, then, serves my discussion as an early example of history fantasized as trauma.

In the final section of Chapter 3 I proceed to consider the ways that Adorno continues and transforms Benjamin's studies of historical images. In a fragment from *Minima Moralia*, Adorno mentions *King Kong* as a

"collective projection of the monstrous total State" (115): the masses attempt to prepare themselves for political terror by familiarizing themselves with giant images of exaggerated violence. As with Benjamin's constellation of the American frontier and Parisian streetscape, I propose that *King Kong* evokes a scene of colonial violence that is not fully acknowledged by Adorno, who also remains preoccupied with the Western metropolitan context. Nevertheless, I suggest that Benjamin's and Adorno's analyses of these popular images employ trauma theory in ways that remain provocative in the context of today's global media culture, allowing us to read a displaced history of Western modernity that haunts these critical texts.

Chapters 4 and 5 examine the postwar intellectual context that comes to a crucial juncture in the historical relation between poststructuralist theory and representations of the Holocaust. In Chapter 4 I read Roland Barthes as a transitional figure. While still engaged in a critique of mass culture he gradually, by way of structural analysis, moved toward a politics of desire and mourning. Trauma emerges as a theme at various moments in his different essays on photography. Revolution and colonialism remain ongoing concerns throughout Barthes's writing, including his essay "The Third Meaning," in which the historical trauma of the Russian Revolution is obliquely addressed by way of meditation on film stills. *Camera Lucida* brings together the personal trauma of his mother's death with his commentary on images from diverse historical contexts. Following Derrida's commentary on Barthes, I read the *punctum* as the trace of a trauma that cannot be located on either side of a personal/public divide but rather as one that reverberates amid the entire political and social field in the manner of a haunting presence permeating the surface of the photographic image. For Barthes the photograph is understood as traumatic as a pure repetition of the (Lacanian) real unassimilated into narrative. I argue that the mother, both shown and withheld from view, becomes the repeated figure of a working-through of the image as well as a means of mourning the utopian aspirations of earlier mass politics. The structural relation of theories of the photographic image to traumatic experience also allows me to read how the political traumas of modernity are negotiated, displaced and worked-over in media theory.

The emergence of the Holocaust into the center of contemporary debates around history and memory fundamentally shifts the discourse about historical trauma. In Chapter 5 I return to the ways that Adorno, in the postwar years, pursued the issue of group projections as traumatic neuroses with reference to German society's failure to come to terms with its narcissistic attachment to Hitler. Adorno saw the manic activity of the "economic miracle" as a substitute for maintaining group identity while denying what he saw as a fundamental complicity between a capitalist economy and the destruction unleashed upon Jews. Adorno pursues this point in *Negative Dialectics* (1973) where he describes Auschwitz as constituting a trauma for philosophical thought. The absolute triumph of the principle of abstract

exchange had achieved the reduction of human beings to disposable objects in the Nazi Final Solution. These two different directions in Adorno's responses to Auschwitz have shaped much of the subsequent debate about representations of the Holocaust. The remainder of this chapter considers how a community of witness has been formed around the Holocaust through responses to video testimony, television drama and both documentary and fictional cinema—particularly in works by Lanzmann and Spielberg. I argue that this community of witness has not adequately addressed the issues of media commodification and mass politics identified in Adorno's earlier criticism. I close this chapter by discussing Jean-Luc Godard's use of Holocaust images in *Histoire(s) du Cinema* with reference to Benjamin's and Adorno's theories of historical trauma.

The final chapter considers the development of trauma theory after the 9/11 attacks, when the unanticipated mass destruction of American civilians became a global media spectacle. This visibility of civilian death provoked a crisis for narratives of liberal individualism and democracy which trauma theory was unable to fully account for, but nevertheless attempted to address. Consequently trauma has become a more pervasive term in public discourse and the media. The condition of Post Traumatic Stress Disorder has been extended to include the experiences of media viewers and citizens of a global superpower have been encouraged to identify themselves as victims. Does this represent the final incorporation of trauma as a critical concept? Have the powerful now fully subsumed the role of victim? Media commentaries described similarities between the spectacle of the World Trade Center attacks, Hollywood disaster movies and terrorist dramas. Subsequent representations of the events replicated features of these popular genres. Never has a catastrophic event been so rapidly assimilated and absorbed into different modes of representation—the role of media went directly from functioning as a shock absorber to producing a fantasy of history as trauma. I consider this in a discussion of the documentary feature *9/11: The Falling Man* (Dir Henry Singer 2006), which investigates narratives behind the widely circulated images of those who jumped from the burning towers of the World Trade Center.

This leads me to a final consideration of Derrida's and Žižek's different propositions about 9/11. What Žižek calls the traumatic "kernel" of history can be understood in relation to what traditional Marxism called class struggle: that is, as a fundamental antagonism that drives historical change. Thus for Žižek 9/11 presented an intrusion of historical reality into the virtual reality of American hyper capitalism. On the other hand, Derrida questioned what he calls the "compulsive inflation" of 9/11 by media and asks us to re-think the nature of the event as the always-initially incomprehensible arrival of the unknown. In these terms any attempt to immediately interpret or label the event is rendered impossible by its traumatic incomprehensibility. Žižek has criticized Derrida's conception of the event as itself resisting engagement with the real political choices it demands.

Both Žižek and Derrida, however, can be seen as engaging in the common project of re-deploying trauma as a critical or philosophical concept after 9/11 and in the face of its absorption and inflation by the media. I consider the usefulness of these different approaches in a final discussion of the Hooded Man photograph taken in Abu Ghraib prison.

If the experience of trauma remains outside representation, then any critical interpretation of historical suffering can be accused of appropriating the experience of others on behalf of specific cultural and political interests. This is exactly the problem originally addressed by Benjamin, who argued that the experiences of the oppressed ceaselessly disappear from historical representation. Yet only by confronting this danger can criticism engage with history. In addressing this challenge, this book is organized around two concerns: first, understanding the appropriation of theories of trauma in critical responses to visual media; and second, understanding the role that these theories of media themselves play in mediating historical experience. Taking Benjamin's and Adorno's traumatic theories of history as a precedent, I seek to bring these two concerns together to allow me to read the complex critical mediation of the legacies of revolution, terror and genocide in trauma theory.

1 Theories, Histories and Images

The failure of the major political projects of the twentieth century—whether fascist, communist or liberal democratic—to deliver the benefits of modernity without also producing unprecedented forms of catastrophic destruction has often prompted a turning away from images of progressive change to those of mourning and loss. In an attempt to understand what is at stake in this cultural shift this book focuses on two distinct historical periods. The first emerges with the onset of World War II. The flight of Jewish intellectuals from the Third Reich led to the production of several texts that in different ways attempted to outline a theory of historical trauma. In *Moses and Monotheism* Freud theorized a trauma that had shaped Jewish identity for over two thousand years. Benjamin and Adorno adapted other writings by Freud in their different accounts of the modernist aesthetics of Baudelaire and Wagner. These analyses situated the modern artist in a political history, in particular the revolutions of 1848, experienced as an unconscious trauma. Finally, Benjamin's theses "On the Concept of History" pictured history as an endless series of catastrophes. All of these texts registered a political crisis which culminated in total war and genocide. Freud's hopes for a liberal society that would embrace the insights of psychoanalysis and Benjamin's and Adorno's hopes for a progressive Marxist transformation, faced a profound defeat.

After World War II cultural theorists gradually rearticulated the idea of historical trauma. Adorno inherited and first published Benjamin's writings and offered his own meditations on Auschwitz as early as the late 1940s, but he did not present his most famous comments on the significance of the Holocaust until the late 1950s and '60s. During this same period Barthes's writings on the media image shared certain features with the Marxist critique of mass culture pioneered by the Frankfurt School. But in his final text *Camera Lucida*, Barthes formulated a new aesthetic of traumatic loss in which personal affect and private grieving were posed against the banalities of conventional representations in mass media. The trauma theory of Felman and Caruth that emerged in the 1990s continued Barthes's tendency to make trauma an authentic yet ultimately inaccessible experience. These critical accounts, drawing on the experiences of Holocaust survivors, now claimed that traumatic memory constituted a direct, if belated, manifestation of historical truth. However, only exceptional texts, literary

or audiovisual, could transmit this encounter with history and any general critique of contemporary culture disappeared from view. This turn away from cultural critique toward a focus on authentic testimony left trauma theory open to an uncritical participation in virtual communities of witnessing and grieving. This became clearer after 9/11, when accounts of the "trauma" suffered by the American public did little to contextualize the event historically or politically. What is lost in the gradual transformation and increasing centrality of trauma as a concept in cultural criticism is a sense of the broader currents of power and violence that traumatize individuals and populations in the first place. Trauma theory, by focusing increasingly on how trauma is transmitted across time, has lost its grasp of the dynamics of group identification and social exclusion that was a central concern of Freud's, Benjamin's and Adorno's theories of historical trauma.

In this chapter I present a critical reading of contemporary trauma theory that includes both influential texts by Caruth, Felman and LaCapra and research that has pursued their arguments further with reference to modern visual media. Caruth and Felman theorize traumatic memories and symptoms as literal traces or physical embodiments of the historical real. They discuss specific film and video texts as representations of historical trauma but they do not develop any broader critique of contemporary media culture. Subsequent research on photography and film, by scholars such as Ulrich Baer and Joshua Hirsch, includes a more sophisticated analysis of media technologies and codes of representation but nevertheless reproduces Caruthian formulations regarding the transmission of traumatic experience. This focus on the transmission of trauma through visual media often assumes acts of identification with specific political communities. LaCapra, while critical of Caruth and Felman, shares their commitment to testimony and witnessing as central concerns of cultural criticism. However, I argue that LaCapra's emphasis on empathy assumes a liberal conception of individual agency that cannot adequately account for the political violence that is the cause of so much traumatic experience. I consider an alternative genealogy of critical thought in the writings of Freud, Benjamin, Adorno and Barthes that has been under-represented or misinterpreted in "canonical" trauma theory. These earlier theorists suggest an understanding of historical trauma that more fully acknowledges the role of both technological mediation and unconscious fantasy in shaping collective experience and identity in modern Western societies. Their work presents us with tools for a critique of contemporary trauma theory and suggests possible directions for further research.

THEORIES

The 1992 publication of *Testimony* by literary scholar Shoshana Felman and psychoanalyst Dori Laub was a turning point in contemporary trauma

studies. The collaboration of Felman and Laub brought together two distinct (and many would have thought antithetical) areas of research being conducted at Yale University: the version of deconstructive literary criticism developed by Paul De Man and the recording of the testimony of Holocaust survivors in the Fortunoff Video Archives. Laub's accounts of working with survivors and Felman's readings of literary texts shared the objective of allowing the traumatic past to speak indirectly through symptomatic gaps, silences, erasures and distorted memories in the discourse of victims of, and witnesses to, historical catastrophe. Deconstructive readings, by attending to apparently insignificant or marginal details that may reveal what a text may ostensibly disavow or "repress," already owed much to psychoanalytic method. In his close readings of Romantic and Modernist European literature, De Man had shown how the tropes, or figures, around which texts were structured always revealed fundamental contradictions, or aporias, leading to an ultimate undecideability of meaning. What was strikingly innovative about *Testimony* was not the influence of De Man, but the way it brought together examples of canonical modern literature—by Dostoevsky, Camus, Celan—with video texts featuring "ordinary" people. Whereas this conjunction potentially raised wide-ranging questions about cultural value, such issues were never addressed in the book. Rather, the juxtaposition of Holocaust testimony with classic literature tended to elevate the former to the status of extraordinary text.[1] This tendency is extended further in the long essay by Felman on Claude Lanzmann's nine-hour film *Shoah* (1985), a documentary on the Nazi Final Solution, which closes the book. In this essay Felman argued that the testimony of survivors, perpetrators and witnesses recorded on film constituted a symptomatic embodiment of a traumatic history.

Responding to the widespread criticism that deconstruction was theoretically abstruse and politically evasive, *Testimony* attempted to return historical experience to the center of literary criticism.[2] Yet in doing so it turned to film and video texts: cultural forms that were more directly engaged with contemporary audiences and practices of media consumption. Felman's and Laub's approach to *Shoah* and the video texts from the Fortunoff archive drew something from earlier studies of the literature of testimony by scholars such as Terence Des Pres and Lawrence Langer. What was at stake for Felman and Laub in this project was to introduce into literary criticism and psychoanalysis "the dimension of the real—the events and implications of contemporary history" (*Testimony* xvi). This was an extraordinary claim, as it presumed these interpretive practices had up to this time been somehow immune from historical reality. The authors granted a special status to *Shoah* as "the work of art of our time" (xix). According to Felman this film was more than an historical document: it offered unprecedented insight into "the complexity of the *relation between history and witnessing*" (205) and revealed an *"historical crisis of witnessing"* (206). For Felman the incommensurability of different acts

of witnessing by victims, perpetrators and bystanders revealed a traumatic crisis of truth posed by the experience of the Holocaust. Felman's reading of *Shoah* gave what had been commonplace in documentary film and television—the presentation of different points of view—the combined weight of both a deconstructive theory of the limits of representation and arguments for the historical singularity of the Nazi genocide.

By focusing on Holocaust testimony Felman and Laub made ethical claims for acts of viewing media texts, but consideration of the broader question of the role of film and television in shaping the perception of traumatic experiences was not part of their book's project. However, representation of the Holocaust had already been at the centre of heated public debate in West Germany after a 1979 screening of the American television miniseries *Holocaust* (NBC 1978). Some commentators celebrated the ways in which the television drama unleashed the first widespread discussion of the Nazi era in postwar Germany. Others attacked the series as melodramatic kitsch or an insult to victims (Kaes 28). Overall the drama's supposed lack of authenticity was not as important as the ways in which it allowed new positions of identification to arise. Presenting the Holocaust as melodrama enabled audiences in both America and West Germany to declare their empathy for, and identification with the victims. Much of the substance of the debates around *Holocaust* were repeated after the release of Steven Spielberg's *Schindler's List* (1994). Lanzmann's public attack on Spielberg's film directly stated the attitude towards popular entertainment and mass media implicit in Felman's and Laub's book. This distaste for mass culture, along with a commitment to the authenticity of Holocaust video testimonies, was given more direct expression in a collection of essays by Geoffrey Hartman, *The Longest Shadow* (1996). Hartman, himself a Jewish exile from Nazi Germany, was also one of a prominent group of deconstructive critics at Yale. As he put it, the video testimonies displayed "a special counter-cinematic integrity" (Hartman 139).

Although Felman's and Laub's readings of testimony on video and film stressed what could not be said or shown about traumatic experience, their appeal to the exceptional quality of Holocaust testimony also depended on the authority of the testimonial embodied in the visual and aural presence of the survivor. These contradictory impulses regarding realism in this interpretation of media were based, on one hand, on psychoanalytic theory and, on the other, on direct presentation of evidence. The elevation of testimony to exceptional text echoed a commitment by earlier theorists such as Benjamin, Adorno and Barthes to avant-garde aesthetics, and yet articulated a new "traumatic" realism. Importantly, however, the validation of testimony as cultural form was no longer accompanied by an analysis of unconscious fantasy in individual memory or in mass culture. Trauma had been isolated and elevated as a cultural category.

Trauma theory chose to engage only indirectly with the mass popularity of, and public debate around, television and film dramatizations of the

Holocaust. In doing so it avoided issues of collective identification that remained unspoken in its own commitment to recorded testimony. This interest in visual media removed from its cultural and political contexts continued in Caruth's edited collection *Trauma: Explorations in Memory* (1995), which included an interview with Lanzmann and an essay by Laub on video testimony. These essays were framed by short theoretical introductions by Caruth in which she argued for the difficulties, and even impossibility, of adequately representing traumatic experience. She proposed that Post Traumatic Stress Disorder posed a limit case not only for psychiatry, but also for historical and literary analysis. She offered the following definition of PTSD:

> a response, sometimes delayed, to an overwhelming event or events, which takes the form of repeated, intrusive hallucinations, dreams, thoughts or behaviours stemming from the event, along with numbing that may have begun during or after the experience, and possibly also increased arousal to (and avoidance of) stimuli recalling the event. ("Introduction" 4)

Caruth went on to propose that this pathology cannot be defined "in terms of a *distortion* of the event":

> The pathology consists, rather, solely in the *structure of its experience* or reception: the event is not assimilated or experienced fully at the time, but only belatedly, in its repeated *possession* of the one who experiences it. To be traumatized is precisely to be possessed by an image or event. ("Introduction" 4–5)

And while Caruth referenced Freud on the uncanny return of traumatic memory, she turned to PTSD in order to define the "*literality* and non-symbolic nature of traumatic dreams and flashbacks." Although Caruth's stress on the literality of traumatic memory is directly influenced by the neurobiological research of Bessel Van der Kolk (whose essay is included in the anthology), we should also note the importance of Felman's and Laub's research on video testimony and *Shoah*. Caruth explained the literality and immediacy of trauma with reference to PTSD, but from the outset it was also related to the status of photographic, filmic and video image in contemporary culture.

This relation between trauma theory and media became more explicit in subsequent research. Eduardo Cadava's *Words of Light* (1997) cited Caruth's articulation of the structure of traumatic memory in support of an interpretation of Benjamin's writings as a "photographic" theory of history. Cadava made the Caruthian proposition that "for Benjamin, history can be grasped only in its disappearance" (Cadava 104). In *Spectral Evidence* (2002) Ulrich Baer further developed the conjunction of trauma

theory and Benjamin's notion of the optical unconscious, proposing that the photographic image shares the structure of traumatic memory as the literal trace of an event (Baer 11). Benjamin's use of Freudian psychoanalysis, however, was significantly different from the deconstructive criticism of Caruth, Felman, Cadava and Baer. Where Benjamin had stressed a political appropriation of memory in the struggle for an oppressed past (4: 391), deconstructive trauma theory discovered an ethical imperative (and thereby a certain moral authority) in the paradoxical act of witnessing a past event that resists both memory and representation. The differences between these two accounts also pertain to their relation to modern media. Deconstructive trauma theory, despite its stress on the limits of representation, has paradoxically aligned a realist claim for the photographic, filmic or video image with the literal quality of traumatic memory.

Although PTSD has a central place in recent trauma theory, Freud also remains a consistent reference. Kaplan and Wang argue that Felman's and Caruth's formulations of trauma can be traced to Freud's model of psychic dissociation and is extended by Van der Kolk's theory of traumatic memory as retained in a separate part of the brain. Following LaCapra, they see the stress on the inaccessibility of trauma to conscious memory and representation as leading to a withdrawal from engagement with social change. Kaplan and Wang propose that throughout his career:

> Freud alternates between seeing trauma as the result of an external event, such as a train accident, war, or family abuse, leading to dissociation; and treating trauma as caused by an internal assault on the ego, stemming from the Oedipal crisis (including fantasies of sex with parents or relatives, and narcissistic impulses); or from internalized loss of a loved one, as in melancholia, and so on. (Kaplan and Wang 6)

Overemphasizing the dissociation model reduces ambivalence and ambiguity in Freud's thought, where even dissociated memories become subject to revision and fantasy as they emerge into consciousness after significant temporal delays. The dissociation model, argue Kaplan and Wang, reinforces the withdrawal of individual memory from social engagement and historical consciousness. In short, the dissociation model is complicit with the privatization of traumatic memory. This critique is consistent with some of Benjamin's and Adorno's early reservations concerning Freud, whose focus on the bourgeois individual, they argued, blinded him to the larger political and historical stakes of psychoanalysis.

Freud also maintained a certain ambivalence toward photography. Freud's earliest studies of psychic trauma, in the Paris clinic of Jean-Martin Charcot, reveal an early link to photography. Charcot had extensively documented and publicized his hysterical patients with photographs. But Freud never directly engaged with photographic practice, although he made reference to it in his explanations of the structure of the unconscious. Freud's

and Breuer's *Studies on Hysteria* (1895) proposed the "seduction theory" which traced the origins of hysteria to specific sexual experiences in childhood. Freud later rejected this model of trauma in favor of one in which traumatic experience was constituted retrospectively utilizing both memories and recent experiences and only assumed psychic significance through the workings of fantasy and desire. In other words, Freud decided traumatic memories could not be accepted as literal accounts of things that happened. However, the literal nature of the photographic image had a cultural impact that Freud never addressed. Photography showed hysterics to the wider world for the first time and later revealed atrocities of World War I that had been previously censored by the state. Photographs revealed new dimensions of human experience: individuals helpless in the grip of psychic disturbance; mutilation by industrial age military technologies; annihilation by mass extermination.[3] The catastrophe of World War I and the widespread pathology of shell shock confronted Freud with a new problem. Surely war trauma could be explained in terms of external forces impacting on passive victims? Freud, however, again attempted to integrate war trauma into his theories of the ego and libido, explaining it in terms of a conflict between the pre-war self and the new combat-oriented self. Freud's model of the individual subject could not accommodate the images of "bare life" presented by photography.

In *Moses and Monotheism* (1939) Freud formulated a theory of collective trauma experienced by the Jewish people over long periods of history. This extension of trauma to a theory of history was preoccupied with the tension between the individual (Moses) and the crowd. Moses imposed a demand on his people (monotheism) that they initially rejected but were unable to free themselves from over time. This question of collective identity also dominates two other texts that were contemporary with Freud's. Both incorporated, in somewhat different ways, the Freudian theory of trauma into their historical analyses: Benjamin's essay "On Some Motifs in Baudelaire" (1940) and Adorno's *In Search of Wagner* (1938). These three texts, composed during the onset of European war by Jewish intellectuals forced into exile by the Nazi state, all develop theories of historical trauma that, explicitly or implicitly, address the dynamics of mass politics. In both Benjamin's and Adorno's essays modernist aesthetics are considered as part of a larger historical dynamic of revolution and fascist ideology. In both texts the individual artist articulates a traumatic relation to the larger social collective.

These earlier theories of historical trauma present a critique of mass psychology. As I will show in more detail in subsequent chapters, these texts make assumptions about collective identity based in racial stereotypes and Eurocentric perspectives of history. However, they do situate trauma in political contexts in ways that deconstructive trauma theory has neglected to do. LaCapra has distinguished what he calls "historical trauma" from "structural trauma" in order to emphasize the ways in which traumatic

experience is embedded in specific events and contexts rather than merely replicating certain psycho-linguistic structures (*History and Memory* 46–47). For example, in *Unclaimed Experience* Caruth discusses the historical trauma in *Moses and Monotheism* as "an endlessly incomprehensible violence that is suffered, repeatedly, both as the attempt to return to the safety of closeness and as the traumatic repetition of the violent separation" (69). In Caruth's reading historical trauma and structural trauma are ultimately indistinguishable. In Chapter 2 I propose that *Moses and Monotheism* responded to specifically modern forms of state violence and that Freud's meditations on Jewish identity displaced a more urgent threat to his political rights.

My approach to the question of historical trauma is also influenced by Agamben's theory of sovereign power in which the state establishes and maintains its power through the violent exclusion of specific individuals and populations. This understanding of power contrasts with liberal political visions in which individuals attempt to influence the state through democratic participation and in which violence by the state is seen as a last resort or necessary evil. Whereas the liberal vision emphasizes the importance of empathy with the suffering of individual victims, Agamben's theory of sovereignty demands we understand contemporary preoccupation with trauma with reference to legal and political structures. Agamben has taken up Foucault's discussion of biopolitics to consider the extension of politics to the domain of biological life. Modern forms of biopolitics include the Taylorist control of labor, the diagnosis and treatment of psychological illness, the Nazi Final Solution and genetic engineering. The central protagonist in Agamben's account of biopolitical power is *homo sacer*, *"who may be killed and yet not sacrificed"* (*Homo Sacer* 8). *Homo sacer* is subject to an act of exclusion ("the ban") through which sovereign power is constituted. Thus "the production of bare life is the originary activity of sovereignty" (83). In Agamben's theory *Homo sacer*, once a marginal figure, has become no longer the exception but the rule: All members of society are increasingly subject to surveillance and control at the level of "bare life," or biological existence. Agamben argues that our understanding of the problem of bare life has been obscured by anthropological theories of the sacred that have emphasized semiotic ambiguity rather than the question of political violence. For these reasons Agamben sees the "sacrificial aura" (114) connotated by the term Holocaust as confusing the problem of genocide as an extreme form of modern biopolitics.

Although he does not cite them, Agamben's argument shares certain features with Adorno's and Horkheimer's discussion of sacrifice in *Dialectic of Enlightenment*. Adorno and Horkheimer argue against the irrational glorification of sacralized violence as a recovery of communal identity and the over-coming of social alienation. They propose that rituals in ancient or "primitive" societies already included the basic principle of exchange that underlies modern capitalism. The substitution of one object for another

in sacrifice is already founded on rational calculation. Sacrifice attempts to negotiate something (for example, a victim) in exchange for another (for example, appeasement of supernatural forces). Christian religion's self-sacrifice is self-preservation by other means: Earthly life is given up for spiritual immortality (Jarvis 28–30). If we read Adorno's and Horkheimer's argument in conjunction with Agamben's, we can understand the moral elevation of the trauma victim or survivor as an attempt to sublimate the condition of bare life and thereby preserve a liberal individualist conception of identity.

To the extent that trauma theory has engaged with the challenge of historical reference it has tended to neglect the relation of the hysteric, the war victim and the refugee to structures of political sovereignty. What Caruth calls the "impossible history" of traumatic memory is also a political history. The origins of this challenge can be traced at least as far back as Freud, whose various attempts to articulate the challenges of trauma can be linked to specific political crises such as World War I and the rise of the Nazi state. Freud's focus on the individual, as early critics such as Benjamin and Adorno perceived, blinded him to the political determinations of the unconscious. We can also see now that it left him unable to confront the problem of bare life, which he attempted to theorize away in terms of individual ego. Given that colonization, denationalization and total war has left large populations without political rights and subject to actual liquidation, the following chapters will consider how this biopolitical and geopolitical history has been both confronted and evaded in the texts of trauma theory, from Freud to responses to 9/11.

HISTORIES

The encounter between deconstructive criticism and the testimony of Holocaust survivors led to a contrast being made between authentic of traumatic experience and images produced by dominant media culture (such as melodrama). This critique associated collective identification with the trauma of the Holocaust with a general bracketing of all forms of its representation. However, as I have shown, from the outset deconstructive trauma theory discussed visual media texts. Indeed it is difficult today for those living in "media saturated" societies to conceive of a collective experience of trauma without considering the role of visual media in representing and transmitting that experience. Catastrophe has become part of the daily fare of news and entertainment in unprecedented ways. The Holocaust has become codified through literary and media representations that reproduce specific narrative and dramatic conventions. The "Holocaust code" has also become an interpretive frame through which events such as the Gulf War or 9/11, are explained. The enemy, whether Saddam Hussein or Osama bin Laden, is invariably fascist and victims always need to be rescued by defenders

of freedom and democracy. The Holocaust also prompts uncomfortable present day parallels when applied to Israeli–Palestinian conflict (Tal 6–8; Lentin 11–13). Whereas images of human suffering are too often situated in a zone inhabited by 'others' who remain outside the range of our empathy, certain representations—for example those of Jews in the Holocaust, Allies in the world wars, Americans in the Vietnam War and civilians in 9/11—have become important sites of Western liberal identification. These media representations are supported by historical argument and psychotherapeutic research that seeks to establish their "traumatic" status as exceeding the direct experience of specific individuals.

Ruth Leys has explained how an emphasis on trauma as an exact repetition or literal trace of an original event has given rise to speculations about establishing a neurobiological basis for trauma. Any theory that trauma is distinguishable from other forms of memory because it is retained in the body as an indelible imprint of an experience supports the notion that revelations of a hidden traumatic cause can achieve therapeutic results where other forms of diagnoses and treatment might fail. Trauma, thought of in these terms, can also explain forms of illness or psychological stress that have no apparent cause. Psychotherapeutic discourses surrounding PTSD—emerging first in relation to Vietnam veterans, then child abuse victims, Holocaust survivors and, more recently, indigenous peoples—have supported new processes of personal and collective grievance and political and legal struggles for recognition and reparation.

The relation between the traumatized individual and political community was a central concern of Judith Herman's influential *Trauma and Recovery*. Herman evoked a scenario in which trauma victims were intimidated into a condition of isolation and silence that enhanced the power of the perpetrator. Thus Herman understood the recovery of traumatic memory as a part of a larger power struggle in which the victim gains the support of a political movement (Herman 7–9). Herman cited both the feminist and anti-war movements as examples of such responses to traumatic experience. On this point Susannah Radstone has distinguished the psychoanalytic approach to trauma from other prominent theories in psychology and psychiatry such as PTSD. According to Radstone, these approaches return to Freud's earlier formulation of the seduction theory and seek to posit an original event which recurs as a traumatic memory and can thereby be clearly situated in a linear, cause-and-effect model of history. For Radstone, only psychoanalysis emphasizes the *mediation* of trauma by psychical processes ("Screening Trauma" 88–89). Freud came to the conclusion that trauma is not simply registered by the unconscious, but is always mediated by fantasy. Radstone argues that the question of mediation has important implications for what she refers to as "victim culture" (90), which seeks to link social disadvantage or political marginality to historical events that have had long-term effects on particular groups. For Radstone such an interpretation of history from the point of view of victimhood needs to be considered as itself

mediated by "primal fantasies" reproduced in the form of ahistorical structural binaries; for example, innocent or powerless victim versus demonic, omnipotent persecutor.

As I have argued, trauma has come to function as a definer of cultural identity, but debates about "victim culture" can also neglect the larger, global horizons that define the problem of identification with the victim. The "iconic" traumas of modern media—Vietnam, the Holocaust, 9/11—can be understood as symptoms of a deeper crisis emerging from the historical impact of imperialism, colonialism and globalization. If European imperial expansion had not occurred, there would be fewer historical "victims" who today compete for cultural, political and legal recognition. I argue that the politics of trauma should not be limited to debates about the validity of competing claims to the rightful status of victim. Rather, trauma needs to be understood as embedded in a larger process of understanding one's place in the world, specifically the problematic status of the West's claim to the universality of its historical projects. Today trauma discourse has become a site where different historical experiences and social traditions, such as those of ethnic minorities and colonized peoples, are brought into play in negotiation with Western modernizing forces. These negotiations present certain contradictions as well as challenges and ruptures to an understanding of modernity as a Western hegemonic project.

In the following chapters I argue for an understanding of historical trauma that is critical of Eurocentric assumptions about identity. In Western liberal thought human history is interpreted as a narrative of progress towards greater liberty, equality and prosperity. This promise is premised on rational thought and behavior. The universalist ideal of liberal democracy remains an important part of the rhetoric of Western global hegemony in the twenty-first century, despite the appalling human catastrophes of the past hundred years, including total war, genocide, mass incarceration and the use of nuclear weapons. Jenny Edkins explains how, according to the liberal account, the state represents the interests of individual citizens. She contrasts this account with Agamben's analysis of sovereign power in which the state is founded through an imposition of force in a situation of emergency or exception. The state of exception founds the legal power of the state, yet is paradoxically outside the law. To what extent, asks Edkins (*Trauma* 10–11), does trauma testimony reproduce notions of the sovereign individual citizen, and when might it, conversely, challenge the sovereign violence upon which rests the power of the state? The distinction Edkins draws is a crucial one because it alerts us to two fundamentally different accounts of trauma: trauma as a question of empathy for, or identification with, individuals or groups, or alternatively trauma as part of a critical theory of society.

Edkins distinguishes two forms of political community that are formed around collective trauma. Whereas any imagined community, particularly the nation, is founded on violent events such as war, revolution and genocide, these events are commemorated with pride as a shared sacrifice for a

desirable goal. However, when survivors return from war suffering combat trauma—such as happened after World War I or the Vietnam War—narratives that legitimize violence on behalf of a nation are called into question. Worse still, mass death of civilian populations in World War II and subsequent conflicts has further shaken belief in the nobility of war. War crimes, including genocide, have been publicly denied leading to a failure to memorialize entire communities or an inability by survivors to communicate the horror of their experience. The documented experiences of traumatized war veterans being betrayed by a state that should have protected them has led to a crisis of trust for some in national identity and national institutions. However, Edkins claims the state can also appropriate the experience of trauma to further justify its sovereignty (Edkins *Trauma* 1–7). In Chapters 5 and 6 I will discuss this dynamic of identification and appropriation in representations of the Holocaust and 9/11.

Agamben has proposed an alternative model for political community, one that is neither the state or existing social movements based on claims of shared identity (such as ethnicity, gender or sexuality). Agamben argues that identity politics ultimately demand recognition from the state, but what the state cannot tolerate is the formation of a community that makes no affirmation of collective identity (Edkins, "Whatever Politics" 74). Such politics would reject the struggle for human rights, which is also dependent on recognition by the state (75). Agamben has proposed that the "refugee is perhaps the only thinkable figure for the people of our time and the only category in which one may see today . . . the forms and limits of a coming political community" (*Means without End* 16). Drawing on the work of Hannah Arendt, Agamben looks to the refugee experience, rather than Jewish identity as such, as the basis of imagining community beyond the nation–state. The image of the stateless person is one that I will pursue in my readings of trauma theory in subsequent chapters. By attending to images of bare life (the hysteric, the colonized indigene, the camp inmate and the victim of terror) I seek to reveal the political forces and structures that define individual and collective trauma.

IMAGES

The adoption of trauma theory by film studies scholars and media analysts has led to a new set of debates about representation. If traumatic experience resists representation, as Felman and Caruth argue, then aren't all representations in modern media inherently inadequate, inappropriate or even obscene? Perhaps, as Baer has argued, the photograph could be approached in terms of its structural analogies with traumatic memory, thereby allowing us to read the "unconscious" of the image. Or should we, as Kaplan and Wang propose (and as I discussed in my Introduction), learn to engage with "inadequate" representations in modern media? In their anthology

The Image and the Witness, Frances Guerin and Roger Hallas write of an "iconoclasm that pervades the production, dissemination and philosophy of the image" (Guerin and Hallas 2). The proliferation of images in contemporary media culture has led to skepticism about the veracity and ideological complicity of media images.

Modern media criticism forms an intrinsic part of this iconoclastic tendency in contemporary culture, as it seeks to expose the ways that images are constructed and manipulated, often in the interests of power elites. Re-engaging with the capacity of media images to bear witness, as Guerin and Hallas propose, may be one useful way to resist this tendency. But the criticism of Benjamin and Adorno reveals other approaches to theorizing images and to engaging with historical trauma that serve as models for my own approach. Benjamin devised a critical technique of constructing "constellations" which owed something to the aesthetics of ruins that he had excavated in German Baroque drama and to both psychoanalytic free-association and Marxist ideology critique. As in the chance juxtapositions favored by the Surrealists, modern life turns up surprising encounters between culturally and historically disparate materials. In these images of the past can be discovered remnants of "oppressed histories" and forgotten and discarded social fantasies. The construction of these images into a montage creates the shock effect Benjamin saw as a defining experience of modernity and of modernist aesthetics. As with traumatic memories, it is what has been denied or unacknowledged by conscious perception that can reveal the most radical new perspectives on the past and potentially new means to transform the present. Adorno famously criticized Benjamin's constructions for being insufficiently mediated by social theory: they were too preoccupied with the aesthetic effects achieved through direct presentation. Nevertheless Adorno also adopted and adapted Benjamin's methods in his own writings. Whether understood as "dream images," "thought images," "historical images" or "dialectical images," the image for these thinkers does not represent traumatic experience in any direct sense but rather embodies a disturbance that is at the same time emotional, intellectual and political.

In the past hundred years we have seen a gradual transformation of images designed to invite collective identification and inspire collective political agency. Images of mass politics—the great leader, the brave soldier, the heroic worker or peasant, the glamorous celebrity, the grotesque minority or bestial enemy—have been employed as part of a mobilization of nations and international political movements and increasingly include representations of traumatic loss. Political power has also been mobilized around images of victims of violence. The most striking recent example of this is 9/11. The first photographic revelations of war atrocities and mass death post-World War I already anticipated the Holocaustic images that permeated the media after Auschwitz. From wars in Vietnam, Cambodia, Rwanda, Bosnia, Afghanistan, Iraq and elsewhere, images of catastrophe

and atrocity have become increasingly familiar. In the writings of Benjamin, Adorno and Barthes we can trace earlier attempts to grasp this new traumatic reality of modern culture and politics and to think through its traumatic logics.

The "dream images of the collective" (*Dreamworld and Catastrophe* 64–65) that Susan Buck-Moss described as seeking to establish mass sovereignty—the general strike, the mass rally or demonstration, the spectacles of mass production and consumption—have been matched by images of catastrophic destruction and mass death. If this negative image of mass sovereignty, manifest in events such as the Holocaust or Hiroshima, has become the more properly "sublime" manifestation of contemporary political vision, then we are faced with a crisis of political agency and an inability to imagine a progressive future. Although he rejects psychoanalytic theory, Jeffrey C. Alexander argues that nations and other imagined communities adopt traumatic narratives when there is an abrupt and unexpected disturbance to "the patterned meanings of the community" (10). For Alexander trauma narratives address a crisis of collective identity. These narratives can also create a sense of national trauma as the basis for acts of violent retribution and revenge. After 9/11 victims of political terror became emblems in the service of the 'war on terror.' The catastrophes of the Holocaust and 9/11 have both served important political functions in the articulation of national identity. Contemporary states demonstrate that traumatic histories can be negotiated symbolically and used to support further violent acts.

In the following chapters I will explore the logics of trauma and political sovereignty in more detail. The remainder of this chapter organizes a complex set of theories and debates into three different approaches to the media image in trauma studies.

The first, which I will call the *traumatic image*, shows us something physically or psychically traumatic: someone is being, or has been, threatened, attacked, abused, starved, imprisoned, enslaved, tortured, murdered or executed, or is shown responding to the reality or consequences of some catastrophe. The image may alternatively show a place that has been destroyed by natural or man-made forces. Traumatic images have potential to shock or disturb the viewer. This potential can be reduced by their reiterations. Modern media has made many traumatic images available to a wide public but exposure to the same media has allowed viewers over time to insulate themselves against the impact of such images, or even to partake in a fascination or voyeuristic pleasure in them. The traumatic image can become "trauma porn." Susan Sontag, John Ellis and Barbie Zelizer have written important essays on these different responses to the traumatic image.

A second approach to the media image in trauma studies is based on the idea of *structural trauma* and is concerned with temporal delays of traumatic memory as understood by psychoanalysis. Freud stressed the belated nature of traumatic memory and how trauma was only formed through

retrospective alignment of experiences and fantasies with memories of earlier events. An image may thereby become associated with a traumatic experience without directly showing anything physically or psychologically traumatic. Several theorists have seen modern media images, beginning with photographs, as participating in a structure analogous to that of traumatic memory. Benjamin was the first to suggest such an analogy with his notion of an "optical unconscious." Critics such as Eduardo Cadava and Urich Baer have pursued this question further in relation to photography by incorporating the deconstructive approach to trauma developed by Caruth.

A third approach to the media image in trauma studies is based on a concept of *historical trauma*, a term that refers to events recognized as traumatic for specific groups of people. These often become signifiers of collective identity—for example: war, revolution, conquest, colonization, genocide, slavery and natural disaster. The memory or commemoration of historical trauma may or may not include literal representations of traumatic experiences. Any person or persons may identity with victims of an historical trauma without experiencing anything directly traumatic themselves. Historical trauma can also be understood as a form of identity crisis involving unresolved ethical, philosophical or political issues. This concept of historical trauma has its philosophical roots in Benjamin's theses on history and Adorno's meditations on culture "after Auschwitz." These critics also developed innovative approaches to representing historical trauma influenced by the constructions of psychoanalysis and the aesthetics of montage.

I argue that a focus on both the traumatic image and structural trauma has led to an exceptionalist approach to media criticism. Either the content of the image (what it shows) is related directly to some traumatic experience or the temporal relation of the image to past events is understood as participating in the structure of traumatic memory. An alternative approach that I explore is one that makes a reference point of historical trauma and thereby makes a case for the political significance of specific instances of violence, suffering or catastrophe in the past. I argue that images cannot be "traumatic" in themselves, and if *all* photographs share the structure of traumatic memory then the analogy loses its value. If a film reproduces the structure of traumatic memory, this mimetic process can also be seen as undermining claims that trauma is an authentic form of experience. Whereas any image might also be interpreted with reference to historical trauma, such an interpretation will be persuasive to the extent that it clarifies the geopolitical stakes of critical approaches to the media.

The Traumatic Image

Discussions of the traumatic image tend to revolve around arguments for and against its ethical or political potentialities. In *Regarding the Pain of Others* (2002), Susan Sontag asks if photographs continue to have the

power to shock or to provoke moral resolve. She also acknowledges that photographs documenting the suffering of war may have power to mobilize militant response. In a traumatic image the victim invariably belongs to a group, a political movement, an ethnicity or a nation (*Regarding* 8–10). Yet something else happens, writes Sontag, in societies characterized by intensive production and consumption of information: "In an era of information overload, the photograph provides a quick way of apprehending something and a compact form of memorizing it" (22). For this reason the power of the photographic image to shock has long been integrated into commercial imperatives of media and marketing. Professionalization of photography has led to ascribing the shock of the real to the amateur, and therefore more authentic, image (27). This dialectic of manipulation and authenticity in the media has been overtaken by what Jean Baudrillard called a logic of hyper reality in which the original becomes indistinguishable from the fake (*Simulacra* 81). Witnesses to the 9/11 attacks for instance persistently described the experience as "like a movie." Sontag rejects Baudrillard's analysis and argues against the dangers of universalizing "the viewing habits of a small, educated population living in the rich part of the world" (*Regarding* 110).

Sontag concludes that there remains an ethical imperative to recognize and recall the suffering of others and the extent of human cruelty. She comments that bearing witness to suffering and cruelty as revealed by photographs is a part of "moral or psychological adulthood" (114) today. She describes the response to these images as being more often one of political frustration on the part of the viewer at being unable to affect the causes of the shown events. John Ellis also writes of "the experience of witness" (9) involving feelings of "separation and powerlessness" (11) mixed with guilt and complicity. In an earlier essay on this question John Berger makes the same point more forcefully. For Berger photographs of extreme suffering confront viewers with feelings of "moral inadequacy" (40) which effectively disperses the shock of the image. Such images are widely available in the media, despite their implicit incrimination of our governments, and their effect is ultimately to depoliticize public response through feelings of impotence.

Sontag's argument for the ethical imperative of witnessing remains something of a noble gesture in the face of media's influence and its orchestration of public opinion. However, despite image proliferation and viewer saturation the ethics of witnessing remains a concern for media critics. In her discussion of Holocaust photography Barbie Zelizer acknowledges that photographs are inherently open to selection, manipulation and misinterpretation in ways that support "identity formation, power and authority, and political affiliation" (*Remembering* 3), but she also proposes that "Bearing witness constitutes a specific form of collective remembering that interprets an event as significant and deserving of critical attention" (*Remembering* 10). Zelizer's later study of journalism and 9/11 goes further in assigning the media a therapeutic role. She claims that after 9/11

American media "newsworthiness was pushed aside to accommodate the images' role in helping people bear witness" ("Photography" 56). This process of bearing witness "brings individuals together on their way to collective recovery" (52).

In these propositions Zelizer adopts a remarkably benign view of the ways news media achieve political consensus. If media are always selective and the meanings of images always contextual, then it is misleading to speak of media "covering trauma" (51). It would be more accurate to consider the media as defining and representing certain events as "traumatic." The political implications of this distinction are clear from Zelizer's comments:

> When trauma involves international assaults, such as the planned violence typical of terrorism and military action, recovery from trauma often involves mobilizing the collective to agree on a plan of compensatory action for the trauma experienced. ("Photography" 49)

The construction of the previous passage assumes such a thing as "trauma" which demands "compensatory action." If only certain events are defined as "traumatic" and are constituted as such by the media, we then see more clearly the political implications of that act of definition, along with its potential consequences in the realms of violence, terrorism and military action.

In her commentary on 9/11, E. Ann Kaplan seeks to differentiate a range of responses to traumatic events. Her approach also appears to assume that specific events are traumatic as such. People do not, as Kaplan claims, "encounter trauma through the media" (2). Viewers are presented with representations of various events, only some of which may be traumatic for those who experience or witness them. What Kaplan calls "mediatized trauma" (2) can only include *either* media representations and discourses that define particular events and experiences as traumatic *or* media representations that are experienced as traumatic for the viewer. Traumatic experience cannot be directly transmitted *through* media.

Kaplan's account of individual and collective trauma visible on the streets of Manhattan after the World Trade Center attacks becomes a reference point by which she analyzes and evaluates mainstream media representations of events. This approach again makes the direct experience of trauma a measure of the real. A more valid approach would be to ask how and why media representations defined these particular events as traumatic when so many other events involving massive human suffering were and are not so defined? Whenever we hear the phrase "traumatic event" we need to ask: for whom is the event traumatic?[4] If we assume events and their representations are not traumatic in themselves, we need to critically examine the role media plays in reproducing traumatic effects and traumatic structures of memory and forgetting. Rather than measure media representations against more direct forms of traumatic experience, media needs to be

considered in terms of its own "traumatic" logics, some of which may be usefully understood with reference to psychic trauma, although not in the same sense as direct human experience of a physical event.

Structural Trauma

The concept of structural trauma turns on a proposition that traumatic memories unconsciously transmit literal traces of an external event. Some theorists of photography and film argue that these media can reproduce the structure of traumatic memory. Leys has argued that a recent emphasis on the traumatic event/image can be traced to an original diagnostic criteria for PTSD listed by the American Psychiatric Association. This defined the traumatic event as intrinsically stressful to anyone who experienced or witnessed it and moved away from earlier psychoanalytic approaches to trauma that emphasized a subjective mediation of experience. By defining trauma as a kind of event, PTSD shifted attention away from the psychic history of the individual to the impact of the external environment (*Guilt to Shame* 94). For example, in Herman's *Trauma and Recovery* trauma is suffered by powerless victims and is clearly aligned with the sexual and violent abuse of women and children. This emphasis on victimhood interprets traumatic experience within a clear polarity of external forces acting on a passive subject. The notion of an event intruding on the interiority of the individual also supports an understanding of traumatic memory as an "indelible imprint of the traumatic moment" (Herman 35). This insistence on the exteriority of the event/image to consciousness effectively dissociates traumatic memory from other processes of desire and fantasy. Herman also asserts that "Traumatic memories lack verbal narrative and context; rather, they are encoded in the form of vivid sensations and images" (38).

Leys explains how physicians had tended to theorize traumatic memory in terms of iconic rather than verbal representation (95) and associates this tendency with Caruth's formulations of trauma as a literal trace of an external event. Her critique of this emphasis on the external traumatic event/image is part of a larger argument developed in her earlier *Trauma: A Genealogy* (2000). Investigating the larger history of psychotherapeutic approaches to the problem of trauma, Leys identifies two conflicting tendencies in trauma theory that she calls "mimetic" and "antimimetic." Mimetic theory posits processes of unconscious identification and psychic regression resulting in compulsive behaviors and symptoms that replay the traumatic "scene." Mimetic theory can be closely aligned with Freudian psychoanalysis. By contrast, antimimetic theory emphasizes a "strict dichotomy between the autonomous subject and the external event." This second approach tends to understand trauma as "a purely external event that befalls a fully constituted if passive subject" (*Guilt to Shame* 9) and rejects or ignores any dimension of unconscious desire or fantasy in determining an experience as traumatic.

Leys's historical analysis of psychotherapeutic approaches to individual trauma is helpful for identifying similar conflicting tendencies in the understanding of trauma as a concept in cultural theory. Stress on the importance of the traumatic event/image in the diagnosis of PTSD is echoed in Felman's emphasis on witnessing trauma and Caruth's notion of traumatic memory as a literal trace of an event. Earlier examples of cultural criticism that directly appropriated Freudian theory—such as Benjamin's and Adorno's—were mimetic insofar as they emphasized the role of fantasy and unconscious identification. Adorno followed Benjamin in seeing mimesis (invoked in Benjamin's charming accounts of children's play) as a utopian merging of subject and object that escapes the alienation of instrumental rationality. However, Adorno saw the mimetic image as overtaken by the commodification of experience in capitalist modernity. For Adorno the reconciliation of subject and object could only be recovered in the art work. In both Benjamin's and Adorno's thought mimesis was understood as a mode of subjective experience that superseded the problem of representation or reference (Hansen, "Mass Culture" 52–53).

The distinction Leys makes between mimetic and antimimetic theories of trauma also recalls earlier debates in film theory. In "The Ontology of the Photographic Image," Andre Bazin proposed that photography and film could be distinguished from other forms of representation (such as painting) by their ability to present a direct trace of pro-filmic reality (Bazin 14–15). Christian Metz later transformed Bazin's propositions and argued that the reality-effect produced by the photographic and filmic image could support an imaginary relation or fantasy (Metz 42–57). In Lacanian film theory the viewer is inscribed as a subject within a visual field composed of a montage of shots. This structural theory of the subject and cinematic discourse is dependent on the reality-effect of the photographic and filmic image which "anchors" the discourse. However, Bazin's ontology of the image is not dependent on any psychoanalytic theory of the subject (Allen 226).

Has contemporary trauma theory shifted, as Leys proposes of therapeutic research, toward an anti-mimetic model and, if so, what are the historical reasons for this shift and what is at stake for cultural criticism? Caruth cites Felman's proposal that trauma provokes a "crisis of truth" (*Trauma* 6) and proposes a paradox "that in trauma the greatest confrontation with reality may also occur as an absolute numbing to it" (6). Because the event could not be witnessed "fully" (7) at the time of its original occurrence, the memory of trauma is experienced belatedly, thereby requiring an act of witnessing to validate it and to make it a part of conscious understanding. Caruth's articulation of the ontology of the traumatic image serves to anchor a temporal relation between the witness and the event. Unlike Metzian or Lacanian film theory, this understanding of traumatic memory fails to acknowledge the role of fantasy and desire in constituting the subject's relation to the image. For Caruth the ontology of the image validates the traumatic nature of the event as it is witnessed, rather than supporting,

through its reality-effect, a fantasy about the past as understood in the Freudian construction of the traumatic scene.

Ulrich Baer employs Caruth's conception of trauma in his discussion of photography. According to Baer photographs "can visually stage experiences that would otherwise remain forgotten because they were never fully lived" (Baer 2). Like traumatic memories, photographs can carry and conceal truths that may have been inaccessible to their human subjects at the time of their occurrence, or invisible to those who originally produced the image or who looked at them at the time of their initial production. This view of photography leads Baer to note "the constitutive breakdown of context that, in a structural analogy to trauma, is staged by every photograph" (11). But if the structural analogy with traumatic memory applies to *every* photograph, then the analogy exceeds any notion of an intrinsically "traumatic" image. Like a traumatic memory, the meaning of a photograph may only emerge in an entirely new and unprecedented context in which it can be witnessed for the first time. Photographic meaning is thereby constituted in a singular event of seeing. The singularity of the "traumatic event" emphasized in literal representations is now transferred to the singularity of the event of witnessing the new truth unveiled in the photograph.

As in Caruth's structural theory of trauma, for Baer the truth of the photograph is witnessed only by way of a spatial and temporal displacement. The possibility of witnessing is grounded in the image as a literal trace of the event. As Leys points out, this structural relation maintains a separation between the external event and an already constituted subject who performs the act of witnessing. Trauma always needs to be defined, as such, through an act of interpretation. The emphasis on literality is always related to a certain claim for the image as affect, otherwise it collapses into the banality of a universal observation about photographic images. For Caruth and Baer the traumatic event is constituted by an unprecedented act of witnessing. But trauma remains bound to a specific event. Whether we are talking about a particularly shocking or disturbing image, or about an unconcealed detail of, or new perspective on, an image, the emphasis remains on the singularity of the visual experience.

The structural theory of trauma has also been adopted in film theory. Joshua Hirsch and Janet Walker both develop theories of a trauma cinema that represents the past in narrative forms that reproduce the structure of traumatic memory. Hirsch understands trauma in terms of a crisis of representation. The mind, unable to comprehend what it experiences or witnesses, cannot situate the trauma in a coherent narrative. Instead the memory is retained in the mind "intact and unassimilated" (Hirsch, *Afterimage* 15). This understanding of trauma is essentially identical to the dissociation model proposed by Caruth. Hirsch presents a discussion of several Holocaust films that he calls "posttraumatic cinema" "defined less by a particular image content . . . than by the attempt to discover a form for presenting that content that mimics some aspect of post traumatic

consciousness itself" (19). Acknowledging that no image is traumatic in itself, Hirsch turns to a structural model to define posttraumatic cinema.

However, the problem of mimesis identified by Leys returns to haunt Hirsch's definition. For if film can mimic the structure of traumatic memory, then audiences may also mimic the symptoms of traumatization in their responses. Rather than relaying or transmitting an authentic link with the past, trauma becomes instead a cultural value that is bestowed on a film through the use of certain codes and conventions used by the filmmaker and by certain acts of identification on the part of the viewer. The fact that the aesthetic strategies of posttraumatic cinema may be different from those of Hollywood narrative realism, which Hirsch claims positions the viewer as a "false witness" (21), does not escape the problem that traumatic memory and its symptoms are open to a mimetic reproduction which, in turn, undermines any claim that traumatic memory is based in a literal trace of an external event. Janet Walker also defines trauma films and videos as those that "deal with traumatic events in a nonrealist mode characterized by disturbance and fragmentation of the films' narrative and stylistic regimes" (Walker 19). Trauma cinema is thus contrasted to narrative, or classical realism, on the basis of its aesthetic forms and representational strategies. However, these strategies of "disturbance and fragmentation" participate in a long history of modernist and avant-garde aesthetics, suggesting that trauma theory tends to reproduce established oppositions between self-reflexive texts and supposedly naive and "illusionist" Hollywood realism. The importance of this underlying opposition in both Hirsch's and Walker's arguments again suggests that trauma cinema is driven as much by a desire to ascribe cultural value to specific texts as it is by a need to understand the past. Whereas trauma involves extreme and exceptional experiences it is nevertheless subject to the logic of mimesis and simulation. The theory of the image as a literal trace of the past supports claims for the historical uniqueness of the Holocaust and its transmission as a traumatic memory across generations. The broader implications of this point become clear when we consider how features of the discourse surrounding the Holocaust were mobilized after 9/11. The violent and catastrophic nature of these two sets of events are not in question. However, the discursive construction of traumatic experience in the two cases show how a community of witness established around the Holocaust could be reproduced in a very different historical situation.[5]

Historical Trauma

Whereas use of the term historical trauma is common in contemporary cultural criticism it is difficult to find a single definition to cover its different articulations. Kaja Silverman offers an early definition of the term, in her *Male Subjectivity at the Margins* (1992), as an event which "manages to *interrupt* or even *deconstitute* what a society assumes to be its

master narratives" (15). Silverman draws on Lacan's account of the individual subject who sustains his/her identity through positioning his/her self in narratives of social belonging and status. Further developing the notion of historical trauma, Felman's and Laub's *Testimony* takes World War II and the Holocaust as its primary point of reference, claiming that the consequences of these events "are still actively *evolving* in today's political, historical, cultural and artistic scene" (xiv). Here the idea of trauma relates to the belated effects of past events. Caruth's definition of trauma as a "symptom of history" gives another inflection to this approach. LaCapra warns that understanding modern history as traumatic runs the risk of confining us in a compulsive repetition of the past (*Representing the Holocaust* 93). But as I discussed in the Introduction, Elsaesser's propositions about the role of contemporary media culture in imagining history as traumatic go beyond LaCapra's reservations. For Elsaesser the contemporary subject "fantasizes history in the form of trauma" because s/he only experiences self-representation in fragmented and displaced images and narratives. In this sense historical trauma substitutes for more located forms of identity that have been shattered in a postmodern culture.

Whereas all of these theoretical articulations of historical trauma are somewhat different, I propose a broader, more encompassing, definition. Historical trauma addresses disruptions to established forms of identity that are repeated in images and narratives and require continued negotiation and "working-through." For this reason historical trauma cannot ultimately be grounded in any conception of realist representation (even a "traumatic" one) or removed from cultural circulation. Rather it is inherently caught up with the general production of images and narratives in contemporary culture. Any understanding of historical trauma today needs to attend to the roles that discourses about, and representations of, trauma play in struggles over identity and the meanings of the past.

The early engagements with Freudian psychoanalysis in the writings of Benjamin and Adorno continue to offer important precedents for thinking about historical trauma. In their different ways, Benjamin and Adorno argued that modern historical experience—including political revolution, technological warfare and the industrial environment—were all potentially "traumatic" in their overwhelming of individual consciousness. For Benjamin this required the critic to seek the traces of catastrophic events in the everyday commodities of an emerging consumer society. For Adorno it implied that modern culture and politics were increasingly defined by group identification and manipulation rather than by critical individualism and historical consciousness. Whereas Benjamin and Adorno remain widely cited in contemporary trauma studies, the questions they raised about the political transformations at stake in modern media culture are often largely disregarded. Trauma studies wants *to bear witness to* history as catastrophe, but this project needs to be distinguished from earlier attempts *to articulate a critical theory of* history as catastrophe. The

difference is a crucial one, to the extent that trauma studies fails to reflect on assumptions about individual experience, representation and political identity. The desire to adequately come to terms with the suffering of others may itself serve as a screen that prohibits understanding of what is at stake in the historical relationship between witness and victim.

Benjamin and Adorno understood the roles of photography and film in terms of an historical transformation of experience. A central concept for both theorists is mimesis: the function of resemblance. Benjamin argued that in Western culture the mimetic function of the art object had gradually become endowed with an "aura" of uniqueness previously attributed to the sacred or taboo. In a society characterized by technological reproduction the aura of the artwork becomes reified and loses its power to evoke uniqueness of time and place. However, Benjamin saw in the "optical unconscious" revealed by photography and film potential to recover this mimetic function of the image. This new mimetic function would be public, profane and utopian. The shock effect of the image could also potentially serve to defamiliarize social reality. Influenced by Brechtian practices of estrangement, Benjamin's discussions of photography and film saw the new media opening a new visual space, the optical unconscious, that could work in the interests of a liberation from capitalist ideology. Adorno, however, countered Benjamin's somewhat visionary account of modern media by pointing to the reification of these visual experiences as a result of the ownership, control and organization of industrial modes of production. Instead of liberating the viewer, he argued, media direct viewers into forms of mass consumption and social conformity (Allen 228–234). As a later, more precise analyses of Barthes would demonstrate, the literal nature of the photographic trace is strongly contained by cultural codes to the point of lending authority to the code, rather than opening the subject to fresh perceptions of the world.

Benjamin and, following his example, Adorno developed the critical practice of constructing "constellations" of images. The constellation was not constrained by any specific structural relation between the image and historical reality but allowed an inherently open-ended and experimental approach to representing the past. Under the conditions of modern life images were encountered without the unifying narratives and shared contexts of tradition. Instead, a logic of shock and surprising juxtapositions of dissimilar objects and images became the norm. The constellation became the critical form that would be responsive to this new state of things. Both Benjamin and Adorno were also influenced by the Freudian conception of the unconscious and the focus of analysis on the marginal or forgotten aspects of modern experience. Benjamin's early study of German tragic drama made him aware of the Baroque fascination with ruins and allegory, whose modern equivalents he found in the commodity and the photograph. Benjamin's most famous application of experimental construction in criticism was the *Arcades Project*: a montage of a massive quantity of

citations and observations about nineteenth-century Paris. Adorno's own experiments with the construction of constellations followed Benjamin in the attempt to present thought-provoking, open-ended reflections on culture directed toward socially transformative ends.[6]

Perhaps the passage from Benjamin most cited in trauma studies is the following one from the theses "On the Concept of History": "Articulating the past historically does not mean recognizing it 'the way it really was'. It means appropriating a memory as it flashes up in a moment of danger" (4: 341). Benjamin wrote these lines shortly before his death in 1940. Two years earlier Virginia Woolf had published *Three Guineas*, which includes a meditation on photographs of the Spanish Civil War. Woolf writes of the shocking impact of these images, which provoked moral outrage in the viewer. Woolf's response to photographs of war belongs to an historical period in which such media representations were relatively new, whereas today such images have become "ultra-familiar" (Sontag, *Regarding* 24). Should the literal representation of suffering in photographs be included as part of Benjamin's evocation of a "true image of the past"? For isn't the photographic image fundamentally bound to a notion of the past as "the way it really was"?

The answer to these questions is again found in different conceptions of mimesis. Miriam Hansen explains the ways that the concept of mimesis is expanded in Benjamin's writings:

> Beyond naturalist or realist norms of representation and a particular relation (copy, reflection, semblance) of the representation to reality, the mimetic is invoked as a form of practice that transcends the traditional subject-object dichotomy and its technologically exacerbated splittings of experience and agency—a process, activity, or procedure, whether ritual, performance, or play, of "producing similarities"; a mode of cognition involving sensuous, somatic, and tactile forms of perception; a noncoercive engagement with the other that opens the self to experience, but also, in a darker vein, "a rudiment of the formerly powerful compulsion to become and behave like something else." ("Benjamin and Cinema" 329–330)

This darker vein was explored in Adorno's analysis of Wagner, fascist propaganda and the culture industry. The mimetic impulse is open to exploitation and mobilization toward destruction and domination. Mimesis also underpins group identity and behavior: the impulse to conform and to appear like everyone else, to regress to a state of collective suggestibility. For both Benjamin's and Adorno's critical vision of modern technological media the importance of mimesis goes beyond an insistence on the literality of the image that is central to so much contemporary trauma theory. The psychoanalytic theory of trauma played an important role in Benjamin's and Adorno's historical account of the modern subject. Whereas writers

like Felman, Caruth and Baer have derived a complex temporal structure from Freud and Benjamin, they have not pursued this broader historical analysis of the subject and media culture. In this sense we can align them with what Leys calls an antimimetic tendency in contemporary trauma theory. This antimimetic tendency, understanding both the media image and traumatic memory as literal traces of events, has the effect of constituting the witness as a source of historical truth.

Benjamin's theory of catastrophe can be contrasted on several points with Caruth's formulations of trauma and history. Caruth argues that because trauma "is not fully perceived as it occurs" then a history of trauma "can be grasped only in the very inaccessibility of its occurrence" (*Trauma* 8). The danger, as Caruth sees it, would be to betray the inherent alterity of trauma by claiming to represent it. The other danger for Caruth is that trauma is transmitted through those who bear witness to it and thereby can contribute to their own secondary traumatization. Benjamin's formulation was different. The danger is also twofold: the first danger is that if not grasped the image of the past will disappear irretrievably; the second danger is one "of becoming a tool of the ruling classes" (391). Benjamin assimilated psychoanalytic theory into a formulation of historical trauma that is explicitly political.

Benjamin's theory of history also differs in important ways from some of LaCapra's influential arguments about historical trauma. LaCapra proposes that work on posttraumatic symptoms is necessary because it can help to address the causes of traumatic experience, "prevent its recurrence and enable forms of renewal" (*History in Transit* 119). Working-through can help to mitigate the anxiety caused by traumatic memory and avoid projection of this anxiety onto scapegoats. LaCapra's critique is directed at positivist historiography that seeks to exclude consideration of any psychological processes or emotional effects such as empathy, and also at over-identification with scenarios of the Holocaust that erode important distinctions between contemporary forms of experience and the realities of the past. For LaCapra, working-through is always partial and incomplete, and thus the traumatic experience always leaves a remainder. LaCapra's emphasis on both incompleteness and the necessity of working-through the past extends to a vicarious experience of trauma, one that would ideally avoid the perils of over-identification with the suffering of others and manifest itself in what he calls "empathetic unsettlement" (125). As he explains:

> However it is figured, empathy, in the sense I am using the term, takes one out of oneself toward the other without eliminating or assimilating the difference or alterity of the other. . . . Neither should empathy be conflated with incorporation of the other into one's own (narcissistic) self or understood instrumentally as a means of discovering one's own "authentic" identity. On the contrary, it induces one to recognize one's internal alterity or difference from oneself—one's own opacities and

gaps that prevent full identity or self-knowledge and prompt a readiness to temper, qualify or even in certain cases suspend judgment of the other. Empathy in this sense is enabled by internal alterity (or the unconscious) and based on one's being open to the other, who is constitutive of the formation of oneself. (*History in Transit* 76–77)

LaCapra's argument neglects to address the broader cultural context that determines much of the capacity for empathy. Some commentators suggest "numbing" may be an important form of viewer self-protection in an age of information overload. Images of suffering may initially provoke viewer outrage which rapidly evaporates to numbed indifference. As Carolyn J. Dean explains, the problem of numbness:

> manifests an important challenge to the liberal ideal that we can empathetically project ourselves into others with whom we share a common humanity, whether strangers or neighbours. For numbness is not only a psychological form of self-protective dissociation, it is arguably a new, highly self-conscious narrative about the collective constriction of moral availability, if not empathy, and may thus constrain humanist aspirations in ways we do not yet recognize. (Dean 5)

LaCapra, like many other writers who employ the trauma paradigm, promotes an ethic of witnessing. But the prominent role of visual media in contemporary culture puts this ethical stance in question. A darker vision of this distancing can be found in Zygmunt Bauman's propositions about modernity. Bauman argues that social and psychological distance, which exceeds physical and optical "distance between actors and the targets of their actions" (Bauman 270) is premised on the different aspects of the modern management of action. First, most actors are unable to control the final outcome of their actions. Second, the actor performs an increasingly limited and specific range of actions. Third, the "targets" of these actions are not represented to the actors as full human subjects. Thus the very structure of modern corporate society impedes the possibility of developing empathy with its subjects and its victims. If Bauman's argument is correct, then LaCapra's emphasis on empathy, despite its nuanced understanding of "internal alterity," maintains an essentially liberal conception of the subject.

Benjamin acknowledged this political dimension of empathy. In Thesis VII "On the Concept of History," Benjamin rejected empathy "which despairs of appropriating the genuine historical image as it briefly flashes up" (4:391). For Benjamin, the empathy of the historian inevitably falls with the victors, thereby making history a tool of dominant power. LaCapra addresses an apparently very different kind of empathy: identification with the victim, in particular the Holocaust victim. Interestingly, Benjamin argued that the origins of empathy lie in melancholy: so identification

could be with either victims or victors, insofar as both accept the *victory* as complete and therefore inevitable. For Benjamin the need to "brush history against the grain" did not require empathy with the victor *or* the victim. Overcoming the consciousness that has learned to protect itself from disturbing images, Benjamin's historian was indeed "unsettled," but was s/he empathetic? On this point Benjamin drew from his formulation of Brechtian interruption, claiming that Brecht's theatre did not appeal to audience empathy but rather aimed to produce astonishment (4: 304). Similarly the "tradition of the oppressed" is not only to be imagined as traumatic but carries with it its own potential for positive transformation. This value can only be redeemed when the historian breaks with the narratives that serve oppressive forms of power.

This Brechtian rejection of empathy in Benjamin can further be seen as an incorporation of the logics of modern visual media. As Sontag describes it:

> Benjamin's own ideal project reads like a sublimated version of the photographer's activity. This project was a work of literary criticism that was to consist entirely of quotations, and would thereby be devoid of anything that might betray empathy. A disavowal of empathy, a disdain for message-mongering, a claim to be invisible—these are the strategies endorsed by most professional photographers. (*On Photography* 76–77)

Insofar as Benjamin's strategy was mimetic rather than empathetic, it also ran the risk of reproducing the emotional distance required by the functioning of modern industrial society. Benjamin attempted to grasp, in dialectical fashion, the ways that the "spark" of the historical real could also be manifest in the image of the past. The memories of oppressed groups potentially interrupt history in the manner of a trauma, in which the violence of the past is once again experienced in all its immediacy, but which also disrupts the normal acceptance by consciousness as simply "the way things are." Benjamin's vision of the "tradition of the oppressed" is a discontinuous and "explosive" interruption of dominant historical narratives. In Benjamin the moment of danger in which the image of the past arises recalls the traumatic experience that breaks through the protective shield of consciousness. The experience of trauma is joined in Benjamin's formulations to the very possibility of change. To the extent that this shock is absorbed by consciousness, the narratives of history as progress that support hegemonic power remain in place. Only the image that flashes up briefly can potentially break the bonds of both conformity and traumatized silence. In Benjamin's vision the meaning of the experiences of oppressed peoples and the political defeats of the past may be potentially transformed.

Other commentary on Benjamin's traumatic theory of history has sometimes attempted to assimilate it into deconstructive trauma theory. For example, Shoshana Felman writes:

Benjamin advances . . . a theory of history as trauma . . . and a correlative theory of the historical conversion of trauma into insight. History consists in chains of traumatic interruptions rather than in sequences of rational causalities. But the traumatized—the subjects of history—are deprived of a language in which to speak of their victimization. The relation between history and trauma is speechless. (*Juridical Unconscious* 33)

Felman imagines the subjects of history only as victims rather than active agents of change. She goes on to propose that history:

is thus inhabited by a historical unconscious related to—and founded on—a double silence: the silence of "the tradition of the oppressed", who are by definition deprived of voice and whose story . . . is always systematically reduced to silence; and the silence of official history—the victor's history—with respect to the tradition of the oppressed. (34)

Felman proposes that "the reality of history is that of those traumatized by history" (29). But when Benjamin invoked the experience of the oppressed he did so not only in terms of traumatized silence but also accorded it "confidence, courage, humor, cunning, and fortitude" (4: 390). One of the more striking silences on Felman's part is the erasure of Benjamin's commitment to Marxism, as she returns once again instead to the precedent of De Manian deconstruction and proposes that "Benjamin's whole writing could be read as work of mourning" (38). In particular Felman points to the suicide of Benjamin's friend, poet Fritz Heinle, at the outbreak of World War I, of which Benjamin's own suicide was a traumatic repetition. Here Felman's reading runs the risk of an empathetic identification with Benjamin himself as an historical victim, rather than continuing to listen for the ways that Benjamin continues to counsel us on the dangers of appropriating the traumatic past. The "true image of the past" demands an attempt to struggle over its meaning. This struggle is given an explicitly political inflection in Benjamin's theses and should not be reduced to a private work of mourning.

Adorno's meditations on culture "after Auschwitz" constitute another influential articulation of historical trauma. The Nazi genocide reduced the individual to a "specimen," the object of the "administrative murder of millions" (*Negative Dialectics* 362). For Adorno the trauma of Auschwitz forces philosophy to become "a thinking against itself" (365), because any philosophical tendencies toward the transcendence of material existence would falsify the actual historical liquidation of the individual in the concentration camps. This philosophical trauma is stated by Adorno in terms that remain significantly different from most subsequent trauma theory. Whereas the experience of the camps casts "the longest shadow" (in Geoffrey Hartman's phrase) over contemporary culture, and the testimony of

Holocaust survivors has played a central role in the development of trauma studies, the claims for traumatic memories as embodiments of historical truth lend a positivity to this experience that Adorno resisted. Adorno poses the question of the legacy of Auschwitz as a fundamental challenge to the very possibility of cultural value.

However, Adorno's challenge has not often been taken up directly in contemporary trauma theory. By putting the question of Holocaust representation at the center of his book *Traumatic Realism*, for example, Michael Rothberg shifted the focus of Adorno's meditation on representation "after Auschwitz" to the problem of the representation *of* Auschwitz. Of course, these two problems are not distinct, as the question of representing the Holocaust is also posed *after* the Holocaust. Yet an important difference lies in the broader implications of Adorno's propositions regarding *all* representations after Auschwitz. According to Rothberg's reading of Adorno, the meditations of culture "after Auschwitz" "suggest the need for new forms of representation capable of registering the traumatic shock of modern genocide" (Rothberg 58). In Rothberg's book this leads to a consideration of specific examples of the Holocaust representation. I do not intend to question the validity, significance, or value of Rothberg's research. Nevertheless, the focus on the representation of traumatic experience does shift the frame away from other possible lines of inquiry that are central concerns of Adorno's criticism.

Claims for the exceptional nature of historical representations and testimony can evade fundamental questions about identification and political community. Deconstructive criticism has used the rhetoric of a crisis of truth and witnessing that has had the paradoxical effect of reinforcing realist claims for modern visual media. Against claims for the transmission of trauma I propose that Benjamin's and Adorno's philosophical meditations on history direct us toward an understanding of historical trauma as a conceptual blockage rather than a crisis of memory. As Huyssen has proposed, we may be suffering from a surfeit, rather than a lack, of commemoration in contemporary culture. The more urgent need is for a way to re-conceptualize identity and agency in response to the forms of violent oppression and exclusion that characterize modern political and economic power. The theory of historical trauma needs to be based on a critical account of this violence and its relation to contemporary culture and media. Despite their uses by recent theorists, neither Benjamin nor Adorno offer a theory of trauma as an authentic experience of history. Rather, their criticism allows us to understand the role of traumatic experience and memory in the cultural and political transformations of modernity. The role of events such as the Holocaust or 9/11 in the constitution of political community reveals that the ways that we imagine trauma are part of ongoing historical struggles. Despite, or because of, the appropriation of trauma discourse by dominant forms of power, historical trauma remains an indispensable concept for cultural criticism today.

2 Photography and Unconscious Optics

How should we understand the historical relation between theories of trauma and of visual media? I begin this inquiry by returning to Freud, whose psychoanalytic theory of traumatic memory had a direct influence on Benjamin, Adorno and other theorists who followed them in developing critical approaches to modern media. This chapter explains how the concept of unconscious optics proposed by Benjamin can be used to understand historical trauma in the writings of Freud. Although Freud tended to theorize trauma with respect to the individual subject, he also developed theories of collective identity and historical trauma. The cultural significance of modern visual media however remained outside the scope of Freud's inquiries. I argue that photography, as a new optical technology, offered perspectives Freud could not fully assimilate into psychoanalytic theory. Photography bears witness to a set of historical transformations that shaped, both directly and indirectly, the theorization of trauma.

Early therapeutic approaches to psychic trauma were contemporaneous with the emergence of photography, so it is not surprising that Freud should refer to photography when outlining his theory of the unconscious. Freud's mentor in the treatment of hysteria, Jean-Martin Charcot, gave photography a prominent role in recording and publicizing his case studies. Freud himself however moved away from direct use of photography and his references to photography remain minimal.[1] Recent criticism that further elaborates the conjunction of psychoanalysis and photography takes its cue from Benjamin's formulation of an optical unconscious. Although critics such as Eduardo Cadava and Ulrich Baer have tended to synthesize Freud and Benjamin in their discussions of photography, I argue that Freud's and Benjamin's relations to photography are fundamentally different. In his "Little History of Photography" Benjamin addressed the self-construction of the bourgeois individual through new visual media. Freud explained the psychic structure of the individual using the analogy of the camera. Benjamin's analysis was historical, whereas Freud's incorporated new media into a timeless model of the self.

Freud proposed that psychoanalysis, by revealing unconscious motivation, itself constituted a trauma for the self-image of the Western individual.

He did not consider the ways in which the individual was, in turn, constructed as an image within the frame of changing optical technologies and visual paradigms. Photography was used extensively in Charcot's clinic, where Freud studied, to document female hysteria. It revealed for the first time in explicit detail the horrific realities and consequences of modern war. It was used by the Third Reich to furnish evidence to support its racist ideologies and to document its own processes of genocide. The new media of photography not only revealed, it participated in, historical transformations of human experience that Freud's theory of trauma never directly acknowledged. Approaching historical trauma by way of photography and unconscious optics I read the various stages of Freud's theorization of trauma as a response to different political crises experienced by the modern subject.

Freud concluded his long career by proposing an account of Jewish identity based on the "primal scene" of the murder of Moses. This theory of collective trauma remains bound to an analogy with the psychic history of the individual. *Moses and Monotheism* was written between 1936 and 1939 during the escalation of Nazi international aggression prior to World War II. Freud fled Vienna after the invasion of Austria and sought safe haven in England for the final year of his life. Cathy Caruth has proposed that *Moses and Monotheism* be read as a text that articulates the trauma of departure (*Unclaimed* 22). In the following discussion I argue that the theorization of trauma in Freud should be understood as a response to specific forms of political violence and social exclusion that he encountered throughout his career. Freud's theory of trauma emerged from situations in which unprecedented numbers of people were subject to incarceration, technological warfare and denationalization.

In the following discussion I extend the idea of unconscious optics to include what Foucault called "biopolitics" and the condition that Agamben has identified as "bare life."[2] Foucault's term refers to the increasing role of the modern state in the management of biological life: birth, death, illness and public health. The forms of biopower that developed in the late nineteenth and early twentieth centuries were often closely aligned with ideologies of race, gender, sexuality and class. Biological research and medical science became important aspects of the control of modern populations, including the development of Taylorist mass production (Foucault, *History of Sexuality* 139–141). Female hysterics, war veterans and camp inmates were all subject to new levels of technological surveillance and violence. The study of hysteria prefigured "research" conducted in Nazi concentration camps on "useless" members of society (criminals, the poor, Jews) which served the development of biopolitical knowledge and power. As a member of an ethnic minority who ended his life as a refugee from Nazism, Freud, like millions of others of his generation, was forced to endure the perils of denationalization. Whereas the modern state assumed new powers over life and death, Freud's theory remained oriented toward the psychic experience of the private individual. The theory of hysteria was itself

founded in the nineteenth-century clinic through the study of institutionalized and disempowered individuals. Power relationships between clinician and patient were the basis of contradictions in psychoanalysis from which Freud was unable to free himself.

I argue that the place of unconscious optics in Freud's work needs to be understood in terms of his turning away from visual evidence and display (both prominent features of Charcot's research) to verbal free association. Interestingly, the use of visual evidence never entirely disappeared from Freud's research. I will explore this in a discussion of an essay on Michelangelo's sculpture of Moses in which Freud's analysis of a visual representation can be usefully compared with Benjamin's theory of the optical unconscious. In Benjamin's formulation the eye searches the photographic image:

> for the tiny spark of contingency, of the here and now, with which reality has . . . seared the subject, to find the inconspicuous spot where in the immediacy of that long-forgotten moment the future nests so eloquently that we, looking back, may discover it. (Benjamin 2: 510)

In this passage the temporality of the photograph is suspended between a forgotten past and an anticipated future, recalling Freud's stress on the immediacy of the traumatic memory, or symptom, of a past that assumes new meaning through its relation with later experiences. This conjunction of the temporality of trauma and the photograph is pursued in commentaries by Cadava and Baer. However, my approach to this conjunction departs from their readings on a number of points. I propose that rather than extending the conflation of psychoanalysis and photography we should attempt to understand both in terms of a response to specific historical circumstances. Although both Cadava and Baer rightly stress that there can be no understanding of history without metaphor or without technological mediation, it must also be acknowledged that the force of any cultural critique rests on some sense of historical singularity. My reading of Feud and Benjamin aims to reveal a prehistory of the ways that contemporary trauma culture and theory also seek to efface the problem of bare life. Thus I argue that Freud's preoccupation in *Moses and Monotheism* with a specifically Jewish collective trauma allowed him to ignore the dangers presented by new forms of biopolitical power.[3] Similarly, I see today's preoccupations with the figure of 'the survivor' as a collective projection, allowing specific groups to reconstitute their identity when confronted with the erasure of individual autonomy by the modern state and capitalist economy.

UNCONSCIOUS OPTICS

Freud's references to photography and Benjamin's discussion of unconscious optics have become enmeshed in several later commentaries. This

section seeks to clarify the differences between Freud and Benjamin. Freud himself never wrote about photography as of interest in itself, although several readings of Freud have been attentive to the ways he employed photography as an analogy for the relation between conscious and unconscious mental processes. As Sarah Kofman explains:

> Freud's use of the model of the photographic apparatus is intended to show that all psychic phenomena necessarily pass first through an unconscious phase, through darkness and the negative, before ascending to consciousness, before developing within the clarity of the positive. However, it is possible that the negative will not be developed. (Kofman 22)

It should not surprise us that Freud referred to photography in this way, simply drawing on a concrete example from his contemporary world in order to update a much older, or more fundamental, metaphor of light and darkness.[4] Freud used the metaphor to explain a process of revelation from obscurity to visibility or understanding. In several passages he compared unconscious memory to a photographic negative that awaits development into an image perceived by consciousness.[5]

Like Freud, Benjamin discussed the camera in relation to the unconscious level of human experience and perception. For Benjamin the camera, like psychoanalysis, has the power to defamiliarize everyday life. For Freud, unconscious memory equated with the photographic negative, whereas for Benjamin unconscious levels of meaning are potentially to be found on the surface of the image itself. In Freud's use of the photographic metaphor, unconscious memory remains obscure until brought into the light of conscious recollection. Through psychoanalysis unconscious images become part of a web of associations by which their significance gradually becomes clear. As Kofman emphasizes, the passage from unconscious to conscious meaning does not happen as a matter of course, but only takes place in and through the practice of psychoanalysis: "To pass from darkness to light is not, then, to rediscover a meaning already there, it is to construct a meaning which has never existed as such" (28). Unlike Freud, Benjamin does not employ photography as a metaphor for the unconscious but looks directly for interpretive strategies made possible by the historical arrival of photography. He bases his analysis on the material conditions of the production and the reception of the photograph. Benjamin is interested in literal traces of the past which can be discovered, he argues, in the details of a photographic image. These details are potentially visible as long as the photograph is available to be viewed and yet they have no significance until they are positioned in a specific narrative or interpretation by the viewer. Like the relationship between analyst and analysand in psychoanalysis, Benjamin searches the photograph for meanings that may exceed both the understanding of the human subject shown in the photograph and the intentions of the photographer. What Benjamin shares with Freud is the notion of an

active construction of a missing history rather than the reconstruction of a past already fully constituted in unconscious memory.

Eduardo Cadava extends Benjamin's insights on photography to include the ways that contemporary media technologies continue to reshape our relation to memory and history. Today, proposes Cadava, there is no event that is not transformed in some way by technological media (Cadava xii, xviii). Cadava argues that Benjamin's imagistic approach to writing history, particularly evident in his *Arcades Project*, was an appropriation of new technical means of reproduction and an intervention in the media apparatus that in its most extreme forms, as employed by the Nazi state, aimed to assimilate all forms of life into a political program of violent domination (xx–xxiv). Cadava contrasts this spectacle of total immediacy promised by modern media to Benjamin's notion of unconscious optics. There is however a contradiction lurking in Cadava's argument. Cadava proposes that both Benjamin and Freud thought that "there can be no camera or photograph that does not have a psychic origin" and therefore "there can be no psyche without photography, without a process of writing and reproduction" (100). This deconstruction of the opposition between psychology and technology undermines Cadava's claim elsewhere that photography constitutes an historical transformation of memory and history (xxii–xxiii). The crucial distinction to be made is that Freud universalized the unconscious whereas Benjamin saw photography as part of a specific historical transformation. If photography and other technical media are potential agents of social change, as Benjamin believed, then they must impact psychic processes in ways that are historically and culturally distinct and therefore not applicable to all psychic processes. To read, as Cadava does, Benjamin's various writings through the figure of photography is potentially to undermine Benjamin's attempt to think through the historical singularity of photography.[6] We need to read both Freud and Benjamin as describing psychic and optical experiences that emerged from a particular set of historical circumstances, including larger forces such as industrialization, urbanization, colonialism and militarism. Following Benjamin's precedent, we should attempt to understand the contemporaneous development of trauma theory and modern visual media before collapsing both into generalities.

Ulrich Baer proposes a "traumatic" theory of the photograph, drawing directly on both Freud and Benjamin. When we view a photograph, explains Baer, "we are witnessing a mechanically recorded instant that was not necessarily registered by the subject's own consciousness" (Baer, 8). Baer proposes that in this way photography shares the structure of traumatic memory:

> Because trauma blocks routine mental processes from converting an experience into memory or forgetting, it parallels the defining structure of photography, which also traps an event during its occurrence while blocking its transformation into memory. (Baer 9)

Baer's comparison differs from both Freud's and Benjamin's references to photography. Freud compared unconscious memory to a photographic negative that can be developed soon after being taken, or after a longer period, or perhaps not at all. Memory, he claimed, only becomes traumatic when aligned with later experiences, memories and fantasies. Trauma is not a quality ascribable to an event or experience, but to the work of memory. Freud's metaphor of a photographic negative that is latterly developed is consistent with reconstruction of traumatic memory through psychoanalysis. But unlike Baer, Freud does not align the photographic image itself with traumatic memory or traumatic experiences. Baer's comparison of photography to the structure of traumatic memory derives from Caruth's understanding of trauma as a literal trace of a concrete external event (as discussed in my previous chapter).[7] Baer draws on both Freud and Benjamin in order to read photographs "differently" according to a logic of traumatic memory, rather than a realist aesthetic or positivist epistemology. This however does not help us to understand how or why trauma has become such a prominent metaphor for modern history and its representation in visual media. In elaborating the prominence of this metaphor I will pursue a different trajectory through Freud and Benjamin; one that is more attentive to the political contexts in which they both formulated their different theories of trauma, photography and history.

THE SUBJECT AND THE PHOTOGRAPH

In his 1925 essay "The Resistances to Psychoanalysis" (19: 213–224), Freud considered the possible motives behind opposition to psychoanalytic theory and practice. He observed that the hostility of the medical establishment was due to the refusal of psychoanalysis to explain psychical processes in purely physical terms, whereas the hostility of philosophers was premised on a rejection of the whole notion of an unconscious. Freud commented that the attention to sexual instincts, particularly their active role in childhood development, was abhorrent to the prevailing moral order, which he went on to accuse of hypocrisy. He then proceeded to compare these resistances to psychoanalysis with opposition to the radical theories of Copernicus and Darwin, an analogy he had developed in his earlier essay, "A Difficulty in the Path of Psychoanalysis" (1917). Freud called these theoretical revolutions the three "blows" to human narcissism: the cosmological blow when Copernicus proved that the earth revolved around the sun; the biological blow when Darwin showed that humans evolved from animals; and the psychological blow when psychoanalysis presented the case for unconscious motivation (17: 140–141). Psychoanalysis, then, not only proposed a radically new theory of psychic trauma but itself constituted a kind of traumatic event. Psychoanalysis presented a crisis for the self-image of the human subject, a wound that must be mourned.

Whereas Freud was attentive to how the ego is threatened by, and therefore seeks to resist, new knowledge, he did not begin to consider how the ego may itself be constituted differently as a result of these theoretical revolutions. According to Freud's account, the theories of Copernicus and Darwin were historically new but impacted on an essentially unchanging human subject. In a more historically nuanced argument, Hannah Arendt attributed a somewhat different significance to Copernicus. Arendt argued that it was not Copernican theory, but rather Galileo's use of the telescope to prove Copernican theory, that disturbed the modern subject's self-conception, a disturbance which she suggests led the way to Cartesian skepticism (*Human Condition* 258–261). Arendt proposed that developments in optics gave rise to a profound suspicion of the evidence of the world furnished by the human senses, in turn leading to a despair at the heart of the modern subject. As we have seen, Freud made reference to optical technologies in order to explain his theories. In *The Interpretation of Dreams* Freud employed the example of the telescope to explain the relation between conscious and unconscious psychic processes.[8] Yet for Freud the telescope, like the camera, remained a metaphor. While seeking to explain the psychic operations of the individual, Freud never considered that basic concepts of what it is to be human might be historically transformed by the advent of different optical technologies. In contrast to Freud, Arendt proposed that the modern subject was formed by way of a technological as well as theoretical revolution. Rather than a trauma in the Freudian sense of a rupture in the ego's psychic defenses, Arendt proposed a more general historical mutation of visual perception that implicitly undermined Freud's self-important comparison of psychoanalysis with Copernican and Darwinian theory. According to the logic of Arendt's analysis we should see psychoanalysis as itself part of a larger set of responses to a radically new set of visual experiences.

Rather than accept Freud's own description of the subversive power of psychoanalysis, we need to understand how Freud's understanding of trauma itself emerged from an historical situation in which visual media was playing significant new roles. In Charcot's clinic, where Freud studied in 1885 to 1886, the new technology of photography had played a central role in the representation of the hysterical subject:

> He [Charcot] and his interns sketched hysterical patients during their attacks, and even installed a full photographic studio, with a professional photographer, Albert Londe, to record the women's movements and expressions. These photographic images appeared in three volumes called *iconographies*; sketches, drawings, and paintings were also reproduced and sold. The best known, Andre Brouillet's engraving of Charcot and his most famous hysterical patient, Blanche Wittman, hung in the lecture hall at the Saltpêtrière, and Freud always had a copy in his office. (Showalter 31)

Charcot's preoccupation with visual records and evidence reflected his understanding of hysteria as originating in particular events that resulted in traumatic disturbances. The first essay in Breuer's and Freud's *Studies on Hysteria* (1895) adheres in general to Charcot's emphasis on the importance of traumas in the symptomatology of hysteria (Jones 155). According to the authors, psychic trauma is to be distinguished from physical injury by the presence of "distressing affects—such as those of fright, anxiety, shame or physical pain" and thereby also "on the susceptibility of the person affected" (Breuer: 6). But Breuer and Freud began to depart from Charcot by emphasizing that trauma may not originate with a single event but be the effect of a cluster of events or causes. All of these qualifications—the different susceptibilities of the individual, the multiplication of "trigger" events and memories—already suspended any straightforward understanding of a catastrophic or violent occurrence as the "cause" of traumatic memory or hysterical symptoms. For Breuer and Freud psychic trauma could not be grounded solely in a singular experience but was primarily a problem of memory. This led to their famous formulation that *"Hysterics suffer mainly from reminiscences"* (Breuer 7). The failure (for either social or emotional reasons) to adequately respond to a particular experience led to its "repression" from conscious memory. Yet, following Charcot's research, Breuer and Freud discovered that these experiences could be vividly recalled and/or re-enacted under hypnosis. Their conclusion was that hysterical neurosis was founded on the dissociation of traumatic memory from normal consciousness. Conscious recollection and verbalization, as a result of therapy, led to the disappearance of the hysterical symptom.

Freud's first real individual innovation as a therapist was to reject hypnosis in favor of techniques of free association. This shift from acting-out under hypnosis to verbal association and construction can also be connected to Freud's apparent lack of interest in Charcot's use of photography as visual evidence. Initially Freud sought to explain hysteria in terms of a trauma of infantile sexual experience (the "seduction theory"). He claimed the failure to discharge, or abreact, the emotional affect attached to these memories resulted in hysterical symptoms which functioned as a defense against traumatic memory (Young 36–37). Meanwhile memories of traumatic experiences, unavailable to conscious recollection, remained imprinted in the unconscious. In Freud's view these associated experiences or attitudes were more often than not sexual in nature. The next turning point for Freud was an assertion that many of the childhood sexual experiences recounted by his patients under analysis had in fact never taken place. That is, not only were the hysterical behaviors and fantasies of adults a displaced expression of experiences from early childhood, but these earlier experiences only became "traumatic" later by assuming their position within a more general scenario of fantasy and desire (Jones 172–173). Freud's emphasis on a period of "latency" implied that it was the process of remembrance rather than the experience itself which constituted trauma

(Leys 19–20). For Freud there could be no transparent, cause-and-effect relationship between memory and experience.[9] Jean Laplanche explains the implications of Freud's thinking with reference to the case of an eight year old girl who was sexually assaulted by a shopkeeper. Later, at age twelve, she fled from a different shop after she believed two shop assistants were laughing at her. Neither of the two "scenes" was properly traumatic: the first failed to produce any direct response and the second was apparently banal. It was rather the relation *between* the two scenes that constituted the traumatic memory, as the second scene provoked an excitement that awakened the memory of the first scene (Laplanche 38–42). The earlier event remained a dormant memory, only triggered by subsequent experience and was drawn into a new configuration of fantasy, anxiety and desire.

So it would seem that Freud's turning away from photography was consistent with his rejection of trauma as a literal trace of a specific event. Only verbal associations could reveal the complex play of memory and desire through which traumatic memory was constituted. A common criticism of Freud's theory is, of course, that it gave free reign to the analyst to impose his interpretation upon the experience of the patient. Emphasis on the role of the analyst in reconstructing a traumatic "scene" could also be seen to support a relationship of domination and possible exploitation of the (usually female) patient by the (usually male) analyst.[10] Freud's first theory of trauma, based in studies of female hysteria, evaded the problematic role that the clinician played in defining the subject of trauma. The importance of Charcot and photography in understanding Freud's view of trauma lies not in returning to the notion of trauma being based in a concrete external event, but in understanding how the psychoanalytic theory of trauma was used to define individuals within institutions using the media technologies of those times.

Freud's relation to Charcot provides an important key to the politics of trauma theory. Charcot's photographs of women in his clinic can be viewed as an attempt to contain the "discoveries" of both trauma and photography within the terms of disinterested scientific inquiry. These photographs also provide striking visual examples of what Foucault later called biopower: the subjection of individual life to regimes of science, medicine and psychology. The hysteric, under the empowered gaze of the clinician, was defined as an object of study and analysis; a definition that undermined the self-regarding subject Freud assumed in his larger comments about the traumatic blows to human narcissism. Within Charcot's clinic the hysteric became a case study and a human exhibit. Under hypnosis the subject was denied individual agency. Charcot's theory of the traumatic origins of hysteria were developed under the institutional gaze of his clinic and the technological eye of a camera.

Sander L. Gilman explains how representation of hysteria was embedded in the production of new forms of knowledge and power:

To see the patient means to develop the technique for seeing, a technique that is "scientific"; the patient, in turn, as the object of the medical gaze becomes part of the disease, a representation that is labeled hysteria. (Gilman 353)

Bodily postures, facial expressions (especially of the eyes), lesions on the skin and other visible evidence, were all understood as symptoms of pathology and patients were regarded as 'text' for a physician to read that pathology's history. Photography could fix visual symptoms, particularly facial expressions, in a permanent record available to be studied at a later time for clues to their hidden causes. As a theory of memory Charcot's trauma theory was only verified in terms of certain regimes of visibility and the embodied presence of the patient. Any subjective point of view of the human subject was overtaken by the objectifying gaze of medical science and technical media. With the aid of photography the patient became a visual "specimen" of disease. As Arendt, Foucault and Agamben have argued in different ways, it is this very alienation of subjective experience that defines modern life, an alienation upon which psychoanalysis launched its theories rather than offering any historical diagnosis.[11] Through photography and public lectures Charcot turned hypnosis and hysteria into visual spectacle that denied subjective agency. Freud withdrew from these practices into the private space of the analyst's office. In doing so he reconstituted the hysterical patient as a bourgeois individual. The private space of Freudian psychoanalysis made the social determinants of class and gender less visible.

Focus on private individuals meant trauma was explained with reference to historical formations of the individual ego rather than in terms of stimuli and response. Yet, according to Ruth Leys, Freud continued to vacillate between a structural theory of the ego and an economic theory of stimulus (Leys 27–28). Freud proposed that the ego is formed through libidinous attachments that "bind" the subject as a psychic entity. Prior to the development of identification with other individuals is a primordial imitative and incorporative desire. These primary identifications precede the very distinction between self and other upon which any individual ego is founded. If traumatic memory belongs to a pre-subjective order of mimetic identification, then it cannot be explained with reference to an earlier stage of the ego, but must be understood to precede the formation of the ego itself. Leys suggests that this may explain why trauma cannot be remembered in terms of a narrative of the individual self, but instead is acted out as a mimetic repetition (29–32). Perceiving Freud's failure to resolve this problem, Leys argues, helps us recognize the importance of later psychotherapeutic studies of war and Holocaust survivors which describe how, under conditions of extreme stress, survivors experienced complete breakdowns or disintegration of their sense of self (36).

Leys's argument suggests another reason for Freud's turning away from Charcot's emphasis on visual evidence to focus on verbal recollection.

Photography had become associated with Charcot's experiments with hypnosis, and thereby issues of a suggestible subject without a structured individual ego. Freud's emphasis on free-association put these issues to one side and instead made the ego-formation of the private individual the object of historical investigation. But what the use of both hypnosis and photography in Charcot's clinic had shown was a subject apparently vacated of any stable ego and open to intrusive forms of control by suggestion. Was such a revelation too "traumatic" for Freud to embrace? Psychoanalytic practice, with its focus on the individual's private history in the bourgeois home, removed itself from the more proletarian realm of Charcot's clinic.[12] Freud perhaps had greater interest in scandalizing the Viennese social establishment with his revelations of sexuality in the bourgeois home, but the possibility of a more radical disturbance of the subject continued to haunt him. In particular, the conception of a subject open to hypnotic suggestion returns in Freud's theory of group identification. Charcot's theories of hysteria directly influenced Gustave Le Bon's writings on the crowd, which in turn became a principal reference point in Freud's study of group psychology. Charcot had used hypnotic suggestion on lower class individuals but Le Bon took his association further and made the hypnoid state characteristic of the proletarian mob. Photography, as it was used in Charcot's clinic, formed part of a larger historical trauma that could not be fully assimilated into Freud's theory of the individual ego. That historical trauma related to the emergence of new political subjects and new forms of power and domination in urban industrial societies.

The unresolved nature of trauma can further be seen in Freud's response to the phenomenon of shell shock in World War I. How could the persistent nightmares of war survivors be reconciled with Freud's theories of the sexual nature of trauma or of dreams as wish fulfillment? Freud himself explained war neurosis in terms of fright, where there is an absence of psychic preparation for an experience of shock. Shock results in the protective shield of consciousness being breached, allowing a direct intrusion of excessive stimuli (Young 78). Freud argued that war neuroses were the result of psychic splitting to protect a soldier's pre-war identity from the new self-endangering experience of the warrior; that is, he sought to explain it in terms of an historical formation of ego and a regression to an earlier stage of libidinal development (Leys 22). Freud's attempt to explain war trauma failed, however, to confront the political realities that were shaping both modern technological warfare and, ultimately, Freud's own precarious national citizenship. By attempting to assimilate war trauma into a theory of the ego Freud could be seen as attempting to sustain his own political commitments to a model of liberal democracy and individualism.

The role of photography during and after World War I provides dramatic testimony to the crisis of liberal individualism. From the mid nineteenth century, new inventions, such as the machine gun, greatly increased the levels of injury and fatality in war. Up to and including World War I

photographs tended to show only the aftermath of battle. It was not until the invention of lightweight cameras, first used to document the Spanish Civil War, that photographs of war conveyed the immediacy of death and destruction, including the bombing of cities and civilians (Sontag, *Regarding* 19–21). The nightmare realities of trench warfare and industrial age weaponry such as tanks, poison gas, and aircraft, all deployed in unprecedented ways in World War I, had been kept invisible through military censorship from most civilian populations of the time. A significant turning point came in 1924 when Ernst Friedrich, a German pacifist anarchist, published *War against War!* making photographic documentation of the horrors of World War I publicly available for the first time. Friedrich accompanied his photographic collection with sardonic captions and anti-war polemics. He aimed to shock the public out of militarist ideologies into which they had been indoctrinated by attacking capitalism as the cause of wars in which working people give up their lives to protect the property interests of the rich. Friedrich also attacked the everyday paraphernalia of militarist ideology including children's toy soldiers, helmets, guns and swords. Even today *War against War!* retains its power to disturb.

Writing in 1919, immediately after World War I, Freud described war neurosis as a "conflict between the soldier's old peaceful ego and his new warlike one" and proposed that "the old ego is protecting itself from a mortal danger by taking flight into a traumatic neurosis" (17: 209). Friedrich's book of photographs told a completely different story: of dead soldiers in trenches, stripped of their clothes and left to be eaten by animals. In one photograph a naked, starved, bald-headed body lies in a mass grave. This image anticipated in an uncanny way photographs that would later emerge after the liberation of concentration camps at the end of World War II. Friedrich's captions described a typhoid patient left to starve to death and later thrown into a pit full of corpses. His images include mass hangings involving thousands of men executed on the gallows. Others show corpses of Armenian civilians—adults and children—left to die of starvation. The images are full of horrors we have come to associate today with the Holocaust. Perhaps the most disturbing of all are those of surviving soldiers with faces mutilated by grenades and stitched back together in operations. In some cases large wounds remain open.

Was this violence to be understood in terms of a conflict between two different manifestations of ego, one formed in peace time and the other in war? These images revealed a far more radical process of dehumanization than could be accounted for by Freud's theories of war neuroses. Any sense of an agential ego appeared eradicated. The photographs in *War against War!* take us beyond the soldier as an actor enmeshed in a psychic conflict. The dismemberment and mass-produced death made possible by industrial military technologies constituted, as Benjamin later suggested in a famous passage, a distinctive trauma of the early twentieth century:

For never has experience been more thoroughly belied than strategic experience was belied by tactical warfare, economic experience by inflation, bodily experience by mechanical warfare, moral experience by those in power. A generation that had gone to school on horse-drawn streetcars now stood under the open sky in a landscape where nothing remained unchanged but the clouds and, beneath those clouds, in a force field of destructive torrents and explosions, the tiny, fragile human body. (3: 144)

The spectacle of mass death and decomposing bodies in trench warfare was unprecedented. Julia Kristeva has argued that such an experience of the *abject*—the body as disgusting *other*—threatens the foundations of the self's sense of individual integrity (*Powers of Horror* 3).[13] The experience of death in the trenches was more than indescribable: it was unspeakable. But photographs could show it.

PSYCHOANALYSIS AND BARE LIFE

Beyond destruction at the front line, World War I brought other catastrophes. Enzo Traverso comments: "Between 1914 and 1918 the term 'concentration camp' entered the vocabulary of Western countries" (Traverso 86). Camps for displaced civilians and prisoners of war began with the internment of civilians by the British in the South African Boer War and multiplied during World War I. The colonial frontier provided the space in which new forms of racist violence and domination were first tested. The camp, as the new site of massive dehumanization, directly threatened Freud, as a Jew, in ways he could not have anticipated. In the larger political context individual rights were also inequitable. Carl E. Schorske described how the rise of anti-Semitic movements in the late nineteenth century in Vienna were to impact on the development of Freud's career, culminating in his ultimate flight from his home country. Without an officially recognized nation, Jews were dependent on assimilation by the liberal, cosmopolitan state (Schorske 129). What Freud saw as the progressive, rationalist values of liberalism gave way to emerging populist Catholic and anti-Semitic parties. As Zionism emerged as a nationalist movement, Freud pursued a professional and intellectual resolution to the predicament of political vulnerability. Schorske argued that Freud's response to his political frustration was to seek recognition of psychoanalysis as a science. Psychoanalysis, Freud believed, would expose the irrationalism of both the old aristocratic order and of the new mass movements. His quest for scientific legitimacy led Freud to depoliticize much of the experiential patient content he analyzed as well as removing it from its larger historical context. His emphasis on instinct and primal fantasy, while subverting the classical culture of the

old regime, could not address new problems of denationalization and state-lessness, both of which Freud himself would eventually be forced to face. His final flight to England, a country that had always represented for him the bastion of liberalism (Schorske 189), saved Freud from directly experiencing the ultimate catastrophes of anti-Semitic ideologies.

Whereas psychoanalysis can be seen as offering an antidote to fascism, it was unable to account for the politics of individual rights in the modern state. Kristeva has proposed that in Freudian theory foreignness is incorporated into a model of a divided self, which she explains with reference to Freud's own ethnic status as a Jewish outsider (*Strangers* 181). With the advent of psychoanalysis we become, in Kristeva's phrase, "strangers to ourselves," required to recognize our own unconscious alterity. Just as Freud sought to reveal that uncanny strangeness is already immanent within the idea of homeliness, so we can say that any idea of the national always already includes its immigrants and its minorities. Indeed, trauma had originally been described by Breuer and Freud as acting "like a foreign body which long after its entry must continue to be regarded as an agent that is still at work" (Breuer 6). Just as he claimed the "talking cure" would free a patient from the secret influence of traumatic memory, Freud's ideal of political liberalism promised to exorcise the fear of the Jewish minority that had been expressed by anti-semites in compulsive repetitions of racial violence. Psychoanalysis could potentially offer a solution to the projection of anxiety by which the Jew continued to be positioned by nationalist propaganda as the "enemy within." Kristeva explains how the psychic disturbance posed by the foreigner as other prompts a *"destructuration of the self* that may either remain as a psychotic *symptom* or fit in as an *opening* toward the new" (*Strangers* 188). Arguably it was a psychotic, persecutive response that dominated the general political milieu in which Freud developed his ideas about trauma after World War I. As Arendt described it:

> This atmosphere of disintegration, though characteristic of the whole of Europe between the two wars, was more visible in the defeated than in the victorious countries, and it developed fully in the states newly established after the liquidation of the Dual Monarchy and the Czarist Empire. The last remnants of solidarity between the non emancipated nationalities in the "belt of mixed populations" evaporated with the disappearance of a central despotic bureaucracy which had also served to gather together and divert from each other the diffuse hatreds and conflicting national claims. Now everybody was against everybody else . . . (*Origins of Totalitarianism* 268)

Freud had hoped the break-up of the Austro-Hungarian empire would bring political emancipation, but it instead created national and ethnic tensions which became increasingly perilous for Jews. With the rise of new fascist

mass movements, Arendt explained, "Denationalization became a power-ful weapon of totalitarian politics" (269).

Freud wrote a short essay "Thoughts for the Times of War and Death" in 1915 in an attempt to understand the crisis for Europeans whose faith in progress, enlightenment, civilized behavior and cosmopolitan values, was shattered by the conduct of their governments in the new conflict. He wrote of a disillusionment brought on by the war that caused civilian citizens to feel powerless to affect the course of events and in which the ideals of Euro-pean cosmopolitanism became debased. While the public was prepared for the continuation of "wars between the primitive and civilized peoples," they did not expect a war between the central states of Europe in which "foreigner" and "enemy" would again become synonymous (19: 275–277). Within the "great nations" of Europe was to be found a unity of culture that transcended differences of language and racial origin. With the war however came a breakdown of international law and a descent of the Euro-pean states into barbarism. Whereas the greatness of European civilization had demanded a high level of repression by the individual citizen, the state was now seen to monopolize violence in the cause of unlimited self interest. Freud, however, argued that this experience of disillusionment presented an opportunity to learn a difficult lesson: that civilized life does not eradicate base instincts, but only holds them in check, often only through obedience and social conformity. Even the best intellects he posited are capable of regression given the opportunities presented by war. As with the problem of war neurosis, Freud attempted to assimilate these radical political trans-formations into his theory of ego.

There is an underlying conservatism in Freud's argument that, while attesting to the debased conduct of the state, preserves Eurocentric binaries of civilization and barbarism and ultimately retains the nation state as the basis of international law. The more traumatic possibility, not considered by Freud, was that the barbarism of modern warfare presented to the civilized West a specter of its own colonial violence—an image of human subjects stripped of sovereignty, of territories appropriated and peoples enslaved and exterminated. The West had witnessed, through its own practices of con-quest and colonization outside Europe, the reduction of 'the other' to the sub-human. Could it ever truly dissociate itself from this 'other' who also embodied its own desires, its fears, its utopian impulses? Freud's analysis of the regression of the European subject failed to consider the possibility that the very foundation of enlightenment only arose through the violent exclusion of a non-Western 'other'.

Again, it was Arendt who developed an argument that may be said to be latent in Freud's reflections on war. For Arendt, World War I not only destroyed the European community of nations and returned the foreigner, or minority, to the status of enemy, but it also gave rise to a new phenom-enon—the stateless person: an individual with no rights and no protec-tion under national or international law (*Origins* 267). The disillusionment

attested to by Freud was for Arendt only the first of a series of steps leading to the cynicism of the totalitarian state under which the individual either conformed to a new social barbarism or submitted to denationalization and the loss of human rights. This new totalitarian violence had been developed, argued Arendt, with the advance of earlier forms of Western imperialism. In *Homo Sacer* Agamben further develops Arendt's propositions. For Agamben the problem is not, as Freud saw it, that "foreigner" would revert to the status of "enemy," or even that minority would revert to "foreigner," but that a more primary mode of exclusion, which he calls "the ban," serves as the basis of sovereign power: "The fundamental categorical pair of Western politics is not that of friend/enemy but that of bare life/ political existence" (*Homo Sacer* 8). The condition of banishment outside the law has its origins in ancient forms of sovereign power, but in the modern state entire populations now become subject to the ban, the emblem of which has become the concentration camp (20). As the question of human rights became increasingly bound to that of national citizenship, political existence grew to become indistinguishable from biological life. Nazi doctrine of blood and soil sought to establish German citizenship and reduced Jewish people to a condition of *homo sacer*, available to be killed with impunity (126–132).

In light of Agamben's argument, Freud's persistent failure to resolve the nature of trauma can be explained by his inability to grasp the biopolitical transformations of modernity within the terms of his own commitment to cosmopolitan liberalism. Freud's theory of trauma can be read as a partial attempt to account for the reduction of the individual to what Agamben calls "bare life," a condition that cannot be explained within the narratives of subject-formation of the liberal individual. The category of bare life can include the colonized subject, the native or indigene subject to imperialist domination, or the victim of genocide (Gilroy 49). The clinic, the battlefield, the colony were all—like the concentration camp—zones of experimentation in which the limits of the individual could be tested, submitted to new levels of stress, and have his or her defensive structures penetrated, fractured and fragmented to a point where any ability to articulate a coherent narrative of self collapsed.

This "destructurated" self, identified in Leys's reading of Freud, can be aligned with a larger political collapse of the European ideal of the civilized individual and the liberal state. Sander L. Gilman's discussion of Freud and hysteria is quite explicit about the parallel between the hysteric, subject to the scopic regime of the clinic, and the Jew, whose visibility through racial stereotyping made him/her vulnerable to political and social exclusion. For this reason Gilman sees Freud's move away from visual evidence as determined in part by his own anxieties about the visible differences ascribed to Jews and his personal desires for assimilation and recognition as a scientist (Gilman 415, 433). Jews were considered inherently vulnerable to hysteria and other nervous disorders. Ironically, nervous disposition was explained

by a long history of persecution. Jews were also nonetheless associated with modernity and metropolitan life (Gilman 405). The direct association of hysteria with race reveals that a disturbing role was played by modern medical discourse in the logic that led to the Nazi's Final Solution. If Charcot was the first clinician to employ a full-time photographer, we should remember that Auschwitz included two photography laboratories devoted to documenting its horrors, including executions, torture, and the experiments of Dr. Mengele (Huberman 24).

IMAGE: MOSES

Freud's struggle with the problem of historical trauma and political identity culminates in *Moses and Monotheism*. It is perhaps appropriate that before this he explored the relationship between the individual and the group in one of his only discussions of a specific visual representation. "The Moses of Michelangelo" was first published anonymously in 1914 by Freud and is one of the few texts in which he analyzes a work of art or a visual representation. As Gilman has noted, despite distancing himself from Charcot's use of visible evidence, Freud occasionally returned to the visual in support of specific arguments (Gilman 366). This essay, then, provides an important opportunity to consider how Freud might have approached the idea of an optical unconscious.

Freud began his essay by declaring that he was "no connoisseur of art, but simply a layman" (13: 211) and was more attracted by the subject matter of artworks than their technical features. Freud's concern was with the effect of the artwork, the fascination it exerted on him as a viewer. Only psychoanalysis, he proposed, can explain the effects of art and theatre which elude rational explanation. For example he theorized that only the Oedipus complex resolves the psychological riddle posed by *Hamlet*. Michelangelo's statue of Moses in the Church of S. Pietro in Vincoli in Rome was originally intended to form part of a gigantic tomb for Pope Julius II. Freud wrote that under "the angry scorn of the hero's glance" he has felt part of the mob "upon whom his [Moses's] eye is turned" (13: 213). Freud then proceeded to discuss the inadequacy of various descriptions of the statue given by other authors. These included diverging accounts of the position of Moses's hands and his bodily posture and facial expression. Freud set out to reconstruct the scene from which this figure of Moses emerged: "It is the descent from Mount Sinai, where Moses has received the Tables from God, and it is the moment when he perceives that the people have meanwhile made themselves a Golden Calf and are dancing around it and rejoicing" (216).

Freud then considered the importance of art connoisseur Ivan Lermolieff, the Russian pseudonym of an Italian physician called Morelli, who had shown that one could distinguish original artworks from copies by shifting

attention from the main features of the picture to minor details such as fingernails or earlobes. Freud pointed out the similarity of this method of visual interpretation to psychoanalysis (222). Like Morelli, Freud proposed studying peripheral details of an image as a means of working back to the authentic origins of the representation. Attention to marginal detail, or the optical unconscious, remained centered in Freud's analysis on an individual artist and an individual artwork. In order to reconstruct the scene in which Michelangelo's figure is placed, Freud used a technique very close to film animation or montage. In this essay Freud came as close as he ever did to direct engagement with the new media of photography and film: photography, with its close-ups that could reveal previously unacknowledged visual details; and film, which through montage could animate stationary figures and create a narrative sequence.

Freud took this approach to analyzing the statue of Moses, looking closely at the placement of hand and beard and at the tables held by his left arm. He employed an artist to produce a series of sketches that animate the hypothetical movements of Moses, resulting in the specific pose he assumes in Michelangelo's statue. From this reconstruction of Moses' movements Freud deduced that Moses transferred the tables from under his right to under his left arm. What Freud sought to demonstrate was that rather than readying himself for action, Moses contained his anger and resisted an initial urge to rise up to express displeasure at the mob. Instead, Moses' concern was to preserve the tables. In so doing, claimed Freud, Michelangelo deviated from the Biblical account of Moses and produced a new humanistic vision showing "the highest mental achievement that is possible in a man, that of struggling successfully against an inward passion for the sake of a cause to which he has devoted himself" (233). Freud also saw in this an implicit critique by Michelangelo of his patron Julius II, who had used violent force in a drive to unify Italy under Papal supremacy. Freud closed the essay by speculating on whether his interpretation, based on attention to minor details in the sculpture, could be assigned to the conscious intention of the artist.

If Freud's method cannot ultimately tell us anything conclusive about Michelangelo's intentions, it may reveal something about his own desires and fantasies. As Schorske emphasized, Freud's assertion of the liberal individual took shape against a backdrop of the rise of anti-Semitic political movements. As such Freud's obsession with visiting Rome, was seen by Schorske as a symptom of an unconscious wish for assimilation into the gentile world (Schorske 189–190). This same ambivalence about identity and assimilation can be seen in Freud's discussion of the statue of Moses. The figure of Moses, the Jew, is sent to subvert Papal authority, but Moses is himself removed from the original Biblical context and becomes the product of a non-Jewish sculptor who nevertheless transcends Christian values and institutions through his revolutionary humanist vision. Freud thus manages to validate the intention, whether conscious or unconscious,

of the individual against religious authority and the conformist behavior of the mob. Freud's analysis of the statue allowed him to remove himself from the angry gaze of Moses in which he felt himself part of the despised mob, and establish instead an identification with Moses as a leader who showed individual restraint in the face of pressure from the collective. The initial "traumatic" impact of the statue on Freud, which haunted him and which he could not explain, was transformed by way of his interpretation into a validation of Freud's own individual struggle with both his Jewish origins and with Roman Catholic power. In this complex reading of the image of Moses, Freud attempts to "transcend" his difference as Jew and escape his vulnerability to persecution. Freud's analytic method, then, allows us to rediscover the relation between traumatic memory and the political dynamic of the individual's relation to the collective.

A year earlier in *Totem and Taboo* (1913), Freud had proposed that prehistoric human communities were led by a "primal father" who was also a sexually dominant figure. He theorized that eventually other males of the horde rose up in jealousy and resentment and murdered the father. This ultimately led to the establishment of a new libidinal economy in which the incest taboo prevented the earlier sexual monopoly of the leader. Guilt for the original crime of collective murder came to be acted out in a ritual in which a totem animal, as a substitute for the primal father, was sacrificed and eaten. Later, in *Moses and Monotheism*, Freud extended these speculations and explained their logic in terms of a violent crime (the murder of the primal father) that is compulsively acted out by the group. (Charismatic leaders in modern societies such as Lenin, Hitler, Gandhi and Kennedy may be seen to recall archaic images of a primal father and thereby activate compulsive repetitions of the original ambivalence of the group.)

Freud returned to the issue of collective trauma in one of his final texts, *Moses and Monotheism*, in which he claimed to seek the truth about the historical Moses outside any "national interests" (23: 7). Again a theory of resistance to a "traumatic" truth was employed, implicitly justifying the truths revealed by psychoanalysis. Freud traced the origins of Jewish monotheism to a heretic tradition within the Egyptian dynasty. He proposed that monotheism was imposed upon Jews by the Egyptian born Moses, in an attempt to rescue religious doctrine from earlier catastrophe that had befallen it in Egypt. Jews eventually rose up and murdered their leader and rejected his religion, as had the Egyptians before them. Freud went on to argue that there was not one but two historical persons joined in the legendary figure of Moses. The other was a Midianite from whose religion originates the god Jahve. Freud proposed that the local cult of Jahve only served to cover the far more challenging doctrine of monotheism, which made entirely new ethical demands on its followers. Yet it is the doctrine of monotheism that ultimately triumphed in Judaism. What distinguished the followers of the Egyptian Moses from those of the Midanite was "an experience which must be regarded as traumatic" (52): the murder of their

leader. But the doctrine of monotheism and the prohibition of polytheistic worship was also a traumatic shock that resurfaced in Jewish culture after a period of latency.

In this final text on trauma Freud once again attempted to transpose the historical crisis of denationalization in his own time onto a meditation on the radical nature of theory, thereby explaining his own persecution in terms of his originality as a thinker, rather than his experience as a member of an ethnic minority. In prefatory notes written for section three of *Moses and Monotheism,* Freud commented on the establishment of the Russian Soviet, Italian Fascist and German Nazi regimes. In his earlier days in Vienna Freud had seen Catholicism as the enemy of free thought, but he now required its protection against Nazi anti-Semitism. He decided to withhold from publication the first section of his bold speculations on Moses because of its potential to offend his new protectors. After June 1938, having fled Vienna for England, he added a second section of notes. While he now feared publication of his manuscript would alienate his new friends, he remained bound to his conviction "that religious phenomena are only to be understood on the pattern of the individual neurotic symptoms familiar to us" (58). That is, that religious beliefs are obsessions based on the return of repressed or forgotten traumas in primeval history.

Freud returns to these various forms of political repression in the final section of *Moses and Monotheism* by defining theory itself as traumatic. Freud compared the delayed success of monotheistic doctrine to radical theories, such as the Darwinian theory of evolution, that are initially rejected, but later are accepted and legitimized, or to a painful truth that an individual attempts to repress but that s/he must ultimately acknowledge. Repressed in the official texts of a culture, monotheism survived in oral tradition. Freud develops this analogy of the oral traditions of a collective and compares it with the traumatic origins of neuroses found in the early childhood experiences of an individual. These experiences are often forgotten and remain inaccessible to conscious recollection, only to be relived later in the form of compulsive repetitions, character traits or defensive behaviors. When the trauma returns after a period of latency, the ego struggles and often fails to integrate the repressed experience. A similar logic pertains to collective human experience, he argues, with prehistory corresponding to the forgotten period of early childhood.

Within this series of analogies between the collective and the individual, Freud now proposed a bold theory of historical trauma which we might read as a further failure to integrate the political experience of his career with his new "science" of psychoanalysis. If we read *Moses and Monotheism* in its political context, we can also understand trauma theory as an attempt to develop an historical narrative that can extricate itself from the violence of the modern state. Cathy Caruth has proposed that *Beyond the Pleasure Principle* and *Moses and Monotheism* represent "Freud's formulation of trauma as a theory of the peculiar incomprehensibility of human survival"

(*Unclaimed* 58). I would argue, contra Caruth, that Freud's history of the Jews in *Moses and Monotheism* represents an attempt to ascribe a collective unconscious to the Jewish people that operates as a substitute for the citizenship that Jews lost under the racist policies of the Nazi state. Similarly, Freud's ongoing attempts to legitimize psychoanalysis as a "scientific" theory mirrored the Nazi biological theories of race, whereas his return to biblical narrative had its counterpart in Teutonic mythology. Ultimately Caruth can only ascribe a structural logic ("both an endless crisis and an endless possibility of a new future" [68]) to Jewish tradition rather than make any reference to actual historical forces impacting on modern Jewish people. If however we follow the logic of Arendt's and Agamben's analyses, we are led to a different conclusion. *Moses and Monotheism* was written under the shadow of Jewish denationalization and racial persecution. Was it the image of the stateless person, vulnerable to extermination, that constituted the historical trauma shaping Freud's theory? Freud indirectly suggested that psychoanalysis, like monotheism, would persist despite its repression, in the manner of a traumatic memory. However, we can reverse his logic by proposing instead that psychoanalytic trauma theory persists as part of an ongoing attempt to explain a more radical historical change in which human experience became subject to new regimes of both visibility and destruction. By remaining attentive to the role of fantasy and projection in the articulation of historical trauma we may better understand its relation to the political status of the human subject.

BENJAMIN AND FREUD

The common understanding of Frankfurt School critical theory as a synthesis of Marx and Freud fails to acknowledge the very different appropriations of psychoanalysis and historical materialism by individual thinkers such as Benjamin and Adorno. Whereas Benjamin approached the question of the unconscious by way of French Surrealism and was always somewhat wary of Freud, Adorno made a specific study of psychoanalysis early in his career. Moreover, when Benjamin finally came around to making a more substantial use of Freud, he situated him in his own complex constellation of Bergson, Proust, Simmel and others. Benjamin's understanding of the unconscious was never purely Freudian. If one follows the direct references to Freud in Benjamin's writings, his interest in psychoanalysis would appear to be relatively undeveloped. Indeed, it is tempting to consider the use of Freud in "On Some Motifs in Baudelaire" as a concession to Adorno after his editorial rejection of the earlier Baudelaire essay. Sarah Ley Roff describes Benjamin's use of Freud as always "tactical" and transformative. This tendency to reposition others' theories within his own critical assemblages was typical of Benjamin's approach: "psychoanalysis is never more than one position amongst many in Benjamin's writings and . . . as it comes

into contact with other positions, it undergoes various kinds of displacement" (Roff 132).

An example of such displacements can be seen in the 1928 essay "Toys and Play," where Benjamin cited Freud's discussion of the *fort-da* game in *Beyond the Pleasure Principle*. In this essay Freud argued that an experience that may originally have been unpleasurable can, through repetition, be transformed into a source of pleasure. He interpreted a child's game of throwing a wooden reel out of his cot as a symbolic representation of his mother's absence and return—this was "the child's great cultural achievement—the instinctual renunciation" (18: 15). Freud situated the child's game within the Oedipal triangle of the bourgeois family as well as within the scene of psychoanalysis itself. For in the context of analysis, repetition is understood as a symptom of an unconscious neurosis, whereas remembering brings traumatic memory to consciousness. The fact that this particular child's father was absent at the battlefront indirectly suggests another set of traumatic experiences that may have shaped Freud's reflections on the significance of repetition. The absence of the father at that time can only be understood with reference to larger social and political structures of nation and empire and the economic and technological forces that define modern war.

Benjamin, on the other hand, considered the significance of the child's game in the context of a history of toys as commodified products of a capitalist economy.[14] He stressed that repetition is not only a way to master frightening experiences, but also a way of celebrating victory again and again. Unlike the subject of psychoanalysis who by transforming trauma into narrative alleviates distress, the child seeks simply to repeat the event "with total intensity" (2: 120). This intensity is not a compulsive acting-out but the "transformation of a shattering experience into habit" through play. For Benjamin the child acts out the utopian potential of play, in which technology is rehabilitated in everyday life. Unlike Freud, for Benjamin the joy of repetition becomes a victory of the child *against* or *in spite of* integration into the adult world. The toy is appropriated *at a moment of danger*: the danger of assuming the structure of guilt and debt that defines adult experience under capitalism, and through which the soldier becomes subject to the imperialist ambitions that had led to the catastrophe of World War.

The differences in Freud's and Benjamin's interpretations of the child's game indicate the general conceptual frame within which Benjamin critically engaged with the Freudian theory of trauma. In the third version of the "Work of Art" essay Benjamin compared the visual worlds made available by film—"by its use of close-ups, by its accentuation of hidden details in familiar objects" (3: 117)—to the details of human behavior first analyzed systematically in Freud's *Psychopathology of Everyday Life*. Again the emphasis is not only, as in Freud, on the revelation of "repressed" materials previously unavailable to conscious understanding, but also on "a vast

and unsuspected field of action" (117). The previously unconscious forms of visual experience which film now makes available hold the promise of releasing the object world from repressive social relations under capitalism.

In these different texts Benjamin consistently repositioned the Freudian interpretation of childhood memory in larger cultural and historical contexts. In both Freud and Benjamin the object and image worlds of earliest childhood experiences carry the traces of historical trauma. The trauma of war haunts Freud's discussion of the *fort-da* game. For Benjamin children's toys owe their existence to the cult of capital and implicitly carry with them the memory of what has been destroyed by the triumph of capitalism. These historical frames are revealed by the tactile appropriation of objects and images in which the past has congealed. This theory of the accumulation of physical traces of memory leads Benjamin in his early formulations of the *Arcades Project* to posit a collective unconscious. As I will discuss in Chapter 3 it was his attempt to develop his own theory of collective memory under modern capitalism that provoked Adorno's insistent criticism and so another return to Freud.

IMAGE: LENIN

As an individual who suffered the fate of denationalization, Benjamin has given us some of the most enduring formulations of modern media's relation to the traumatic experiences of the early twentieth century. Further, Benjamin's writings register the crisis of the liberal individual in the face of World War I and the emergence of a new culture of "the masses." In his "Little History of Photography" (1931), Benjamin wrote of the congruence between early photographic technology and the aura of bourgeois portraiture. Early photographic portraits, with their prolonged exposures and low light-sensitivity, captured "an aura that had seeped into the very folds of the man's frock coat or floppy cravat" (2: 517). Advances in optics banished this world of shadowy depths in much the same way that the social conditions that had defined this historical class were disappearing with "the deepening degeneration of the imperialist bourgeoisie" (517). The taste of this new class, with its preference for retouched negatives, family albums, painted landscapes and "artistic" settings for portraits, exhibited the destruction of the aura that Benjamin perceived as inhabiting the earliest photographs.

In revolutionary times, Benjamin claimed, the role of photography is different. Whereas the bourgeoisie had learned to indulgently preserve images of themselves for posterity, the proletarian and peasant faces (as captured in the films of Eisenstein and Pudovkin), and the range of individuals documented in other photographs (such as those of August Sander), allowed the observer to study the physiognomy of social class. Benjamin's history of photography revealed a crisis for the bourgeoisie, viewed with a

certain nostalgia but understood to be giving way to new forms of collective experience and to the experiments of the avant-garde. Whereas Freud understood this crisis as an uncovering of "primitive" instincts that had not disappeared in an advanced civilization but were simply repressed, Benjamin posited that photography reveals an "optical unconscious" (510–512): a claim through which disillusionment gives way to illumination. For Benjamin, the deepest memory-traces to be discovered in photographs are not those intended to be preserved for posterity by bourgeois conformity and fashion; rather, they reside in the unique existence of the individual—their aura—or in unconscious traces of social class formations. Where Charcot employed photography to study the physiognomy of hysteria, Benjamin looked at photographs to study the physiognomy of the political collective.

Concern with the aura of an image and its relation to social class was a feature of a series of reflections Benjamin wrote in 1927 on Moscow, where he had seen Sergei Eisenstein's film *Potemkin* (2: 824). Benjamin's account of his visit to Moscow stressed his inescapable direct encounter with collective life in the streets, as opposed to his experience of relatively "deserted and empty" (2: 23) streets of Berlin. Street markets sold children's toys and holy icons; he encountered war orphans and street beggars as well as beautifully decorated Christmas trees. On a visit to a classroom, Benjamin noted the many children's drawings of Lenin, the icon of this new collective culture and saint of the revolution. Benjamin commented: "Bolshevism has abolished private life" (30). The cult of Lenin was the religion of the new collectivized culture.

Benjamin closed his essay with a meditation on the image of Lenin. He noted that public mourning for Lenin "meant also mourning for heroic Communism" (2: 45). As the period of Lenin's revolutionary leadership rapidly receded with the establishment of Stalin's regime, Lenin became a more remote figure. "Nevertheless," wrote Benjamin, "in the optic of history—opposite in this to that of space—movement into the distance means enlargement" (45). This "optic of history" can be compared to the structure of traumatic memory which although apparently forgotten increases in emotional intensity and returns with a vivid sense of immediacy. Like Freud's Moses, it was Lenin who made the greatest psychic demands on his followers and it was Lenin, not Stalin, who remained the true symbol of the revolution and its martyr. The new Soviet version of Ford mass production was advanced under Lenin's name. Part of the logic of this appropriation was the reproduction of Lenin's image or statue in a multitude of different locations in Soviet society. The most common image was Lenin the orator, but Benjamin's gaze was caught by another image that he believed spoke perhaps more intensely and directly:

Lenin at a table, bent over a copy of *Pravda*. When he is thus immersed in an ephemeral newspaper, the dialectical tension of his nature

appears: his gaze is turned, certainly, to the far horizon; but the tireless care of his heart, to the moment. (2: 45–46)

Benjamin's attraction to this less popular image of Lenin was consistent with his interest in the optical unconscious made available by photography. In the image of Lenin as orator, the relationship of speech and leadership is made manifest: through speech Lenin is present as the representative of the masses. By contrast in Benjamin's chosen image Lenin is immersed in the daily ephemera of the new mass media. Like his image, which is produced according to the logics of industrial technology, Lenin does not separate himself from the culture of the masses. Benjamin's discussion of the image of Lenin, then, contrasted in several ways with Freud's commentary on the Moses of Michelangelo. As opposed to an individual artwork, it is a mass produced image. As opposed to an individual rejecting the mob, an individual is immersed in mass consciousness. As opposed to a "timeless" masterpiece, it portrays a transitory world of political struggle and mediated information. For all their differences, in both images the issue of traumatic identification is enmeshed in political issues specific to new mass societies and ideologies of the early twentieth century.

There is another image Benjamin does not mention: the embalmed corpse of Lenin displayed in a sarcophagus in his tomb in Moscow. The day after Lenin died Stalin made a speech in which he claimed: "We, the Communists, are people of a special make. We are made of special material. The Communist body does not decay" (cited in Buck-Morss, *Dreamworld* 71). Lenin, as the symbol of the collective, was transformed, in death, into a biopolitical body. Lenin's body was preserved, like one of the Pharaohs, using the latest technological advances in refrigeration. Like Communist society he would be immune from degeneration. The embalmed corpse of Lenin was the antithesis of the image of Lenin Benjamin hoped to rescue. By preventing the decay of Lenin's corpse, the Soviets attempted to appropriate the collective memory of the revolution and remove it from the domain of ongoing interpretation and struggle. Interestingly, Andre Bazin later wrote in "The Ontology of the Photographic Image" that the practice of embalming the dead constituted an unconscious drive of visual representation in painting and sculpture. For Bazin, photography and film were the greatest modern extensions of that primal impulse to defeat death: "The photographic image is the object itself, the object freed from the conditions of time and space that govern it" (14). Benjamin resisted this drive to embalm Lenin in the photographic icon by placing his image back into the circulation of everyday life and politics.

The embalming of Lenin embodied the new biopolitical control that the modern state pursued over the life and death of its subjects. As Benjamin later wrote in his theses "On the Concept of History": *"even the dead* will not be safe from the enemy if he is victorious" (4: 391). The photograph was an important feature of this power over the dead because it could remove

an image from sites of political conflict and maintain them in a mediated, mythic time. Susan Buck-Morss has also noted the similarities between the architectural plan for the Palace of the Soviets, featuring a giant statue of Lenin at its pinnacle, and the closing images in *King Kong* in which the giant gorilla ascends to the top of the Empire State Building. The Palace of the Soviets was planned to overtake the Empire State as the highest man-made structure in the world. The plans, however, were never realized. Buck-Morss asks if this image of Kong was in fact a deliberate reference to the plans for the Soviet palace, but the links remain somewhat tenuous (*Dreamworld* 175). What the two images have in common, she proposes, is that "both are symbols *of* the masses, displayed as spectacles *for* the masses" (176). Images of the masses as primitive, savage and animalistic were common at the time. In *King Kong* the killing of the giant gorilla was symbolic of the defeat of the proletarian threat by American capitalism. But in the USSR the embalmed body of Lenin represented a new political collective whose biological existence was increasingly incorporated into the interests of the state. Although the most extreme forms of biopolitics are associated with the Nazi Third Reich, the Soviet state also advanced new forms of biopower over labor, housing, child care, hygiene, marriage, sexuality, birth control and abortion (*Dreamworld* 190–205). Benjamin wrote of Moscow:

> Each thought, each day, each life lies here as on a laboratory table. And as if it were a metal from which an unknown substance is by every means to be extracted, it must endure experimentation to the point of exhaustion. No organism, no organization, can escape this process. (2: 28)

Benjamin saw all this in terms of the triumph of collective life over the private individual. The dissemination of Lenin's photograph throughout every location of Soviet life became an important image of these forms of social experience. So whereas Stalin's embalming of Lenin symbolized a new stage in the domination of life and death by the state, Benjamin grasped an image of collective biopower at a moment of danger. His images can never be fully contained by an understanding of history as traumatic in a negative sense. Benjamin's conception of the shock of radical social change, at least in these early texts, also included a positive sense of social mobilization.

3 Critical Theory, Mass Culture and Film

The concept of historical trauma allows us to grasp how political communities are formed and how they perpetuate themselves. Freud argued that group identity is based in acts of violence and feelings of collective guilt, repeated in ritual sacrifice. Drawing directly from Freud, Benjamin and Adorno explained, in different ways, the sacrificial logic underlying modernist aesthetics and mass culture. Benjamin wrote of Baudelaire: "He named the price for which the sensation of modernity could be had: the disintegration of the aura in immediate shock experience" (4: 343). In modern cities transitory encounters with others, rapid changes to the physical environment, the numbing impact of industrial technologies and spectacular displays of commodities all gave rise to new forms of collective experience. Benjamin argued that under these conditions the new media of photography and film served as substitutes for earlier lived traditions and bourgeois privacy. Adorno argued that shock experience also defined participation in mass culture and politics.

As I showed in Chapter 2, Freud's theory of historical trauma retained the model of the individual psyche whereas Benjamin looked to new forms of collective experience in modern life. For Benjamin, shock experience demanded the destruction of middle class individual consciousness. In *Minima Moralia* (1951), Adorno responded to Benjamin's reading of Baudelaire with the counter proposition: "The sensations which the masochist abandons himself to the new are as many regressions" (*Minima Moralia* 236). Shock, Adorno argued, had become a commodity and the new was destined to become mere repetition. For this reason fascism itself depended on the shock tactics of modern sensationalism. Despite their differences, Benjamin and Adorno both showed that the Freudian theory of trauma demanded a new conception of the individual's relation to the social collective.

In Chapter 2 I considered how Freud's historical relation to photography revealed political crises that his theory never directly acknowledged. Photography, understood in terms of the optical unconscious, makes visible the forms of historical trauma that remain "unthought" in Freud's writings. In this chapter I argue that film, as the great collective cultural form of the twentieth century, can enlarge our understanding of historical trauma

in the cultural criticism of Benjamin and Adorno. In support of this argument I borrow Homi Bhabha's notion of an "exilic optic" which allows us to perceive the scene of colonial violence in the heart of the metropolitan environment. Bhabha's rearticulation of the optical unconscious enables me to read the historical trauma of European imperialism and colonialism in Benjamin's discussion of the Native American in nineteenth- century French fiction, and in Adorno's various comments on King Kong—both also iconic images of modern cinema.

Later critics, including Hannah Arendt, Enzo Traverso and Paul Gilroy have argued that the ideologies of racism and the deliberate policies of genocide that were exemplified by Nazism were formed in earlier phases of imperial conquest and colonial settlement. Visual stereotyping of racial difference and class conflict formed part of early psychotherapeutic discourses about trauma and also informed the psychological analysis of crowds by Gustave Le Bon, which in turn influenced Freud and Adorno. Although Benjamin's relation to these discourses is somewhat less direct, what Traverso described as "class racism" can be seen to resonate in Benjamin's analysis of nineteenth-century French literature. Benjamin struggled with the relationship between civilization and barbarism in his final theses "On the Concept of History," but never directly acknowledged how this binary was based in European imperialism. In Benjamin's and Adorno's different attempts to develop a theory of historical trauma we can read these different instances of political violence as they are consciously or unconsciously addressed in their writings. Benjamin's writings on Baudelaire and Adorno's Wagner study anticipate in important ways certain theories they would pursue in relation to modern media and particularly film. Film, as the mass cultural form *par excellence*, embodied for these critics many of their anxieties about individualism and collective political action. Further, lower-class crowds were often imagined by middle class intellectuals in racialized terms, aligning the "problem" of the urban masses with that of the colonial native.

Prominent and influential figures in the trauma debate, such as Cathy Caruth and Dominick LaCapra, have paid relatively little attention to Benjamin or Adorno.[1] Although references to Benjamin are common enough in trauma studies, particularly to his famous theses on history, there is often a distinction between post-Holocaust appropriations of Benjamin and work that focuses on his studies of modernity. The reluctance to engage with Benjamin's particular appropriation of Freud in trauma studies was perhaps most clearly articulated in some comments by Geoffrey Hartman in *The Longest Shadow* (1996), when he proposed that the irreversible losses of the Holocaust refuse redemptive narratives and even resist representation altogether. For Hartman, Benjamin "writes as if the potentially explosive impact of past on present were still possible" (45) whereas for Hartman it is "impossible to think of Benjamin's incursions into the 'dark backward and abyss' of time as post-genocidal" (46). Hartman saw contemporary

experience as either formed by the annihilation of cultural memory in extreme events such as the Holocaust, or by a superficial engagement with history offered by electronic media. Yet Benjamin's insights into art, technology and politics continue to suggest useful approaches to contemporary trauma theory in which the figure of the victim/survivor sometimes functions as a kind of successor to the modern artist and trauma assumes the status of an authentic experience of modern history. One alternative to this perspective is to see individual survivors and trauma victims as images of the collective: whether understood as members of an oppressed social group or as 'specimen' of a general cultural condition. Just as every form of sovereign power is based on the violent exclusion of specific individuals and groups from the political community, so does the trauma victim in turn serve as the basis for new collective identifications.

In this chapter I provide an account of Benjamin's and Adorno's discussions and arguments about trauma and the unconscious in modern culture. In his original outline of the *Arcades Project* Benjamin proposed a collective unconscious which included utopian wish-images. He saw both the emerging consumer culture and the class struggles of the mid-nineteenth century generating fantasies about new freedoms and pleasures promised by modernity. Adorno was critical of this notion of a collective unconscious, arguing that these fantasies were embedded in alienated consciousness and commodity fetishism. When Benjamin produced his first essay on Baudelaire, Adorno was again unhappy. This time he claimed Benjamin had merely juxtaposed interpretations of the poems against images of metropolitan modernity without providing any theoretical account of their historical relationship. Finally, Benjamin submitted a second essay on Baudelaire in which he used Freudian trauma theory and proposed that the psychic defense against shock, which Freud had theorized with respect to war trauma, was characteristic of modern experience in general. On the basis of this hypothesis he argued that Baudelaire's shock aesthetics was an exemplary poetic articulation of modernity. He also argued that the camera performed new mnemonic functions in a culture defined by shock experience. This approach was more readily accepted by Adorno because it grounded Baudelaire's poetry in historical actualities by way of a Freudian theory of memory and perception. However, the second essay significantly lacked the more explicit political contexts—including terror, police surveillance and insurrection—foregrounded in the earlier draft.

In his later work Adorno extended the use of Freudian trauma theory in ways that undermined Benjamin's argument about Baudelaire. Instead of understanding shock experience as part of an original modernist sensibility, Adorno argued that shock had itself become a fetish and commodified. Adorno referred to traumatic neurosis as characteristic of modern culture in a completely negative sense. In Adorno's analyses of fascist propaganda and the culture industry, group identity is explained (following Freud) as based in regressive identifications and compulsive repetition.

This analysis also carried over in Adorno's various writings on film. So the use of Freudian trauma theory in both Benjamin's and Adorno's criticism led overall to a pessimistic account of cultural development and political progress in modernity.

In the following discussion I focus on specific images in Benjamin's and Adorno's texts related to the prehistory and early development of film. In particular I see questions of political sovereignty and collective experience as central to their different analyses of mass culture and film. It has often been noted that Benjamin offers a more positive account of popular sovereignty than Adorno, who is deeply pessimistic about mass culture. I am interested in the ways that both theorists employ images of the colonial "other" to articulate their positions. I read these figures—the Mohican in Benjamin and King Kong in Adorno—as images that unconsciously register the historical trauma of colonial genocide. Whereas Benjamin and Adorno develop different interpretations of modern Western culture neither directly address the significance of European colonialism and imperialism. Images of colonial violence in their texts, however, anticipate certain political crises that become inescapable in the postwar era. The spectacle of "bare life" in contemporary media culture exposes the global nature of human catastrophe in ways Benjamin and Adorno could not have anticipated.

The reduction of humans to disposable things is central to Adorno's meditations on the significance of Auschwitz. His critique of postwar West German society is consistent with many of his earlier propositions about group identity. Adorno never directly addressed the testimony of Holocaust survivors and his criticism, despite often cited remarks about the status of culture after Auschwitz, should not be automatically aligned with more recent studies of Holocaust representation. The danger with this later research is that it constructs the testimony of the trauma victim/survivor as an authentic *alternative to* cultural reification. This has the trauma victim/survivor inherit a position Benjamin assigned to the modern artist—that of presenting an exemplary articulation of modern experience. Adorno's response to Benjamin, that modern culture reifies shock experience itself, suggested a cautious approach to trauma testimony that has not always been heeded. I will discuss these issues further in Chapter 5. Only by attending to the shock effects characteristic of modern media *and* the experiences of victims can we develop a critical theory of trauma and media that adequately responds to Benjamin's and Adorno's earlier work.

MASS CULTURE AND POLITICS

Although both writers were critical of what they saw as the ideological limitations of psychoanalysis, Benjamin and Adorno developed different appropriations of Freud simultaneously in the late 1930s. Writing to Benjamin in 1934, Adorno proposed that Freud should be employed "dialectically"

for the purpose of both a critique of Jung's notion of a collective uncon-
scious and for a political appropriation of Freud's analysis of the individual
psyche (*Correspondence* 62). Adorno's study of Wagner, written in 1937–
38, stands as perhaps the first use of the Freudian theory of trauma as part
of an historical critique of modern culture. Benjamin cites Freud's *Beyond
the Pleasure Principle* in his 1940 essay "On Some Motifs in Baudelaire"
in which he formulates his own understanding of modernity and shock. It
is possible Benjamin's use of Freud in this essay was partly an attempt to
accommodate the views of Adorno, who had been critical of what he saw as
crude applications of historical materialism in an earlier draft of the essay.
Of the two critics, Adorno had taken a longer interest in psychoanalysis
(even writing an early dissertation on Freud),[2] whereas Benjamin's interest
in Freud had been more reserved.

Although the studies of Baudelaire and Wagner are concerned with aes-
thetics in literature and music, they can also be read as important state-
ments about emerging nineteenth-century mass culture. Benjamin read
Baudelaire in the context of contemporary newspapers, popular fiction and
photography. Adorno's study of Wagner, as Andreas Huyssen has argued,
can be read as an early instance of what would later become a critique of
the culture industry ("Adorno in Reverse" 29). Both Benjamin and Adorno
refused false separations of high and mass culture and both of these criti-
cal studies, in different ways, showed how the cultural logics of mass pro-
duction and mass media inform modernist aesthetics. Trauma became an
increasingly important concept in their critical theory, particularly in Ben-
jamin's theses "On the Concept of History" (1940) and in Adorno's post-
war writings on Auschwitz. Whereas Benjamin was initially resistant to
psychoanalysis, his use of Freudian theory in his reading of Baudelaire had
a number of clear resonances in his final meditations on the philosophy of
history. There is no doubt that the increasing prominence of a language
of trauma in Benjamin's and Adorno's writings revealed an intensification
of the historical crisis of the late 1930s. In particular, the Nazi–Soviet
alliance appeared as the final catastrophe for Benjamin's commitment to
Marxism. The postwar writings of Adorno on Auschwitz shifted away
from ideas of revolutionary transformation to concerns with confronting
and mourning a traumatic past.

The challenge of supporting or creating aesthetic practices that would
critically engage with new technologies (photography, radio and film) and
with social change (industrialism, urbanism) has assumed different forms
since the period in which Benjamin and Adorno exchanged ideas. Benjamin
and Adorno have been repositioned with respect to the wider discussion of
representing the Holocaust and the politics of memory and identity in the
postwar period. This discussion however has tended to "forget" the preoc-
cupation with mass culture that was central to debates of the 1930s. These
preoccupations surfaced again in the 1960s and still formed the basis of
much of discussion of postmodernism in the 1980s. Such a dissociation

78 Trauma and Media

of critical concerns suggests that trauma theory, in its preoccupation with history and memory, to some extent presents a conservative response to the apparent impasses of postmodernism.

As I showed in Chapter 2, whereas Freud employed optical metaphors to explain his theory of the unconscious he never considered optical technologies as agents in any historical transformation of the human subject. Benjamin's understanding of the unconscious, on the other hand, was explicitly related to optical experience and technologies. Benjamin argued that the camera provided new visual experiences previously unavailable to conscious perception. In his two essays on Baudelaire, Benjamin explored the visual experience of the nineteenth-century metropolis. The wanderings of the *flâneur* and the paranoia engendered by police surveillance gave his account of the modern subject a distinctly optical turn. In the second essay on Baudelaire the camera was discussed in terms directly derived from Freud's theory of trauma and shock. Whereas the camera mediated the shocks and collisions of the urban environment, deeper historical realities were nevertheless registered as unconscious traumas that could be read in Baudelaire's poems. In Benjamin's reading of Baudelaire the optics of nineteenth-century Paris revolved around the central problem of the masses. The *flâneur*, as individual subject, sustained an ambivalent relation with the crowd, both attracted by its restless movement and repulsed by its conformism. Meanwhile the state attempted to monitor and control the masses. Underlying this anxiety about the crowd was a longer history of political terror. The crowd was specifically threatening in a post-revolutionary society, but fear of the crowd had deeper roots in the history of Western imperialism and colonialism. In his first essay on Baudelaire, Benjamin explored in detail the myth of the masses as savages, as they were imagined by numerous writers who drew from the novels of James Fenimore Cooper. The encounter with the urban masses was imagined through a displacement of historical encounters with the indigenous peoples of the New World.

Although neither Benjamin nor Adorno ever wrote anything that would pass today as a film analysis, their various writings on photography, film, television and other forms of visual media continue to be influential on the development of contemporary film and media studies.[3] Adorno proposed that: "reading popular novels a hundred years old like those of Cooper, one finds in rudimentary form the whole pattern of Hollywood" (*Minima Moralia* 147). This statement demands to be taken as an indirect reference to Benjamin's first essay on Baudelaire, which made so much of the influence of Cooper on nineteenth-century French fiction. Adorno's point, however, is that popular culture in the age of film is rarely new in terms of its content or its genres. The first popular film genres, such as the detective drama or the western, had their origins in nineteenth-century popular fiction. What changed, according to Adorno, was the relationship between culture and society. The deliberate integration of kitsch into mass

production of commodities represented for Adorno the "incorporation of barbarity" (148) and a failure of high culture to lead society to enlightenment. In Benjamin's discussion of Cooper there is an entirely different interpretation of kitsch: that dream images of modernity gave expression to utopian impulses at the same time as they served the ideological structures of industrial capitalism. Benjamin was influenced by the Surrealists' interest in popular culture as containing subversive energies. The madness and hysteria that lurked in the details of everyday life, which psychoanalysis had revealed yet sought to contain, was to be released as a political energy. Adorno took a darker view of this energy, seeing it as harnessed by fascism in a return to a mythic cult of violence.

Film as a medium is historically bound to the behavior of crowds and to the image of the crowd (Brill 1). Adorno's reference to Cooper and Hollywood can be seen as not only referring to narrative structures and codes, but also to the image of the crowd. For Adorno the movies evoked the specter of primitive impulses orchestrated by mass political movements. He wrote in "Transparencies on Film":

> That, among its functions, film provides models for collective behavior is not just an additional imposition of ideology. Such collectivity, rather, inheres in the innermost elements of film. The movements which the film presents are mimetic impulses which, prior to all content and meaning, incite the viewers and listeners to fall into step as if on a parade. (*Culture Industry* 158)

Differences between Benjamin's and Adorno's accounts of mass culture can partly be explained by the influence of earlier thinkers. One central figure in Benjamin's first essay on Baudelaire, "Paris, Capital of the Nineteenth Century" is Victor Hugo. Hugo was one of the inventors of the modern myth of 'the masses.' In *Les Miserables* Hugo gave a detailed, if phantasmatic, account of the lower strata of French society. Hugo's vision, however, was that education and enlightenment of the masses would transform the ignorant into a sublime entity: "the people." The French Revolution was the archetypal instance of this transformation. Through revolution the sovereignty of the people and of the state became identical. Modern mass sovereignty also gave rise to new forms of terror and with the invention of the guillotine, the first mass production of death (Buck-Morss, *Dreamworld* 9–11). But 'the people' were also capable of reverting to criminal violence and in so doing betraying their "true" political sovereignty: the ideal of "the people" could degenerate into the irrational behavior of "the mob" (Jonsson 59–65). Benjamin developed a critical reading of Hugo as an example of the shifting relationship between the individual writer and the mass public.

Adorno, who in his analysis of fascist propaganda developed his own approach to mass psychology, was primarily influenced by Freud and,

through him, Gustave Le Bon. Le Bon made the first attempts to analyze the psychology of the crowd. A contemporary of Charcot and himself a doctor, Le Bon diagnosed the crowd as hysterical and subject to hypnotic suggestion. Both Charcot and Le Bon participated in medical discourses of the time in which criminals and the poor were classified as sick or insane. Le Bon's innovation was to see the crowd as inherently transforming otherwise normal individuals into a potentially pathological mass. Le Bon's theory, in which the crowd liberated primitive impulses that society had repressed, inverted Hugo's ideal of 'sovereign people.' This emphasis on unconscious impulses made Le Bon's theories appealing to Freud, who made extensive use of them in his *Group Psychology and the Analysis of the Ego*. The institutionalization of hysteria in mental hospitals, the experience of which stimulated Freud's early formulations of psychoanalysis, was directly related to perceptions of the masses as inherently dangerous and even criminally insane (Jonsson 72–74). Adorno followed Freud and Le Bon in seeing the crowd as characterized by the psychological regression of a collection of rational individuals to an irrational collective. This notion of the crowd as defined by a hypnotic state later became central to Hitler's conception of mass politics.

For Adorno the myth of the masses was regressive and reactionary. For Benjamin the myth offered images of popular sovereignty. These two different approaches to the crowd and to mass politics shaped Benjamin's and Adorno's different appropriations of Freud and the psychoanalytic theory of trauma. The "traumatic" experience of the crowd, as articulated by various commentators in the nineteenth century, became for Benjamin a moment in which the historical struggles of the period could be grasped as they registered in works of both literary and sociological imagination. The Mohican was for him an image of shock experience in the nineteenth century. For Adorno, the masses were seen as subject to compulsive behaviors and psychological projections that resembled hysteria and traumatic neuroses. Adorno's preferred crowd symbol would be King Kong.

AN "EXILIC OPTIC"?

Benjamin's and Adorno's different conceptions of the masses are embodied in iconic images from early cinema that in turn derive from the Western colonial imagination. In the following discussion I consider the significance of these images in ways that exclude the analysis of film narrative, cinematography, technical effects and so on. I am interested in the ways that Benjamin and Adorno used images to embody historical trauma. However, the fact that these images can be situated with respect to film as a cultural form is highly significant. Benjamin and Adorno did not analyze individual films, but film held an important place in their different understandings of mass culture. Benjamin proposed that photography and film could reveal

an optical unconscious, opening up new fields of perception that could form part of a materialist cultural critique. Adorno criticized film as a central part of the culture industry through which a regressive group conformity was installed in the individual by way of shock and repetition. Film can also be understood to form part of an optical experience that remained unconscious in Benjamin's and Adorno's own writings. Film extended the geopolitical imaginary of Western metropolitan culture. In so doing it presented images of the colonized 'other' that can be re-motivated, in the spirit of these earlier critics' work, so as to better perceive the historical trauma which remained at the horizons of critical theory itself.

Benjamin's "Work of Art" essay featured prominently in the synthesis of continental theory promoted in *Screen* in the 1970s and 1980s, where it was read in conjunction with texts by Brecht, Lacan and Althusser. Miriam Hansen argues that there is a contradiction between the avant-garde aesthetics of shock and ideological demystification reformulated by *Screen*, and Benjamin's arguments about the decline of experience in other essays such as "The Storyteller" or "On Some Motifs in Baudelaire" ("Benjamin, Cinema and Experience" 185–186). Benjamin's concern with the traumatic disruption of traditional experience by industrial modernity and technological warfare are at odds, she claims, with his more Brechtian formulations about the destruction of the aura and the appropriation of images by the masses. This apparent contradiction can be explained both as part of an historical shift which saw the revolutionary hopes of the Left give way to the triumph of Hitler and Stalin in the later 1930s, and in terms of the different influences of Brecht and Adorno on Benjamin's thinking. However, Hansen argues that this contradiction is partly overcome by Benjamin's insight that the aura, even if mourned rather than actively dismantled, could only be recognized at the moment of its historical disintegration (189).

In a second essay on Benjamin and cinema, Hansen returns to the question of technological modernity and distinguishes two moments in Benjamin's thinking regarding the destruction of the aura. The first focused on progressive Modernism and the destruction of aura (the position still dominant in *Screen* theory) and the second focused on the theory of shock. Hansen links these two positions to different historical traumas: the first to the impact of World War I and the collapse of bourgeois humanism; the second to fascist aesthetics and the emergence of what would later be called the 'military industrial complex.' By the second account media is as deeply imbricated in population desensitization as industrial manufacturing is in the de-skilling of labor, or motorization in the drastic loss of freedoms of the urban *flâneur*. The ultimate implication of this decline of experience, suggests Hansen, is the destruction of the faculty of memory itself:

> What is lost . . . is not merely the peculiar structure of auratic experience, that of investing the phenomenon we experience with the ability to return the gaze, a potentially destabilizing encounter with otherness;

what is also lost is the element of *temporal disjunction* in this experience, the intrusion of a forgotten past that disrupts the fictitious progress of chronological time. ("Benjamin and Cinema" 311)

Benjamin's theory of the optical unconscious was his attempt to recover this temporal disjunction within the logics of new visual media. But as Benjamin noted with respect to Baudelaire's Modernism, the price for these insights was the destruction of both traditional cultural values and bourgeois private experience. Today the "traumatic" images made available by visual media reveal further destruction of human community and political rights. The era of modern technological media and consumerism has been characterized by widespread terror and enforced exile. These "repressed histories," including the experience of geographic and cultural displacement, have prompted Homi Bhabha to propose an "exilic optic" which connects the everyday practices of metropolitan modernity with the extreme (but often physically distant) realities of war, revolution and ethnocide. Exile serves for Bhabha as a name for another temporality, one attuned to "sites of violence, inequality, exclusion, famine, economic oppression" (x). The exilic optic, then, is proposed as an alternative to the "imagined community" of the nation–state: "Nationalist awareness and authority has been brutally asserted on the principle of the dispensable and displaceable presence of 'others' who are either perceived as being premodern and therefore undeserving of nationhood, or basically labeled 'terroristic'" (Bhabha x).

Bhabha adopts Benjamin's notion of the optical unconscious in order to theorize this exilic optic, by which the "other scene" of colonial alterity is glimpsed amid the perpetual montage of metropolitan visual culture. Bhabha asks: "Could this unconscious anteriority of the metropolitan location be the memory of the scene of colonial and postcolonial alterity?" (xii) The movement of the camera through time and space at speeds and intensities that exceed the previous limitations of human vision, was linked by Benjamin to the congestion and anonymity of modern urban life. The physical and social estrangement experienced in the crowded metropolis included encounters with the figures and faces of those displaced by both colonial rule and the terrorist state.[4] The question of exile also demands that we confront the traumatic experiences of modernity and the politics of terror which has also often been the condition of exilic flight. Benjamin has given us a theory of modernity as trauma and shock but his writing on the *flâneur* have not often been looked at through the lens of exile. This is somewhat surprising, given that Hannah Arendt, in her introduction to the first collection of Benjamin in English, *Illuminations* (1968), explicitly made a link between *flânerie* and the conditions of the homeless and stateless ("Introduction" 21).

Visual media, from photography to film to cyberspace, have been employed in the interests of imagined communities of the nation and the West, but they also have potential to destabilize those established forms

of identification through the acceleration of spatio-temporal displacement. In the great cities of the late nineteenth and early twentieth centuries Benjamin saw that the emergence of new collective identifications (which he understood in Marxist terms as formed through class struggle) were registered in the interstices of Baudelaire's highly individualized lyric poetry. We can however follow Bhabha's lead and consider whether Benjamin's own status as exile—and later refugee—sensitized him to the foreignness and unhomeliness that haunted the modern city.[5] This exilic consciousness was also shaped by the larger histories of imperialist conquest and colonization upon which the wealth of the metropolis was founded.

As we have already seen in Freud, the ways that the metropolitan "masses" were imagined often expressed the anxieties of those who identified with the figure of the liberal, enlightened individual. But images of the modern masses were also formed in an era of European global hegemony. The masses were seen by an educated elite as either never having become part of a civilized polity or, as an entity that in states of crisis was likely, to "regress" to savagery. Urban masses threatened the status of the liberal individual and this reflected a larger global struggle. Europe regarded the vast majority of humankind that did not participate in the privileges of "civilized" life and was subject to colonial rule and economic exploitation as "other." These structures of power and domination were in turn perpetuated through medical and scientific discourses and ideologies of social Darwinism, eugenics and biological racism. Modern Europe first elaborated this colonial imaginary with the discovery of and conquest of the Americas. Carl Schmitt argued that the New World destabilized a system of international law that had operated in Europe since the Middle Ages. From the sixteenth century a new legal system emerged premised on a colonial "outside" where "uncivilized" inhabitants of the Americas and Africa could be enslaved and killed at the will of conquerors. To use Agamben's term, the Native American was *homo sacer* and thereby subject to genocide. This American holocaust was one price of Western modernity; another was mass enslavement of Africans.[6]

During centuries of European colonial expansion indigenous peoples were enslaved and exterminated according to a justification that they were non-Christian and premodern savages. This imputed savagery and barbarity justified European aggression and domination. When European masses were mobilized by twentieth-century ideologies of fascism, communism and consumer capitalism, this specter of savagery and barbarism needed to be exorcised. For Nazism this required the displacement of barbarism onto "subhuman" Jews and the designation of Eastern Europe as a space of colonial expansion.[7] Whereas Communism evoked a premodern collective life before the enshrining of bourgeois individualism and private property, Soviet ideology reinvented the masses as future oriented and collective agents of technological modernization. In America the "specter of Communism" could not but evoke the bad conscience surrounding indigenous

extermination and African enslavement. In response Hollywood enshrined the myth of the American West and the "outlaw hero,"[8] thereby overlaying the violence of capitalist expansionism with fantasies of freedom and self-regeneration. Ella Shohat and Robert Stam have explored the historical conjunction of the emergence of cinema and the high point of European imperialism. They argue, for example, that the most prolific film-producing countries were also the leading imperialist powers and the colonialist imaginary was central to many of the first popular film genres, including the Western (100–101).

This understanding of a relationship between the politics of imperial conquest and the social practices of modern urbanism has not been reflected in the bulk of Anglo-American cultural theory which has made Benjamin such a constant point of reference. For example, Anne Friedberg's notion of a *"mobilized 'virtual' gaze"* (2), situates the nineteenth-century *flâneur* as part of an emerging culture of visual consumption, including dioramas, panoramas, arcades, department stores, tourism and later film, television, video and computers. The revolution in technologies of mobility over the last two centuries—including trains, planes, cars, as well as electronic media—made possible and necessary new modes of perception and subjectivity attuned to progressively globalized forms of consumer capitalism. Both the panoptic and panoramic gazes of modernity can of course readily be associated with colonialism and imperialism, but Friedberg does not pursue this historical relationship. In his book *The Language of New Media*, Lev Manovich compares the nineteenth-century *flâneur*, who negotiated an historical transition from traditional social structures to modern metropolitan environments, with the heroes in Cooper's novels of the American frontier (Manovich 270). For Manovich a comparison of *flâneur* and wilderness scout reveals a metaphorical basis for today's digital interfaces such as Netscape Navigator and Internet Explorer (273). But Manovich does not mention that Cooper is already a significant source of reference in Benjamin's discussion of the *flâneur*. Whereas Manovich distinguished the *flâneur's* negotiation of the metropolitan crowd from the solitary exploration of the natural wilderness, Benjamin showed how these two imaginaries are bound to each other at a more fundamental level. As Richard Barbrook once put it, "If this is the electronic frontier, who are the Indians?" (Barbrook 52). In the following section I consider how the image of the Native American in the context of nineteenth-century urbanism registers the historical trauma of colonial violence.

IMAGE: THE MOHICAN

In 1935, at the request of the Institute of Social Research in New York, Benjamin sent Adorno a synopsis of what would become the *Arcades Project*. In the expose Benjamin outlined six features of nineteenth-century Paris:

arcades, panoramas, the world exhibitions, the domestic interior, streets and barricades. Benjamin also proposed his theory of wish images in which "the collective seeks both to overcome and to transform the immaturity of the social product and the inadequacies in the social organization of production" (*Arcades* 4). Wish images look back to a "primal history" or classless society, whose memory is "stored in the unconscious of the collective" as a utopia. In the arcades the array of consumer goods recalls a fantasy of arcadian plenitude; the panoramas bring "the countryside into town"; the world exhibitions "confer a commodity character on the universe"; the interior reconstitutes the world in the private space of objects; the streets offer a home for the alienated individual; the barricades restore the dream of revolution (4–13).

Adorno responded in a letter, from Merton College, Oxford, in which he congratulated Benjamin on his achievement but raised some questions about Benjamin's references to a collective unconscious. Adorno suggested that Benjamin's understanding of consciousness was undialectical and failed to show how much modern consciousness was itself an effect of an historical relation to the commodity (*Correspondence* 92–93). This initial response by Adorno was then followed by a much longer letter some months later in which he presented a detailed critical reading of Benjamin's text. In the second letter Adorno returned to the issue of "a conception of the dialectical image as if it were a content of some consciousness, albeit a collective consciousness" (105). Adorno formulated that dialectical images "are generated by the commodity character, not in some archaic collective ego, but amongst alienated bourgeois individuals . . ." (107). Adorno insisted that:

> If you transpose the dialectical image into consciousness as a "dream," you not only rob the concept of its magic and thereby rather domesticate it, but it is also deprived of precisely that crucial and objective liberating potential that would legitimate it in materialist terms. The fetish character of the commodity is not a fact of consciousness; it is rather dialectical in character, in the eminent sense that it produces consciousness. (105)

For Adorno the notion of a collective consciousness or unconsciousness, which failed to differentiate between social classes, only served to reinforce the psychology of the bourgeois individual and to disguise the objective conditions of alienated subjectivity.[9] Adorno's materialist critique, while it sought to reveal the bourgeois individual as alienated, remained primarily concerned with the consciousness of the individual.[10]

Margaret Cohen comments that whereas Adorno pressed for an understanding of the dialectical image as a constellation composed of objective social conditions, Benjamin's dialectical image resembled the constructions of psychoanalysis which include facts along with fantasy and reveal

a history invested with libidinal energies and attachments. Such constructions cannot ultimately be verified as objective truth but demand to be evaluated both for their recovery of forgotten material and their impact on the subject of analysis. In Benjamin's constructions the analogy for libidinal investment is the utopian impulse manifest in the image (Cohen 47–48). On this account the historical reality of the commodity could not ultimately be positioned in the dialectical relation with consciousness that Adorno demanded. Rather, for Benjamin the dialectical movement was realized in the critical appropriation of the image from within the play of transformative desire and fantasy. For Adorno, the virtue of Freud was his demystification of the bourgeois family whereas what Benjamin shared with Freud was an interest in psychic energies that might not only be released, but redirected through, a reconfiguration of memory with the present. Historical catastrophe resulted from the containment of these energies by material and ideological forms, but their reification did not preclude them from recovery for new purposes.

Benjamin's and Adorno's different appropriations of Freud for a cultural materialist critique replay some of the problems that have beset trauma theory since Freud. Freud's decision to abandon the "seduction theory," and thereby dissociate traumatic memory from any foundation in an original event, shifted psychoanalytic construction into a realm that defied any empirical verification. Cohen proposes that Benjamin made a similar move in his understanding of the dialectical image as including a subjective dimension (Cohen 27). Adorno's understanding of the value of Freud, on the other hand, was always based in the power of psychoanalysis to demystify irrational beliefs and thereby potentially to support a critique of bourgeois ideology. By insisting on the objective existence of the commodity, Adorno attempted to maintain a clear historical orientation for understanding the dialectical image. In contrast Benjamin's formulations pursued some of the more unsettling and ambiguous epistemological implications of Freudian psychoanalysis.

The second important exchange on these issues took place in 1938 when Benjamin sent Adorno his essay "The Paris of the Second Empire in Baudelaire." Again Adorno replied with an extensive critique, this time rejecting the piece for publication. This time Benjamin's analysis was judged guilty of the reverse problem to that identified in the earlier synopsis of the *Arcades Project*. Now Benjamin was seen as relying too heavily on "objective" facts about nineteenth-century Paris without showing how these facts were mediated by larger economic structures and historical processes. The first essay on Baudelaire was organized around many of the same images that Benjamin had outlined in his earlier expose: the arcades, the panoramas, the interior, the *flâneur* and the street. Benjamin's struggle to have this essay on Baudelaire accepted for publication was exacerbated by an ever-increasing urgency in regard to the international situation for Jews. In a letter dated February 1, 1939, responding to Benjamin's essay, Adorno

began by explaining that he had been delayed in writing by concerns for his elderly parents who were trapped in Nazi Germany and had been subject to violent harassment and brief imprisonment after the infamous *Krystalnacht*. Adorno went on to warn Benjamin, then resident in Paris, of his fears of impending war in Europe (Benjamin 4: 200–201). In an earlier exchange of letters (Nov–Dec 1938) regarding the same essay Benjamin had referred to the "practically hopeless" plight of his thirty-seven-year-old sister, unable to work due to illness (110). His brother later perished in a Nazi concentration camp. By May of the same year Benjamin's German citizenship was revoked and he officially became a stateless person; by September he was in an internment camp (Benjamin 4: 432–438).

In keeping with his own increasingly precarious situation, Benjamin's essay was focused on the restless experience of the city street and the atmosphere of political terror. In his essay Benjamin approached the cityscape by way of a series of figures. These figures correspond to the urban types described by the nineteenth-century *physiologies* designed to familiarize a recent arrival to the city with the social fabric of the complex metropolitan environment. In this bewildering new space the *physiologies* aimed to make this visual experience intelligible. Under the assault of intense sensory stimulation they also functioned as shock-absorbers. Of course, the figures that Benjamin used to organize his essay function somewhat differently from the *physiologies*. They became allegorical figures by which a political history of the nineteenth century, specifically the class struggle, became readable. The first of these figures was the political conspirator who inhabits the bohemian underworld. Benjamin noted that Napoleon III himself began his rise to power in this environment. Benjamin then went on to compare Baudelaire's style of criticism to the political style of the conspirators. From the outset he suggested a link between the figure of Baudelaire and arch conspirator Auguste Blanqui and in the closing lines of the essay Blanqui was again evoked along with the failed hopes of the insurrection of 1848. The second figure in Benjamin's essay was the *flâneur* who loitered on the boulevards and particularly in the arcades where he was able to stroll without the discomfort of poor weather. The arcade was a threshold space, half way between a street and an interior. Like the *physiologies*, arcades were designed to make metropolitan environments appear familiar and feel inhabitable while making the competitive struggle between different social classes less visible.

Benjamin, pursuing the logic of the wish image, then began to explore the ways in which a city is an imagined natural landscape, particularly with reference to the American frontier novels of Cooper. The transferal of Cooper's adventure narratives to the urban context, he argued, gave rise to a new genre, the detective story. Just as the woods and prairies in Cooper's works are characterized by a terror of ambush by natives, the imaginary Parisian cityscape is haunted by invisible, underground terrorist organizations. Benjamin noted that the emergence of detective fiction coincided with

a period of political terror and intensified police surveillance. However, like *physiologies* that sought to transform the bewildering spectacle of urban life into a parade of familiar stereotypes, the detective genre offered the comfort of resolvable mysteries in an environment characterized by uncertainty and anonymity. Benjamin discovered this constellation of stroller, detective and conspirator in Alexandre Dumas' novel *Mohicans de Paris*, in which the hero "decides to go forth in search of adventure by following a scrap of paper which he has given to the wind as a plaything" (4: 22), leading him into the labyrinth of the criminal underworld. It is at this point in the essay, where he noted the influence of Cooper on the Parisian literary imagination, that Benjamin also opened up a passage to what Bhabha terms the scene of colonial alterity.[11]

Benjamin quoted Baudelaire: "What are the dangers of the forest and the prairie compared with the daily shocks and conflicts of civilization?" (39). For Benjamin such remarks were at one level an attempt to make the strangeness of the modern city less disquieting and thereby have the ideological function of "naturalizing" historical processes of rapid change. At another level, Benjamin suggested that this image of the landscape can also be read as an occulted, spiritualized image of the contemporary crowd and the political threat it posed to the regime of the Second Empire. Benjamin wrote that in this emerging police state, "when everyone is something of a conspirator" (40), strolling afforded the best opportunities for observation: "Criminological sagacity coupled with the pleasant nonchalance of the *flâneur* " (41). The underbelly of metropolitan anonymity was political conspiracy. By reading Dumas' *Mohicans de Paris* as an allegory of this political situation, Benjamin re-politicized the image of the landscape.[12] For Benjamin the abyss that separated Paris and the Mohicans was not illuminated by the talents of Dumas as much as by the dialectical image whereby landscape, cityscape and interior collided and were reconfigured in a new historical constellation. Behind the detective story which located itself in the industrial cityscapes of Paris and London could be discerned the prairies and forests of the New World.

Benjamin's contemporary, the political theorist Carl Schmitt used the Greek word *nomos* to describe the first land appropriation that established a bounded space governed by law (*Nomos* 67) or "the immediate form in which the political and social order of a people becomes spatially visible" (70). *Nomos* is related to the concept of ruler, the sovereign power that founds the possibility of law, yet itself is not subject to law. For Schmitt the conquest of the New World was "the basic event in the history of European international law" (83). Struggle for the appropriation of land in the Americas established the global ambitions of European states. According to a consensus of European powers, Schmitt contended, the New World remained outside the domain of European legal, moral and political values and therefore was open to looting, plunder and the open use of force. In this state of natural violence only the rule of the strong applied (93–94).

Justification for European conquest supported new racial ideologies including the characterization of natives as subhumans and thereby available for enslavement or extermination. For Benjamin both the fantasy of the metropolis as primeval forest and the bourgeois interior as dwelling functioned as phantasmagoric substitutes for the *nomos*. In the image of the native the trauma of political terror was displaced onto a primal landscape.

This phantasmal landscape was also found in the image-space of the cinema. Three years before the completion of Benjamin's essay on Baudelaire, Sergei Eisenstein discussed Cooper's influence on the detective story in one of his many papers on montage. Eisenstein's discussion shared many concerns with Benjamin's, including the process by which elements of earlier systems of knowledge survive as images—fragments of a lost world view now available for allegorical interpretation. Like Benjamin, Eisenstein also attempted to explain this process with reference to Marxian dialectics. In the case of the detective story, Eisenstein noted how its ideology of private property was underwritten by Cooper's narratives which exalted colonization. The methods of the "pathfinders" in the "virgin backwoods of America" were transplanted to the detective's search for clues in the "labyrinth of the alleys and byways of Paris" (Eisenstein 128). Eisenstein likened this historical layering of imagery to inner speech (the process by which the film viewer links images into meaningful structures and narrative forms), which takes place at the pre-logical, "image-sensual" level of cognition (130).

Eisenstein's theory of image-sensuous thinking, which informed his own practice of montage, also shared much with Freud's notion of the unconscious. In both cases "savage," "primitive" modes of thought were seen to survive in the logic of artistic production in "civilized"/repressive cultures (Moore 34–35). As in Eisenstein's notion of montage, Benjamin's theory of the optical unconscious sought to align such "primitive" (or in Benjamin's writings more usually "mimetic") thinking with new possibilities of technologically mediated perception. Eisenstein's theory of image-sensuous thinking shared similarities with Benjamin's notion of a tactile appropriation of the image that works at an unconscious level of habitual behavior. According to Benjamin, by reconnecting with this tactile level of the filmic image, the viewer is potentially reconnected with an active, less alienated response to the social environments of industrialized modernity (Moore 42). Benjamin's emphasis on tactile appropriation thus inverted Schmitt's characterization of *nomos* as an appropriation of territory. In Benjamin's vision of history as catastrophe the appropriation of the image deployed a violence that destabilized dominant forms of power without seeking to establish a new state. If behind Cooper's heroic narratives there lurked historical realities of ethnocide, there was also a dream of a faraway landscape and a repressed wish to return to a utopian society that the "discovery" of "primitive" peoples had once presented to the European imagination (even if that wish had sometimes been redirected into colonizing aggression). So for Benjamin the Mohican was not only an ideological construction of

alienated bourgeois consciousness, but also an image charged with libidinous energies that were potentially utopian.

Reproduced in numerous Hollywood films, TV remakes, comic strips and abridged print versions, Cooper's *The Last of the Mohicans* remains a pervasive myth in modern popular culture. The survival of the Mohican myth can be explained in terms of its ideological function in providing a heroic, romanticized version of white settlement of North America in which Native Americans are characterized as "savages." The hero of many of Cooper's narratives, Leatherstocking or "Natty" Bumpo, is an Englishman raised among Indians. Through this figure, the "best" of Native American culture is assimilated into the colonial culture whereas indigenous peoples "naturally" suffer extinction. At the time of its first publication, *The Last of the Mohicans* was well received in Europe and was particularly popular in France, where Leatherstocking was seen as an embodiment of Rousseau's "noble savage."[13] The other side of this romantic idealization of the native was expressed in a range of medical and scientific discourses that associated the working class with racial "inferiors" through their shared propensity for physical and moral degeneration. As Enzo Traverso explains:

> this primitive barbarity [of the working class] was identified with that of the "savages" of the colonial world. The figures of the proletarian insurgent, the criminal, the hysteric, the prostitute, the savage, and the wild beast now became interchangeable. The class enemy was not recognized as a legitimate political opponent, but was "racialized" and animalized. (Traverso 108)

The poor were imagined as tribes, the urban slums imagined as a "dark continent." Criminal anthropology likewise defined criminals in terms of hereditary defects and physiognomic types—an iconography that would later be applied by the Nazis to Jews and Bolsheviks. In nineteenth-century France, criminals, anarchists and terrorists were already defined as subhuman monsters (Traverso 115).

By the end of the nineteenth century "the Apache" had replaced the Mohican as the popular term for savages who inhabited outlying areas of Paris. This was how newspapers described street gangs who came from over-crowded, disease-ridden slums that had emerged during rapid industrialization. These same northern and eastern suburbs would later become sites for workers' strikes in the early years of the twentieth century. In the image of the Apache, underemployed and impoverished workers were psychologically linked with the threat of Native American resistance to colonial power and European civility. The Apaches became associated with political philosophy of direct action as espoused by Georges Sorel, who developed the theory of the general strike. Fear of the Apaches was also used in arguments that supported capital punishment (Nye 196–209). Mohicans and Apaches were seen as foreign bodies and enemies of society

and therefore quickly became understood as *homo sacer*. Their execution or extermination would re-establish the sovereignty of the modern state.

The image of the Native American is part of an ongoing history of appropriation and struggle. Benjamin showed how it formed an important part of the optical unconscious of the nineteenth-century metropolis. Through this image a threat posed by the proletarian crowd was conjured and exorcised. The image could also be inhabited and remolded as part of a montage of metropolitan visual culture. The Mohican and the Apache were early examples of modern media stereotypes and urban subcultures. Their descendants include the modern skinheads who favor the Mohawk hairstyle.

If Benjamin himself did not directly address the question of imperialism, his theory of unconscious optics nevertheless allows us to focus on images that invoke the historical trauma of genocide in the Americas. By displacing its own political struggles and victims onto the distant terror of the American woods, nineteenth-century Paris summoned the imaginary of a larger globalized movement of imperialist and colonial violence, while also foreshadowing the logic of terror which would become manifest in the following century. Nicholas Mirzoeff has commented that "As Benjamin imagines himself wandering through the convolutes of the Arcades, using avatars like Baudelaire and Blanqui, he never encounters Jews" (246). Mirzoeff's insight allows us to read the image of the Mohican as bearing an uncanny relationship to the missing figure of the Jew who would, like the Mohican in the American woods, be forcibly made to disappear from the landscape. Violence that had previously been directed at inhabitants of remote colonial landscapes now returned "home" to the cityscapes of Europe. For Benjamin the Second Empire in Baudelaire was characterized by conspiracy, terror, anonymity, disappearance and corruption. The arcade, the interior and the photograph all attempted in different ways to mediate this disturbing and threatening social environment. One ultimate destiny of the modern crowd, under the Nazi and Soviet states, was that whole sections of populations were rendered invisible; made to disappear without a trace.

MODERNITY AND SHOCK

Benjamin's reading of the image-space of nineteenth-century Paris allows for no ultimate distinction to be made between the material conditions of the modern city and the fantasies through which it is imagined. In this Benjamin's approach shared something with the ways that Freudian psychoanalysis constructed "primal scenes" for traumas that could not be verified by either empirical evidence or conscious memory. In psychoanalysis these scenes were validated by their therapeutic effectiveness.[14] This approach did not sit well with the Institute of Social Research, which was committed at the time to what it saw as a more rigorously materialist analysis. Benjamin's

study of nineteenth-century Paris in Baudelaire was refused publication by Adorno. In response Benjamin produced a second version in which he made specific use of Freudian trauma theory. The first essay had situated Baudelaire in a panorama of figures, thereby allowing the unconscious optics of the cityscape to be read in Baudelaire's poems. The second essay defined Baudelaire's relationship with the metropolis as explicitly pathological. I have argued that the first essay can be read, using the theory of the optical unconscious, as registering the historical trauma of 1848 and, less directly, of colonial genocide. The second essay defines more precisely an authentic experience of modernity as traumatic. Identifying Baudelaire's aesthetic as one of shock, Benjamin articulated an approach to modern culture that remains with us in today's preoccupation with trauma. However, the broader implications of Benjamin's use of Freud have not always been adequately addressed in contemporary trauma theory.

Benjamin's second essay on Baudelaire was written during his expatriation by the German state and immediately prior to his final desperate slide to the status of wartime refugee. "On Some Motifs in Baudelaire" was composed while Benjamin was in great financial difficulty and plagued by persistent noise and other distractions (4: 436). The overall situation for Benjamin lent a dark irony to the opening line: "Baudelaire envisaged readers to whom the reading of lyric poetry would present difficulties" (4: 313). The essay began by discussing attempts to distinguish poetic experience supported on one hand by collective tradition and on the other by private existence. Both forms of experience were contrasted with the "alienating, blinding experience of the age of large-scale industrialism" (314). Benjamin found in Proust's work the most sustained attempt in the modern age to recover this earlier form of poetic experience. He argued that the integration of private experience and collective tradition had become less possible with the rise of mass media such as newspapers, in which information had become separated from long-term experience (*Erfahrung*). The isolated consciousness of the individual gave rise to a new form of standardized experience (*Erlebnis*) based in immediacy and repetition without deeper structures of meaning. However, Benjamin resisted the urge (which he found in Bergson) to establish the grounds of "authentic" experience in order to counter this. Instead he looked to trauma as a key to understanding the distinct logic of experience in modernity (314–319).

In *Beyond the Pleasure Principle* Freud argued that consciousness, or the perceptual system, *mediates* stimuli from the outside world. Memory traces, on the other hand, "are often most powerful and most enduring when the process which left them behind was one that never entered consciousness" (18:25). Sensory stimuli "expires" as it becomes conscious. Consciousness *resists* stimuli by developing a "protective shield" (27). Permanent memory traces only arise when this resistance is overcome. Such experiences, powerful enough to break through the protective shield of consciousness, are "traumatic" (29). In "On Some Motifs in Baudelaire,"

Benjamin took up Freud's propositions in *Beyond the Pleasure Principle*, but read them alongside Proust's notion of involuntary memory. Like a traumatic experience whose memory traces are all the more powerful as a result of bypassing consciousness, involuntary memory refers to "what has not been experienced explicitly and consciously" (4: 317). To the degree that consciousness has to defend itself against shock, involuntary memory becomes less possible. Consciousness is thereby opposed to deeper memory traces preserved in the experience of the private individual. In the age of industrialization and emergent mass culture, Benjamin argued, the experience of shock (*Chockerlebnis*) became an everyday affair. Consciousness had to work harder to screen the onslaughts of the urban environment. At this point new technological media intervened more directly in the work of memory. Like a dream or neurotic symptom in which a sufferer of trauma attempts to master his experience retroactively, the camera repeated experiences that had been registered by a desensitized consciousness:

> If we think of associations which, at home in the *memoire involuntaire*, seek to cluster around an object of perception, and if we call those associations the aura of the object, then the aura attaching to the object or of a perception corresponds precisely to the experience (*Erfahrung*) which, in the case of an object of use, inscribes itself as long practice. The techniques inspired by the camera and subsequent analogous types of apparatus extend the range of *memoire voluntaire*; these techniques make it possible at any time to retain an event—as image and sound—through the apparatus. They thus represent important achievements of a society in which long practice is in decline. (4: 337)

For Benjamin shock is understood in terms of the decline of auratic experience. Deeper memory traces preserved in the "long practice" of pre-industrial modes of production and within the stable private existence of bourgeois life—captured definitively in Proust's great novel—were shattered by the experience of the industrial age. The camera mediated this crisis by extending the range of conscious memory. However, photography and film can also be examined to reveal an optical unconscious by which historical change is illuminated. Thus the camera can be said to mediate modern experience in two ways: as a screen against shock and as a means of registering historical trauma outside individual consciousness.

Benjamin adopted Freud's theory that permanent memory traces are erased by consciousness. Thus the most powerful and enduring memory traces are those that never enter consciousness. Here the theory of memory returns to the issue of trauma. To the extent that consciousness registers shock, it diminishes its traumatic effect (317). Consciousness, while protecting memory from shock, also removes the possibility of poetic experience. The challenge faced by Baudelaire, Benjamin argued, was to produce lyric poetry in an era where the conditions for poetic experience had been

seriously eroded. Benjamin's theory of shock allowed him to read the presence of the urban crowd as a "hidden figure" (321) in Baudelaire's poems. The poet was the modern hero who has learned to parry the shocks presented by the urban masses. He had learned to defend himself against their "attraction and allure" (322). Refusing to describe the crowd directly, Baudelaire was able to invoke it indirectly and thereby transform it into a poetic experience. But only traumatic experience registered deeply enough to overcome the short-term memory of conscious experience. Trauma had replaced long practice as the source of histroical experience.

Margaret Cohen has noted an inconsistency in Benjamin's use of the concept of trauma, in that Benjamin's notion of unconscious experience does not include Freudian understandings of repressed memories. Rather it refers to experience accumulated over long periods of time. Benjamin followed the Freudian model of trauma only to describe modern metropolitan experience (Cohen 207). As Cohen puts it: "He [Benjamin] asserts that Baudelaire cannot bring the crowd to direct presentation but rather occults it, much as the neurotic represses a formative psychical trauma" (209). We can also see Benjamin's use of Freud in "On Some Motifs in Baudelaire" as an attempt to satisfy Adorno's demand for an objective point of reference for the dialectical image. Instead of the historical status of the commodity, Benjamin made traumatic memory serve as the historical trace of the metropolitan environment. However, this use of traumatic experience to define Baudelaire's relation to modern life was significantly different from Benjamin's earlier formulations of utopian wishes as congealed in commodified images. This is an important point because it shows that trauma, in its Freudian articulation, functioned specifically as a theory of modernity for Benjamin. The theory of archaic wish images situated the utopian impulse in terms of a desire to step outside the material conditions of modern urban life, yet only the traumatic encounter with the modern metropolis could register its historical actuality.

Later in his essay Benjamin returned to the question of technological media in this dialectic of conscious and unconscious memory. The experience of the metropolitan crowd as a social force in the nineteenth-century metropolis was "subtle and profound" (324). It evoked "fear, revulsion, and horror" (327) in early observers:

> The camera gave the moment a posthumous shock, as it were. Haptic experiences of this kind were joined by optic ones, such as are supplied by the advertising papers of a newspaper or the traffic of a big city. Moving through this traffic involves the individual in a series of shocks and collisions. At dangerous intersections, nervous impulses flow through him in rapid succession, like the energy from a battery. (328)

By situating the urban subject with respect to these early accounts of the crowd, Benjamin sought to recover an experience of the metropolis that

had disappeared as the protective shield of consciousness gradually mastered the shocks directed at the human sensorium by the intensities of the urban environment. Baudelaire was both attracted to and repulsed by the crowd; he was almost, but not quite, a member of it. Thus he illuminated the transformation of perceptual apparatus undergone during this historical period: what was initially a traumatic experience for some—the individual confronting an urban crowd for the first time—has been forgotten, but is registered in the compulsive behaviors and physiognomies of modern life. Benjamin described the smiling face of a passerby in a crowd as a "mimetic shock absorber" (328). In this analysis photography presented the initial technological form by which this new experience could be mastered. Then with film "perception conditioned by shock was established as a formal principle" (328). The fragmented, serial form of film corresponded to the restructuring of perceptual experience undergone under industrial capitalism. The reification of consciousness found a new prosthetic form in the camera.

Benjamin's theory of the transformation of the perceptual apparatus borrowed both from Marx's theory of the alienation of labor under capitalism (329) and Freud's theory of trauma. The slow apprenticeship required by handcrafting is an individual experience supported by social tradition. But Freud observed that certain shocks such as those experienced in train wrecks, happened so suddenly and catastrophically that they could not be assimilated as an individual experience in this way. Instead they could only be "worked over" retroactively through the process of psychoanalysis and if this did not occur the victim was doomed to a compulsive repetition of the traumatic experience. In the same way, argued Benjamin, photography transforms the experience of shock into a pure repetition. The event is registered as a trace rather than experienced by the individual in terms of established cultural meanings and patterns of social life. As the long and slow accumulation of haptic skill and individual memory disappeared under the conditions of industrial mass production and metropolitan life, the photograph replaced former functions of memory (337). Benjamin also drew on Georg Simmel's theory of metropolitan life as defined by the *"intensification of nervous stimulation"* (Simmel 410). Benjamin went beyond Freud in seeing the train wreck as only one catastrophic instance of a more general condition in which the individual became subject to new technological and social forces in the modern city. For Simmel these experiences demanded a new "matter-of-fact attitude" (411) which included greater intellectualism, specialization and division of labor.[15] For Benjamin, photography and film were the new media that embodied these tendencies of, on the one hand, intense sensory stimulation and, on the other, emotional distance (or "numbing"). These two tendencies gave rise to a dynamic in which technological media needed constantly to increase its capacity to shock and surprise.

Benjamin's theory of modernity and shock continues to serve as an important reference point for contemporary trauma theory. LaCapra cites

Benjamin's distinction between *Erfahrung* and *Erlebnis* in support of his own argument for working-through traumatic symptoms. Benjamin proposed that the psychic defense against shock experience "assigns an incident a precise point in time in consciousness, at the cost of the integrity of the incident's contents" (4: 319). In contrast to this short-term consciousness, LaCapra proposes that the experience of trauma is "unlike the traumatizing event in that it is not punctual or datable. It is bound up with its belated effects or symptoms, which render it elusive" (*History in Transit* 118). LaCapra argues that the purpose of working-through traumatic experience is to transform it into, in some limited form, *Erfahrung*. Benjamin's argument was different. He proposed that Baudelaire's poetry gave "immediate experience [*Erlebnis*] . . . the weight of long experience [*Erfahrung*]" (343). That is, in Baudelaire's poems the transitory, fleeting experiences of the modern city became memorable and enduring images. For Benjamin shock experience could be transformed into something poetic and historically illuminating. This did not mean, however, that it restored earlier forms of long experience. LaCapra, however, claims that trauma can become part, even if in a limited sense, of deep memory and authentic experience. Like Caruth, LaCapra is looking for a more "fully lived" experience, whereas Benjamin's analysis already assumed an impoverished (or potentially revolutionary) mode of experience as central to modernity. This is a crucial point of difference for debates about trauma in cultural criticism. For, as Ulrich Baer has pointed out, what Benjamin called shock experience can be aligned with today's culture of technical simulation (Baer, *Remnants* 3).

Comparing Baudelaire to Paul Celan, Baer proposes that Celan's post-Holocaust poetry must also address what traumatic shock has made unavailable for conscious memory and representation: "The mass traumatization of individuals during the twentieth century's catastrophes . . . turned Baudelaire, forever warding off traumatic shock, into the prototype of modern existence" (9). This analogy leads Baer to propose the witnessing of trauma as a model for literary interpretation. However, there are different directions that can be pursued from this point. Benjamin reads Baudelaire's "pessimism" and "decadence" as articulating *an historical truth about* modern experience. Baudelaire (to paraphrase Brecht) began with the bad new things rather than the good old ones. However, making trauma victims the bearer of historical truth runs the risk of making trauma an authentic *alternative to* the fragmentary, disorienting experiences of modernity and postmodernity. La Capra's model of working-through seeks to avoid mystifying or sacralizing trauma. But it runs another risk: that of denying the actual nature of contemporary experience, including the pervasive influence and impact of visual media. It is only by attending to the ways that media redefine memory and perception, as Benjamin did, that we can properly situate our relation to the trauma victim's experience.

ADORNO'S ALTERNATIVE

Benjamin's two essays on Baudelaire were written in an ongoing dialogue with Adorno, who had been highly enthusiastic about Benjamin's plans for his *Arcades Project*. Whereas Adorno was critical of Benjamin's theory of a collective unconscious in the Arcades expose and of his overtly materialist approach in the first Baudelaire essay, he accepted the second version that utilized a Freudian theory of shock. Benjamin's emphasis on the reification of experience is consistent with Adorno's concerns at the time. These were evident in his essay on Wagner which was composed during the same period. Adorno later presented his own, more pessimistic account of Baudelaire in *Minima Moralia*, where he argued that the modernist aesthetics of shock had been fully assimilated into commodity consumption. The cult of the new in modernity "is a rebellion against the fact that there is no longer anything new." In the age of industrial mass production the experience of shock was itself commodified. The promise of the new was really a dream of an "unpremediatedness" (*Minima Moralia* 235) in a society where all experience was increasingly mediated. The new "becomes in its sudden apparition a compulsive return of the old, not unlike that in traumatic neuroses" (236). In attempting to free itself of the reified abstract quality, the thing-like nature, of modern experience, shock aesthetics merely compulsively repeated itself in the manner of a traumatic memory that cannot be assimilated by consciousness. Moreover, the sensationalism that made Baudelaire's poems a public scandal and, subsequently, became an element of avant-garde aesthetics, also anticipated the fascist state in which "the abstract horror of news and rumor was enjoyed as . . . stimulus" (237). In Adorno's analysis, then, Benjamin's attempt to link an authentic poetic experience of modernity with traumatic shock was undermined. For Adorno Benjamin's argument was true only in a negative sense insofar as it revealed the individual's entrapment in the reification of experience under capitalism.

Of the various members of the Institute of Social research who took an interest in Freud, Adorno was the most consistently critical of psychoanalysis as a therapeutic practice, seeing it as an instrument of social conformity (Lee 18, 22). What distinguished Adorno from other Frankfurt School theorists (such as Eric Fromm) was his refusal to use psychological categories to explain historical developments. Rather, Adorno understood the psyche in terms of a relationship between historical conditions and instinctual drives. Thus, for Adorno, Freud need not be reproached for analyzing the individual while neglecting historical and social conditions. Rather, Freud's focus on the individual expressed the historical truth of the alienation of individuals in modern society. Adorno also consistently rejected any notion of the proletariat as privileged possessors of revolutionary consciousness, but rather upheld the rational basis of truth over pragmatic concerns of

political praxis (Buck-Morss, *Origins* 26). All of these concerns were artic-
ulated in Adorno's critical responses to Benjamin's various drafts of the
Arcades Project and the Baudelaire essays. Adorno's own style of cultural
critique, strongly influenced by Benjamin's writings, was dedicated to the
material phenomena of culture, which in both its organizing structures and
apparently insignificant details could be shown to manifest larger social
and historical forces. In this way bourgeois culture, he argued, would not
only be revealed as ideology but could also be shown to manifest an histori-
cal truth despite its overt intentions. These "historical images," analogous
to what Benjamin would call "dialectical images," although objectively real
and socio-historically specific, nevertheless required the production of a
critical reading to reveal their truth (Buck-Morss, *Origins* 102–103).

An example of Adorno's historical reading of Freud can be found in his
critique of fascist propaganda. Adorno made direct use of Freud's theory of
group identity and proposed that Freud anticipated the rise of fascist mass
movements. In his reading of Freud, Adorno attempted to achieve what he
accused Benjamin of failing to do in his theory of a collective unconscious:
explain the unconscious with reference to the objective conditions of mod-
ern capitalism. In Adorno's analysis of fascist propaganda, it is not that
archaic, primitive forms of behavior re-emerged in a modern society but
rather that in a technologically advanced culture individuals experience
pleasure by releasing themselves from inhibitions imposed by competitive
social relationships. The alienated private individual surrenders his/her
atomized existence in order to participate in the collective. For Adorno this
regression to the expression of unconscious impulses could only be seen as
a failure to achieve political maturity. Adorno did not live to witness or to
comment on the ways that representations of the Holocaust in turn became
the basis for group identification.

Adorno's study of Wagner was written in 1937 and 1938, but not pub-
lished until 1952. Although it was contemporary with Benjamin's study of
Baudelaire, Adorno's assessment of Wagner was more negative. Inspired
by the overthrow of the French monarch in 1830, Wagner had played an
active role in the failed Dresden uprising of 1849 and later went into politi-
cal exile. Wagner embraced revolutionary ideals of destroying the old order
and creating a new world, and themes of political revolt are prominent in his
early operas. The figure of Siegfried, for example, embodies the rebellion of
natural instinct against the authority of law and religion, and romantic love
against the capitalist system of exploitation for profit. This romantic anti-
capitalism also lent support to Wagner's increasing anti-Semitism. Wagner's
radicalism gradually transformed into a nationalist mythology celebrating
the sovereignty of the monarchy and the *volk*—the latter becoming central
to official interpretation of his work by the Nazi state.[16] The Wagnerian
hero manifested the transcendent impulses and yearnings of the "German
spirit" or folk community. In Wagner's vision the modern state, embodied
in the sacred figure of the monarch and *volk*, assumed a sublime form.

However, because the ideal of the monarch was unlikely to be fulfilled in practice, it fell to individual genius to manifest the national spirit in works of art (Wagner 3–34). Whereas the Nazis remade Wagner in their own image as a prophet of the *fuhrer* and the Third Reich, Adorno's critique interpreted Wagner as anticipating fascist ideology.

In Wagner, Adorno saw the prototype of a fascist leader and producer for the culture industry. The pose of the master artist was a form of pseudo-individualism: he sought to overwhelm the public with spectacular effects because at heart he was one of them, a conformist (*In Search* 20). Adorno's analysis of Wagner was more formal than Benjamin's reading of Baudelaire and he employed specific musicological terms such as motif, sonority and color which he then situated with respect to a Marxist socio-economic analysis of cultural production. For example, Adorno argued that in Wagner's operas the alienation of the modern artist is overcome through the repetitive *leitmotiv*, which mirrors the commodity form. Wagner, suggested Adorno, replaced musical development with an associational logic corresponding to "ego weakness" (21) in the mass public and his music consists of impotent repetition with pretense to the sublime. In the inflated status of the composer-genius "we catch a glimpse of that tendency of the late bourgeois consciousness under the compulsion of which the individual insists the more emphatically on his own importance, the more specious and impotent he has become in reality" (40). Like the shock tactics of Poe and Baudelaire, Wagner's pseudo-sublime aesthetics are also locked into a compulsive repetition because of their failure to consciously assimilate the realities of modern experience. The image of Wagner as larger-than-life only revealed the loss of individual autonomy that he could not acknowledge.

In Wagner, on this account, history is replaced by myth. The Wagnerian hero is a "savage" who is really a bourgeois projection. Adorno understood this regression of the subject as a symptom of the failure of bourgeois liberalism to achieve its historical mission. As in a traumatic neurosis, the hero is locked into the mythic order of fate in which historical change becomes meaningless. However, for Adorno this regression embodied an historical truth in spite of itself: that the individual in an advanced capitalist society is subject to laws and economic forces that are outside his/her individual control. Adorno argued that the disappearance of history and politics in Wagner's work and its replacement by a mythic phantasmagoria was partly due to the defeat of the 1848 revolution. Yet Wagner's use of myth undermined the humanism he espoused at an ideological level, for with myth comes the image of the primitive as bourgeois projection. Repressed violent impulses are given free expression in the dream-like atmosphere of artwork. Mythic fate reflects an historical actuality: the impotence of the individual in the age of the bureaucratic state and monopoly capitalism. This regression to a pre-individual condition is experienced as a mixture of nostalgia and aestheticized violence (*In Search* 103–110). Fantasies of violence thus functioned as symptoms of the unresolved political trauma of 1848.

Adorno also saw in Wagner's mythic violence an unmasking of the law's origins in pure force and "the lawlessness of a society dominated in the name of law by contract and property" (*In Search* 108). With Wagner's Siegfried the "revolutionary turns into the rebel" (120): the proletarian is transformed into a mythic individual and ultimately a representation of the *Volk*. Adorno calls the character Wotan "the phantasmagoria of the buried revolution":

> He and his like roam around like spirits haunting the places where their deeds went awry, and their costume compulsively and guiltily reminds us of that missed opportunity of bourgeois society for whose benefit they, as the curse of an abortive future, re-enact the dim and distant past. (*In Search* 123)

My purpose here is not to assess the validity of Adorno's critique of Wagner but to consider the ways that certain Freudian themes form an important part of his analysis. Adorno's analysis of Wagner anticipated Adorno's later definition of the culture industry as "psychoanalysis in reverse." Adorno's use of the psychoanalytic theory of regression is most explicitly developed in the essay "Freudian Theory and the Pattern of Fascist Propaganda." Whereas in Freud's formulation "where id was, ego shall be," fascism reverses this process "through the perpetuation of dependence instead of the realization of potential freedom, through expropriation of the unconscious by social control instead of making their subjects conscious of their unconscious" ("Freudian Theory" 136). In the essay on fascist propaganda Adorno made extensive use of Freud's argument in *Group Psychology and the Analysis of the Ego* (1922) where he rejected the simplistic hypothesis of a "herd instinct" and instead developed a theory of the group as a regressive identification on the part of individuals in a liberal capitalist society. In Freud's analysis the group ideal replaced the ego ideal (Freud 18: 129), in which the individual forms a sense of self through internalizing a series of role models. This sense of self, however, is only maintained at the cost of repressing contradictory impulses of love and hate (the Oedipus complex). The group ideal allows the subject to identify instead with a group projection, the primal father, who provides a narcissistic image of omnipotence uninhibited by social conscience. Without the repressive structure of the ego ideal, the subject constituted by identification with the group idea is free from moral prohibitions and identifies only with the desire of the group.

For Adorno, Freud's interest in group psychology after World War I aligns with historical forces that made earlier studies of individual hysteria typical of the pre-war era. Whereas Freud's and Charcot's early studies of hysteria arose in a period of bourgeois liberalism, the post-World War I period was characterized by new socioeconomic conditions and a decline in individual autonomy. The reduced economic autonomy of individual entrepreneurs led to greater influence from social institutions and business

corporations on psychological development. Importantly, the weakening of the individual ego and the concurrent increase in dependence on large social structures eroded the basis of political solidarity. Under these circumstances the mass psychology of the culture industry assumed greater powers. For Adorno, mass psychology is not based in instinct but must be produced through agitation. Rational individuals must be transformed into a mass of unreflective consumers or party members: a crowd. This transformation of self-interested individuals raised and educated in a liberal and competitive society takes place according to the logic of the pleasure principle, as a release from the repression of unconscious instinct ("Freudian Theory" 120–121). Adorno's analysis of the mass psychology of fascism was extended in his later assessment of a failure in postwar Germany to acknowledge a collective identification with Hitler. In the postwar context he claimed that manic economic activity took the place of mourning narcissistic attachment to the Nazi group. In this later analysis, which I discuss in Chapter 5, the Nazi past functioned as an un-worked-through trauma.

IMAGE: KING KONG

In contrast to Benjamin's theory of utopian impulses manifest in images of a primal past, Adorno used a Freudian notion of a primitive violence at the origins of collective identity. In several different texts, Adorno used the figure of King Kong to embody this primitive violence in its new form as a mass culture image. As I have shown, according to Adorno's analysis fascism is psychologically regressive. Individual relationships are replaced by identification with an authoritarian leader (the archaic primal father) and ideas of nation and *Volk*: "It is one of the basic tenets of fascist leadership to keep primary libidinal energy on an unconscious level so as to divert its manifestations in a way suitable to political ends" ("Freudian Theory"123). The weakened ego gives way to a masochistic relation to the father-figure. The leader is a narcissistic projection, an idealized self-image who can satisfy what the individual ego cannot under the conditions of advanced capitalism. Thus the leader is part superman, part average person. With the weakening of the ego, self-love is transferred to the ego ideal, which is able to remain completely narcissistic and self-absorbed. But with the departure of the leader, group identity collapses. The group ideal, for example the fascist leader, thus appears as a strange combination of the superhuman and the familiar: "While appearing as a superman, the leader must at the same time work the miracle of appearing as an average person, just as Hitler posed as a composite of King Kong and the suburban barber" ("Freudian Theory" 127). As in the analysis of Wagner, Adorno stressed the combination of the sublime and the mundane, the genius and the conformist, in the *fuhrer* figure. The experiences of powerlessness experienced by the individual in modern technological warfare and the capitalist

market in crisis was transformed into a giant image that is both terrifying and ridiculous. However, Adorno concluded his essay by stressing that fascism is not primarily a psychological issue but can only be understood with reference to economic and political interests which seek to capitalize on mass psychology:

> In a thoroughly reified society, in which there is virtually no direct relationships between men, and in which each person has been reduced to a social atom, to a mere function of the collectivity, the psychological processes have ceased to appear as determining forces of the social process. ("Freudian Theory" 136)

In this situation Adorno understood the figure of the savage as a regression emerging from the failure of liberal individualism:

> The purpose of the Fascist formula, the ritual discipline, the uniforms, and the whole apparatus, which is at first sight irrational, is to allow mimetic behavior. The carefully thought out symbols (which are proper to every counterrevolutionary movement), the skulls and disguises, the barbaric drum beats, the monotonous repetition of words and gestures, are simply the organized imitation of magic practices, the mimesis of mimesis. (*Dialectic of Enlightenment* 185)

The Nazi rally, like a scene from *King Kong* or a Wagner opera, simulated mythic time but in doing so only acted out the failure of a more progressive politics.

However, despite his persistent references to the primitive, the historical actuality of colonial power that supported the bourgeois world held little interest for Adorno. In a fragment from *Minima Moralia* (which dates from the same period as the essay on fascist propaganda) entitled "Mamoth," Adorno commented on "the discovery of a well-preserved dinosaur in the state of Utah":

> Such pieces of news, like the repulsive humoristic craze for the Loch Ness Monster and the King Kong film, are collective projections of the monstrous total State. People prepare themselves for its terror by familiarizing themselves with gigantic images. In its absurd readiness to accept these, impotently prostrate humanity tries desperately to assimilate to experience what defies all experience. (*Minima Moralia* 115)

In this passage Adorno elaborated, as had Benjamin in the essay on Baudelaire, Freud's theory of trauma to develop a critique of modern mass media. Giant monsters such as King Kong embody a traumatic reality that consciousness struggles to assimilate. Because the realities of corporate capitalism, the bureaucratic state and totalitarian terror can overwhelm or indeed

annihilate individual consciousness, group projections function as attempts to protect identity by anticipating, or mastering retrospectively, their traumatic impact.

The figure of the giant body as an image of the masses is common throughout twentieth-century propaganda. The masses may be embodied in the figure of the leader (often in political posters directly through photo montage) or another giant body by which the crowd assumes the sovereign form of a people as political agent.[17] Susan Buck-Morss has discussed the figure of King Kong as a symbol of the masses and a dream image of mass culture: "He embodies the force of our own desire to find a romantic dream world solace for the industrial civilization that brutalizes the physical animals all of us remain" (*Dreamworld* 180). But the figure of King Kong has precursors in other examples of popular culture, for example, the great villain *Fantomas*, who appeared in his most famous visual representation as a giant man in an evening dress and mask towering over the cityscape of Paris. This personification of limitless terror fascinated the Surrealists as a subversion of law and order and of narrative closure. Whether images from popular culture such as *Fantomas* or King Kong can be fully accounted for by Adorno's notion of projection of the state is certainly open to dispute. Following Benjamin's precedent we could read King Kong, in the spirit of Surrealism, as an embodiment of a potentially anarchic violence.

For Adorno the figure of Kong was related to Hitler: a partly ridiculous, yet terrifying figure of unrestrained violence and the domination of the individual by the political collective. But the figure of Kong also recalls another historical trauma that is not acknowledged in Adorno's comments: the same colonial violence embodied in Benjamin's figure of the Mohican. In both cases the "scene of colonial alterity" (Bhabha) returns to the metropolitan cityscape. In these figures the distinction between the urban proletarian mass and the colonized native becomes confused. Attempting to unravel this confusion, Noel Caroll argues that horror films stage anxieties about social and economic exclusion. Thus *King Kong* dramatizes a social Darwinist vision of the survival of the fittest and capitalism as a "jungle" in the harsh years of the Great Depression (Caroll 215–216). The dinosaur theme that features in *King Kong* (more recently popularized in Spielberg's *Jurassic Park* series) has its origins in the mid-nineteenth century and was popularized in the fiction of Jules Verne, Sir Arthur Conan Doyle and Edgar Rice Burroughs. Whereas Verne's fictional world was pre-Darwinian, the later writers developed evolutionist narratives along racialist lines that implicitly justify colonialism (Caroll 218–219). These biologically charged fantasies also function as allegories for economic competition and survival in the modern capitalist marketplace. For Buck-Morss and Caroll, like Adorno before them, the "savage" functions as an allegory for the modern city dweller. I, however, argue that we can read a more radical form of violence into these images that prefigures genocide as a feature of European politics in the twentieth century.

This visual construction of the "primitive" later took on spectacular forms in expositions and fairs featuring captive people as "exhibits" and in mass entertainment films such as *King Kong* (Shohat and Stam 106–107). Scenes of ritual sacrifice to Kong emerge from a genre of ethnographic film that formed an important part of the spectacle offered by early cinema. Indeed the makers of *King Kong* began by producing travel documentaries (Erb 27). This tendency to make spectacle of the exotic 'other' is one of the historical links between Benjamin's image of the Mohican, Adorno's image of Kong and the origins of cinema. The projection of Native Americans as a disappearing race, as part of a more general ideological construction of the noble savage, has one of its most famous articulations in *The Last of the Mohicans*. Photographing and filming of indigenous ceremonials formed part of a cultural genocide by which the sacred practices of living communities was commodified for popular consumption by the dominant culture (Griffiths 181). In 1894 Thomas Edison filmed *Sioux Ghost Dance* in his Black Maria studio in New Jersey (Griffiths 171). In *King Kong* this fascination with the ethnographic 'other' is dramatized in ways that highlight the mixture of erotic fascination and anxiety that characterized the audience's relation to the image of the native.

However, if we return to the fragment on King Kong in *Minima Moralia* we find that Adorno also found a different desire inhabiting the image of the monster:

> But the imagining of primeval animals still living or only extinct for a few million years is not explained solely by these attempts. The desire for the presence of the most ancient is a hope that animal creation might survive the wrong that man has done it, if not man himself, and give rise to a better species, one that finally makes a success of life. Zoological gardens stem from the same hope. (*Minima Moralia* 115)

However, Adorno concluded, this hope fails because these images, like zoos, are too fully absorbed into urban technological society to allow reconciliation with nature. Elsewhere in *Minima Moralia* Adorno reflected on animals and their use in racist stereotypes in propaganda. The "assertion that savages, blacks, Japanese are like animals, monkeys for example" (105) supports the actual extermination of the dehumanized other. The characterization of the human as animal is a projection of group narcissism.

In these different texts by Adorno, King Kong appeared as a projection of the total state, the superhuman fascist leader and the racist stereotype of the subhuman. In each case animalistic violence was associated with modern forms of technology and political power. Kong has become one of the most enduring and potent images in modern popular culture, perhaps because he condensed in one figure so many fundamental anxieties in modern Western imagination. Cynthia Erb has discussed the ways that the narrative of the Japanese horror classic *Godzilla* (1954) also drew from *King Kong*. It is

widely acknowledged that *Godzilla* stages traumatic memories for the Japanese nation directly related to the dropping of the atomic bomb on Hiroshima and Nagasaki and the firebombing of Tokyo. The giant beast also embodies anxieties regarding the revenge of colonized peoples (Erb 143–151). Images of Kong and Godzilla, then, can be seen as specters of "bare life": the reduction of the human to an object of pure domination or annihilation. This radically subjected figure threatens to return as a destructive, vengeful force because it has not been assimilated into the consciousness of societies who continue to imagine themselves as liberal and democratic.

CONCLUSION

In Benjamin's and Adorno's criticism Freudian theory, and particularly its treatment of trauma, went through several transformations. Benjamin's theory of unconscious optics allowed him to address questions of historical materialism that Freud's focus on the bourgeois individual apparently precluded. In his essay on photography, the expose of the *Arcades Project* and the first essay on Baudelaire, Benjamin developed different approaches to the question of the unconscious in modern culture. All of these works used images from literature and from urban visual culture to construct an historical panorama which included emergent practices of consumerism, developments in technical media and political conflict. Benjamin's greatest achievement lay in his attention to the ways that utopian aspirations and revolutionary struggles were condensed in images as collective memories. For this reason Benjamin's texts stand as important contributions to any understanding of historical trauma.

Adorno's response, that any notion of a collective unconscious could only be understood with respect to alienated consciousness, defined his approach to historical trauma. Adorno understood the traumatic primarily in terms of compulsive repetition and reified consciousness that he saw as characterizing mass culture. Benjamin's direct use of Freud in developing his own theory of modernity and shock was closer to Adorno's conception than the idea of a collective unconscious he employed in the earlier essays. But his apparent accommodation of Adorno's criticisms came at a price: images of collective political struggle disappeared from Benjamin's second essay on Baudelaire. The specific theory of the modern artist's traumatic relationship to urban experience developed in Benjamin's second Baudelaire essay resulted in a narrowing of political perspective. I would therefore argue that Benjamin's attempts to mobilize images of collective aspiration in his criticism were effectively "repressed" by Adorno. However, the issue of oppressed histories returned in his final theses "On the Concept of History" (which I discuss further in Chapter 5).

The traumatic became a measure of a distinctive experience of modernity for the first time in Benjamin's theory of poetry and shock. In Adorno's

postwar writings this possibility was radically reduced as the shock of the new was understood to have been commodified in a consumer culture. Adorno saw fascist violence itself participating in modern aesthetics of shock. There is a certain irony, then, that Holocaust testimony has given rise to a critical culture in which traumatic experience is understood as a form of "deep memory." The dangers of this approach were prefigured in earlier discussions between Benjamin and Adorno. The need to work-through the traumatic experiences of the past should be understood in the context of distinctive forms of memory and representation in contemporary culture. A therapeutic model cannot in itself adequately address the role that visual media play as shock-absorber. To the extent that victims and survivors become the center of group identification and a community of witness, we may miss the broader dynamics of trauma and shock in modern aesthetics and politics.

Benjamin and Adorno both refused to make claims for any recovery of the forms of individual and collective experience that were shattered by modern capitalism. Instead, the critical reading of images and visual experiences that emerged in capitalist society became the key to recovering some degree of historical consciousness. They shared with Freud an attention to the role of fantasy in constituting traumatic memory. Whereas Benjamin's and Adorno's criticism cannot serve as a direct model for criticism today, they do help us to perceive much of what is at stake in these broader dynamics. For this reason historical trauma should remain a vital concept for approaching the range of issues surrounding political identification, memory and community in their writings. As early proponents of a theory of historical trauma, Benjamin and Adorno continue to suggest directions for further critical reflection on media, aesthetics and politics today.

4 Barthes

The Traumatic Image
and the Media Code

This chapter discusses how the theme of trauma and media is developed in several essays by Roland Barthes. I propose that Barthes's writings on photography register the historical traumas of both colonial and revolutionary violence. In his critique of ideologies purveyed by mass media, Barthes looked for different ways that the photograph carries traces of historical reality. Several critics have seen Barthes's structural analysis of the image as inadequate to confronting the political crises of his era whereas I argue that Barthes presents an important account of the ways that the photograph is situated with respect to individual and collective identity and the modern experience of violence and death. In short, I see Barthes's reflections on the structures of photographic meaning as incorporating a sustained meditation on historical trauma.

Barthes's writings on photography articulate a significant shift in the use of the psychoanalytic theory of trauma in cultural criticism. Although he was not directly influenced by Benjamin or Adorno, Barthes reinstated some of the key issues that arose in earlier exchange between these thinkers on the politics of mass culture. In his *Mythologies* (1957) and in the essays "The Photographic Message" (1961) and "The Rhetoric of the Image" (1964), Barthes was preoccupied, like Adorno before him, with the ways that cultural values and historical consciousness have been overtaken by commodity forms and stereotyped thinking. Like Benjamin he looked to a traumatic experience of modern visual culture as a means of penetrating everyday habitual consciousness. What distinguishes Barthes's approach from these earlier critics is not only his use of Saussurian linguistics and structuralist terminology to explain the codes operating in mass media, but his increasingly personalized account of mourning that goes beyond the limits of ideology critique.

In the following discussion I consider Barthes's writings on the photograph in terms of the different categories of the image which were outlined in Chapter 1. Barthes began with an interest in the traumatic image (an image that shows a violent or catastrophic event) and then shifted to a structural account of trauma and the image (the relation of all photographs to reality as one of absence and loss). In both cases trauma was conceived by

Barthes as disrupting conventional patterns of meaning. Whereas Barthes's essays consistently attended to images of political violence he tended to undermine their impact by foregrounding the role of rhetorical codes that direct interpretation by viewers. However, his final comments in *Camera Lucida* (1980) brought together the two dimensions of structuralist theory and historical catastrophe in a series of striking formulations about photography and death. I read his final meditations on the image as indirectly (perhaps unconsciously) registering the historical trauma of the Holocaust. Although Barthes's essays on photography anticipated many of the concerns of subsequent trauma theory, his conception of violence and representation differed from these later theories in significant ways. Barthes attempted to articulate a traumatic relation to the image that refused assimilation into any community founded on oppressive violence. So I argue that although Barthes's writings are characterized overall by an increasing skepticism toward established ideologies, he never withdrew entirely from a political account of the image.

Barthes's pursuit of an historical reality that eludes the ideologies purveyed by the media code led him first to images that shock and overpower the habitual responses of viewers. In "The Photographic Message" (1961) Barthes wrote that whereas traumatic experience can bring about a "suspension of language" and a "blocking of meaning," the photographic representation of these experiences leads to their capture by a rhetorical code which "distances, sublimates and pacifies" (*Image* 30) their traumatic impact. In the mass media of newspapers, magazines and advertizing he noted that the photograph is usually produced according to styles and conventions of professional journalism, and even when it is not, it is never seen without a caption or accompanying visual information which determines its meaning in some way.

Barthes later sought to define a more intimate relationship between the individual body of a viewer and traces of the past recorded in an image. In his final essay *Camera Lucida* the question of a traumatic relationship to the image was explored by way of two opposing new terms: the *studium* and the *punctum*. Barthes saw the intentions of the photographer and the visual codes of composition at work in professional photography and photo journalism as negating the impact of images of violence or suffering which he had previously discussed as traumatic. Under the reign of the *studium* the traumatic was reduced to mere repetition. For Barthes only marginal, unexpected detail could retain a capacity to shock or "wound" the viewer. So it was not a question of Barthes abandoning his interest in trauma altogether but of refashioning it around a politics of desire and mourning. In Part One of *Camera Lucida* Barthes appeared to reject direct representation of traumatic experience in favor of the specific desires of the viewer. However, in Part Two he returned to the question of traumatic loss in his meditation on an image of his recently deceased mother pictured as a child.

In *Camera Lucida* Barthes wrote about historical events in terms of individual emotion and desire, thereby distancing himself from the sacrificial violence (including revolution) and collective mourning associated with membership of any specific political community. Recognizing that the literal image of traumatic suffering will always be subject to commodification by the media code, Barthes turned to the unconscious trauma experienced as a symptom within the body of a viewer. Barthes adopted a Lacanian account of trauma as the enigmatic core of the real around which individual neurosis is constituted. This focus on the body of the viewer as a source of photographic truth appeared to move away from any direct concern with historical trauma. For Barthes the meaning of the photograph now appeared contained by a private narrative of loss as an authentic alternative to the banality of the media code.

In his journey toward a more embodied form of criticism Barthes gradually moved away from ideological analysis of the media image. The critic began to occupy a space more akin to the modern artist who (as Benjamin had proposed of Baudelaire) articulates his historical situation through the aesthetics of shock. For Barthes, as for Benjamin, photography formed an intrinsic part of the modern relation to history. This shift in Barthes's approach anticipated later developments in trauma theory that focus on the relation between testimony and witnessing. In trauma theory the overwhelming experiences of trauma victims can often only be communicated indirectly through physical symptoms and through silences and evasions. Resistance to conventional representation became in later trauma theory a means of validating the historical actuality of extreme experiences. This in turn led to sacralizing a communal relationship to trauma. After Barthes, trauma became increasingly bound to what cannot be shown or represented. For example, Claude Lanzmann's film *Shoah* forsook all archival footage and instead explored the relation between embodied testimony and witnessing. For Lanzmann, like Barthes, the conventions and stereotypes of the media appeared to be tainted by their association with mass politics and ideology.

Barthes's meditations on the traumatic dimensions of the photograph appear to fit a contemporary cultural mood in which the individual, by identifying with the victim, inserts him/herself into a history which is imagined as traumatic. However, if we read Barthes's essays on photography in the context of his overall engagement with modern media and with the political transformations that shaped his career, we can understand the significance of Barthes's writings differently. Barthes never retreated entirely from the political realm into private experience but nor did he position himself as belonging to any established political community. Rather, he always situated his subjective responses in relation to a more general politics of the image. The political gesture preferred by Barthes was one that disrupts the alignment of the signifying force of the image with the violence employed by the state.

TRAUMAS OF MODERN TIMES

In Barthes's writings the photograph is caught in a struggle between the banalities of the media code and more authentic forms of visual experience. Barthes himself was also caught in the contradictions of post-World War II politics and the culture of the intellectual left during the Cold War period. My discussion does not attempt to offer a detailed account of Barthes's relation to the shifting political positions and debates during this period. However, certain key events, such as Stalin's reign of terror, the Algerian War of Independence and the May '68 revolt provide important historical reference points for understanding the development of Barthes's thought. For many on the French left, a crisis of faith in the Communist Party led to a demand for a new politics of desire and the body. Barthes's intellectual career exemplified this shift. Yet images of political struggle and violence continued to haunt Barthes's writings on photography up to and including *Camera Lucida*. So although Barthes appeared to reject the mass media representation of politics along with earlier forms of leftist commitment, he nevertheless remained engaged with questions of violence and power until the end.

Barthes understood writing as always negotiating larger ideological structures and historical transformations. In his first book *Writing Degree Zero* (1953) he argued that modern literature needed to be interpreted with reference to the failed revolution of 1848 (another perspective he shared with Benjamin and Adorno). Before 1848, argued Barthes, bourgeois ideology in its universalized, liberal form was bound to a classical ideal of writing. With the rise of industrial capitalism in the second half of the nineteenth century the political interests of the middle class became more openly tied to economic self interest and abandoned the movement toward universal democracy. As a result the modern writer was alienated from the "timeless" serenity of the classical style as the embodiment of enlightened thought. Out of this situation emerged, on one hand, a conventional realism designed for popular consumption and, on the other, the formal experiments of the avant-garde. The emphasis on shock and novelty formed a central part of both mass culture and a struggle to create authentic forms of modern writing. Photography first emerged in this same historical period.

Following the precedent of Barthes's historical analysis, I read his writings on photography as an attempt to negotiate, or work-through the political crises of his own period. Whereas Barthes tends to be remembered as one of the intellectual heroes of French structuralism and post structuralism, his writing emerged from a substantial engagement with Marxism. I read this Marxist legacy as an historical trauma discernable in Barthes's writings. On this point I follow Jacques Derrida's approach in *Specters of Marx* (1994). Derrida cites Freud's discussion of three traumas that have disturbed the narcissistic illusions of humanist thought: the theories of psychoanalysis, evolution and the over-turning of the Copernican cosmology. He then adds to this list of traumas the Marxist "blow" which includes both

its utopian projections and totalitarian forms. Derrida goes on to speculate that the legacy of totalitarian terror marks possibly the "deepest wound" for the modern subject, more traumatizing in its implications than the theory of the unconscious (*Specters* 98). By emphasizing totalitarian violence Derrida is also able to address the legacies of the Holocaust, genocide and terrorism. Yet Derrida's propositions in *Specters of Marx* concerning the historical traumas of political violence have so far had little currency in contemporary trauma theory, despite the direct influence of deconstructive criticism on the work of critics such as Felman and Caruth.

Writing in the early 1990s after the collapse of the Soviet Union, Derrida comments that deconstruction developed in France out of a consciousness, already present in the 1950s, of the catastrophes of Stalinism (*Specters* 14–15). However, deconstruction differentiates itself from the jubilant celebration of the end of Communism—epitomized for Derrida in the pronouncements of Francis Fukuyama—through its attentiveness to the politics of mourning:

> At a time when a new world disorder is attempting to install its neo-capitalism and neo-liberalism, no disavowal has managed to rid itself of all of Marx's ghosts. Hegemony still organizes the repression and thus the confirmation of a haunting. Haunting belongs to the structure of every hegemony. (*Specters* 37)

The dominant discourses of global capitalism celebrate the triumph of liberal democracy and the free market along with the demise of Marxist governments and movements. Derrida argues that this attempt to conjure away the specters of Marx resembles the compulsive repetition symptomatic of an un-worked-through trauma (97). One of the principal ways that this neo-liberal hegemony installs and maintains itself is through mass media and information networks. According to Derrida this tele-technical dimension of contemporary culture could not have been anticipated by Marx in his analysis of nineteenth-century capitalism.

Derrida's comments on the role of media do little to acknowledge the analyses of Benjamin, Adorno, Barthes and many others who have made Marxist theory an important feature of the critical analysis of modern media. However, Derrida's insistence on the ongoing legacies of Marxism directs us toward an important, and often unacknowledged, dimension of historical trauma. In the following discussion of Barthes's essays I propose that he continually returned to and attempted to work through the historical trauma of revolution and its relation to modern visual media. In Barthes's writings on photography the methodologies of structural linguistics and the legacies of Marxism (and Sartrean commitment) were deployed with continual tension.

Writing Degree Zero appeared soon after a series of events that had captured the attention of intellectuals in Paris and around the world. The

publication in 1951 of Albert Camus's *The Rebel* drew harsh criticism from Jean-Paul Sartre's journal *Les Temps Modernes*. Camus argued that Marxism–Leninism, and specifically Stalinist tyranny, had perverted the nineteenth-century philosophical rebellions of Marx and Nietzsche by using revolutionary ideology to justify mass murder. This premeditated, rationalized murder by the state was contrasted with passionate, spontaneous gestures of revolt against injustice and intolerable oppression. Camus upheld rebellion against the rational methods of the totalitarian state which had reduced the individual to an object of total control, calculation and domination. Initially Francis Jeanson's review in *Les Temps Modernes* attacked the book for playing into the hands of the anti-communist right and for its philosophical idealism: Camus's rebel was another incarnation of Hegel's "beautiful soul" who seeks to transcend historical struggle through the individualist gesture of rebellion (Jeanson 99). Camus responded by challenging the dogmatic assumption that any criticism of Marxism was inherently right wing and by challenging the left's refusal to confront the issues of political terror (Camus 118–121). Sartre then further responded to Camus, arguing that Camus had failed to understand his own complicity in the anti-communist media apparatus and the wider dynamics of Cold War politics.

The Sartre–Camus debate might well be regarded as a "wound" in postwar French intellectual life, a symptom of a deeper disturbance for all who wished to hold on to an image of Soviet Russia as a utopian alternative to Western capitalism. Barthes was embedded in this political milieu. *Writing Degree Zero* was composed of articles that first appeared in *Combat*, a newspaper closely associated with Camus, and the idea of a "writing degree zero" was first applied by Barthes in a review of Camus's *The Outsider*. Barthes argued that the pared-down, spare prose of writers like Hemingway and Camus, sought to escape the false pathos of conventional writing to be found in both bourgeois literature and mass media journalism.

This ideal of written language as a neutral conveyor of ideas, grounded in an accurate observation of social reality and a struggle with dominant aesthetic forms and ideological structures, had strong resonances with Barthes's later attempts to theorize meaning in photographs. Barthes also tried to separate the tired codes of the media, which imposed conventional meaning and ideology, from the purely denotative force of the photograph. Barthes showed how understanding the photograph as a visual trace of an external reality could be used both to validate ideological representations and to potentially challenge and subvert them. However, he had already argued that "writing degree zero" could not escape larger contradictions of a capitalist culture in which any new style in its turn becomes conventional and loses its ability to defamiliarize social reality. The photograph, as the central form of image in mass media, also quickly lost its ability to shock. As with modern writing, the ways we look at images needed to be continually interrogated and reinvented. This

recognition led Barthes through a series of critical strategies that created new perspectives on the photograph.

Barthes began with an analysis of images in mass culture. By the 1950s a new stage of capitalism was installed in France, bringing with it the consumer society, or what Guy Debord would later call "the society of the spectacle." Barthes rejected Sartrean commitment and developed instead a sophisticated application of structural linguistics as part of an ideological analysis of both literature and contemporary media culture. Mass media newspapers, magazines, advertisements and movies created a system of modern mythologies analyzed by Barthes in a series of newspaper articles later published as a book. Since its translation into English in 1972, Barthes's *Mythologies* has become a canonical text in cultural and media studies, serving as a prototype for the semiotic analysis of mass media text. The political environment out of which his work emerged has been ignored as a result of this enlisting of Barthes to cultural studies and its immersion in popular rather than literary or avant-garde culture.

First collected together in book form in 1957, the short essays in *Mythologies* were published between 1954 and 1956. Yet the world explored in *Mythologies* bears little trace of the then current debate over totalitarianism. Barthes, however, did comment in his preface that he had written "on topics suggested by current events" (*Mythologies* 11). By discussing the cultural meanings of popular spectacle, Hollywood movies, magazine articles, literary criticism, advertising, toys and cuisine, Barthes focused his attention on the minutiae of everyday life and steered clear of any explicit reference to the politics of the Cold War, let alone the legacies of World War II or the Holocaust. His first published essay was contemporary with the 1954 uprising in Algeria. As the essay series developed over a two-year period, his attacks on colonial ideology became more direct (Stafford 40–41). The long essay which closed the collection, "Myth Today," includes the following famous anecdote:

> I am at the barber's, and a copy of *Paris-Match* is offered to me. On the cover, a young Negro in a French uniform is saluting, with his eyes uplifted, probably fixed on the fold of the tricolor. All this is the *meaning* of the picture. But, whether naively or not, I see very well what it signifies to me: that France is a great Empire, that all her sons without any color discrimination, faithfully serve under her flag and that there is no better answer to the detractors of colonialism than the zeal shown by this Negro in serving his so-called oppressors. (*Mythologies* 116)

Myth, wrote Barthes, is a meaning system which takes hold of a signifier (the "young Negro soldier") and "turns it suddenly into an empty, parasitical form." Through the power of myth "history evaporates" (117). In the mythic system the individuality and historical singularity of the young soldier has disappeared but his meaning as a sign has become complete,

finished and timeless: already known. The paradox of this semiotic opera-
tion, which Barthes sought to explain, is that the apparent transparency of
the signifier (its evident materiality and immediate legibility) served to sup-
port the unquestioned coherence of the linguistic system into which it had
been subsumed (the myth of French imperialism) (118–119). This linguis-
tic function of myth duplicated the historical process of colonization: the
"young Negro soldier" was deprived of his history, his existence now made
to serve the interests of his imperial masters (122–123). However, Barthes's
use of the phrase "so-called oppressors" implicitly acknowledged that the
anti-colonial interpretation also subsumed the soldier into a ready-made
system of meanings.[1] The relation between the historical actuality of what
was shown and the ideological structures that the image served would be a
consistent theme in Barthes's writings on photography.

Barthes's interest in the mass-produced photograph was part of a
larger intellectual engagement with realist representation and history. His
thoughts on the image of the young soldier were anticipated in earlier com-
mentary on Camus and Sartre. In *Writing Degree Zero* Barthes argued
that socialist realism, as the official style of the Communist Party, was
bound to the same conventional morality of realism as capitalist societies.
He commented that the writing in Sartre's journal *Les Temps Modernes*
embodied a particular notion of political commitment which became "a
complete blind alley" (*Writing* 28). Commitment itself came to function as
a mythic system. Barthes described how in their attempts to step outside
the stylistic experiments of literary modernism, both socialist realism and
the writing of commitment could not escape the traps of literary conven-
tion: "The writer, taking his place as a 'classic,' becomes the slavish imita-
tor of his original creation, society demotes his writing to a mere manner,
and returns him a prisoner to his own formal myths" (78). Yet Barthes's
comments on Camus's style are consistent with Jeanson's and Sartre's criti-
cisms of Camus in *Les Temps Modernes* insofar as he saw the "neutral"
style as attempt to stand outside history which inevitably led to manner-
ism (98). Edward Said later renewed this assessment of Camus: he took
on an aura of universality and humanism which removed him from the
historical situation of French colonialism out of which his writing emerged
(Said 208). Like the French soldier on the cover of *Paris Match*, the Arab
famously murdered by Mersault in *The Outsider* is a deprived of any his-
tory, individual or collective (Said 212).

Photography is bound to these same problems of realism: to the extent
that it appears as neutral or objective it merely reinforces dominant ideolog-
ical structures. In "The Photographic Message" (1961) Barthes developed
a structural analysis of the photographic image which he argued is defined
by a paradoxical "*message without a code*" (*Image* 17). Mechanical traces
of the real produced by the camera avoid stylistic traces of humanly pro-
duced forms of direct presentation such as drawing or painting. However,
he claimed, this extra-linguistic or extra-cultural feature, which defined

what was radically new about the photograph, was always subsumed back into cultural systems of meaning. The photograph presents the possibility of a pure form of denotation which nevertheless is subject to a cultural field of connotation and stereotypes. Like Camus's "neutral" style, this pure mode of denotation supports rather than escapes myth, its realism functioning as "anchorage" in a rhetorical system of photographic meaning. For example:

> If one photographs Agadir in ruins, it is better to have a few signs of "Arabness" at one's disposal, even though "Arabness" has nothing to do with the disaster itself; connotation drawn from knowledge is always a reassuring force—man likes signs and likes them clear. (*Image* 29)

Here a scene of French colonialism is linked with catastrophe, its potentially traumatic impact evaded by the "clarity" of the mythic system. The analogical force of the photographic message, its founding possibility as a form of historical testimony, is overtaken by the legibility of the code of stereotypes. This continual tension between the possibilities of historical reference and assimilation by conventional representations shaped Barthes's references to trauma in his discussions of photography.

THE TRAUMATIC IMAGE

When Barthes applied a semiotic model in "The Photographic Message" he insisted on the "structural autonomy" (*Image* 15) of the photograph—namely that although the photograph is almost always embedded in a linguistic (verbal) context, the content of the photographic message is a "literal reality" (17). He then went on to distinguish the photograph from other analogical reproductions (drawings, paintings, cinema, theater) that according to his analysis carry various stylistic and connotative meanings that supplement analogical message in its pure form. Yet Barthes acknowledged that the photograph is always mediated by codes, stereotypes and symbolic systems and that the purely denotative status of the photograph is probably "mythical" (19). The photograph "in actual fact has no denotated state, is immersed for its very social existence in at least an initial layer of connotation, that of the categories of language" (29). If there is anything that exists as pure denotation, wrote Barthes, it is perhaps "at the level of absolutely traumatic images" (30). But denotation *of* traumatic experience cannot communicate how an event is experienced *as* traumatic:

> The trauma is a suspension of language, a blocking of meaning. Certain situations which are normally traumatic can be seized in a process of photographic signification but then precisely they are indicated via a rhetorical code which distances, sublimates and pacifies them. (30)

In his view the photograph of a catastrophe or violent death is dependent on the implied presence of a photographer who "verifies" its reality but thereby also neutralizes its effect: the image has "survived" the destructive force of the event. The impact of the event on human experience cannot be transmitted by the image. For Barthes's the rhetorical codes of the media serve the same function as consciousness does in Freud's theory of shock. The photograph, no matter how traumatic, will always be assimilated into a system of cultural meanings. Yet Barthes held on to the possibility of traumatic images which may exceed the media code: "The more direct the trauma, the more difficult is connotation; or again, the 'mythological' effect of a photograph is inversely proportional to its traumatic effect" (31). The literal nature of the photographic trace is supplemental to the linguistic system of connotation: it lends it authority yet it can never be fully assimilated by it. The truly traumatic image, on the other hand, "is the photograph about which there is nothing to say" (31).

Despite his skepticism about the denotative function of the photograph, Barthes held out some hope for the traumatic impact of the image. However, such a hope was inconsistent with the more general tendencies of Barthes's thinking. With his critical attack on realism and his support of the avant-garde (particularly the French New Novel), Barthes had little use for realistic representation of violence, pain and suffering. His gesture toward the potential traumatic effect of the image can be read as the remainder of a political crisis that haunted Barthes's writings. His increasingly sophisticated analyses of the codes of representation undermined any possibility for directly presenting historical reality. The question of trauma returned in his final essay on photography in the form of a more individualized symptom. Interestingly, the list of traumatic events that Barthes included in "The Photographic Message"—"fires, shipwrecks, catastrophes, violent deaths" (30–31)—(unconsciously?) evoked the death of his own father, who was killed in a naval battle when Barthes was only eleven months old. This conjunction of traumatic public events with a personal history is given a more deliberate, self-conscious presentation in *Camera Lucida*.

STRUCTURAL TRAUMA

Barthes did not return to the issue of the traumatic image in any direct way in his later essays on photography. Instead the question of trauma was subsumed into a structural analysis of photographic signification which also tended to avoid overtly political material. In his second essay on photography, "The Rhetoric of the Image" (1964), Barthes analyzed an advertisement for Italian pasta. After considering the denotative and connotational meanings available in both verbal and pictorial codes, Barthes returned to the issue of messages without code or the "non-coded iconic message" (*Image* 36). The non-coded message provided *"anchorage"* (39) for proliferation of

potential connotations. Barthes identified the ideological function of this literal, denotative level of the image as one of naturalizing codes and stereotypes operative at the connotative level. Yet the image as literal trace always generated a certain remainder or supplement that could never be completely exhausted by connotations. Moreover, the objects or events denoted in a photograph also communicated another meaning: that of once "*having-been-there*" (44). In this the photograph—and this distinguished it from animated film—potentially drifted free of language and narrative and "can in some sense evade history" resulting in "a decisive mutation of informational economies" (45). The unprecedented denotative capacity of the photograph cannot be fully assimilated into an understanding of the image as visual information. This structural paradox is of greater interest to Barthes than the photograph's ability to directly show extreme events. Barthes's move away from any interest in the image as explicitly traumatic, however, potentially supports a different understanding of trauma and photography. Martin Jay comments:

> Beyond the fact that the denotative power of photographs was most evident when they showed explicit traumas, the inevitable aura of a lost past attached to all photographs suggested an implicit trauma as well: the pain associated with mourning that loss. (Jay 444)

According to Jay's reading, Barthes's "decisive mutation" is to be understood as the structural trauma that lends the photograph a specific pathos. By transferring the traumatic quality of the image from its potential to shock the viewer to it's "aura of a lost past," Jay positions Barthes in a genealogy that led to later deconstructive trauma theory. But Jay's commentary may go too far in anticipating the pathos of *Camera Lucida* rather than analyzing the specific development of Barthes's thinking about the media image.

The structural logic of trauma which Jay confers on the photograph derives from the difference between photography and film that Barthes first proposed in "The Rhetoric of the Image" and developed further in his later essay "The Third Meaning: Research Notes On Some Eisenstein Stills" (1970). Several images Barthes selected from Eisenstein's films show dramatized events from the Russian Revolution and it is doubtless significant that Barthes composed this essay subsequent to the insurrections of May '68. As in the earlier "Rhetoric of the Image," Barthes distinguished three levels of meaning. In the 1964 essay these were linguistic (verbal), iconic and non-coded iconic (message without a code) (*Image* 35–36). In the essay on film stills there was the informational, the symbolic and the third or "obtuse" meaning. Like "message without a code," the "third meaning" is non-iconic, bound to analogical density of photographic and filmic images. The third meaning is "supplementary" (55), potentially leading to a slippage of the "obvious" (informational and symbolic) meanings.

In "The Third Meaning" the close-up shot of a clenched fist in Eisenstein's *Battleship Potemkin* "obviously" symbolizes proletarian anger and resolve. By making this point Barthes undermined one of the icons of leftist ideology. As Lesley Brill has commented, *Potemkin* presented "an honoring of the Russian Revolution conceived as the development of crowds and their transformations" (Brill 24). The film was composed primarily of a number of different crowd formations and crowd symbols. The clenched fist was one such crowd symbol and has often been used in political posters to communicate collective will and the threat of aggressive action.[2] If we return to the logic of Barthes's early comments about the traumatic image, we might say that the more "obvious" an image of the revolution, the less powerful its effect. Barthes turned to the "obtuse" meaning that he discovered in details that had no apparent significance for the overall narrative direction or political goals of the film. When Barthes came to describe examples of obtuse meanings they appeared ironic, or camp, rather than traumatic. The scarf worn on a woman's head, for example, created "a facetious, simpleton look" (57). The effect of the third meaning tended toward the comic, the derisive or the erotic, rather than the revolutionary heroism celebrated in Eisenstein's films.

The "drift" of the third meaning appeared to be the antithesis of the arresting quality of the traumatic image evoked in "The Photographic Message." The third meaning could be sentimental or "loving" (59)—anything but obvious in the polemical sense that Eisenstein employed. Does this attention to the intimate, the erotic, even the second-rate allow for an emotional response which is indirectly but perhaps more potently attuned to the historical traumas of revolution? For Barthes it was a question of resistance. The third meaning, claimed Barthes, is "indifferent to the story" (61). It cannot be entirely integrated into narrative, and therefore cannot be entirely "emptied" by myth. Thus it "does not *yet* belong to today's politics but nevertheless *already* to tomorrow's" (63). Interestingly the only image discussed in "The Third Meaning" essay that was not a still from one of Eisenstein's films was a photograph included in Mikhail Romm's *Ordinary Fascism* which showed Hermann Goering arching a bow and arrow surrounded by various Nazi cronies. Whereas Barthes's attention to marginal details in this image pursued meanings that were free of the "obvious" stereotypes that so central to Nazi visual culture (Barthes wrote of the "blond silliness of the young quiver bearer" [60]), the suggestion of a possible equivalence between Eisenstein's images of Russian Revolution and the imagery of fascism implied an association of revolution and totalitarian power. In "The Third Meaning" traditional political polarities of right and left were undermined by a gesture towards a more general refusal of ideology.

Barthes's attention to marginal details in an image, rather than its denotative force, was part of a more general shift in French intellectual culture. Kristin Ross proposes that this movement was already present in Barthes's

turn to structuralism and away from the materialist analysis that character-
ized his early essays collected in *Mythologies*. She argues that:

> the rise of structuralism in the 1950s and 1960s was above all a frontal
> attack on historical thought in general and Marxist dialectical analysis
> in particular; its appeal to many leftist French intellectuals after 1956
> was over determined by the crisis within the French Communist Party
> and Marxism following the revelations of Stalin's crimes and the Soviet
> invasion of Hungary at the end of that year. After such messy historical
> events, the clean, scientific precision of structuralism offered a kind of
> respite. (*Fast Cars* 189)

Ultimately, proposes Ross, "what is at stake in the erasure of the study of
social movement in favor of that of structures is the possibility of abrupt
change or mutation in history: the idea of Revolution itself" (*Fast Cars*
189). For Barthes the revolution as historical referent appears to have been
overtaken by the "decisive mutation" (*Image* 45) in visual representation
presented by the photograph.

However, "The Third Meaning" marked a shift from the relatively "sci-
entific" approach of the two earlier essays on the photograph. This shift can
be understood in relation to broader political transformations of Barthes's
era. Peter Starr notes that 1965 saw a rebirth of the French left, prompted
by the American escalation of the Vietnam War, and the publication of key
theoretical works by Althusser, Derrida, Foucault and Lacan. According to
Starr leftist enthusiasm collapsed following the economic crisis of the mid-
1970s, concurrent with the publication of Solzhenitsyn's *Gulag Archipelago*
and other events such as the Khmer Rouge massacres in Cambodia (Starr
3–4). After the failed revolt of May '68 the French left fractured as new
social movements such as ecologism, minority rights and anti-psychiatry
gained momentum. Starr explains that these post-May '68 cultural politics
were widely influenced by Lacan's theories of structural repetition, accord-
ing to which revolution reestablishes authoritarian tyranny, and exposes
"the narcissism underlying the rebel's demand for a confirmation of his
revolutionary hope" (8). What the revolutionary really seeks, according to
Lacan, is a Master (Starr 20). Theorists such as Barthes turned increasingly
toward a logic of cultural subversion and away from the apparent impasse
reached by direct revolutionary action in an advanced capitalist society.

Starr proposes that French post structuralism be understood as "a
cultural-historical phenomenon that plays its evident, symptomatic role in
the process of binding a traumatic loss" (32). That loss is the hope of revolu-
tionary change and renewal. In her study of May '68, Kristin Ross questions
the relevance of trauma theory to account for the historical circumstances
of the wildcat strike by eleven million workers and its associated social and
political upheaval. This situation was further complicated, she proposes,
when we consider that revolutionary politics have become associated with

the Soviet Gulag and thereby the Holocaust, as if these great catastrophes of modernity were a necessary outcome of radical social change (*May '68* 2–3). What is at stake for Ross is the collective memory of revolution. In the "Third Meaning" Barthes playfully mocked representations of revolutionary struggle and traumatic loss. Did such an approach negate the memory of revolution or manifest its essential anti-authoritarian spirit? The earlier Sartre–Camus debate reverberates through these questions. Any gesture of revolt that distanced itself from a clear position of commitment invited accusations (from Sartre's highly influential journal) of political irresponsibility. On the other hand, after May '68 the commemoration of revolution in Eisenstein's films could be seen as having been subsumed into an official left culture that had become inflexible and oppressive.

Ultimately Starr finds Barthes guilty, along with most other French theorists, of characterizing "the perils of revolutionary action in radically simplified, ahistorical terms" (32). According to Starr's analysis Barthes's particular form of textual utopianism refuses political responsibility altogether (137). However, Starr does not test these propositions with respect to any of Barthes's writings on visual media. For the purposes of my discussion these problems were exemplified in Barthes's "Third Meaning" and *Camera Lucida*. In these essays Barthes found the shock of the revolution to have been recuperated by media code, and the historical document captured by the stereotype. Thus he argued that the image of capitalist consumption could no longer be opposed by the reality of political violence, as the representation of history had itself been fully commodified. Barthes's third meaning and *punctum* were interpretive strategies intended to block or to short-circuit recuperation by media code. I do not believe Barthes should be dismissed for a failure to produce a realist account of historical events—rather I propose his interpretive strategies should continue to offer insights into the politics of the media image. We need to pay attention to the psycho-political logic of the images chosen in Barthes's texts. For example, against the compulsive overturning and re-establishment of the political father hypothesized by Lacan, Barthes turned repeatedly to the image of the mother in mourning.

IMAGE: THE MOTHER

In *Camera Lucida* Barthe's tripartite analysis of the image developed in earlier essays gave way to a dualism: the *studium* (iconography, code) and *punctum* (wound). As an example of pure *studium* Barthes chose a photojournalist's image of the rebellion in Nicaragua (23). As in "The Third Meaning" the "obvious" meaning was linked to revolution. The realities of political violence had given rise to journalistic myth and visual style, thereby reducing the traumatic impact of the image. The *studium* could not convey trauma, only the *punctum*, that which wounds, was appropriate to

the experience of traumatic loss which was at the heart of the photographic experience. Certain images might shock in the short term but they "shout" (41) rather than wound. Like the third meaning, the *punctum* was bound to feelings of desire and love: Without emotional investment, no trauma affected the viewer as real.

Trauma in Barthes's later writing was linked to Lacan's concept of *jouissance,* suggesting both the pleasure of seduction and the pain of a wound. The reasons for this dualism originate with the Freudian theory of trauma and its relation to the scene of seduction experienced in childhood. Freud argued that the seduction only became a wound, or trauma, through its later reactivation as a memory. As Andrew Brown explains:

> Trauma straddles binary oppositions which are fundamental to the way we unreflectingly tend to categorize experience. It is not one event, but always, at least, two: it splits time (being neither a "then" nor a "now") and meaning (being neither significant nor nonsensical); it is neither pure fact nor pure fantasy, it comes both from within the subject (the endogenous fantasy) and from without (the original scene of seduction, and the second, possibly quite banal event that recalls it). The trauma disrupts all forms of self-presence, even when its disastrous effects on the patient's life set the analyst off in pursuit of origins, events, dates, the "real." (Brown 239)

"The real" is a term introduced by Lacan into psychoanalytic theory of trauma. "The real" cannot be located within binary oppositions and resists integration into language or any system of meanings. For Lacan "the real is an encounter, and the trauma is a missed rendezvous in so far as the subject always encounters the object of desire too early or too late" (Brown 240). Trauma is the hidden, unconscious origin of the subject's neuroses and an inaccessible point around which the structure of his/her identity is fixed. This Lacanian theory of the real was adopted by Barthes because it fitted his concept of a literal dimension to photographs that resists assimilation by the media code (*Camera* 4). *Camera Lucida* pursued an understanding of the traumatic dimension of the photograph which led back to the prehistory of the individual subject. The photograph was bound to the real only within the terms of the individual's private trauma and neurosis.

Barthes began *Camera Lucida* by declaring his desire to understand the "essence" of photography. Does photography have an ontological status that can be understood outside the context of its technological nature or its cultural uses? Is there a way of understanding photography that goes beyond various empirical, rhetorical or aesthetic definitions? What the photograph shows us is that something has occurred: it designates a reality or event that has become absent. Yet the photographic sign cannot be separated from its referent, which it carries with it as a physical trace: Every photograph brings about "the return of the dead" (9). This notion of the

photograph's adherence to its object of reference gave rise to an affective response in Barthes that took him outside technical or sociological analysis. He wrote about photography as an observer of, not as a producer of, images. His desire was to write about photography in a way that did not betray this emotional connection with an image. Photography thus served Barthes as an object that would allow him to resist systematic analysis as an ultimate horizon of his critical writing. Refusing to organize his discussion of photography around the *ouevre* of certain celebrated photographers, Barthes insisted on discussing only images that "provoked tiny jubilations, as if they referred to a stilled center, an erotic or lacerating value buried in myself" (16). The photograph was approached on the basis of a viewer's attraction or fascination for certain images. Many photographs seemed "dead," or without interest, to him, the viewer. Only certain images "animated" the viewer's desire or grief. Photography must be explored "not as a question . . . but as a wound" (21).

By this rationale photographs showing the revolution in Nicaragua could be categorized as "banal"—even one of a mother mourning a dead child covered in a blood-spattered sheet (24). Such images, Barthes proposed, were of general political or historical interest which he denoted with the term *studium*. Barthes refused to claim any necessary empathy with these images of suffering, but viewed them with the detachment that the mass media demanded as part of everyday image consumption. Whereas the particular moment of time captured in any photograph would always contain details belonging to the order of the *studium*, not all would "wound" the spectator and arouse his or her affective response. In an important passage Barthes distinguished the *punctum* from the photographic "shock" derived from images of rare and strange objects or people ("freaks")—moments containing decisive actions, details unavailable to the human eye ("the explosion of a drop of milk, to the millionth of a second" [33]), and other technical special effects or chance juxtapositions of actions and objects. Barthes declared his lack of interest in these "surprise" effects which have been assimilated into the tired conventions of mass media and some of which belong to what Benjamin had called unconscious optics, in an earlier moment of enthusiasm for the possibilities created by the new technology.

The codes of professionalism that prescribed the functionality of the mass media image demanded a certain unity of composition and effect that aimed to exorcise the *punctum*. The *punctum* was the contingent detail that provoked deeper forms of memory. Barthes wrote of a photograph by Andre Kertesz: "I recognize, with my whole body, the straggling villages I passed through on my long-ago travels in Hungary and Rumania" (45). The *punctum* was understood with reference to fundamental psychic structures and impulses. For example, an image of an old house in Grenada (39) awakened in Barthes a desire that he associated with an uncanny return to the mother's body as the familiar "home" (40).

The *punctum* continually led Barthes back to the autobiographical and to the family scene. In a portrait of a black family Barthes focused on a necklace worn by a woman in her Sunday best:

> Reading Van der Zee's photograph, I thought I had discerned what moved me: the strapped pumps of the black woman in her Sunday best; but this photograph has *worked* within me, and later on I realized that the real *punctum* was the necklace she was wearing; for (no doubt) it was this same necklace (a slender ribbon of braided gold) which I had seen worn by someone in my own family, and which, once she died, remained shut up in a family box of old jewelry (this sister of my father never married, lived with her mother as an old maid, and I had always been saddened whenever I thought of her dreary life). I had just realized that however immediate and incisive it was, the *punctum* could accommodate a certain latency (but never any scrutiny). (*Camera* 53)

Like the subject of psychoanalysis, Barthes pursued a web of associations and memories that clustered around an image. These associations could only arise once the image was released from cultural discourses of technique, art, realism etc. that encased the photograph within cultural codes and conventions of meaning.

The photographic trace of an actual person who existed in the past constituted for Barthes a scandal, a shock, a source of continual astonishment and led him to meditate upon "the inexorable extinction of the generations" (84). If death was no longer to be redeemed by religion, then its meaning might be found in photography:

> everything, today, prepares our race for this impotence: to be no longer able to conceive *duration*, affectively or symbolically: the age of the Photograph is also the age of revolutions, contestations, assassinations, explosions, in short, of impatiences, of everything which denies ripening—And no doubt, the astonishment of "*that-has-been*" will also disappear. It has already disappeared: I am, I don't know why, one of its last witnesses . . . and this book is its archaic trace. (*Camera* 93–94)

In this passage Barthes pitted the structural trauma of the photograph—its pathos of loss—against the restless and catastrophic momentum of modernity. Nevertheless, this pathos did not attempt to remove itself from history as much as situate an emotive response to photography as itself a symptom of historical change. Barthes did not only position himself as a witness to history but also understood his position of witness as historical.

In *Camera Lucida* Barthes became directly concerned with death and mourning, particularly in a discussion of a photograph of his mother. After his father's death, the infant Barthes was raised by his mother and lived with

her until she died in 1977. The famous "scene" of *Camera Lucida* concerned
Barthes, shortly after his mother's death, sorting through some photographs,
looking to recover an image of her. For Barthes this image did not belong
to a history understood as a past from which we must separate ourselves in
order to describe or to analyze it. He considered that individual personal his-
tories negate history in the sense of a past that excludes our living experience
of memory. Barthes found that different photographs of his mother only
captured fragments of her being and therefore only communicated a partial
truth of her life. Nevertheless he claimed to find "the" image of his mother.
She was aged five, standing with her brother "at the end of a little wooden
bridge in a glassed-in conservatory, what was called a Winter Garden in
those days" (67). Because the photograph was taken at the time of her par-
ents' divorce, Barthes discovered in the image of his mother an "innocence"
that he situated outside the moral code of the patriarchal family.

Barthes proceeded to take this photograph of his mother as a child (which
he decided to withhold from publication in the book, as its *punctum* existed
only for him) as a "guide" (73) to all the photographs of the world—as a
guide, then, through the world of the dead. This one photograph of his
mother led Barthes outside the domain of the family—evoking
an earlier essay, included in *Mythologies*, in which he criticized a photo-
graphic exhibition "Family of Man." The mother was not an archetypal
mother image, but the singular, irreplaceable mother with whom Barthes
shared most of his life. This singularity was present in the photograph in
the form of the *punctum*, the wound whose pain recalled to him a sense of
loss that no labor of mourning could entirely heal.

This unmournable loss could nevertheless be extended beyond the singu-
lar, intimate relationship. Barthes also experienced the *punctum* in his hor-
ror at discovering a photograph of a slave market. The incontestable reality
of slavery attested to by the photograph demonstrated how an historical
trauma was, for Barthes, best perceived by way of insights gained from a
personal trauma. Thus Barthes's final meditations on photography, clos-
ing on the Winter Garden photograph of his mother, demands to be read
"backwards" into the corpus of his earlier critique of the mass media image.
Rather than retreating from the realm of politics into a private world, Bar-
thes sought to re-engage politics and history through embodied experience.
Critics have not always acknowledged this complex relationship between
the personal and the political. John Tagg commented:

> The trauma of Barthes's mother's death throws Barthes back on a sense
> of loss which produces in him a longing for a pre-linguistic certainty
> and unity—a nostalgic and regressive phantasm, transcending loss, on
> which he founds his idea of photographic realism . . . (Tagg 4)

Tagg rejected Barthes's poignant meditations on absence and argued for a
return to an analysis of discursive systems and semiotic processes. But Tagg

never considered his own pragmatics of media analysis as possibly "regressive" in his haste to dismiss affective response rather than to engage as a part of a political experience of seeing. Marjorie Perloff described Barthes in *Camera Lucida* as engaged in a redemptive reading of the photograph allowing a possibility for "individual transcendence" (Perloff 58). But Perloff's reading of Barthes's essay does not account for the emotion of mournfulness which touches other photographs which do not include members of Barthes's family. Indeed the very absence from the book of the image of Barthes's mother suggests that his very individual experience of grief which could not be shared extended beyond this missing space to touch other non-familial images of human experience displayed in the book. The inclusion of the personal testimony *in the company of* the meditations of various other kinds of photographs undermines Perloff's claim that Barthes sought to avoid the "collective scene of mourning" (Perloff 58). Thus we might consider the photograph of a weeping mother or another of passing nuns on the streets of Nicaragua in the context of images of grieving women and other mourners discussed in "The Third Meaning." Other images— of workers shoveling snow in Stieglitz's photograph of New York; of poor children in Little Italy; various portraits of black Americans including an ex-slave; and Nadar's portrait of his mother—all participate in a pathos, a mood of mourning which found its most intense expression in the meditation on the missing Winter Garden photograph.

BARTHES AND TRAUMA THEORY

As trauma theory has become prominent in contemporary cultural criticism it has replayed arguments developed in theorizations of media. In particular, the critique of trauma theory pursued by Ruth Leys returns to questions raised in Barthes's essays on photography. Leys argues that Caruth's influential application of trauma theory in the field of literary studies is premised on the neurobiological arguments of Bessel van der Kolk. Van der Kolk understands traumatic memory as a direct imprint or indexical trace of an empirical reality (*Trauma* 250). For Caruth, traumatic memory is a literal repetition of an event which returns because it eluded conscious memory in the first place. What Caruth's and Van der Kolk's articulations of trauma share, according to Leys, is an understanding of symptoms, dreams and flashbacks as truthful and literal representations of a traumatic event. Leys argues that the neurobiological formulation of trauma as a literal trace of an event or experience ultimately contradicts the therapeutic emphasis on the role of narrative in integrating trauma into the fabric of memory, for if trauma is radically outside symbolization, how can it be narrated without compromising its status as literal truth? Instead of representation only compulsive repetition could be said to "communicate" traumatic experience, for even if the experience is visualized as a dream or "flashback" then some

degree of symbolization and fantasy must always be operative (249). As I have shown, Barthes's reflections on photography were preoccupied with a similar tension between symbolization and traumatic affect.

Leys presents a critical reading of the way that Caruth uses Van der Kolk's understanding of trauma as a literal trace of an event or experience. The traumatic experience returns as a "flashback" that somehow exceeds notions of representation. Trauma is understood as transmitted in its incomprehensibility, perhaps from victim to therapist or across generations (Leys 253–254). Caruth, argues Leys, draws from specific articulations of trauma in the Freudian corpus "in order to support her performative theory of language" (275). In contrast to Caruth, Leys argues that Freud:

> oscillated between two competing notions of representation: one de-
> fined in terms of a "representative theatricality" that underscores
> notions of the specular self-distanciation and conscious recollection
> in trauma; the other defined in terms of an originary and affective
> "mimesis" or identification that emphasizes notion of nonspecular ab-
> sorption in a traumatic scenario that is immemorial not because of
> a constitutive breakdown of all representation but because that sce-
> nario is unavailable for a certain *kind* of representation—theatrical
> self-representation—and hence for conscious memory. (Leys 275)

This oscillation that Leys finds in Freud's grappling with trauma recalls Barthes's distinction between *studium* and *punctum* in *Camera Lucida*. Barthes described the experience of being photographed: "I constitute myself in the process of posing . . . I transform myself in advance into an image" (*Camera* 10). As with the patient in analysis, the subject defends himself against a trauma of the real through a theatrical self-representation, a reproduction of a fiction of the self. But the *punctum* penetrates this conscious self-representation, demanding that its meaning be situated in a field of unconscious fantasy and involuntary memory. Barthes showed that this oscillation did not necessarily result in a stark choice between self-consciousness and compulsive repetition.

For Barthes the *punctum* was very often in details that could not be explained by either the projected self-image of a subject or in terms of the compositional interest intended by the photographer (for example, the fin-gernails of Andy Warhol in a portrait by Richard Avendon [*Camera* 45]). As in the distinction pursued by Leys, it was not that these details are outside representation but that they exceed the limits of a certain mode of represen-tation in which the subject is constituted as a recognizable *imago* or sus-tained by a consistent narrative of self-hood. With the *punctum* the subject encountered his/her non-identity and future death. As Derrida put it, com-menting on Barthes's text, "because we know that, once it has been taken, captured, this image will be reproducible in our absence, because we know this *already*, we are already haunted by this future, which brings our death"

(*Echographies* 117). Photography, film and video—indeed all modes of language—participate in this structural trauma by which our physical bodies are transformed into spectral images. In his essay "The Deaths of Roland Barthes" Derrida addresses the peculiar relation of *studium* and *punctum*:

> The "subtle beyond" of the *punctum*, the uncoded beyond, compares with the "always coded" of the *studium*. It belongs to it without belonging to it and is unlocatable within it; it is never inscribed in the homogeneous objectivity of the framed space but instead inhabits or, rather, haunts it . . . (*Work of Mourning* 41)

The punctum, writes Derrida, "lends itself to metonymy" (57). The *punctum* "allows itself to be drawn into a network of substitutions" and thereby "it pluralizes itself" (57). Thus the Winter Garden photograph, while it is never shown, "irradiates" (58) the entirety of *Camera Lucida*. Although the alterity of the specific image remained bound to Barthes's private grieving, this mourning work potentially extended to illuminate other images included in this particular book and beyond. As Derrida puts it, the *punctum* haunts the *studium* in a way that returns us to the subject's relation to historical trauma. The *punctum* functions as a form of excess, a supplementary meaning that is carried along with the ideologies of the media apparatus. It can never be entirely separated from the *studium* but participates in the coded meaning without being reducible to it. If the *punctum* was entirely separate from the *studium*, it would have no social or political significance.

If we accept Derrida's argument, then there can be no ultimate separation of mediated and unmediated trauma. Derrida, of course, demonstrated that this is a structural condition of all language: Every signified can always in turn become a signifier in a different linguistic context. Because this perpetual movement of *différance* can be discerned in the photographic image, it similarly allows us to consider how the trauma presented by the photograph is always constituted, through cultural codes, in history. Understood in this way trauma situates a subject in history, while potentially mobilizing a radical force that continually disrupts the stability of historical narratives. Through the *punctum* the photograph functions as a site of undecidability that allows the unbinding of self and the replaying of "primal" identifications and mourning. The process of mourning, or working-through, must always return to this dissolution of the subject and object relationship in order to reconstitute it in a new narrative of the subject.

I have argued that Barthes's structural linguistic analysis of the photograph did not withdraw from history as much as attempt to rethink the subject's relation to history. By the same token, Barthes's introduction of the personal, anecdotal dimension into his discussion of photography in *Camera Lucida* did not remove itself from representation of history in the mass media. However, this remains problematic for some critics. For

example, Dominick LaCapra considers the use of the "middle voice" in Barthes as a way of writing trauma (*Writing History* 19). For Barthes the middle voice in modern writing was an attempt to bracket any reference to reality and replace it with a self-reflexive concern with discourse itself. Barthes's use of the middle voice enacted the play of Derridean *différance*, resisting binary oppositions in a space of undecidability. However, LaCapra raises a further issue:

> undecidability and unregulated *différance*, threatening to disarticulate relations, confuse self and other, and collapse all distinctions, including that between present and past, are related to transference and prevail in trauma and in post-traumatic acting out in which one is haunted or possessed by the past and performatively caught up in the compulsive repetition of traumatic scenes . . . (*Writing History* 21)

That is, LaCapra diagnoses the self-reflexive middle voice as haunted in a purely negative sense and thereby acting out rather than working through trauma: "One's bond with the dead, especially with dead intimates, may invest trauma with value and make its reliving a painful but necessary commemoration or memorial to which one remains dedicated or at least bound" (22). LaCapra relates this to the impulse to sacralize traumatic events such as the Holocaust or the bombing of Hiroshima. However, by associating disarticulation of the self with compulsive repetition, LaCapra does not consider the value of haunting as a force that can potentially disrupt oppressive forms of power and identity. Confronting his own death in the photograph, Barthes sought to resist an authoritarian violence that constrained his relation to photography and to history.

IMAGE: THE CONDEMNED MAN

Barthes identified photography with a specific historical crisis of representation. Like Benjamin, who saw in photography the destruction of the aura surrounding an individual object/image, Barthes considered photography a "decisive mutation" (*Image* 45) in the history of Western representation. As I have shown, this mutation was based in Barthes's conception of the photograph as a literal trace of a missing object or past event. Identifying the *punctum* with the Lacanian real, Barthes saw the essence of photography as (in Freud's phrase) beyond the pleasure principle that he associated with the *studium*. Ultimately he found that the conventions and stereotypes of the media never release us from something more fundamentally disturbing in the photograph. Can this historical crisis of representation be related directly to a political crisis? Barthes began his career in *Writing Degree Zero* by identifying an aesthetic impasse reached by the writing of commitment: the quest for the purest form of social realism only ended by

producing new codes and conventions. I propose that the political crisis acted out in the Sartre–Camus debate about Soviet state terror registered in subsequent Barthes's writings as a gradual withdrawing from any commitment to collective struggle, even as he persisted in discussing images of revolution and political oppression. Barthes associated the banality of media code with dominant forms of political action and power.

It is not possible to entirely dissociate Barthes's meditations on photography from politics. In the closing pages of *Camera Lucida*, Barthes made a link between the structural trauma presented by photography and historical trauma related to modern experiences of death. First he wrote that the photograph "is violent not because it shows violent things, but because on each occasion *it fills the sight by force*, and because in it nothing can be refused or transformed" (91). The literal nature of the photograph refuses assimilation into narrative and confronts us with an incontestable reality that ultimately prefigures our own death. In this the photograph can be seen as part of more general change: "Photography may correspond to the intrusion, in our modern society, of an asymbolic Death, outside of religion, outside of ritual, a kind of abrupt dive into literal Death" (92). Photography shows us what, like Agamben's *homo sacer*, can be killed but not sacrificed. The *punctum* presented a new degree zero of signification, wounding the viewer with an intimation of absolute extinction. Although Barthes never named it as such, this literal, asymbolic death has been associated by theorists such as Adorno and Agamben with the Holocaust.

Images of the Holocaust are notably absent from *Camera Lucida* and Barthes's earlier essays on photography. This omission might be explained in terms of his move away from a direct concern with the "traumatic image" but, as I have shown, images of political violence and mourning featured prominently in both "The Third Meaning" essay and *Camera Lucida*. James Berger has noted that avoidance of the Holocaust was characteristic of poststructuralist theory in the late 1960s and in the early 1970s. He further comments:

> What becomes striking in retrospect, however, is that this neglect of the central, most traumatic violence of the century coincided with a rhetoric that was intensively apocalyptic, filled with invocations of rupture, decentering, fragmentation, irretrievably lost identity, the shattering of origins and ends. (*After the End* 107)

I have argued that Barthes's writings on photography included an ongoing negotiation of the legacies of revolutionary and colonial violence. Despite the extreme nature of the Holocaust, and despite the intense preoccupation over the past two decades with its history, meaning and representation, there is a danger of imposing the Holocaust retrospectively as *the* single historical trauma driving all intellectual work in the postwar era. We must acknowledge, however, Berger's point that the "general and understandable

avoidance of such a recent and overwhelming horror" (107) was a highly significant feature of the period from the mid-1940s until the 1960s, and in French theory through to the 1980s. (I discuss these issues in greater detail in Chapter 5 of this volume.)

After his comments on photography and the changing status of death, Barthes went on to present a meditation on the image of Lewis Payne, who was sentenced to hang for an attempted assassination of the American Secretary of State in 1865. Barthes never discussed why Payne attempted this act of political terrorism. His interest remained with the structural trauma, or *"catastrophe"* (96) presented by every photograph: Lewis Payne's and our future deaths. But if we think about Payne's death in terms of political sovereignty then the "intractable reality" (119) that Barthes claimed for the photograph is related to the power of the state to preside over the life and death of its subjects. In the twentieth century new forms of mass terror developed by the Soviet and Nazi states, and in subsequent regimes elsewhere, showed that anyone, anywhere, might be subject to absolute annihilation. This shock of recognition went beyond liberal humanist dismay at images of violence. Only a reflection on the structures that perpetuate this violence can go beyond an experience of shock that is complicit in the commodification of human suffering. Barthes's *punctum* is ultimately aligned with a death that cannot be assimilated into narratives of liberal individualism.

We can speak of two "scenes" of death in *Camera Lucida*: the private work of mourning related to the discovery of the Winter Garden photograph and the public display of death in other documentary images. The image of the condemned man embodied the sovereign violence of the law. Under the rule of modern totalitarian states entire populations have been condemned without trial for the "crime" of their racial identity or ideological affiliations. Barthes's grieving for his mother refused both this juridical political violence and the violence of photography that enforced certain ways of seeing. The crucial point in *Camera Lucida* is that the *punctum* informed *both* the withheld image of the mother *and* the image of the condemned man. The *punctum* did not withdraw from the realm of politics but potentially disrupted oppressive forms of power and visibility. In the image of the condemned man we confront our own deaths not through empathy with his situation but through the structural violence of the image in conjunction with the sovereign violence of the state. Agamben has proposed that "The only truly political action . . . is that which severs the nexus between violence and law" (*State of Exception* 88). This rupture can take place in the work of mourning or in carnivalesque humor (seen at play in "The Third Meaning" essay) in which the force of the law is suspended and its violence exposed and mocked. The rupture is only political when it confronts and seeks to dismantle the structures that legitimize this violence. Of course, these structures are not transformed simply by some act of looking. Nevertheless, there is a politics of looking related to complicity of media and political institutions. Barthes offered us an anti-empathetic

account of viewing the photograph that returned us to historical trauma—incorporating both a literal and structural dimension of representation—as a basis for our understanding of the image.

CONCLUSION

Like Benjamin and Adorno before him, Barthes struggled with historical representation in mass media. Psychoanalysis prompted these critics to look for a relationship to the past that could escape narratives and stereotypes that were continually reproduced in photographs and films. Structural linguistics allowed Barthes to reformulate these problems by locating the indexical dimension of the photographic sign as a supplement that could never be fully assimilated by the media code. By initially linking the possibility of traumatic shock to images of extreme events, Barthes gradually looked for a relationship to the photograph that was inscribed as a symptom on the body of the viewer. However, in subsequent applications of trauma theory to photography and film this embodied understanding of trauma gave rise to discourses of testimony and witnessing. What often disappeared from these discourses was a more general critique of the ideological function of modern media which had played such a central role in the criticism of Benjamin, Adorno and Barthes.

This shift toward a greater emphasis on identification with the victim in contemporary trauma culture was also related to larger political transformations. Barthes's writings on photography were shaped by the Cold War and the problem of totalitarian terror. Perhaps Barthes respected a taboo among leftist intellectuals in the West against comparing Communist regimes with Nazism. As Sartre's attack on Camus showed, there was a sense in which Soviet terror constituted a trauma for the left (Ackermann 169). Barthes's writings acted out this trauma. He never made representation of the Holocaust one of his direct concerns, yet visual evidence of political violence and terror did not disappear from his writings. His ambivalence toward organized politics was evident in both his disdain for ideology and his proclivity for anti-authoritarian forms of interpretation and writing. Barthes attempted to draw both a literal representation of suffering and a structural analogy between the photograph and traumatic memory into an articulation of historical trauma. He understood the image as part of larger processes of accelerated change and intensified violence in modernity.

The relation between linguistic theory and historical catastrophe has been an ongoing concern in different debates on trauma and representation. For example, both Jacques Derrida and Shoshana Felman have argued that Paul De Man, although he never publicly acknowledged his youthful anti-Semitic writings, engaged in a work of mourning for the errors of Nazism through his deconstructive readings of Romantic and modern literature. However, other critics such as Eric Santner and Dominick LaCapra

have responded by arguing that structural linguistic theory is not adequate in itself to address the historical trauma of the Holocaust.[3] I have argued that Barthes's use of semiotic and Lacanian theory in his discussions of photography enabled him (if only indirectly) to address larger political and historical issues. Unlike De Man, Barthes apparently had no earlier ideological affiliations of which he was ashamed. However, as a Cold War intellectual on the left he can be accused of neglecting to address the Holocaust. Nevertheless, his engagement with modern history is plain to see in his choice of examples. By making himself a witness to the singular pathos of the photograph, Barthes also situated himself with respect to a particular history of modernity.

Whether Barthes's meditations on the photograph are adequate to the specific challenges of representing the Holocaust is another question. The work of mourning in *Camera Lucida* may not be translatable to situations involving mass anonymous death. The task of attempting to mourn a loved one who has literally disappeared without a trace is one that survivors of the Holocaust and other modern catastrophes have had to face. In *Camera Lucida* the act of mourning the lost mother was confronted with the specter of an unredeemable death. Barthes closed his final book by confronting the possibility that in the future private mourning, along with an intimate relationship with images of those we love, may no longer be possible. If this is the case, then the *punctum* will have been fully absorbed by the media code. Barthes's work of mourning, however, remains exemplary in its attempt to think through a relationship between trauma, media and power.

5 After Auschwitz
A Community of Witness

Although Adorno's comments on the status of culture after Auschwitz, along with Benjamin's theses on the philosophy of history, have become standard references when discussing representations of the Holocaust, new forms of recorded testimony and television melodrama have raised issues that were not anticipated by these earlier theorists. Contemporary post-structuralist trauma theory, emerging from DeManian deconstruction and the study of Holocaust testimony, has conceptualized traumatic memory—and often photographic, video or film images—as a literal trace of a past event. However, this theory of the traumatic image becomes, in the context of Holocaust studies, not so much a means of evading ideology (as I have argued it was for Barthes) but a basis for recovering historical experience through verbal testimony or archival images. As a result, specific representations of the Holocaust have been granted special status and removed from their more general contexts in contemporary media culture. I argue that such claims for the transmission of traumatic experience through visual media reduce our ability to grasp the larger historical significance of the image.

Recent research on Holocaust representation has responded to a proliferation of recorded testimony and dramatizations of the Holocaust that has been produced since the late 1970s. Before this period the Nazi genocide received considerably less attention. During the early stages of the Cold War, Nazi war crimes were treated as a political liability by Britain and America—countries that had sought to establish a new liberal democratic consensus in West Germany. In postwar Israel memories of the atrocities and the camps tended to be effaced as the nation looked to establish a strong and independent self-image. The 1961 trial of Adolf Eichmann proved a turning point, creating an important public space for survivor testimony and attracting widespread international interest—notably in Hannah Arendt's trial coverage in the *New Yorker* and in her subsequent book *Eichmann in Jerusalem*.[1] After the Six Day War in 1967, growing interest in the Holocaust in America became increasingly associated with political support for Israel. The 1978 NBC television mini series *Holocaust* attracted large audiences in both America and West Germany. The establishment

of the Fortunatoff Video Archive at Yale University in 1981, along with Lanzmann's *Shoah* (1985) and Spielberg's *Schindler's List* (1995) generated further public interest, debate and academic criticism and research.

Debates about Holocaust representation have repeatedly contrasted narrative realism and modernist experimentation. These different approaches were first established in the Hollywood film *The Diary of Anne Frank* (Director George Stevens 1959) and the documentary *Night and Fog* (Director Alain Resnais 1955). Recent criticism has drawn on trauma theory to challenge this binary of realism and modernism. For example, LaCapra's notion of empathetic unsettlement seeks to incorporate both historical forms of identification and the insights of psychoanalysis and structural linguistics regarding the de-centering of the human subject. In this way LaCapra attempts to dissociate empathy from narcissistic forms of identification associated with popular narrative forms. Similarly, Michael Rothberg's use of the term "traumatic realism" aims to overcome any simple opposition between realist and anti-realist forms. Rothberg argues that in the case of extreme events such the Holocaust the objective stance of conventional realism is inadequate and gives way, in specific texts, to a "traumatic" relation between the subject and the external world that more adequately conveys the reality of catastrophe.

To the extent that these interventions side with empathy and realism, they seek to reconstitute an individual subject or recover the historical 'real.' Cultural theorists such as Jean Baudrillard and Andreas Huyssen have proposed that such attempts to redeem traumatic experience are futile. For these thinkers the Holocaust presents a particularly dramatic historical occurrence in a culture increasingly characterized by historical amnesia, instant obsolescence and commodified nostalgia. As I have shown in previous chapters, both Adorno and Barthes argued that modern visual media represent history by means of codes and conventions that foster group identification and ideological mystification. Thomas Elsaesser has proposed that today trauma narratives play an increasingly important role in the ways we imagine history. Under such conditions a revitalized theory of realism may ultimately reinforce this "traumatized" imaginary, whereas high modernist positions reconstitute a sterile polarity between "serious" and popular culture.

In the following discussion I argue that debates about Holocaust representation have been more deeply enmeshed in the politics of identity than is often acknowledged. I begin by considering the historical relationship between contemporary trauma theory and the Holocaust. I then discuss the importance of Agamben for my own approach to this topic. In *Remnants of Auschwitz.* Agamben proposes that the figure of the *Muselmann* serves as a testimony to the impossibility of witnessing Auschwitz. Agamben's discussion of the Muselmann is not concerned with the psychological experience of trauma but with structures of sovereignty and biopolitical forms of power. In this way Agamben's theory of bare life engages the significance

of the Nazi Final Solution beyond its special status for Jews to include the contemporary experience of "ethnic cleansing," torture and, refugee camps, along with other historical instances of enslavement and genocide. I then go on to consider how certain aspects of Agamben's approach were anticipated in Adorno's meditations on Auschwitz. Adorno's understanding of historical trauma became more complex in his postwar writings. At one level Adorno continued the critique of group identification developed in studies of fascist propaganda. This branch of Adorno's work also included his participation in an empirical research project *The Authoritarian Personality* (1950). Analysis of group identity was extended in the work of Alexander and Margarete Mitscherlich, associates of Adorno, who argued that the defeat of the Third Reich was a national trauma for Germany that gave rise to a collective failure to mourn its identification with Hitler. Some of Adorno's postwar essays also engaged with these issues.

In *Negative Dialectics* Adorno proposed that philosophy experienced a form of trauma in its attempt to understand the unprecedented horror of Auschwitz. Adorno's notion of philosophical trauma—that which overwhelms any remaining confidence in enlightened thought—was an extension of, and response to, Benjamin's thesis that "There is no document of culture which is not at the same time a document of barbarism" (4: 392). In Adorno's meditations on Auschwitz the repressed barbarism contained within culture returned with a force that destroyed all pretensions to transcendent truth. Adorno's famous, and often misinterpreted, comment that "To write poetry after Auschwitz is barbaric" (*Prisms* 34) has often been cited in subsequent responses to representations of the Holocaust. Sometimes, as in the case of *Holocaust*, critics repeated Adorno's criticisms of inauthenticity in productions of the culture industry. With the advent of video testimony by Holocaust survivors and Lanzmann's *Shoah*, certain intellectuals redeployed Adorno's critique in ways that held up oral testimony as a complex and authentic representational form that could be counter-posed to Hollywood melodrama and narrative realism.

Adorno's critique of culture after Auschwitz emphasized the exploitation and violence that underpins capitalism as a social and economic system. Although he foregrounded the issue of guilt for survivors of the Holocaust, Adorno is often associated with Alexander and Margarete Mitscherlich, who stressed the necessity of developing empathy for others in order to overcome the narcissistic identifications of Nazi racial ideology. I argue that this emphasis on empathy too easily colludes with an appropriation of the position of victim, a shift that was evident in later responses to television and film dramatizations of the Holocaust. Empathy can itself serve as a means of evading guilt and responsibility.

The controversy surrounding representations of the Holocaust in mainstream media was further complicated by the critical interest in film and video testimony taken by Shoshana Felman and Geoffrey Hartman. Their criticism has a direct historical link with Cathy Caruth's influential theory

of trauma as a symptomatic trace of the historical 'real.' These different debates and positions are made more complex by their relationship to a range of national and historical contexts. Whereas Adorno emerged as a major intellectual presence in postwar Germany, the discussion of video testimony in America was influenced by a therapeutic culture which developed in the late 1960s around treatment of Vietnam War veterans and Holocaust survivors (Luckhurst 60–64). Adorno's concern was with the failure of German society to confront the significance of the Nazi era, whereas American psychotherapists and literary critics moved to make the victim/survivor a figure of collective identification and an embodiment of historical truth. Witnessing became embedded in a specifically American–Jewish identification with the Holocaust (Cole 12).

Lanzmann's *Shoah* was the subject of a long essay by Felman, who lauded the film for its refusal to employ archival images and for its direct transmission of historical trauma through the testimony of survivors and witnesses. Felman made sweeping claims for Lanzmann's film as the embodiment of historical truth, leading to more cautious and critical readings by LaCapra and others of both the film and Felman's interpretation. LaCapra argued that both Lanzmann's film and Felman's commentary were in danger of sacralizing the Holocaust and thereby effectively removing it—and the archival representations that Lanzmann insisted on excluding from *Shoah*—from ongoing historical analysis (*History and Memory* 100, 111). Neither Felman's nor LaCapra's discussions of *Shoah* sought to consider the significance of the film in the wider context of contemporary media culture. Arguably, Lanzmann's decision to exclude archival footage from *Shoah* was a direct response to dominant media apparatus by which any event is subject to dramatization and thereby transformed into entertainment. Lanzmann himself publicly attacked Spielberg's *Schindler's List* for its historical misrepresentation of the Holocaust, and its reduction of the sufferings of millions to sentimentality and kitsch. Subsequent debates about *Schindler's List* and *Shoah* inscribed the two films within the opposition of realist and modernist strategies of representation: *Schindler's List* exemplified Hollywood's dominant mode of narrative realism, whereas *Shoah* questioned the adequacy of narrative realism, with its reliance on visual convention and dramatic stereotype, to do justice to the radical alterity of the Holocaust as an historical occurrence.

The *Schindler's List/Shoah* debate takes on another dimension when we consider Jean-Luc Godard's *Histoire(s) du Cinema*. This long video essay, which was made for French television and incorporated new digital editing technologies, has been introduced into the debate about Holocaust representation by Georges Didi-Huberman and Libby Saxton. Godard's film includes a meditation on archival images of Auschwitz, including a provocative juxtaposition of documentary images from the camp with images of Elizabeth Taylor. Godard also includes an image taken from Lanzmann's *Shoah* as part of his extensive and complex montage. Because Godard

situates images of the Holocaust within a general archive of modern cinema and media culture his video essay allows us to raise questions, problems and issues not directly addressed in other studies of Holocaust representation. *Histoire(s) du Cinema*, then, presents an important opportunity to enlarge the discussion around the Holocaust understood as an historical trauma. I conclude this chapter by discussing an image of an Auschwitz survivor included in *Histoire(s) du Cinema*. I argue that the experience of the camps cannot be directly transmitted by an image because the image is always framed by a missed encounter with reality. However, an image can convey important insights into reality, if we are conversant with the complex histories of its production, reproduction and dissemination.

TRAUMA THEORY AS SYMPTOM

Whereas there has been increasing interest over the past three decades in representations of the Holocaust, several commentators have suggested this preoccupation should itself be seen as symptomatic of broader cultural change. As I mentioned in my Introduction, Andreas Huyssen suggests that the contemporary preoccupation with memory and, more specifically, the traumatic past can be understood as a response to a "crisis of temporality . . . brought on by the interface of technological change, mass media, and new patterns of consumption, work and global mobility" ("Trauma and Memory" 21). For Huyssen trauma theory is only one articulation of a desire to reclaim the past in a globalized consumer culture which constantly promotes instantaneous communication and rapid obsolescence. He claims the disorienting transformation of space and time by cyber capitalism provokes a compensatory desire to locate the self and social relations in narratives that reach beyond those of the nation. Although he disavows the "cult" surrounding Walter Benjamin (18), Huyssen's argument itself owes much to Benjamin's widely discussed theory of modernity and shock. Huyssen writes of "informational and perceptual overload" (24) leading to a collapse of confidence in the future and a general mood of nostalgia. As opposed to Benjamin's modernism in which the recovery of oppressed histories promised to revitalize political struggle, Huyssen sees today's trauma theory as part of a conservative impulse to anchor identity in some relatively stable sense of the past. As public memory is increasingly recoded as digital information and stored in databases, a panic about forgetting manifests itself in an impulse toward memorializing. Whereas Modernism looked forward to a utopian future, contemporary culture, confronted by the catastrophes of modernity—most notably the Holocaust—looks to slow the pace of change and to heal the wounds of the past.

The impulse to recover the past addresses the present in ways that are more political than those acknowledged by Huyssen. For example, in their foreword to *Testimony*, Shoshana Felman and Dori Laub designated

World War II as an historical trauma both central to various texts discussed in their book and an event to be understood as having ongoing and evolving effects today in Eastern Europe and the Middle East (Felman and Laub xiv). The authors understand the difficulties of bearing witness to the Holocaust as having provoked a crisis of representation that they consider in certain literary texts and in *Shoah*. Their readings of these texts allow Felman and Laub to address major intellectual disputes and postwar positions, including existentialism and deconstruction—or what they refer to as the story of the experience of a generation "from whose bewildering complexity and from whose chaotic implications we have not yet emerged" (xix). There is a hope, which they find in Lanzmann's film, that the silence surrounding the Holocaust can be broken, leading implicitly to some form of political renewal. According to the historical scenario evoked by Felman and Laub, trauma theory addresses a symptomatic blockage in post-World War II intellectual and cultural life that has real political consequences.

By suggesting trauma studies is symptomatic of a broader crisis of temporality and cultural globalization, Huyssen effectively shifts his focus from the historical significance of the Holocaust. Huyssen rightly points to the problem of over-generalizing the Holocaust and making it serve as model for other genocides. His skepticism about imagining history as trauma, however, prevents him from considering further any stronger sense of historical reference that trauma theory attempts to claim. That is, trauma theory may indeed be symptomatic of a desire to anchor history in response to intensified transnational mobility and instability, but it may also address key political problems raised by the geopolitical transformations of the past century. One obvious counter argument to Huyssen's critique of trauma culture is suggested by Agamben's proposition that the concentration camp is "the hidden matrix and *nomos* of the political space in which we are still living" (*Homo Sacer* 166).

Agamben argues that whereas classical Greek politics was premised on a separation of private life from participation in the political community, modern politics is characterized by increasing state jurisdiction over biological existence. The camp is the new political space where the very distinction between life and death is called into question. In the concentration camp the individual citizen, without being guilty of any crime, is reduced to a condition of "bare life," available to be killed by the machinery of the state. Agamben argues that suppression of civil rights in a political state of emergency has over the past century become, not the exception, but the rule (168–169). The plight of political prisoners, civilians in war zones and refugees deprived of national citizenship, can all be seen as contemporary manifestations of "bare life." Because he understands the Nazi Final Solution as the most extreme manifestation of new forms of bio power, Agamben rejects the term "Holocaust":

The Jew living under Nazism is the privileged negative referent of the new biopolitical sovereignty and is, as such, a flagrant case of a *homo sacer* in the sense of life that may be killed but not sacrificed. His killing therefore constitutes . . . neither capital punishment nor a sacrifice, but simply the actualization of a mere "capacity to be killed" inherent in the condition of the Jew as such. The truth—which is difficult for the victims to face, but we must have the courage not to cover with sacrificial veils—is that the Jews were exterminated not in a mad and giant Holocaust but exactly as Hitler had announced, "as lice" which is to say, as bare life. The dimension in which the extermination took place is neither religion nor law, but biopolitics. (*Homo Sacer* 114)

Whereas Huyssen questions the universalization of the Holocaust as the contemporary nation state faces a crisis of legitimation, Agamben insists on the historical example of the Nazi extermination as an ultimate example of more general political transformation. Instances of genocide and "ethnic cleansing" in the post-World War II and post-Cold War periods have shown how crises of national sovereignty can produce mass displacement and destruction of human populations. To remove, as Agamben suggests, the sacrificial aura from the Holocaust and confront its underlying political reality may enable us to better understand why trauma studies has flourished in the wake of the legitimizing narratives of the nation.

Agamben proposes that whereas an adequate historical account of the Final Solution is available, we have yet to grasp its ethical and political significance (*Remnants* 11). There is an apparently unbridgeable gap between the traumatic experience of the victims/survivors and our own understanding of its larger implications. Agamben studies Holocaust testimony in an attempt to close this gap but arrives at a further problem: "the survivors bore witness to something it is impossible to bear witness to" (13). For Agamben the significance of testimony must exceed its legal function of leading to judgment or a sense of moral responsibility. The problem for Agamben, realized through his reading of various testimonials, but particularly the writings of Primo Levi, is that the only true witness did not survive (33–34). Yet Agamben distinguishes his own approach to this from that of Felman and Laub, who also focused on the impossibility of witnessing. Agamben sees Felman's reading of *Shoah*, in which history "returns" in the song of a survivor, as aestheticizing and thereby falsifying the inaccessible actuality of testimony. For Agamben only a rupture in representation itself can bear witness to the extreme reality of the camps (his example is Levi's discussion of the child Hurbinek in Auschwitz who made sounds that no-one could interpret [37–39]).

The extreme figure of the impossibility of witnessing is the *Muselmann*, the camp inmate whose condition has degenerated to one of total submission to violent force and who lives a robot-like existence that is a form of

living-death. For Agamben the state of exception, in this case the emergency powers by which the Nazis assumed total state power in 1933, is embodied in the person of the *Muselmann* as an object of total domination. The *Muselmann* is the figure whom we do not want to see, whom we cannot bear to look at. By focusing on the image of the *Muselmann* Agamben avoids positioning testimony as a performance of historical truth. Instead the historical truth embodied in the image of the *Muselmann* provokes ambivalence and dread. The *Muselmann* "marks the threshold between the human and the inhuman" (55). Agamben argues that the Final Solution intervened in an unprecedented way in what was previously understood as the human experience of death. Death was transformed by a factory-like mass production of corpses. Death was dehumanized. The *Muselmann*, then, serves for Agamben as the image of an historical trauma—not a literal image (as the *Muselmann* remains virtually invisible) but the figure of an unthinkable reality, an incomprehensible historical transformation of the human subject "into a bare, unassignable and unwitnessable life" (157).

Because he makes the experience of the camps central to his account of contemporary politics, Agamben is often associated with other trauma theorists whose work is preoccupied with the Holocaust. As Roger Luckhurst has argued, therapeutic research on sufferers of PTSD has played an important role in the emergence of a general trauma culture in which survivors of the Vietnam War and the Nazi concentration camps became morally elevated and the object of emotional and cultural identification (Luckhurst 64). Whether or not the figure of *homo sacer* in Agamben's writings participates in this cult of survivor-heroism is an important question. However, if Agamben argues against sacralization of the Holocaust, perhaps we should assume the condition of bare life should not be imbued with an equivalent cultural aura. Agamben's reflections on Auschwitz do not solicit identification with, or empathy for, the trauma victim. Rather, the figures of *homo sacer* and the *Muselmann* are presented as defying identification because of the extreme alterity of their experience. I read Agamben's reflections on Auschwitz as an account of an historical trauma: a conceptual blockage based in a crisis of identity that demands an attempt to reformulate political community.

In his preface to a 1975 translation of the Mitscherlichs' book *The Inability to Mourn* (1967), Robert Jay Lifton compared German experience to the crisis suffered by many Americans during and after the Vietnam War. Failure to confront the moral implications of American intervention in Vietnam led to an inability to mourn Americans who had died there and a disappearance of historical awareness of the war. In both cases, German and American, "psychic numbing" and denial became cultural norms. As LaCapra explains:

> The traumatic event has its greatest and most clearly unjustifiable effect on the victim, but in different ways it also affects everyone who comes into contact with it: perpetrator, collaborator, bystander, resister, those

born later. Especially for victims, trauma brings about a lapse or rupture in memory that breaks continuity with the past, thereby placing identity in question to the point of shattering it. But it may raise problems of identity for others, insofar as it unsettles narcissistic investments and desired self-images, including—especially with respect to the Shoah—the image of Western civilization itself as the bastion of elevated values if not the high point in the evolution of humanity. (*History and Memory* 9)

Why "especially with respect to the Shoah"? Why not question European Enlightenment values with respect to earlier and ongoing genocide of indigenous peoples, or other colonial and neo-colonial interventions? One answer to this question is that the Western Enlightenment was formulated with, and on the basis of, the appropriation of colonies and Western imperialist conquest. As Ranjana Khanna has argued, psychoanalysis was the product of an era in which the European nation state's formation was based in colonial expansion (Khanna 6–7). Our understanding of trauma has been so profoundly influenced by psychoanalysis that it carries traces of Western universalistic thinking.

Robert Eaglestone has noted another reason for the centrality of the Holocaust to trauma debate: recognition of the term genocide dates from 1944 and thereby has become inextricably linked to the revelations of the Nazi Final Solution (Eaglestone 343). Eaglestone has called for more research into the relationship between the Holocaust and post-colonial politics and the colonial genocides of Native Americans, Australian aboriginals and the Herero in Namibia. An important precedent for considering the relation of Nazism to earlier forms of imperialism was suggested by Hannah Arendt in *The Origins of Totalitarianism*, when she commented that late nineteenth-century European imperialism in Asia and Africa could be considered "a preparatory stage for coming catastrophes" (125) (although this narrative itself implies an historical priority accorded to the Holocaust). The genocidal destruction of those who stood in the way was the price to be paid for the Western ideology of progress.

Building on Agamben's insights, Paul Gilroy proposes that our understanding of biopower under the modern state must be enlarged to consider the different forms of the metropolitan center and the space of colonial conquest. The ideologies and discourses of racism formed a fundamental part of defining the relation between these different spaces of power. The torture and massacre of colonial subjects and indigenous peoples provided vivid precedents for the Third Reich's annihilation of "subhumans" (Gilroy 44–50). Gilroy comments:

Once the history of empire became a source of discomfort, shame, and perplexity, its complexities and ambiguities were readily set aside. Rather than work through those feelings, that unsettling history was

diminished, denied, and then, if possible, actively forgotten. The re-
sulting silence feeds an additional catastrophe: the error of imagining
that postcolonial people are only unwanted alien intruders without any
substantive historical, political, or cultural connections to the collec-
tive life of their fellow subjects. (Gilroy 91)

Genocidal violence has gathered force over the past century and has shaped
European history since the conquest of the Americas. It has had its basis
in defining the non-European 'other' as less-than-human. If we follow Gil-
roy's argument, we could understand this enslaved or exterminated 'other'
as continually returning as the figure of an unworked through trauma
for the Western subject. Rather than attempt to explain modern history
by adapting psychoanalytic trauma theory, we need to consider how the
concept of trauma is itself shaped by certain political crises of modernity.
According to such an approach, trauma theory would designate a field
of unresolved problems concerning the modern political subject. Such a
perspective requires understanding trauma as first of all a crisis of a sub-
ject constituted by way of linguistic structures and cultural codes that
situate him/her in history. That historical narrative, by which the subject
constructs his/her self-identity, is disturbed and disrupted by the spectral
appearance of another who does not appear human, or has been situated
outside history and outside of law. This spectral 'other' threatens the iden-
tity of the subject who attempts to sustain him/herself in a coherent or
progressive historical narrative.

In trauma, wrote Caruth, "the outside has gone inside without any
mediation" (*Unclaimed Experience* 59). How should we understand such
a structural proposition in genuinely historical terms? If the "outside" is
aligned with non-Western and colonized, and the "inside" with the West
and the centers of imperial power, then historical trauma is embodied in
the figure of the displaced person, the refugee, or the immigrant who con-
fronts the xenophobic hostility of the dominant culture. This relationship
of historical trauma to the geopolitical imagination requires greater atten-
tion when considering the claims of trauma theory. Between Huyssen's and
Agamben's contrasting positions we can discern a third possibility: that
trauma theory attempts to respond to both new cultural terrain defined by
media and information technologies *and* new forms of violence and power
to which individuals and groups are subject. Different articulations of
trauma in cultural criticism may not, however, be adequate to account for
these cultural and political realities. In order to consider the ways trauma
theory might meet this challenge we need to take a longer view of the role
trauma has had in cultural criticism over the past century.

Ruth Leys has argued that Agamben's propositions about bare life par-
ticipate in the same anti-mimetic logic as Felman's and Caruth's articu-
lations of trauma: that is, the reduction of the individual subject to the
condition of bare life would take place as a traumatic event exterior to and

impacting on a fully constituted subject. For Leys the emphasis on social exclusion aligns bare life with trauma as an external event and thereby fosters processes of identification with the position of victim (*Guilt to Shame* 164). However, if we read Agamben as claiming bare life, or more specifically the experience of the camp and the figure of the *Muselmann*, as the embodiment of a social and political reality that remains largely unassimilated by critical thought or historical consciousness, then its relation to trauma theory can be understood differently. It then becomes possible to argue, contra Leys, that bare life functions as a trauma that prohibits collective identification with the figure of the victim. For Agamben the victim of Auschwitz prefigures contemporary forms of political violence and exclusion that we fail to recognize. Leys reads Agamben as equating the historical trauma of bare life with the actual experience of the camp (*Guilt to Shame* 163). But Agamben's proposition is that the camp is representative of certain political transformations of modernity and demands that we attempt to think beyond the identarian politics that made the camps possible in the first place.

LaCapra, in his long and highly critical discussion of Agamben's *Remnants of Auschwitz*, finds the work to be an often ambiguous and unhistorical account of the Holocaust. He sees in Agamben a tendency he finds also in Felman and Lyotard—that of approaching Auschwitz or the Holocaust in terms of an aesthetics of the sublime which emphasizes the impossibility of adequate representation (*History in Transit* 174). LaCapra argues that Agamben neglects to consider the more partial and gradual ways that giving testimony and bearing witness can enable survival and working-over of traumatic experience (175–176). This aspect of LaCapra's response to Agamben is premised on the desirability of understanding the witness as an individual subject and (at least potentially) an active agent. However, such a reading of Agamben misconstrues the importance of the *Muselmann* as an image or figure embodying an historical trauma. Although Agamben's account of the *Muselmann* relies heavily on the testimony of Primo Levi, he is not interested in the psychological or social dimensions of testimony as much as he is in locating the image of an impasse in understanding the significance of the Nazi death camps.

Auschwitz poses for Agamben, as it did for Adorno, a philosophical and political enigma whose apparent incomprehensibility had potentially traumatic effects. Unlike LaCapra, these thinkers are less interested in the psychodynamics of human recovery and empathy, or the claiming of traumatic experience on the part of a collective identity, than in the challenges that this extreme catastrophe presents for historical understanding. LaCapra finds Agamben's reflections "transhistorical" (178) but they may be more accurately described as embedded in a political struggle over the representation of history. For in his claim for a more mediated account of testimony and working-through, LaCapra reproduces the ideal of "balance" inherent in a liberal model of the individual and of political community.

For Agamben the image of the *Muselmann* disturbs this liberal model of historical consciousness. Rather than empathizing with the experiences of the traumatized, critique after Auschwitz needs to confront its own disturbances and blockages. LaCapra has little to say about the precedents for Agamben's approach in earlier texts by Benjamin and Adorno on the philosophy of history. It is to these texts that my discussion now turns.

ADORNO "AFTER AUSCHWITZ"

One of the most cited texts in trauma studies, Benjamin's "On the Concept of History," was written in 1940 after Benjamin was interned in a labor camp and shortly before his suicide at the Spanish border whilst attempting to escape Nazi-occupied France. Adorno and Horkheimer received a copy of Benjamin's theses in June 1941 and they published it in a limited edition in 1942 (Buck-Morss *Origins* 168–171). In an important commentary on Benjamin's essay Sigrid Weigel focuses on the following passage from Thesis VIII:

> The current amazement that the things we are experiencing are "still" possible in the twentieth century is *not* philosophical. This amazement is not the beginning of knowledge—unless it is the knowledge that the view of history which gives rise to it is untenable. (Benjamin 4: 392)

Weigel considers these remarks in the context of the normalization of violence and catastrophe in modern life. Against a false sense of shock, Benjamin's notion of history as catastrophe demanded that we reject a liberal humanist optimism about history as progress. However, Weigel suggests that Benjamin did not reject amazement as such, but rather called for a different sense of amazement at the failure to recognize the catastrophic nature of history (Weigel 158–159). For Weigel this amazement represents a boundary for philosophical understanding potentially leading toward a new perception of history. The experience of amazement is given concrete form in Benjamin's image of the angel of history: "Where a chain of events appears before *us, he* sees one single catastrophe, which keeps piling wreckage upon wreckage and hurls it at his feet" (392). The gaze of the angel of history resembles the plight of the traumatized subject, unable to escape the repeated return of violent, shocking events. As Weigel stresses, it is the alterity of the angel's vision of history that is at stake in Benjamin's account. This is why amazement is a boundary case, both inside and outside philosophical cognition (Weigel 162). A similar sense of amazement and alterity is also at the center of Agamben's refelctions on the *Muselmann*.

According to Weigel's reading, Benjamin's image of the angel of history demands that we recognize an experience of history that can never be fully assimilated into a linear narrative but rather disrupts linear temporality

in the manner of a traumatic repetition. This disruption refuses both false amazement that such catastrophes are "still possible" and a negative teleology in which catastrophe is simply accepted as the historical norm. Rather, the genuine shock of recognition required by Benjamin's sense of amazement is compared with a distinctive political experience of history: "The tradition of the oppressed teaches us that the 'state of emergency' in which we live is not the exception, but the rule. We must attain to a conception of history that accords with this insight" (Benjamin 4: 392). Here Benjamin adapted the notion of the state of emergency that was central to the political theology of Carl Schmitt. In Schmitt's theory sovereign power inaugurates a state of emergency at a moment of decision making, such as a seizure of power or a declaration of war. Benjamin reversed the meaning of this moment of decision by evoking a vision of the oppressed who are excluded from sovereign power and are threatened with destruction. However, this did not involve identifying with the position of victim, but rather attempted to learn from the catastrophes of the past.

Weigel argues that in Adorno's later meditations on Auschwitz guilt functioned as a border case for philosophical thinking in a similar manner to Benjamin's image of amazement. In *Negative Dialectics* Adorno drew on his own experience as a Jew who, unlike Benjamin and millions of others, had survived the Nazi extermination:

> The guilt of a life which purely as a fact will strangle other life, according to statistics that eke out an overwhelming number of killed with a minimal number of rescued, as if this were provided in the theory of probabilities—this guilt is irreconcilable with living. And the guilt does not cease to reproduce itself, because not for an instant can it be made fully, presently conscious. This, nothing else, is what compels us to philosophize. And in philosophy we experience a shock: the deeper, the more vigorous its penetration, the greater our suspicion that philosophy removes us from things as they are . . . (*Negative Dialectics* 364)

Like Benjamin, Adorno evoked an historical experience that could not be fully assimilated into philosophy but instead was recalled in the manner of an un-worked-through trauma.

To fully understand this we need to return to Adorno's original formulations about representation "after Auschwitz." Adorno's comments were not limited to the representation *of* Auschwitz. As we saw in Chapter 3, Adorno drew on Freud to develop a negative critique of mass psychology. These preoccupations continued in Adorno's writings in the postwar period. The collective struggles with which Benjamin attempted to identify his own work were now dismissed as historically exhausted and Adorno attacked more directly all forms of collective identification which he saw as potentially fascist. Adorno's political interest in group psychology has played a relatively minor role in more recent debates about Holocaust representation

whereas his comments about the status of culture after Auschwitz have become part of an ongoing set of debates about representation.

As I showed in Chapter 3, although he was critical of Freud's failure to address the political and economic dimensions of subjectivity, Adorno saw psychoanalysis as establishing an important precedent for reading unconscious motivations in ways that subverted bourgeois ideology. With Benjamin, Adorno developed a theory of historical images in which the desires and fantasies given expression in modern cultural forms revealed an historical truth, despite the conscious intentions of those who produced them. The experience of shock itself assumed a commodified form that Adorno compared to the compulsive repetition of traumatic neuroses. Thus the productions of the culture industry functioned as "psychoanalysis in reverse," traumatizing the public as a screen against a recognition of real historical forces that governed their lives. Iconic figures in mass media, from Hitler to King Kong, were narcissistic projections of the group driven by the anxieties of a competitive capitalist society. These specters of desire and fear allowed for forms of collective identification that concealed the historical truth of the actual liquidation of the individual in modern industrial society. Auschwitz became the most extreme realization of this destruction when even the death of the individual was appropriated by the apparatus of the state. In the postwar period Adorno diagnosed German society as failing to acknowledge the historical reality of the Nazi period. Collective narcissistic identification with Hitler had left an unhealed psychic wound that was thereafter covered over by the manic activity of the "economic miracle." Adorno's meditations on culture "after Auschwitz" sought to demand a recognition of the fundamental complicity between capitalist exchange value and the politics of extermination. Economic recovery was not a way out of the catastrophe of the Nazi period but a perpetuation of its underlying logic.

The earliest published version of Adorno's meditations on Auschwitz are included in his 1949 essay "Cultural Criticism and Society." This essay can be read as an elaboration of Benjamin's thesis that "There is no document of culture which is not at the same time a document of barbarism" (4: 392). Adorno began his discussion by developing a critical genealogy of the cultural critic. He noted the contradiction that underlies cultural criticism: it places itself in an intellectually superior position to that upon which it is dependent. The origins of this contradiction lie in the historical professionalization of criticism. Critics were originally those who profited from the promotion of culture and in later periods the critic has remained bound to the culture industry from which s/he often seeks to free himself. But any attempt to remove culture from its basis in the material conditions of life "becomes increasingly suspect when confronted . . . by the threatening annihilation of uncounted human beings" (*Prisms* 20). Adorno argued that to the extent that the critic participates in an uncritical sublimation of culture, s/he also participates in barbarism.

For Adorno the individual freedom with which the critic claims to express his/her views is also compromised by the increased reign of market values over all social relations. He proposed that even the fascist suppression of criticism was subject to a logic of sadistic violence that was already implied in the arrogant stance of the critic. Against this false inflation of criticism through its complicity with the commodification of culture, Adorno offered the formulation: "Culture is only true when implicitly critical" (22). Although one response to this situation would be to withdraw from the market, such a conservative position ultimately helps to keep in place the exploitative system from which it seeks to extricate itself. On the other hand, Adorno saw the relegation of culture to a by-product of economic production as allowing culture to falsify reality as ideology. Moreover, direct criticism of consumer culture in the name of higher things is itself ideological if it fails to recognize that *all* culture is contaminated by the barbarism of society. If it is to avoid these various false positions, Adorno proposed that cultural criticism must seek to preserve "the notion of culture while demolishing its present manifestations as mere commodities and means of brutalization" (28). The logic of this argument prepares us for Adorno's often quoted maxim that "To write poetry after Auschwitz is barbaric" (34). To the extent that poetry, like criticism, participates in this barbarism it falsely maintains the apparent autonomy of culture in the face of its complete assimilation into reified social relations.

Adorno's position can also be understood within the context of his personal situation as an intellectual after Auschwitz. Peter Hohendahl explains how Adorno as a member of the Jewish middle class (like Freud and Benjamin) was part of a larger historical project of assimilation through education into German high culture. Adorno's career was characterized by a troubled relationship with the university, including the termination of his academic position by the Nazi state and his later expatriate experience in England and America. It was only in the postwar period, with his return to teach at the University of Frankfurt, that Adorno became widely regarded as an important educator. Adorno's experience of expatriation and exile intensified his already highly critical attitude to "official" culture. The historical experience of modern war and enforced emigration were traumas that the dominant intellectual culture of positivism or "instrumental reason" refused to acknowledge. For these reasons the established educational system which claimed to foster individual development, but which actually tended to reproduce unthinking social conformity, needed to be challenged.

Adorno's role as an educator in postwar Germany can also be seen as part of the "denazification" project imposed by the victorious Allied powers. As a German himself, Adorno was faced with the deeper concern of re-evaluating the traditions of high culture after their misappropriation by Nazi ideology. With the return of the Institute of Social Research to Frankfurt studies of the authoritarian personality begun in America were

continued with empirical research on political consciousness in West Germany (published in 1955 under the title *Group Experiment*). This research led to a thesis that postwar German society was characterized by its failure to work through the meanings of its Nazi past. Adorno's position was inclined toward the darkest view that fascism persisted in an unresolved ideology for many Germans. This would constitute the greatest challenge faced by the educator in postwar society (Hohendahl 47–52). In 1956 the Institute organized a series of public lectures on psychoanalysis, whose participants included Herbert Marcuse, Erik Erikson and Alexander Mitscherlich. Adorno saw this as part of an important struggle to re-establish Freud's intellectual influence in postwar Germany (Muller-Doohm 388–389). For Adorno this influence needed to extend beyond individual therapy to social and historical criticism. However, Adorno's critical position did not extend to the support of the radical student movements of the 1960s. Adorno's reliance on Freudian theory for his critique of group identification led to an unrelenting pessimism about collective political action under conditions of advanced capitalism.

In the 1959 essay "The Meaning of Working Through the Past" Adorno insisted on the persistence of Nazism within democratic West Germany. The group experiment conducted by the Institute of Social Research had revealed a number of neurotic symptoms in Germans' relationship to the past: "defensive postures where one is not attacked, intense affects where they are hardly warranted by the situation, an absence of affect in the face of the gravest matters . . ." (*Critical Models* 90). These symptoms were also seen by Adorno as part of a larger failure of historical consciousness based in a willful denial of political responsibility (91–93). Moreover, the Nazi state could be viewed with nostalgia to the extent that it had protected the masses from the disasters of capitalism experienced in the Weimar period (95). On this point Adorno returned to Freud's theory of group psychology and collective narcissism. The narcissistic attachment to Hitler had not disappeared but continued, often taking new forms such as national identity. Whereas the nation had lost its historical substance as a political entity, nationalism remained a motivating force organizing economic goals (97–98). Adorno prescribed a working through of the past that would enable the development of a strong sense of self (102). In the 1966 essay "Education After Auschwitz" Adorno stressed the need for those who came after Auschwitz to develop self-awareness and critical self-reflection and to struggle against collective identifications. Adorno' concern was with ongoing potentially fascist identifications that continue to make Auschwitz a possibility.

Adorno's final writings on the question of Auschwitz and his turn to a philosophical understanding of trauma form the first part of his "Meditations on Metaphysics" in *Negative Dialectics*. After Auschwitz, Adorno proposed, we must resist any claim that historical time can be reconciled with transcendent truth. To do otherwise would be to attribute a false

meaning to the victims of genocide. For Adorno the senseless deaths of the victims of Nazism must not be falsely affirmed by any redemptive narrative as "actual events had shattered the basis on which speculative metaphysical thought could be reconciled with experience" (362). Mass murder by the machinery of the state had deprived the individual's life of meaning. This destruction of the individual was a consequence of "a world whose law is individual profit" (362) and cold calculation. The guilt of surviving genocide, he proposed, is so great that it may no longer be a question of writing poetry after Auschwitz as one of being able to go on living at all. Yet the shock of survival also compels the formulation of new philosophical positions. Negative dialectics is "a thinking against itself" (365), a philosophy that can only define itself through what it is unable to think. This philosophy is also driven by the imperative that Auschwitz must never be allowed to happen again. After Auschwitz culture can no longer think of itself as transcendent but must confront its basest materiality as "dog shit" (366) and "garbage" (367).

In 1967, the year following that in which Adorno reflected on the legacies of Auschwitz in *Negative Dialectics* and in his radio talk "Education After Auschwitz," Alexander and Margarete Mitscherlich published *The Inability to Mourn*, a psychological study of Germany in the postwar period. The Mitscherlichs noted the failure of Germans to acknowledge the implications of their wartime aggressions, particularly against Russia. Germans behaved as if their actions in the war had been those of a legitimate state and indeed that they were victims of an unjust settlement imposed after the war. Along with this denial of the radicalism of the Nazi past, the Mitscherlichs noted a failure to attempt to understand the rapid social change of the postwar era. Like Adorno they saw a situation in which the individual is overwhelmed by corporate power and technological capability that reduces his/her ability to engage emotionally and intellectually with the world. The Mitscherlichs followed the tradition of analysis established by Simmel and Adorno which held that modern capitalist society was characterized by ego weakness (Mitscherlich 11). The Nazi era had overcompensated for this frustration of individual ego with a narcissistic idealization of the *Volk* and a gross overestimation of its own military strength. The wounded narcissism left by the defeat by the "subhuman" enemy was covered by a renewal of a competitive work ethic.

The Mitscherlich's argument was that there was a complete failure in postwar Germany to confront the realities of the Final Solution. The responsibilities of the German people for the persecution and extermination of the Jews had been repressed. One straightforward version of this repression was to blame Hitler for everything that had happened (17). Yet the fall of Hitler was traumatic for the collective masses who had identified with him as collective ego ideal. The ego weakness that allowed identification with Hitler also allowed evasion of moral responsibility. The Mitscherlichs argued that a precondition for being able to mourn a lost object is

an ability to empathize with another (27). Germans proved incapable of empathizing with the victims of Nazism:

> Empathy is required here in relation to events the very scale of which makes empathy impossible. Thus we cannot hope to achieve total under-standing. However, there must come a gradual expanding recognition of the fact that with the Third Reich a dictatorship utterly contemptu-ous of humanity returned to the center of German civilization. This was something we hoped had been overcome, but instead it has since found imitators in many parts of the world. (Mitscherlich 67)

The emphasis that the Mitscherlichs placed on empathy distinguished them from Adorno, who had called for a more critical consciousness. Whereas both accounts of postwar Germany drew on a Freudian theory of group identity and stressed the need to 'work through' experiences of the past, Adorno took a somewhat darker view of both the psychological and ideo-logical persistence of fascism. Interestingly, whereas the Mitscherlichs called for empathy with the victim as a condition of mourning, they also acknowl-edged the limits, or impossibility, of empathy in the case of genocide. Adorno, perhaps following Benjamin's critique of empathy in "On the Con-cept of History," attempted to remain true to the alterity of what Benjamin had called the "oppressed past" (Benjamin 4: 396). The danger of empathy, Benjamin warned, was that it always translates into identification with the victors. This danger became clear in the public response in West Germany to the screening of the first television dramatization of the Holocaust.

Holocaust

The NBC television miniseries *Holocaust* was first screened in the United States in 1978 and in West Germany the following year. The series attracted large audiences but was also subject to fierce criticism, including statements by Auschwitz survivor Elie Wiesel who accused the program of transform-ing history into a soap opera (Kaes 28). Other survivors were less critical. Writing from Italy, Primo Levi commented that "Even if the film came about as a business proposition with a colossal budget, on the whole it seems to me to display good faith, decent intentions and results, a discreet respect for history . . ." (Levi 56). While finding numerous inaccuracies and inadequacies in the series as an account of the experience of the camps and their historical origins, Levi ultimately defended the television dramatiza-tion as a significant public testimony to the historical catastrophe of the Holocaust, particularly in the German context.

The series dramatized the persecution and murder of Jews in the form of Hollywood narrative realism, combining period reconstruction, docu-mentary footage and multiple narratives connecting a series of characters which included both Nazis and Jews. The screening of *Holocaust* in West

Germany coincided with ongoing trials of Nazi war criminals and was seen by over 20 million viewers. The screening of this television drama led to a further set of "media events," including extensive discussion and debate in the press and on television and public testimony by phone-in. Some commentators argued that the series had performed an important social and political function in opening up these historical events to discussion after a long period of silence and denial. Such defenses of the program, along with attacks on it as sentimentalized, kitsch, or even fascistic, both reawakened and transformed earlier debates about mass culture. To many it appeared that American populism had succeeded in enabling a working-through of the past where German high seriousness had failed. Numerous television documentaries on the Nazi genocide had attracted considerably less public attention than *Holocaust*. Others were skeptical about public outpourings of grief as forms of exhibitionism, or attacked the American production as an appropriation of German national history (Kaes 30–34).

These public responses and debates appeared to amplify and polarize the more subtle distinctions between Adorno's and the Mitscherlichs's diagnoses of postwar German psyche. Whereas Adorno had been unrelenting in his critique of the American culture industry and the commodification of social existence, the Mitscherlichs's emphasis on developing empathy with the victim lent support to voices who claimed that *Holocaust* had enabled exactly such an empathetic response. The television dramatization of the Holocaust, along with the public responses it provoked, also revealed some of the deeper tensions in Adorno's different writings on culture after Auschwitz. In particular, Adorno's comments on guilt and its unconscious effects as a traumatic limit case for philosophy appear to have been overtaken by the other logic of group conformity that he had identified in his critique of mass culture. The public confession and testimony provoked by the screening of *Holocaust* could be seen as another instance of "psychoanalysis in reverse" in which individual unconscious memory, instead of informing an ongoing working-through of the past, was transformed into an occasion for collective identification and, implicitly, relief from the guilt carried by the individual subject.

What *Holocaust* allowed, argued Andreas Huyssen, was a collective identification with the victim (*Great Divide* 99–100). It is this collective psychodynamic of empathy and identification that goes against the grain of Adorno's insistence on strengthening the individual subject. Huyssen argued that the avant-garde aesthetics favored by the cultural left, such as Brechtian estrangement, required the rejection of narrative realism and emotional identification with individual characters. The Brechtian emphasis on rational argument and analysis, he proposed, prohibited the more emotive response necessary for the working through of traumas of the past (*Great Divide* 99–108). However, Huyssen's proposal that *Holocaust* revealed the impasses in leftist aesthetics did not fully acknowledge the power of the medium of television to overshadow other cultural forms such as live theater. Nor did his characterization of leftist aesthetics as overtly

rational acknowledge Adorno's stress on the unconscious dynamics of guilt and trauma. The argument for the necessity of empathy allowed forms of identification with the victim that evaded guilt and responsibility for the Nazi past and its continuing ideological legacies.

In America, *Holocaust* attracted an estimated 120 million viewers and also prompted widespread public discussion. The size of these audiences, as Judith E. Donesan emphasizes in her discussion of *Holocaust*, is not insignificant: To watch television is to experience a feeling of collective belonging (Doneson 143–144). In America, argues Donesan, the Holocaust played a key role in redefining Jewish identity. Moreover, World War II held a particular nostalgic value for post-Vietnam America as it allowed Americans to identify with an historical scenario in which good and evil appeared relatively clearly defined. *Holocaust* offered positions of identification to American viewers that escaped the social and political divisions of post-Vietnam society. The Holocaust, as represented, also offered a master code that made equivalent various atrocities in other parts of the world, effectively providing a universalized imagery of suffering (Donesan 145–148). In America identification with the Holocaust victim allowed for another displacement of political responsibility for violence exercised by the state.

The assimilation of the Holocaust into a televisual imaginary was deeply problematic in terms of Adorno's earlier critique. Discussing a television play in the early 1950s, Adorno wrote:

> One gets the impression that totalitarian states are the result of the character defects of ambitious politicians and that their fall is due to the noblesse of the personalities with whom the public identifies. An infantile personalization of politics is being pursued here. Certainly politics in the theater can only be undertaken at the level of the individual. But in this case it would be necessary to show what totalitarian systems do to the people who live under them, instead of showing the kitsch psychology of celebrated heroes and villains, whose power and greatness the viewer is supposed to respect even when the reward for their deeds is their downfall. (*Critical Models* 63)

Many of these comments could accurately be applied to *Holocaust*, which portrayed Jewish characters as cultivated, generous, self-sacrificing and courageous, whereas Nazi brutality was shown to be rooted in personal ambition, resentment and delusions of grandeur. Because of this dependence on stereotype, *Holocaust* could only reinforce moral assumptions that were already widely accepted, whereas the unconscious desires and anxieties that led to identification with the characters remained obscure.

In the absence of Adorno as a public intellectual whose voice would no doubt have carried great authority in such debates, the provocative commentary of Jean Baudrillard on *Holocaust* read like a strange synthesis of Adorno and Marshall McLuhan. He began with the Adornoesque aphorism:

"Forgetting the extermination is part of extermination, because it is also the extermination of memory" (*Simulacra* 49). However, unlike Adorno, Baudrillard did not see the failure to confront the reality of Auschwitz as a continuation of fascist barbarism. Instead he subsumed Adorno's comments on representation after Auschwitz into a McLuhanesque analysis of television as a "cold" medium. Baudrillard ran dangerously close to suggesting that the effects of genocide and television are somehow comparable, or worse, equivalent: "Same process of forgetting, of liquidation, of extermination, same annihilation of memories and of history, same inverse, implosive radiation, same absorption without an echo, same black hole as Auschwitz" (*Simulacra* 49). For Baudrillard all debates about aesthetics, empathy and identification must include an understanding of the effects of technological media. Whereas Baudrillard would thereby reject Adorno's insistence on the importance of aesthetic questions in cultural criticism, he extended Adorno's insight that the productions of industrial mass culture are premised on the liquidation of the interiority of the individual subject, and that Auschwitz and contemporary capitalist consumer society are part of the same historical logic. However, Baudrillard also depoliticized Adorno's position by making the historical realty of the Holocaust of secondary interest to the cultural effects of visual media.

VIDEO TESTIMONY

The different responses by members of the public and critical intellectuals to the television drama *Holocaust* were shaped by on-going debates about the significance of mass culture. The approval given by many intellectuals appeared to fulfill what Adorno had argued so passionately against: "aesthetic differentiation and individuation . . . recanted in favor of a fetishized collectivism" (*Critical Models* 56). However, the contrary view to Adorno's has become the more established one in contemporary media studies. For example, television drama scholar Glen Creeber proposes that the achievement of *Holocaust* was "to translate 'the essence' of complex and difficult histories for a (primarily) American mass audience." Creeber goes on:

> If television drama has a role in such matters at all, both serials [*Roots* and *Holocaust*] are testament to the unsurpassed ability of television drama (particularly the historical miniseries) to create an "emotional" sense of reality that goes far beyond the historical limitations of a "classical" or "empiricist" rendering of the real. As such, the purpose lies not in *recreating* the past, but in *reassembling* it in such a way that it begins to take on a shape and structure almost recognizable as our own. Perhaps only then, can we ever truly begin to appreciate the humanity of the past, i.e., the fact that history happens to people not fundamentally different from ourselves. (Creeber 36)

This appeal to the universalizing of human suffering through television dramatization can help us to grasp what is at stake in trauma theory as an intervention in film and media studies. Should the traumatic experiences of others be translated into the code of media stereotypes as the basis of collective identification and emotional empathy, or does the unconscious dimension of traumatic memory, considered in Freud's and Adorno's analyses of group identity, demand that we forgo this optimism and become attentive to the disruptive alterity of the past?

The establishment in 1981 of the Fortunoff Video Archive for Holocaust Testimonies at Yale University led to new articulations of this problem with respect to representing the Holocaust. Geoffrey Hartman called the video testimonies "counter cinematic": "No theatricality or stage-managed illusions" (*Longest Shadow* 123). Hartman argued that the presence of the survivor embodied the complex relation of past events and recollection and thereby humanized the victim. On the other hand, he noted the danger that the technology of video recording imposes a sameness and sense of repetition on the individual's testimony. For Hartman the media has the potential to standardize memory and again to reproduce a mediated collective shaped by television and cinema viewing (*Longest Shadow* 91–92). Adorno had cited the example of Proust's aesthetic individuation as a counter-example to the fetishized collectives of the mass media audience (*Critical Models* 56). Hartman made similar claims by proposing that video testimony allowed for new forms of individuation:

> Memory is allowed its own space, its own flow, when the interview is conducted in a social and non-confrontational way, when the attempt to bring memories of the past into the present does not seek to elide a newer present—the milieu in which the recordings took place. (*Longest Shadow* 92)

In this way, proposed Hartman, "a temporal complexity is created very close to the dimensionality of thought itself" (92). For this reason the Yale video testimonies "cannot be collectivized" (133). Yet Hartman went on to claim that the individual testimonies repeated "the same trauma," depicted "a single event" and documented "a collective fate" (134). Indeed Hartman's discussion proceeded quite rapidly toward a rhetoric of community and shared identification:

> the insistence on personal experience in *testimony* is not meant to silence us but to record and value a collectively endured history. The authority of testimony is linked to an immediacy that reinforces rather than displaces what can be generalized. It does not come from the singularity or even extreme character of what was undergone. For injustice has a universal structure: it arouses feelings of sorrow and indignation that can be shared, even when the actual experiences cannot. (*Longest Shadow* 137)

In this passage Hartman progresses from the authenticity of testimony to a collective experience of history and then to an empathetic participation in that history. But can the experience of Nazi persecution and violence be assumed to be "collectively endured" when there is much evidence, including the testimony of Holocaust survivors, to show that the experience of oppression can perpetuate violence and isolate victims? The collectivity claimed by Hartman is premised on the basis of a willing identification with and empathy for the sufferings of the victims which comes after the fact of their destruction. In Hartman's vision of testimony the survivors speak on behalf of the dead, sometimes leading to "a confusion between different if convergent destinies" (142). The video testimonies have "a special counter-cinematic integrity" (139): unlike narrative realism nothing is artificial; unlike a documentary there is no narrative voice-over directing the interpretation of events; unlike archival images the events are not consigned to the past. In the video testimony "there is nothing between us and the survivor" (140). Hartman's evocation of unmediated presence also ignores the multiple and complex ways that even unedited verbal testimony can be constructed as a textual form.[2] Lawrence Langer makes similar claims in his detailed study *Holocaust Testimonies* (1991): "Nothing . . . distracts us from the immediacy and the intimacy of conducting interviews with former victims . . . and watching them on a screen" (xiii).

LaCapra has commented on the dangers of survivor testimony allowing the viewer to identify with the victim or use his/her suffering as the basis for group identity. He notes that "videos may present in an especially powerful form the temptation of extreme identification" ("Holocaust Testimonies" 218). In response to claims for the immediacy and authenticity of video testimony Oren Baruch Stier has inquired into the interpretive and representational frames used to construct the speaker in video testimony. These frames include role play, interviewing strategies, camera techniques and institutional contexts (Stier 70–71). Yet Stier concludes that the video medium does effectively "lead us back to a more solid and grounded sense of the presence of the past and to a clear feeling for the importance and relevance of Holocaust memory" (108) and that "the making of memory is an ongoing collective, communal and cultural process" (109). Stier's discussion also draws attention to the packaging and promotion of Holocaust video testimony for educational use in schools and in television documentaries, books and CD ROMs (103–106). Yet he does not question the promotion of the Holocaust as the 'privileged instance' of racist persecution and political violence in the twentieth century. One inevitable effect of this level of publicizing of the Holocaust must be that various social groups who identify with other histories of violence may feel under-represented or socially excluded.

Hartman looks to video testimony for a special communion between the survivor and the witness, between the living and the dead, that shares many qualities with a religious community. In his and others' commentaries on

these videos there is an emphasis on intimacy, immediacy and identification and yet a repeated insistence also on the alterity of the survivors' experiences. This rhetorical construction of the videos' significance fosters a community of identification while also communicating a sense of exclusivity based on the extreme nature of certain historical experiences. However, Hartman does propose similar projects could be undertaken for other groups such as Vietnam veterans, African Americans, Native Americans or the survivors of war in Bosnia (143). So whereas much of Hartman's argument is based on a critique of media representations eroding a sense of historical reality—including *Holocaust* as a "sanitized and distorted" (21) version of the past—his validation of video testimonies as a more authentic and less mediated form stresses emotional identification and community in ways that invite comparisons with earlier validations of *Holocaust* itself. Whereas West German intellectuals saw the popular reception of *Holocaust* as a challenge to avant-garde aesthetics and modernist criticism, Hartman and others hold up video testimony as a complex form and an authentic alternative to commercial media.[3] Both responses are rooted in earlier debates about Modernist aesthetics and mass culture. The *Holocaust* debate anticipated the populist ethos of much postmodern culture and criticism. With the wane of postmodernism, video testimony and trauma theory offer a new historical authority. What both the writings on video testimony and the defenses of *Holocaust* have in common is a desire to articulate a sense of community and common purpose around traumatic experiences of the past and in so doing both implicitly acknowledge an absence of other images and narratives around which political solidarity and cultural value might be advanced.

Hartman comments that "information technology can infiltrate and mediate everything, so that our search for authentic or unmediated experience becomes more crucial and desperate" (91). This may be so. However, we need to ask why we should be so desperate to locate an authentic or unmediated experience located in the past and what the implications this may have for the articulation of identity. Baudrillard took a position that is directly contrary to Hartman's. For Baudrillard any such search for authentic or unmediated experience was futile:

> Auschwitz can be reactivated, recollected in terms of archives, made a museum piece, presented for consumption in an un-present that is ours, in which everything passes into the instantaneousness of real time, dissolves in that instantaneousness. That is our fate. (*Paroxysm* 29)

Baudrillard proposed that "the mirror-stage has given way to the video-stage" (*Paroxysm* 50). The very possibility of identification is replaced by the real time of electronic media which "is our mode of extermination today" (30). This deliberately provocative comparison of media culture with the Final Solution nevertheless resembles Hartman's own account of

the progressive eradication of authentic experience and memory. Baudrillard did concede that the testimonies of survivors have an authentic relation to the event via information technology. But he saw any attempt in contemporary culture to recover this authenticity by way of media technology as both inherently distancing and sanctioning it, thereby removing its capacity to convey its traumatic force (*Paroxysm* 30).

TESTIMONY AND DECONSTRUCTION

The engagement of deconstructive theory with trauma and media representation itself has a complex history. In the 1960s psychiatric studies by Henry Krystal and William Niederland had argued for the need to revise Freud's earlier theory of traumatic neurosis. The availability of new studies, including those of concentration camp survivors, showed that symptoms of trauma could persist in an individual over long periods of time and were often characterized by periods of latency (Krystal 31–32). The first important study by a literary critic, *The Survivor* (1976) by Terence Des Pres, helped to establish testimony as a significant object of analysis and commentary. Des Pres presented an early articulation of the survivor as a culture hero inviting empathy and identification. He offered the following definition of this figure:

> The survivor-as-witness . . . embodies a socio-historical process founded not upon the desire for justice (what can justice mean when genocide is the issue?), but upon the involvement of all human beings in common care for life and the future. (Des Pres 47)

According to this account a universalized ethical imperative of witnessing is more important than specific political contexts that determine struggles for social justice. Bearing witness to "objective conditions of evil" (49), the survivor embodies a particular "wisdom" which "carries a terrible price" (47). For this reason, proposed Des Pres, the value of the survivor belongs to the moral conscience of the collective.

Similar arguments were advanced in Lawrence Langer's *The Age of Atrocity* (1978), which discussed the literature of testimony as providing "a new idea of tragedy, anchored in chaos rather than order and granting to the humiliation of the body a priority once reserved for the dignity of man's moral nature" (*Age of Atrocity* 2). The survivor of totalitarian violence and persecution was presented by Langer as a new kind of culture hero who teaches the crucial moral lessons for our era. This moral interpretation of the survivor was subsequently aligned by Langer with accounts of the specific nature of survivor's memory, particularly traumatic memory. In *Holocaust Testimonies* (1991) Langer wrote of survivors who in their attempt to begin a new life had to separate themselves from the horrors

of the past, which nevertheless persisted in the form of "deep memory." Langer borrowed this term from Charlotte Delbo, who had described the return of her memories of Auschwitz in terms of an intense physical pain that she contrasted with the intellectual, reflective part of her memory (Langer 5–7). Delbo explained how surviving the traumatic experiences of the camps required a splitting of the self giving rise to a discontinuous sense of time. The earlier self had "died" and yet lived on as the ghostly double of the survivor's new identity. Langer proposed that what he calls "common memory" (6)—the conscious and deliberate express attempt to narrate the past—is disturbed and disrupted by the intrusive force of deep memory. This theory of individual memory based on the experience of the camps was soon assimilated into a more general cultural theory. In the early 1990s Saul Friedlander asked whether the Holocaust may have left "traces of a deep memory beyond human recall, which will defy any attempts to give it meaning" (Friedlander 119). On this point Friedlander cited Caruth's propositions about the inaccessibility and latency of traumatic memory. For Friedlander even the "working-through" of the past may never fully dispel the deep wounds left by the Nazi genocide.

Without seeking to question the validity of psychotherapeutic research with Holocaust survivors, or the authenticity of their testimony, we may nevertheless question the significance that this testimony has sometimes assumed in contemporary cultural theory. The impulse to protect the historical experience of the Holocaust from inadequate or appropriative media representations has lent support to a deconstructive critique of representation in which historical truth can only be made accessible through the absences, aporias and disruptions of narrative flow. Both Felman's and Caruth's criticism extends the literary theory of Paul De Man into new therapeutic and historical contexts. The "scandals" that pursued Heidegger's and DeMan's relations to Nazism were one form in which the problem of historical responsibility was raised for deconstruction.[4] Felman and Caruth can be seen as responding to this problem by drawing directly on psychotherapeutic research on trauma in an attempt to anchor representation in historical experience.

Caruth suggests that the problem of trauma takes us to a threshold where the very possibility of identifying a traumatic event or memory is thrown into question. However, whereas a DeManian reading might have reflected on the interplay of blindness and insight in trauma theory by paying scrupulous attention to its rhetorical tropes, Caruth places the DeManian suspension of linguistic reference on the side of experience itself. Caruth transforms De Man's "theory of the impossibility of theory" (De Man 19) into a consideration of the ways that "trauma opens up and challenges us to a new kind of listening, the witnessing, precisely, of *impossibility*" (*Trauma* 10). Impossibility now lies not only in the ultimate incapacity of language to refer to the world (and therefore implicitly with the problem of articulating experience) but with traumatic experience which remains

"outside" language. Caruth thereby posits an equation of historical truth with an extra-linguistic reality. As in De Man, 'the real' is invoked in terms of absence and inaccessibility, yet for Caruth it is also experienced with an intensity that leaves it unavailable to representation:

> It is this literality and its insistent return which thus constitutes trauma and points toward its enigmatic core: the delay or incompletion in knowing, or even in seeing, an overwhelming occurrence that then remains, in its insistent return, absolutely *true* to the event. (*Trauma* 5)

This absolute truth appears to be removed not only from conscious memory but from the often confusing world of representations that proliferate in an increasingly mediated world. Interestingly, at the moment when Caruth positions traumatic memory outside language her argument recalls the structure of Barthes's analysis of the photograph as a material trace of the real that served both to anchor and exceed the visual codes and conventions by which it was deciphered. The traumatic "core" of memory could similarly be seen to establish for Caruth an indelible trace of the real. But unlike Barthes, and Benjamin before him, Caruth neglects to position her argument with reference to the historical context of contemporary media. Indeed in her attempt to directly address the question of history, Caruth can be seen as unwittingly gesturing toward problems of modern media already excluded from De Manian deconstruction. For both Barthes and Benjamin the photograph was understood as both a screen against shock *and* the trace of a traumatic reality. We need to read Caruth according to such a logic: her theorization of trauma as literal trace both invokes a truth "outside" of representation while suggesting visual media's modes of recording and repeating events. In this way Caruth's trauma theory, insofar as it dissociates itself from some of the most prominent forms of contemporary culture, appears to be bound to an uncanny repetition of media theory. Perhaps for this reason her work has been adapted by scholars such as Cadava, Baer and Hirsch. Caruth's alignment of De Manian referential "impossibility" with traumatic experience also distinguishes her approach from Derrida, who has explicitly addressed the question of media technologies in several texts.[5]

In *Testimony*, Laub considered the problems of bearing witness to a massive trauma as "an event that has not yet come into existence, in spite of the overwhelming and compelling nature of the reality of its occurrence" (Laub 57). The testimony is "not simply a factual given that is reproduced and replicated by the testifier" but "an event in its own right" (62).[6] But whereas Laub emphasized the inability to witness the traumatic event based in the collapse of inter subjective relations in the concentration camps,[7] Caruth cites Laub in order to support her thesis about the immediacy of the event that destroys the capacity to witness it (*Trauma* 7). Laub argues, drawing on psychotherapeutic experience, that trauma needs to be witnessed in

order to be brought into consciousness and thereby into society and history. Witnessing, then, is the social mediation of memory. Caruth, on the other hand, by insisting on the immediacy and the literality of the traumatic imprint emphasizes the inherent dislocatedness of the event and its unsettling of historical reference. Caruth thereby incorporates the ethics of witnessing into a metalinguistic theory of history. The problem with Caruth's argument, however, is that attention to questions of linguistic structure ultimately makes *all* experience inaccessible, insofar as experience is only available indirectly by way of testimony, witnessing, therapy, interpersonal relationships, documentation or communication media; in short, insofar as it is only available as a linguistic event of some kind.[8]

SHOAH OR *SCHINDLER'S LIST*?

Preoccupation with testimony and witnessing is not unique to literary theory but is characteristic of broader cultural tends. Thomas Elsaesser proposes that "No longer is storytelling the culture's meaning-making response; an activity close to therapeutic practice has taken over, with acts of re-telling, re-remembering, and repeating all pointing in the direction of obsession, fantasy, trauma" ("Subject Positions" 146). This repetitive structure, argues Elsaesser, has its most prominent contemporary form in television. The television dramatization of the Holocaust belongs to a series of catastrophic events that have established a new televisual memory system—amongst them the Kennedy assassination, the Vietnam war, the death of Lady Diana Spencer, and the September 11 attacks. Public responses to, and critical debates surrounding, such media representations as *Holocaust* and *Schindler's List* have themselves become media events. Elsaesser proposes that these media events create subject positions through which different identifications (national, ethnic, sexual, ideological, etc.) can be made with an imagined past. In this way media representations become important sites through which individuals attempt to situate themselves in historic narratives, albeit in quasi-therapeutic modes ("Subject Positions" 167). Further, in a trauma culture even the film director is deprived the strategies of modernist irony or disdain for mass culture and is instead drawn into the public arena of media promotion and controversy (175). These subject positions play a significant part in a politics of mourning. When one considers the legacy of guilt faced by postwar Germans and the dangers in representing their past, it helps us understand the apparent eagerness with which the German public welcomed an American dramatization of the Holocaust. It is in this context, argues Elsaesser, that we need to consider the complex problems posed by Spielberg's *Schindler's List*.

Representations of the Holocaust cannot be evaluated only with reference to the authentic testimony of survivors. For the survivor too, I have argued, has been constructed as a privileged source of truth in contrast to

mass media representations. Alert to these issues, Miriam Hansen reads the controversies surrounding *Schindler's List* as symptomatic of the more general relationship of intellectuals to mass culture. The critical response to the film often replayed aspects of the modernist critique of the culture industry and realist representation. Claude Lanzmann, director of *Shoah*, went further in his critique by raising the whole issue of representing the unrepresentable. However, Hansen argues that to contrast *Shoah* to *Schindler's List* in terms of a choice between showing and not showing creates a false perception of what is at stake in these different approaches to questions of representation. Hansen goes on to argue that Spielberg's film is more self-conscious and self-reflexive than many critics of the film have allowed ("*Schindler's List*" 301–303). Attempting to move beyond what she sees as a sterile polarity between modernist aesthetics and mass culture representations, Hansen suggests alternative approaches:

> We need to understand the place of *Schindler's List* in the contemporary culture of memory and memorializing; and the film in turn may help us to understand that culture. This might also shed light on how the popular American fascination with the Holocaust may function as a screen memory (*Deckerinnerung*) in the Freudian sense, covering up a traumatic event—another traumatic event—that cannot be approached directly. ("*Schindler's List*" 310–311)

Hansen goes on to suggest that this other traumatic event could be the Vietnam War or the genocide of Native Americans. Arguments about the limits of representation, then, may in fact function as displacements of deeper anxieties about political identity.

In her long essay on *Shoah*, Felman gives an account of witnessing as the transmission of historical experience. Given the massive destruction by the Nazis of the evidence of their crimes, she argues, bearing witness to the Holocaust becomes an ethical imperative. Felman describes the Nazi concealment of the Final Solution as creating a "proof less event" and she presents *Shoah* as evidence of "the radical impossibility of testimony" (227). For Felman, Lanzmann's film is characterized by a refusal to provide a narrative account of the Holocaust and instead reverts to strategies of silence and listening on the part of the filmmaker, thereby bearing witness to the gaps, silences and evasions that characterize traumatic memory. Such an understanding of bearing witness to trauma leads Felman to engage in her own interpretations of the verbal testimony and body language of the survivors and witnesses who appear in *Shoah*.

Felman's reading of *Shoah* continually returns to the impossibility of representing the Holocaust and the impossibility of witnessing the events of the Final Solution. However, she concludes her long essay with an evocation of the song sung by Simon Srebnik, who had been forced as a thirteen-year-old boy to burn bodies for the Nazis in a field outside the Polish village

of Chelmno and who survived his own attempted execution by the Nazis. Lanzmann filmed Srebnik singing the song he sang as he worked in the fields burying the dead (and sometimes still living) victims of the Nazi gas vans. For Felman, Srebnik's song enacts a return of the dead and becomes a redemptive moment in the film where an impossible history can be witnessed. Felman proposes that the return in *Shoah* of Srebnik to Chelmno and the eyewitness accounts of the Polish villagers allowed the silence of the dead to speak "from within and from around the false witness" (266) of the Poles.

For LaCapra, Felman's insistence on the paradoxical nature of traumatic memory as historical reference functions itself as a compulsive inflation of the singularity of *Shoah* as a cinematic event. That is, instead of working-through the historical problems posed by the film, Felman's interpretation acts out her own identification with the filmmaker and the victims. LaCapra sees in both Lanzmann's film and Felman's essay a danger of sacralizing the Holocaust. He finds it difficult to countenance what he sees as Lanzmann's willingness to once again traumatize survivors in his quest to show their reliving of the traumatic past (*History and Memory* 111). As LaCapra points out, the insistence on presence, immediacy, intimacy and authenticity in film or video testimony conceals a more primary desire for identification with the victim and thereby for the image of the victim which serves a myth of political community.

Neither Felman nor LaCapra consider the extent to which *Shoah*'s quest for historical authenticity by way of audiovisual recording of testimony could be understood as a response to the prominence of visual media in contemporary culture. That is, *Shoah* attempted to do what all other dramatizations of, or documentaries about, the Holocaust could not do—escape their complicity in a general logic of exchange that defines the proliferation and circulation of images in contemporary media culture. The tendencies by Lanzmann and Felman toward identification with the victim reveal how *Shoah* must inevitably be reinscribed within this economy of circulation, exchange and profit. The images and verbal testimony in *Shoah* are themselves subject to preservation in archive, citation in other texts and transformations of meaning through their ongoing displacement in time and space.

Thus Michael Rothberg is correct to point out that both *Shoah* and *Schindler's List* participate in different ways in a desire to resurrect 'the real' in a direct and immediate way. Rothberg attempts to move beyond the realist/modernist, or realist/anti-realist opposition suggested by Lanzmann's response to Spielberg, and proposes his own third term, "traumatic realism," as an alternative to this binary. For Rothberg traumatic realism both remains bound to realism's quest to ground representation in material evidence, while acknowledging that traumatic memory radically disrupts and throws into question any simple mimetic notion of representation. Rothberg acknowledges that "the desire for realism and referentiality" along with "a commitment to documentation and realistic discourse"

(99) have become almost sacred positions in the study of the Holocaust. He argues that despite the influence of post-structuralism and the association of narrative realism with reinscriptions of ideology, realism needs to be recovered in a new "traumatic" sense. Film scholars Janet Walker and Joshua Hirsch pursue similar directions to Rothberg. Walker uses the indexical relation of film and video image to 'the real' as a basis for communicating individual experiences of trauma to a larger public (Walker xix). Hirsch discusses examples of what he calls a "post-traumatic cinema" that "not only represents traumatic historical events, but also attempts to embody and reproduce the trauma for the spectator" (Hirsch xi). The purpose of this post-traumatic cinema is to enable the viewer "to encounter the Holocaust in the deepest possible sense" (xi).

Hirsch discusses Alain Resnais's *Night and Fog* (1955) as an example of post-traumatic cinema that incorporates elements of expository documentary along with Brechtian alienation effects and elements of Modernist poetics. He interprets Resnais's modernism as a response to the difficulties of representing the extreme experiences of World War II (Resnais also later directed *Hiroshima, mon amour* [1959]). Resnais rejected classical linear narrative and incorporated poetic voice-over, a modernist music score and juxtapositions of contemporary color footage of empty camps with "flashbacks" using archival footage and still photographs. Explicit attention to questions of time and memory in *Night and Fog* appears to suit the notion of a post-traumatic cinema. However, Hirsch's interpretation runs the danger of imposing a specific theory of memory—Post Traumatic Stress Disorder, as inflected through Caruth's trauma theory—onto a Modernist film. For example, Hirsch compares the black-and-white sequences in *Night and Fog* to the "involuntary, hallucinatory repetitions" (53) of PTSD. In this way he suggests an analogy between the supposed literal nature of both the traumatic memory and the photograph or film image. Resnais and screen writer (and camp survivor) Jean Cayrol doubtless understood the traumatic nature of the experience of the camps and also the ultimate inadequacy of images to represent those experiences. Yet an attention to the more general issues of historical trauma may be more appropriate to understanding this film than the very specific theory of PTSD, which was not coined until later decades. Hirsch's theory of post-traumatic cinema potentially narrows interpretation of *Night and Fog* by attempting to bind its formal strategies to a clinical theory of memory. It may be more useful to think of *Night and Fog* an open-ended, experimental response to the challenges of representing a history of extreme violence and unprecedented human catastrophe.

HISTOIRE(S) DU CINEMA

The limits of Hirsch's approach can be appreciated if we apply it to Godard's *Histoire(s) du Cinema*, which also used techniques such as experimental

montage, fragments of Modernist music and a poetic voice-over to represent the period of World War II and the Holocaust. Godard's film cannot be positioned within the frame of trauma and witnessing that shapes Hirsch's discussion of *Night and Fog*, which was based on the direct experience of the historical events shown. However, Godard's use of fragmentation, repetition and shock owes much to the Modernist representation of trauma pioneered by Resnais. Indeed, as Hirsch comments, *Night and Fog* and *Hiroshima, mon amour* are seen as founding works of the French New Wave from which Godard's work originates. I propose that Hirsch's model of the transmission of traumatic experience through cinematic form tells us little about Godard's film. Instead an understanding of historical trauma—whose precedents are found in earlier texts by Adorno and Benjamin—best illuminates Godard's complex film.

Whereas Godard publicly criticized *Shoah* for its absence of archival footage, Libby Saxton argues that Godard's and Lanzmann's films also have much in common:

> both Godard and Lanzmann have courted controversy by creating resistant, challenging, provocative films which reflect directly on the ethics of representation. Both have abandoned narrativity to explore cinema as a way of rethinking time, memory and history when fractured by atrocity. For both, moreover, the moving image remains a privileged witness to the alterity of historical trauma, capable of producing ethical moments where self-conscious fiction collides with the shock of the real. (Saxton 46)

Both Godard and Lanzmann reject conventional forms of mainstream cinema as inadequate to representing the Holocaust. As Saxton points out, both are also preoccupied with the failure of film as a medium to document the reality of the camps and the implicit role of the Nazi apparatus in both falsifying and eliminating documentation (48). Thus, despite Godard's attention to fantasy and visual spectacle (completely absent from *Shoah*), he remains committed at another level to a realist aesthetic. For Godard the archival image offers a testimony to historical reality in the face of the dominant forms of the medium.

Georges Didi-Huberman argues for the continued importance of analyzing archival images of Auschwitz and suggests that Lanzmann's refusal to engage with them has resulted in a dogmatic and inflexible position (Didi-Huberman 92–93). *Shoah* has assumed the status of an exceptional film that derives its singular authority from the uniqueness of the Holocaust. As an alternative to Lanzmann's absolutist position upholding testimony over the archival image, Didi-Huberman argues for the necessity of montage. For Didi-Huberman there is no archival image that can provide a pure reflection of an event because images always appear in the context of other images and texts and their meanings can only emerge from a specific construction composed of these different sources.

Didi-Huberman makes claims for "the fertility of *knowledge through montage*" but he cautions that "it is valuable when it opens up our apprehension of history and makes it more complex, not when it falsely schematizes" (121). He compares Lanzmann's use of montage in *Shoah* with Godard's in *Histoire(s) du Cinema* and comments that whereas Lanzmann places a ban on archival images Godard sees *all* images as having the potential to reveal historical truth:

> Jean-Luc Godard, in *Histoire(s) du Cinema*, chooses to *show* cinema itself and its own reminiscence through a *montage* totally organized around the economy of the *symptom*: accidents, shocks, images collapsing one on top of the other allow something to escape that is not *seen* in any one fragment of film but *appears*, differentially, with the force of a generalized haunting memory. (Didi-Huberman 134)

Montage, he argues, has the capacity to intensify and transform the impact of the image by bringing together disparate materials into unlikely and unpredictable juxtapositions. Discussing the *Histoire(s) du Cinema* series with Youssef Ishaghpour, Godard cites Benjamin's image of the constellation in which "there is a resonance between the present and the past" including "the visible and the invisible, and then within that locating through the traces that exist of them, other constellations" (Godard 7). Explaining the mix of words and images in the video text, Godard comments on the practice of montage: "eventually the text, when the time comes, springs from the images, so there's no longer this simple relationship of illustration, and that makes it possible to exercise your capacity to think and reflect and imagine, to create" (11).

Whereas Godard's montage aesthetic has an obvious precedent in Benjamin's *Arcades Project*, Lazmann's aesthetics would appear closer to Adorno's. Hansen, however, has explained that Adorno's various writings on film often return to the problem of the apparent grounding of the image in 'the real,' leading to claims for its unmediated presentation of empirical reality (Hansen, "Mass Culture" 44). For Adorno this immediacy of the image had the ideological effect of advocating acceptance of the world as it appears, rather than as it might be redeemed by, for example, aesthetic experience or political progress. The emphasis on the objective nature of the world undercuts both subjective experience and collective agency (Adorno, "Transparencies" 157). Against this tendency of film toward realist illusionism, Adorno saw montage as remaining an important alternative. Rather than creating the illusion of reproducing the object world, film juxtaposes images and "arranges them in a constellation akin to that of writing" (158). However, Adorno warned that the principle of shock is not in itself adequate for montage to be effective and that interpretation cannot be left entirely to the audience. The filmmaker must take responsibility for the arrangement of images.

As Saxton has shown, both Godard and Lanzmann pursue a redemptive idea of the cinema or video image. Both, in different ways, seek to make

the image give testimony to the historical real. But there is another way to understand the differences between their two approaches. If we return to Benjamin's formulation that the true image of the past must be appropriated as it "flashes up at a moment of danger," then we are returned to the moment or act of appropriation and interpretation as the crux of these debates. There can be no selection or reproduction of any image, nor any interpretation of that image, or any identification with an image, without a certain appropriation. The stakes of historical truth, Benjamin warns us, lie in the politics of this appropriation. All debates over whether or how an image may give direct access to 'the real' or give testimony to 'the real in its absence' can be understood as different kinds of rhetorical attempts to ground an interpretation or an impulse of identification with reference to some idea of authenticity, and thereby lend that appeal some moral, political or ethical authority. The impact of Lanzmann's important film depends not only on the authenticity of the historical testimony that it presents but also on the appropriation of that testimony by the filmmaker *and* interpretations made by viewers. The solicitation, selection and juxtaposition of testimony that is re-presented in *Shoah* constitutes a significant and provocative appropriation of historical evidence mobilized into a deeply emotive and disturbing statement by the filmmaker.

If we return to Adorno's insight that images can function as projections in the manner of a traumatic neurosis, and yet these images may nevertheless reveal an historical truth, despite the intention of those who reproduce them, or identify with them, then there is nothing singular or unique about the case of representations of Auschwitz. What Adorno proposed was that Auschwitz constituted an historical threshold, the catastrophic realization of certain tendencies within modernity, from which there could be no simple retreat and for which there could be no simple redemption. The philosophical and political implications of this trauma applied not only to the relationship of postwar society to the historical actuality of Auschwitz, but implicitly to the production of any and all representations, because representations are produced within an economy of exchange and calculation that itself informed the violence of the Nazi state at a fundamental level.

IMAGE: THE MAN AT THE FENCE

I conclude this chapter by discussing in detail a specific appropriation of an image of Auschwitz survivors waiting to greet their liberators at the barbed wire fences of the camp. Joshua Hirsch writes of the impact of the first images of the concentration camps on Western consciousness. They showed "bodies and faces apparently stripped of everything that the Western imagination associates with meaningful human existence" (Hirsch 14). He goes on to position this shock with respect to a post-traumatic cinema that can transmit and reproduce trauma in others. I propose that rather than trying

to demonstrate this transmission, it may be more useful to understand the revelation of the camps as an historical trauma related to what Agamben calls "bare life," or to the philosophical shock articulated by Adorno in *Negative Dialectics*. Neither Agamben nor Adorno attempted to link this shock to an indexical theory of the image that underlies Hirsch's notion of a post-traumatic cinema.

Like others who have grappled with issues of representing the Holocaust, in *Histoire(s) du Cinema* Godard appears obsessed with film's ability to bear witness to the reality of the camps. At various moments in his film Godard incorporates archival images of the Holocaust. One image in particular, of a man staring at the camera, can help bring into focus the stakes of Godard's montage history. The image is taken from a film showing survivor inmates of Auschwitz standing along a barbed-wire fence, many huddled in blankets or wearing striped prisoner uniforms. Stills taken from this film are among the most often reproduced images of the Holocaust. The footage was shot by Soviet cameramen in May 1945, three months after the liberation of Auschwitz by the Red Army on January 27. Selections from the original reels can be seen in a documentary called *The Liberation of Auschwitz*, one of a series of films on the Holocaust released on DVD by Pegasus Entertainment. The presentation of *The Liberation of Auschwitz* follows the form of expository documentary explaining the organization of the camp and narrating the events subsequent to its liberation. The film includes the testimony of Captain Alexander Vorontsov as an older man, the only surviving member of the Soviet camera crew, who says of the experience of filming at Auschwitz: "Time has had no power over these memories of mine. It has not erased the horror of what I saw and recorded." The fact that today these images can be openly circulated through commercial modes of distribution gives question as to whether such a traumatic experience is relayed to those who see the images today.

The image of the man at the fence has become an iconic image of the Holocaust and Godard uses it in the context of other iconic images. In the larger sequence of which it forms a part Godard juxtaposes newsreels of German soldiers invading France with shots of Siegfried on horseback from Fritz Lang's *Die Nibelungen*. In this sequence Godard evokes Wagnerian, mythic imagery that was appropriated for the purposes of Nazi ideology. Across the image of the man at the fence is written in capitals: "CINEMA OF THE DEVIL." The image is preceded by an image from Lang's *Dr. Mabuse* and followed by an image of Hitler on a train, laughing with various associates (including Herman Goering). The entire sequence recalls Siegfried Kracauer's argument in *From Caligari to Hitler* (1947), that Weimar cinema anticipated Hitler's Germany. The inclusion of the image of the man at the fence, however, extends this interpretation to include Auschwitz as part of the imagery of the Nazi state and, more generally, German cinema. The documentary images of Auschwitz, Hitler and invading German troops are interspersed with sequences from Lang and

Fassbinder (*Lili Marlene*). Another image, that follows soon after, features slave children from Lang's *Metropolis*, further evoking (whether intentionally or not) documentary images (which Godard does not include) of survivor children after the liberation of Auschwitz. The rapidly changing sequence of images juxtaposed with written captions, voice over by Godard and samples of music and movie soundtracks, creates a rich and sometimes overwhelming effect. The incorporation of the documentary image of the camp survivor into a larger set of cinematic imagery suggests that however we interpret the image of the man at the fence, he is a part of a dream-like series of images, caught in a logic of association, rather than of reference, or straight testimony, to fact. Auschwitz, Godard's film suggests, has become what Benjamin called a dream image of mass culture. More specifically, in this sequence from Godard's film, Auschwitz appears to serve as an image of Hell.

The longer section of Godard's film dealing with World War II and the Holocaust, of which this particular sequence forms a part, also includes the commentary: "1940–41 One insignificant 35mm frame, terminally scratched, saves the honor of the real world." The image shows corpses in what looks like a state of decomposition. The commentary suggests the important role that Godard sees the cinema playing as witness to the Holocaust. There is also a later sequence which mentions and shows the first color footage of the camps shot by director George Stevens. The image of the man at the fence is not accompanied by commentary about its original production by a Soviet camera crew. Instead the image is positioned between Dr. Mabuse and Hitler. Like Benjamin's dialectical images, Godard's montage produces a space where history and myth converge. Over the image of Hitler, Godard superimposes an image of a man firing a rifle. The relationship between the Auschwitz survivor and the following image sequence of Hitler's (virtual) assassination suggests a simple wish for revenge against the individual ultimately most responsible for the Final Solution.

These image sequences can be seen as following a different logic than that of narrative cause-and-effect (Hitler caused the Final Solution in turn provoking a desire for retribution). The image of Hitler and the man at the fence can also be interpreted in terms of structures of sovereign power. Agamben has discussed what he calls the "symmetry between the body of the sovereign and that of *homo sacer*" (*Homo Sacer* 102). If we see Hitler as an image of absolute sovereign power, granted through a state of emergency declared in February 1933, then the concentration camp inmate constitutes the ultimate object of this political power. Agamben explains that just as the killing of *homo sacer* does not constitute homicide, "there is no juridical-political order . . . in which the killing of the sovereign is classified simply as an act of homicide" (102). The symmetry between Hitler and the man at the fence lies in their embodiment of the structures of sovereign power and political violence. Hitler cannot be killed, and the man remains captive behind the boundary of the barbed-wire fence. In

this sense the man at the fence can be understood as an iconic image of the new, extreme mutation of biopolitical power represented by the concentration camp. As Agamben comments, the French Revolution achieved an earlier transformation of sovereign power by putting the king on trial before executing him. His execution in turn legitimized mass executions by guillotine. Between the execution of the king and the concentration camp emerged a modern state with the technological capability for genocide. Perhaps Godard instinctively combines images in ways that manifest unconscious political structures. Certainly he deliberately works at the level of myth. As he comments in the voice-over to *Histoire(s) du Cinema*: "The masses love myths and cinema addresses the masses."

However, questions of intention may be less important in this case than the effects of contextualizing archival footage as part of a more general economy of the image. Hirsch, Didi-Huberman and Godard all appeal to different examples of archival footage that transmit or testify to the historical actuality of the Holocaust.[9] Agamben himself also discusses the significance of a few images of the *Musselmann* in an English film shot after the liberation of Bergen-Belsen (*Remnants* 50). Behind the image of the man at the fence, however, lies another interesting story. These particular images of Auschwitz survivors have been reproduced countless times. The original footage appears to have been shot on May 7, 1945. On that day Soviet cameramen staged a "recreation" of the liberation of Auschwitz in which inmates crowded at the gates of the camp cheering and embracing their liberators. The man at the fence was part of a propaganda exercise. The film was never shown because the crew who shot it felt it to be such a falsification of the reality of the actual circumstances of liberation.

When the Red Army arrived at Auschwitz Birkenau on January 27 they found the vast industrial plant of IG Farben covered in snow and apparently empty of people. The SS had evacuated the camp ten days earlier, cutting power and heating. Initially the Soviet film crew were unable to film inside the barracks as they were too dark and there was no source of electric light. As the snow thawed over subsequent weeks the horrors of the camp were gradually revealed and the survivors were fed and given medical assistance. Images of survivors standing at the barbed-wire fence were shot more than three months after the liberation, so the physical state of the prisoners in the pictures does not accurately reflect their state under SS jurisdiction. The actual liberation of Auschwitz was nothing like the liberation the Soviets attempted to portray after the event. Nor was the discovery of the camp traumatic in the sense that it would be when it its realities were more fully uncovered. Each moment constituted what Lacan calls a missed encounter with the real. Beyond the atrocious sufferings of its victims, the trauma of Auschwitz is historical: its traumatic nature is not transmitted directly through testimony or archival images but emerges between images and events, themselves never properly traumatic, but distorted by fantasy, staged for the camera or shrouded in darkness and snow.

This image of the Auschwitz survivor is not authentic in the way most who see it probably assume (it appears inmates have come to the fence to greet their liberators). It does not suit Hirsch's notion of a post-traumatic cinema because the image does not register the trauma of the camp in a direct, but in a belated, sense. The image does not transmit a traumatic shock, but rather survives as part of a collective memory shaped by media representations that usually served some political interests—whether Nazi, Soviet or Allied. Nevertheless, the man at the fence stares back at us, challenging us to witness his suffering, a challenge we can never adequately meet. Godard's montage presents a constellation that includes archival documentary images as well as images from Hollywood and European cinema, all of which participate in the modern mythologies of mass culture. He does not oppose a post-traumatic realism to the narrative realism of Hollywood, but incorporates both into a representation of historical trauma. His representation of this historical trauma does not attempt to ground itself ultimately in empirical reality, or in the reality of traumatic experience. It can only reveal the traumatic past in the context of structures of power and a collective imaginary shaped by modern mass media.

6 Virtual Trauma
After 9/11

Since the terrorist attacks of September 11, 2001, the notion of collectively experienced trauma has taken on a new significance. Prior to these events psychotherapeutic work with Holocaust survivors had shown that traumatic experiences can have lifelong consequences, their effects possibly even extending across generations. As I discussed in Chapter 5, study of the transmission of trauma has been extended to audio-visual media in the work of several critics, including Shoshana Felman, Geoffrey Hartman and Joshua Hirsch. It was claimed after 9/11 that potentially all Americans and everyone in Western societies experienced a traumatic shock. The idea of collective trauma now became more closely bound to the imagined community of the nation and to the role of mass media in defining the experience of that community. Precedents for 9/11 as a mass-mediated American event included the assassination of John F. Kennedy, the explosion of the Challenger space shuttle and television coverage of the Vietnam War. Each of these events gave rise to occasions for public mourning. After 9/11 the media went a step further, as "most newspapers and television stations labeled the event a national trauma without hesitation or explanation" (Trimarco and Depret 30). This therapeutic interpretation assigned the public the role of passive victim and thereby implicitly denied the possibility of political agency in response to the events (Furedi 16).

In the previous chapter I argued that claims for the special status of particular Holocaust representations supported forms of collective identification that were not adequately acknowledged in theoretical and critical texts. I also contrasted these claims with arguments by earlier theorists such as Adorno, who repudiated the image as a literal representation of reality and who persistently criticized group identity as regressive. After 9/11 media images of the catastrophe played a central role in attempts to redefine American identity. Binaries that seemed to belong to an earlier era, such as us and them, civilized and barbaric, freedom and intolerance, were reactivated in public discourse. A supposed shared experience of trauma allowed for a displacement of guilt for the forms of violence, exclusion and exploitation through which Western nations enforce global hegemony. Academic criticism, to the extent that it participated in this communal

experience, was able to evade its own complicity with the privileges and expediencies of postmodern consumer culture. The construction of 9/11 as traumatic implicitly reaffirmed the moral legitimacy of the West. Perhaps more importantly, however, the attacks shattered the self-image of liberal democratic societies as immune from massive destruction.

In this chapter I discuss 9/11 as an example of "virtual trauma" in order to suggest a complex relationship between traumatic experiences and their mediation to larger communities. I use the term "virtual" in the sense of technologically mediated *and* in the sense of the potentialities that may emerge out of a radical disturbance of established social and political structures. So as to explore these two senses of virtual trauma I present a critical reading of several responses to 9/11 that drew on the precedent of the Holocaust, and I also discuss the different responses of Jacques Derrida and Slavoj Žižek. In both these thinkers there is a critical engagement with the construction of the events as a trauma for America and the West but also a continued negotiation of trauma as a critical concept. I argue that whereas 9/11 revealed the dangers of trauma theory in a situation of political crisis, Derrida and Žižek indicate in important ways that trauma retains the potential to serve as a critical concept in the future. I explore their arguments with reference to two iconic images that emerged in post-9/11 media culture: the Falling Man (from the World Trade Center catastrophe) and the Hooded Man (from Abu Ghraib prison).

Critical and theoretical discourses about trauma and witnessing took on new and problematic inflections after 9/11, becoming more directly imbricated with mass media representations and exposing with a new clarity the ways in which the claim of witnessing already constitutes, as much as the term "trauma," a specific kind of interpretation of events. The sufferings of the victims and that of their families on and after 9/11 came to serve as a justification for cultural critics and academic scholars to participate in a community of witness. Their participation in a collective trauma imbued commentary with a certain moral authority that precluded more critical and analytical responses. To speak critically of representations of 9/11 (as with the Holocaust), is to risk accusations of appearing emotionally callous. Conversely, discourses of trauma and witnessing after 9/11 appeared to be disengaged from political dissent and debate. Use of a therapeutic model of social analysis was problematic given the rapid mobilization of public opinion in support of the subsequent American invasions of Afghanistan and Iraq.

Because images of the 9/11 attacks were viewed "live" by American and international audiences there was an immediacy to the events which was replicated in public discourse about them. The events were *immediately* "traumatic." This almost instantaneous labeling made the understanding of the 9/11 trauma fundamentally different from the case of the Holocaust, in which it had sometimes taken decades for the trauma suffered by survivors and their communities to be publicly acknowledged. The stress that

psychoanalysis places on latency, which is a central tenet of trauma theory for Cathy Caruth and others, appeared to collapse into a conception of the traumatic event as instantly recognizable as such.

The American Psychological Association published an online brochure "Coping with Terrorism" that recognized media coverage as a possible source of traumatization. Various academics engaged in research attempting to support such a hypothesis. Empirical research after 9/11 extended the category of PTSD to include *"distant traumatic effects"* in order to distinguish between those directly exposed to the events and those who witnessed them on television or through other media (Young 28). This understanding of trauma was supported by telephone and web-based surveys and recorded interviews, many with children and adolescents. However, as Allan Young has pointed out, the same media that transmitted events were also the source of discourses which defined them as traumatic, creating a loop-effect in which it became ultimately impossible to distinguish actual traumatization from unconscious group identification or mimicry of traumatic symptoms (Young 35).

After 9/11 the general population of America—not only those who experienced or witnessed the events first hand, not only the family and friends of those who died, but anyone who became aware of the events by way of telephone, television, newspapers or Internet communications—were potentially seen as participating in a traumatic experience. At the same time, media commentators often described the events as themselves appearing to unfold "like a movie," recalling the already familiar images of disasters and terrorist conspiracies produced by Hollywood. This would not have been said of the first published images of the Nazi concentration camps, or even of the televised images of the Vietnam War. The "trauma" of 9/11 was also quickly linked with the mass circulation and persistent re-screening of certain images, particularly those of the planes crashing into the World Trade Center towers and the subsequent collapse of the towers themselves.

This apparent contradiction between a violent shock and an already familiar scenario has been a consistent feature of representation of traumatic experience in modern media. As Benjamin explained, photography and film take on an increasingly important function as shock absorbers in societies characterized by intense visual stimuli and rapid social change. Media produce images and narratives designed to anticipate possible catastrophes and, through repetition, seek to make catastrophes familiar and less disturbing. Photographs and moving images also allow us to remember something that we could not fully assimilate at the time of its occurrence. As Barthes explained, trauma blocks our ability to make sense of events, whereas the media, through the production and reproduction of images, are always bestowing meaning. These meanings are usually familiar and ideological rather than directly responsive to what is new or unexpected. In this way visual media serve as a screen that protects us from the traumatic effects of events, even as they also seek to arrest our

attention through the shock impact of images. Although public discourses claimed to make sense of 9/11 as a traumatic experience, the continual repetition of media images of the events could be seen as symptomatic of a collective failure to fully assimilate into conscious understanding the most disturbing features of the events.

I argued in previous chapters that trauma has been employed as a concept in cultural criticism in ways that are closely linked with the representation of political collectives in modern mass societies. As Paul Virilio has commented, mass politics as it developed in the mid-nineteenth and early twentieth centuries has given way in more recent decades to "*simulators of proximity*" (including media such as television, the Internet, mobile phones, etc.) which create an "*imposture of immediacy*" (Virilio 41). The immediacy of technological media has become central to the experience of collective identity. The responses of some intellectuals to 9/11 revealed their readiness to join up to virtual communities based in mediated perceptions of catastrophe. Discourses of trauma and mourning served as an eloquent, already fully theorized, means of identifying with collective acts of commemoration and grieving. The historical precedent for these collective experiences was not, as both politicians and critical commentators claimed, the struggle against Hitler's evil empire, but more recent mediated events such as CNN coverage of the 1991 Gulf War or the media orchestrated grieving for Lady Diana Spencer after her sudden death in 1997.[1]

Constructions of 9/11 as a collective trauma disregarded the most fundamental propositions of psychoanalysis, in that they ignored or 'forgot' everything Freud proposed regarding fantasy and wish-fulfillment. One notable exception was an essay by Susannah Radstone in which she argued that to speak of 9/11 as a trauma already suggested the viewpoint of an innocent victim. For Radstone such a perspective did not acknowledge the role of unconscious fantasy—namely that this catastrophe had previously appeared as a scenario anticipated by Hollywood ("War of the Fathers" 118–119). Jean Baudrillard offered his own typically hyperbolic version of such an analysis when he argued:

> The fact that we have dreamt of this event, that everyone without exception has dreamt of it—because no one can avoid dreaming of the destruction of any power that has become hegemonic to this degree—is unacceptable to the Western moral conscience. Yet it is fact, and one which can indeed be measured by the emotive violence of all that has been said and written in the effort to dispel it. ("Spirit" 5)

Baudrillard went on to suggest that this wish for destruction goes beyond any resentment toward the United States by those "on the wrong side of the global order" (6) (or as President Bush had posed the problem: "Why do they hate us?"). He found evidence of this wish for destruction in numerous Hollywood films in which apocalyptic disaster is simulated with increasingly

sophisticated special effects. What was at stake for Baudrillard in the 9/11 attacks was the hegemony of a global system whose technological capacities makes it inherently vulnerable to terrorist acts. If Baudrillard's analysis is correct, then responses to 9/11 that emphasized trauma and witnessing were seeking forms of social and political solidarity and adopting interpretive strategies that are effectively redundant in a contemporary, technologically advanced society. This explains the disappearance in these discourses of an entire history of geopolitical conflict with the exception of World War II and the Holocaust—as if the American interventions in Korea, Vietnam, Chile, Nicaragua, El Salvador and Iraq had never occurred.

In his essay on 9/11, Žižek listed a number of films which have portrayed modern American capitalism as a gigantic simulation of reality. This theme culminated in *The Matrix* (1999), in which material existence itself was replaced by a computer generated virtual world. Žižek proposed that the collapse of the World Trade Center towers was experienced for many through the lens of Hollywood spectacle, an optical illusion that Žižek saw as symptomatic of "*virtual* capitalism, of financial speculations disconnected from the sphere of material production" ("Welcome" 132–133). The sense of unreality that accompanies this privileged position in the global economy is also symptomatic of an underlying anxiety that the "real" world upon which virtual capital depends is one of impoverishment and exploitation. Žižek closed his essay by asking if "America will finally risk stepping through the fantasmatic screen separating it from the outside world" (135).

For Žižek 9/11 presented a traumatic intrusion into the virtual reality of American hyper-capitalism. Derrida, on the other hand, questioned what he called the "compulsive inflation" (Borradori 89) of 9/11 by media and asked us to re-think the nature of the event as the always initially incomprehensible arrival of the unknown. For Derrida the attempts to immediately interpret or label the event refused its traumatic incomprehensibility. Žižek's commentary can be seen as participating in this inflation of the events. Conversely, Žižek has criticized Derrida's response to the events as refusing to engage with the real political choices they demanded. Both Žižek and Derrida, however, can be seen as re-deploying trauma as a critical or philosophical concept after 9/11 and doing so in the face of its absorption and inflation by the media. I propose that both thinkers offer important perspectives for understanding 9/11 as an historical trauma.

"AFTER 9/11"

Today it has become common to speak of a post-9/11 world. Should the notion of a world irrevocably changed "after 9/11" be accepted? The familiarity of the disaster scenario should alert us to already existing violence that characterizes a society that speaks so quickly of historical transformation.

The phrase "after 9/11" suggests a critical breaking point or turning point that gave rise to a distinctively new set of conditions. We could alternatively understand 9/11 as traumatic because it demanded recognition of something that had long existed but that only became visible as a consequence of painful and undesirable events. This latter understanding is closer to a classical Freudian conception of trauma. Images of violence and catastrophe in Western news and entertainment media are so pervasive, they cannot in themselves be understood as traumatic for viewers. They require some form of identification with events situated within a specific narrative scenario and discursive construction in order to be understood as traumatic.

What is at stake in the construction of historical events as traumatic is the assimilation of human suffering into narratives of identity and history. The phrase "after 9/11" reasserts fundamental structures of sovereign violence insofar as it suggests new levels of public anxiety and military aggression. In this sense interpretations of 9/11 should be contrasted with Adorno's earlier proposals about Auschwitz. "After Auschwitz," wrote Adorno, we "balk at squeezing any kind of sense, however bleached, out of the victim's fate" (*Negative Dialectics* 85). For Adorno the historical legacy of the Nazi Final Solution was that death was to be feared as an event that no longer conformed in any way to the course of an individual's life. He proposed that survival in a world in which the absolute value of capital overrides any human suffering "calls for the coldness, the basic principle of bourgeois subjectivity without which there could have been no Auschwitz" (87).

Such a critical association of historical trauma with capitalism has not been typical of public discourse about 9/11. In his essay "History and September 11" (first published in *Newsweek* in 2002 as "Their Target: The Modern World"), Francis Fukuyama wrote that the end of the Cold War and the dot.com boom meant that "the US economy was going gang busters and democratic institutions seemed to be making headway in all parts of the world" (Fukuyama 27). Fukuyama took this opportunity to reiterate the central thesis of his 1992 book, *The End of History and the Last Man*, that the evolution of human societies has culminated in modern liberal democracy and free market capitalism (28). He then proposed that the 9/11 attacks represented a backlash of Islamic fundamentalism against Western secular modernity and its underlying principles of freedom and equality.[2] Fukuyama's vision of the world after 9/11 is antithetical to Adorno's arguments about the conditions of social existence after Auschwitz. For Fukuyama modern science and technology and the production of material wealth are historical forces that give rise to greater individual freedom (29). By identifying the enemy of freedom as "Islamo–Fascism" (32), Fukuyama invoked the memory of World War II and implicitly justified American military intervention in the Middle East. For Adorno, however, the historical forces of democracy and capitalism gave rise to *both* the modern liberal individual *and* to the fascist state that liquidated the individual in

concentration camps. By analogy it can be argued that the forces of modernity (including American global interests) have played their role in the rise of Islamic fundamentalism and nationalism in the Middle East.

Several years before the 9/11 attacks in *Specters of Marx* (1994), Derrida identified Fukuyama's arguments with what he called a "triumphant" (56) or dominant discourse proclaiming the death of Marxism. For Derrida, Fukuyama's speculations on the end of history, along with the dominant media discourses of post-Cold War ideology, manifested a common impulse to exorcise the specter of Marxism as a promise of political emancipation and social justice. In Fukuyama's reading of modern history, the catastrophes of political terror or genocide are empirical phenomena that in no way refute the narrative of progress of human societies toward liberal democracy and the free market (*Specters* 57). Derrida noted the crudeness of such an argument which by separating the empirical and ideal is able also to discount any evidence of the violence and injustice that support the actual historical existence of liberal democratic states (61–64). That is, any empirical evidence of progress toward liberal democracy is permitted in Fukuyama's argument whereas any empirical evidence that contradicted his political ideal is deemed irrelevant.

In *The Shock Doctrine* (2007), Naomi Klein presents a body of empirical evidence against corporate capitalism. She argues that the triumph of neoliberal ideology has not been achieved through the advance of freedom, but through violence and terror. Aggressive deregulation of national markets and privatization of nationally owned assets has, according to Klein, been premised in many cases on mass slaughter and torture of those who resist the supposed benefits of the free market. Klein cites Chile and Argentina in the 1970s, China in the 1980s, Russia in the 1990s and Afghanistan and Iraq over the past decade as examples of such violent interventions. In each case liberalization of markets was accelerated by wars, invasions or military coups and these catastrophic events traumatized citizens and paralyzed their ability to question or oppose radical change. Klein sees the U.S. government response to 9/11 as following the same logic: grasping an opportunity made possible by massive public shock to impose an agenda of military mobilization, curtailment of civil liberties, cuts to social spending and tax reforms that favor the wealthy.

Derrida's account of Marxism as an historical trauma adds an important dimension to Klein's analysis of shock, because it alerts us to the ways 9/11 inevitably invoked the injustice and violence perpetrated in the name of capitalism. Whereas nationalist responses in America emphasized innocent victim-hood and called for retaliation, the breach in psychological defenses achieved by the attacks reopened deeper wounds and oppressed histories. So despite the political opportunities 9/11 presented to the political right in America, it also undermined their self-image of an advanced capitalist society as invulnerable and all powerful. As Derrida proposed in an interview shortly after 9/11, the events were traumatic in terms of structures of

sovereign power: the violence that the American state was free to exercise internationally in the name of democracy was redirected against its own territory through the hijacking of its own technological apparatus (Borradori 95).

THE HOLOCAUST CODE

Instead of attempting to grasp the full dimensions of 9/11 as an historical trauma, public responses by many intellectuals to 9/11 repeatedly turned, explicitly or implicitly, around questions of empathy and identification. Were the American civilians who died to be compared to Holocaust victims or was it more timely to consider the innocent victims of American military aggression elsewhere? In his response to 9/11 Michael Rothberg asked "whether and how trauma theory can provide intellectual resources for large scale historical and political tasks" ("No Poetry" 147). Rothberg saw some value in the shock of the attacks awakening Americans to suffering in other parts of the world. The experience of trauma, Rothberg proposed, can create the basis of empathy across cultures.

The construction of 9/11 in terms of us and them, good and evil, West and East, was consistently articulated by reference to World War II and the Holocaust. Both media commentators and academic critics employed what Israeli critic Moshe Zuckermann calls the Holocaust code. Zuckermann argues that actual memory of the Holocaust has been replaced by a cultural code—continually reinforced by images, rituals and monuments, which effectively represses historical reality from conscious understanding (cited in Lentin 11–13).[3] The most commonly repeated version of this code in the case of 9/11 was that the terrorists were fascists and the Americans innocent victims who must now take military action against enemies of freedom and democracy. Thus Bush justified the invasion of Iraq by evoking scenarios from World War II (Torgovnick x).

Prominent voices from trauma studies made use of the Holocaust code to make sense of 9/11. Psychoanalyst Dori Laub did not hesitate to describe the events as "an experience of massive psychic trauma" ("September 11" 204) and supported Bush's characterization of the terrorists as fascists and Nazis. Laub developed his own analogies between 9/11 and the Holocaust: like the Holocaust, 9/11 has given rise to a traumatized silence on the part of the victims. As with the Holocaust, over time a narrative will need to be produced to make sense of the events. Laub discussed the trauma of 9/11 in terms of "we" or "Western society" (205) and failed to mentioned the historical impact of American military interventions on non-Western nations. Conversely Geoffrey Hartman used Holocaust analogies to compare American paranoia about Muslims with Nazi persecution of Jews and saw danger in events that had apparently "unified Americans, perhaps for the first time since World War II" ("On That Day" 9). E. Ann Kaplan wrote

of her direct experience of the attacks on Manhattan and how they reawakened her childhood memories of the World War II bombings of London. This traumatic return of an earlier experience allowed her to make a new kind of political identification with the sufferings of fellow New Yorkers after 9/11 (Kaplan 3).

These different responses all attempted to bring a psychological understanding of trauma into a situation of political crisis. Most turned on the question of who was most deserving of empathy in situations of shock and disorientation. To decide this they looked to the dominant historical narrative of political identity—the Allied victory in World War II—in which American democracy and capitalism triumphed over fascism. These responses often lacked the sense of Western capitalism as already traumatized by its own history of violence and injustice that informed Adorno's and Derrida's different accounts of historical trauma.

A decade or more of academic analysis of trauma and representation and traumatic memory provided a set of discourses ready made to respond to 9/11. Barbie Zelizer, who had already produced a significant body of research on Holocaust representation, analyzed the important role photography played in news media representations of 9/11. If the traumatized are unable to articulate their experience verbally, then photography, proposed Zelizer, has sometimes filled the gap where other forms of narrative were yet to offer a coherent interpretation of events. Zelizer argued that the precedent for the visual representation of 9/11 included photographs of the liberation of the German concentration camps at the end of World War II. These images had focused on public reaction to the spectacle of death and suffering presented by the camps. Photography was used in both instances to enable the public to bear witness to events, while at the same time securing support for American military operations overseas. Zelizer's discussion of photo journalism and 9/11, however, assumed the American public was traumatized by 9/11 and that photography played a role in facilitating "movement from trauma to a post-traumatic space" ("Photography" 49). Zelizer did not consider that the role of the media may have been to define 9/11 as traumatic in a more primary sense. Apart from a relatively small number of people who witnessed the events first hand, the significance of 9/11 was amplified through media images reaching millions of American and international viewers. The media image was the first thing which for most people shaped their knowledge and understanding of the 9/11 attacks.

Zelizer's discussion of photographic representations of 9/11 adopted the discursive frame of witnessing as developed by Felman and Laub, emphasizing the construction of a shared collective experience through public acknowledgment of particular events as significant. Zelizer, however, made a crucial observation about the role of witnessing that had been absent from Felman's earlier discussions(for example, in her essay on *Shoah*). Zelizer noted that in American media representations of genocide in Cambodia,

Bosnia or Rwanda, there was no emphasis on public witnessing, but rather there was simply the reproduction of direct representations of suffering and death (54). Zelizer argued that whereas the role of witness offers a space of identification for viewers, implicitly humanizing catastrophic events, the direct presentation of extreme forms of suffering may not invite identification or even empathy, allowing the viewer to adopt a position of voyeuristic fascination or emotional disengagement. The general point I derive from Zelizer's research is that certain events are designated traumatic by the media through representations of witnessing, whereas other events which are equally or more horrific, are not. We must conclude from this is that corporate media do not respond to public trauma as much as they define public trauma.

Certainly 9/11 was profoundly shocking and disturbing for many people and those events impacted American citizens in ways that similar violence in distant nations did not. However, the iconic status of Holocaust images today demonstrates that the cultural prominence of certain historical events over others has more to do with the ubiquity of media representations than it does with the actual psychic experiences of human populations who survive them. The Holocaust survivors and their families who suffer traumatization comprise a relatively small proportion of the population of the Western world. Whereas the lasting impact of the Nazi genocide is greatest in Israel, even there the horror of those historical events remained relatively unacknowledged for political reasons for many years. In the case of the Holocaust the magnitude of the crime and the unprecedented masses of deaths make an incontestable claim for historical significance. 9/11 resulted in a comparatively small number of people being directly impacted, either as victims or as immediate witnesses.[4] It was the technological sophistication and global reach of the media that was able almost instantaneously to amplify its historical significance.

Zelizer showed how the media defines the process of witnessing as part of the construction of particular events as traumatic for the general public. Images of responses of shock and dismay provide a visual cue for a culturally acceptable or politically appropriate public response. Yet one does not need to look back to the images of the concentration camps to find a precedent for this, as it is a device that is used in almost any Hollywood film or television drama: the reaction shot. Why look to a 1945 precedent when one could look back to an event as recent as the death of Lady Diana Spencer in 1997 to study how mass media orchestrate discourses and representations of grief and mourning toward a national, and even global, consensus on the significance of "tragic" events?

Although she acknowledged the very different nature of 9/11 and the Holocaust as historical events, Zelizer insisted that the liberation of the concentration camps provided the precedent for media representations of 9/11 (51). What these events had in common, she explained, was America's geopolitical interests and the importance of persuading the public that

the events were horrific enough to demand a military response. Zelizer's research demonstrates that the prevalent comparison of 9/11 to the earlier events of World War II and the Holocaust had more to do with amplifying their importance in the minds of the public than in the historical actuality of any collectively suffered trauma.

IMAGE: THE FALLING MAN

The virtual, or mediated, experience of trauma gives rise to its own distinctive politics of the image. In this section I discuss the significance of one controversial image of the World Trade Center catastrophe: the widely published photograph of a man falling to his death. This image is the subject of a documentary feature, *9/11: The Falling Man* (Director Henry Singer 2006) which uncovers the story of the production, transmission, publication and reception of the images of those who jumped from the twin towers. One photograph in particular, showing the so-called Falling Man, appeared in news media throughout the world shortly after the events, but was quickly withdrawn from circulation. Journalists later attempted to discover the identity of this victim and to make contact with his family and colleagues. Ultimately, the film concluded, the actual identity of the Falling Man is less important than his iconic significance for collective memory: the national trauma of 9/11.

The World Trade Center catastrophe was the most photographed and videotaped event in history. However, photographs of people who jumped from the burning buildings were not widely published in newspapers. "Live" television coverage of the events as they unfolded quickly stopped showing images of people falling to their deaths; the most famous exception to this self-censorship being the photograph of the Falling Man. This picture was first published by a small Pennsylvanian newspaper, *The Morning Call*. The editors saw it as a potentially iconic news image, comparable to images of the Nazi concentration camps, the Vietnam War and the Kennedy assassination. Whereas its initial publication invited hostile responses from local readers, it was later widely published internationally and became available on the Internet. This global dissemination resulted from one journalist's assignment to discover the identity of the Falling Man. The man was first identified as Norberto Hernandez, a kitchen worker in the *Windows on the World* restaurant in the World Trade Center; however, further investigations by writer Tom Jerod revealed the Falling Man was not actually Hernandez.

The film argues that the exclusion of images of falling bodies from media coverage of 9/11 resulted in a failure by the American public to confront this horrific aspect of the events. Instead the news media reproduced images of firefighters and rescuers as heroes of the day, allowing for feelings of positive identification and national pride. By pursuing the identity of the Falling Man and telling the story behind his photograph, the film claims to be

engaging in a work of mourning for the traumatic loss of life on 9/11. Jerod comments that because their deaths were not acknowledged in the media, those who jumped from the towers were excluded from "the consecrated ground of American soil." The Falling Man was *homo sacer*, able to be killed, but not sacrificed for the glory of the nation.

By emphasizing the individual identity of The Falling Man the film avoids confronting the larger political issues of the terrorist attacks. The individualizing of the catastrophe is constantly reinforced by the documentary form itself, which is structured around individual witnessing and testimony. The emotive nature of the testimony is reinforced by the use of music and lighting. Personal photographs of those who died and interviews with family members help to encourage identification and empathy with victims of the attacks. Those in close relationships with the victims tend to describe the act of jumping as a final act of individual will, thereby lending some dignity to their deaths. Reaction shots of bystanders on the streets below as they look on in horror at people falling from the towers and recorded vocal responses of the crowds as they cry out in shock reinforce the construction of 9/11 as a collective trauma. Of course we need to acknowledge the necessity of mourning by families which required the identification of bodies and the localizing of remains. However, by re-presenting this private work of mourning to a large audience the film reclaims the individual for the national community and its implicit ideological structures. The mandate of mourning and trauma recovery assumed by the film detracts from the full implications of the events for civilians as objects of terrorist violence.

Although the film presents an interesting case study of a compelling news image, it offers no critical analysis of the production processes it documents. For example, professional photographer Richard Drew, who shot the image of the Falling Man, is interviewed. He describes "instinctively" taking photographs of bodies falling. As he puts it: "It's what I do." Drew describes the camera as "a filter" between himself and the events he is photographing. Recalling showing his photographs on the day to a senior editor he comments: "I said 'I really like this one'." This response seems strangely out of place in the general atmosphere of catastrophe and grieving. Drew comments on the specific image of the Falling Man: "I see this not as this person's death but as part of his life. There's no blood, there's no guts, it's just a person falling." These comments might have been placed in the larger context of the politics of representing victims of war and terror in the media. However, the film, seeking to maintain a consistent mood of sorrow and respect for victims, allows them to pass without comment.

By foregrounding issues of trauma and mourning the film participates in a larger culture of photography that arose after 9/11. Zelizer proposed that photography provided a response to the catastrophe that compensated for the disruption of public discourse caused by the traumatic shock of the events. Photographs quickly became bound to a work of commemoration and collective mourning that effectively depoliticized the events.

For example, Marianne Hirsch's essay on taking photographs after 9/11 wholeheartedly embraced the language of trauma and witnessing. Her account was highly emotional in tone and framed by a direct identification of herself with a community of witness, as she wrote of "the sense of monumental, irrevocable change that we feel we have experienced" ("I Took Pictures" 71–72). For Hirsch the photographic snapshot captured this traumatic moment, allowing the possessor of the image to engage in processes of mourning and to resist the "gradual normalization" of the catastrophe. Hirsch did not consider how photographs themselves normalize, functioning as a shock absorber rather than enabling deeper forms of psychological engagement and allowing the viewer to distance him/herself from the shown events. Hirsch cited several "classic" theoretical texts on photography—Benjamin, Barthes, Berger—in support of her interpretation of events. These earlier texts all share a clear political purpose: the critique of the image as instantly consumable commodity along with the search for alternative affective experiences. In Hirsch's commentary on 9/11 the photograph serves a community of mourners that are implicity identified with the national family and thereby absolved somehow from the commodification of suffering.

One of the most striking aspects of 9/11 was that more images of the events were produced by ordinary people, utilizing digital and video cameras, than were produced by corporate media. A photographic exhibition mounted in Soho only weeks after the attacks, "Here is New York: A Democracy of Photographs," eventually included thousands of images recorded by both amateurs and media professionals. This impulse to provide a grassroots, democratic image space helped create a sense of a unified community of witness. Through the diversity of displayed images viewers were invited to reflect on the multiplicity of experiences and interpretations of the events and to feel part of a larger collective defined by a shared trauma. Despite the diversity of images, 9/11 had already been interpreted as significant in ways that over determined the differences contained in specific images. For this reason we need to question to what extent such exhibitions represent an alternative to mainstream professional media. The exhibition later toured the United States, Europe and Japan (Holloway 132–133) and an exhibition website recorded hundreds of millions of hits, revealing the extent to which catastrophic events attract international interest as well as the apparent widespread desire to become a part of a virtual community of witness—a phenomenon that has sometimes been referred to less generously as "disaster tourism."

Images of bodies falling from the World Trade Center towers has a specific significance for trauma theory that potentially unsettles formations of communities of witness. The theme of falling, as it relates to witnessing and historical reference, runs through several essays by Felman and Caruth.[5] In her essay "The Falling Body as the Impact of Reference," Caruth addresses the criticism that poststructuralist theories of reading deny the possibility of

access to historical reality. In response to this criticism Caruth presents her own reading of several different essays by Paul De Man and suggests that the problem of reference in the history of thought is "inextricably bound up with the fact of literal falling" (*Unclaimed Experience* 75). Caruth explains how the discoveries of Isaac Newton in the late seventeenth century gave rise to a new problem of linguistic reference: that is, how to describe the world in which objects fall through space under the force of gravity. The concept of gravity, although comprehensible according to a mathematical formula, could not be adequately described by verbal language. De Man argued that one result of this problem of reference was that philosophy attempted to become a more self-reflexive system. For Immanuel Kant this system became a transcendental philosophy which was entirely conceptual and no longer depended on empirical facts for verification. De Man argued that in order to make this very distinction between the transcendental and the empirical Kant made use of a literal example of bodies in motion. Kant's figure for a self-referential philosophical system was the human body conceived as an organic whole composed of inter-related parts (*Unclaimed Experience* 77–79). De Man proposed that through this figure Kant also *disarticulated* the human body in ways that could not be reconciled with his project of establishing a unified philosophical system. According to De Man's deconstructive reading, Kant's linguistic dismemberment of the figure of the body through the naming of its different parts reveals how the problem of reference reasserts itself in his idealist philosophy (88).

Caruth's argument shows that problems of linguistic reference complicate the representation of falling bodies, suggesting parallels with the problem of making the photograph of the Falling Man an icon of 9/11. Neither Caruth nor De Man discuss how the camera further complicates the problem of linguistic reference. Is the camera able to refer to falling in ways verbal language cannot? Benjamin drew attention to the ability of the camera to reveal visual realities previously unavailable to the human eye. With the touch of a finger the camera could capture a moment in time during an historical period when the inhabitants of the modern metropolis were learning to block out various "shocks and collisions" (Benjamin 4: 328) that increasingly characterized their everyday experience. Thus the crisis of linguistic reference in modern philosophy and literature is registered differently in technological media. Photography and film can capture the multiple and complex movements of a body falling, second by second through space, in ways unavailable to unmediated human perception and to verbal description.

Because the photograph of the Falling Man fails to affix the image to the death of a recognizable individual, it makes the image available to be fixed to a narrative of national trauma. The suffering of this one individual is thereby subsumed into a *telos* of collective mourning and, potentially, healing. However, this specific image reveals a further failure of reference, not only to an identifiable person, but also to the physical movement of a body falling through space. As the series of photographs of the Falling

Man (as originally shot by Richard Drew) shows, the single chosen image that was widely published fails to represent in any empirically accurate way the actual motion and turbulence of his falling through space. The series from which the published Falling Man image was taken highlights the importance of the photograph in both frustrating and facilitating processes of mourning after the event. The photographs also draw attention to the impossibility of representing the experience of the Falling Man himself. Photography, no better than verbal language, can convey the reality of bodies in motion in terms of the perceptual experience *of that body itself.* Even though the camera can provide an accurate recording of that motion and can potentially simulate the visual perspective of a falling body, the frozen motion of the photographic image only heightens the unknowable quality of the human suffering that it makes visible. In that sense the photograph cannot possibly transmit the trauma of falling.

Despite its important role in contemporary forms of public mourning, the news photograph tends to reproduce what Adorno saw as the emotional coldness and distancing characteristic of modern capitalist societies. To subsume human suffering into a narrative, even one of national mourning, risks reproducing the violence implicit in that system. The image of the Falling Man should not be falsely individualized. Rather the man's fall is an horrific reminder of what an individual in a modern, technologically sophisticated, metropolitan environment can be reduced to by the machinations of political terror.

Focus on the fall of an individual man (rather than a confused mass of bodies) supports the idea that even in moments of extreme violence the individual is able to come to an autonomous decision and engage in independent acts (such as "deciding" to jump from a burning building). The actual chaos and horror of the World Trade Center catastrophe is revealed in other photographs taken on the day which feature clusters of people leaning from windows to escape heat and smoke. The depicted panic and desperation of those trapped in the towers comes as shock to any cherished belief in the sovereignty of the individual. Thus Jenny Edkins has proposed that the 9/11 attacks revealed that the violence exercised by Western states designed to secure global hegemony is actually unpredictable and beyond control:

> Like the state they [the attacks] produced life as nothing more than bare life—life that could be taken with impunity. The lives of those that were killed were regarded as worthless, expendable. And their deaths too were taken from them. They did not die as individuals; they were obliterated, rubbed out, disappeared. They didn't die, they vanished. They became the missing. Their grieving families had no bodies to bury, and no certainty as to what had happened to them. (*Trauma* 227)

Yet the deaths of 9/11 were clearly located by the destruction of targeted buildings and hijacked planes. Victims did not disappear in a comparable

way to those who are arrested by terrorist states (or suspected terrorists arrested by Western governments). The catastrophic deaths of several thousand people on one day should not be compared to the systemic terror inflicted on some societies over decades. Edkins's account does not include the deaths of those who executed the attacks, who are regarded by many as martyrs. However, Edkins's point about the victims of 9/11 and the condition of bare life allows us to see the anonymity of the Falling Man as an image of victims of terror everywhere.

Ariel Dorfman considers these issues further in an essay comparing the 2001 attacks with events of September 11, 1973, when the Chilean government led by Salvador Allende was overthrown by a CIA-backed military coup. In both situations Dorfman sees innocent civilians subject to political terror, confronting their own deaths and the deaths and disappearances of their friends, associates and loved ones. It needs to be reiterated, however, that a democratically elected American government was not overthrown by the 9/11 attacks. The popular socialist government of Allende cannot usefully be compared to a global superpower with enormous military capacity to strike back at those it deems enemies. There can be no simple equation between the overturning of the government of a relatively small nation who attempted to resist the interests of multi national corporate power and an attack on one of the centers of global capitalism. However, as Žižek comments, the increasing number of events in which governments accept the deaths of their own citizens as collateral damage in a struggle against terrorism demonstrates that everyone is potentially *homo sacer*: "It is not that some of us are full citizens while others are excluded—an unexpected state of emergency can exclude *every one* of us" (*Iraq* 55).

VIRTUAL TRAUMA

Žižek proposes that the object of the 9/11 attacks was the center of virtual capitalism, removed from the material basis of the production of wealth. In a similar sense the virtual realities made possible by media technologies and information networks suspend the world of physical actualities, geographical locations and "facts" which have been the substance of conventional (realist) historical analysis. In the context of this new virtual culture discourses about trauma have become increasingly prominent. Trauma theory has often attempted to return to the physical actuality of history and its indelible traces, whilst at the same time problematizing of historical locatedness and linear narrative in new ways. The contemporary preoccupation with trauma, however, can be seen as itself a symptom of what Žižek calls virtual capitalism. As in the case of the Falling Man, the "traumatic image" can serve an attempt to reconnect with the reality of an event that nevertheless persistently resists understanding.

Derrida's *Specters of Marx* suggests other ways to understand the relationship between historical trauma and virtual culture. Derrida writes of a "virtual space of spectrality" (*Specters* 11) punctuated by ghostly presences, who address us from beyond the limits of self interest, and who call on us to perform a work of mourning. These ghosts may be the victims of violence or oppression and therefore demand that we engage their name in an ongoing struggle for social justice. Derrida writes of a 'new world order' which seeks to install "an unprecedented form of hegemony" (50) and attempts to exorcise, once and for all, the ghosts of Marxism—whether understood as those who died in struggles for social justice, or as victims of totalitarianism. Another feature of this hegemony is the spectralizing of politics and public space through technological media. Derrida argues that this hegemony continually solicits testimony in support of its free market ideology in the realms of politics, the media and academic culture (52–53). I have proposed that trauma discourse, in both its corporate media and academic forms, sometimes bore testimony in support of this hegemony after 9/11.

Derrida raises important questions concerning the role of technological media in the work of mourning. He writes that mourning is always caught in an attempt to "ontologize remains, to make them present, in the first place by *identifying* the bodily remains and by *localizing* the dead" (4). However, the drive to localize through mourning can never saturate any social space, because—as contemporary forms of globalization and telecommunications persistently remind us—it is always already inhabited by another virtual space which includes all of those tele presences that increasingly populate our private and public spaces and define the "frontier between the public and the private [which] is constantly being displaced" (50). Derrida's comments suggest useful perspectives on the image of the Falling Man. Although the death of this individual demanded a practical work of mourning by his friends and family, it is necessary to resist returning his image to the custody of the national community if we are to address the larger issues raised by his ghostly reappearance as a media image. Images of 9/11 made available through photography, television and the Internet, gave rise to large the virtual communities of viewers who are left collectively to attempt to exorcise virtual specters haunting contemporary mediascapes and public space. Derrida comments:

> As in the work of mourning, after a trauma, the conjuration has to make sure that the dead will not come back: quick, do whatever is needed to keep the cadaver localized, in a safe place, decomposing right where it was inhumed, or even embalmed as they liked to do in Moscow. (*Specters* 97)

The stillness in the posture of the Falling Man "embalms" him and allows him to be mourned in ways that reinstall hegemonic discourses about

identity and community. If we consider the Falling Man as a specter, in Derrida's sense—that is, as a figure who demands justice—then we must first acknowledge the alterity of his experience. For this reason his image continues to return as a trauma, demanding further reflection on the significance of his death.

In *Echographies* Derrida returns to these questions with respect to Barthes's writings on photography. For Barthes, comments Derrida, the photograph "has the force of authentic testimony" (*Echographies* 97). However, the apparent presence of the person or object is always a haunting presence that also signifies absence (115). It is these two tendencies identified by Barthes as qualities of the photographic image—to bear witness as the trace of an irrefutable presence and yet at the same time to signify its own absence—that Derrida attributes to the specter: "A specter is both visible and invisible, both phenomenal and non phenomenal: a trace that marks the present with its absence in advance" (117). The photograph of the Falling Man, considered as a virtual specter, bears witness not only to a form of political violence but also to the violence by which the media image haunts and disturbs us.

In an interview conducted shortly after 9/11, Derrida argued that the repetition of this date was an attempt to "conjure away" (Borradori 87) the event, the anxieties it provokes and inability to grasp its full significance. Derrida went on to speak of a "compulsive inflation" (89) of this "*major event*" (88) which was not as historically singular as was claimed. The importance attributed to 9/11 was a direct expression of American global power, but the repetition of this date was symptomatic of a trauma that had not been fully comprehended. There is also the question of how one understands the very concept of the event. In its rush to label, to define, to interpret, to assign meaning and to commemorate, the media refused traumatic encounter with the event. In so doing it substituted its own traumatic structures of re-presentation and repetition. But for Derrida what more genuinely constituted the event labeled "9/11" remains unknown and unpredictable.

Derrida went on to speak of "a certain *unappropriability* of what comes or happens":

> although the experience of an event, the move according to which it affects us, calls for a moment of appropriation (comprehension, recognition, identification, description, determination, interpretation on the basis of a horizon of anticipation, knowledge, naming and so on), although this movement of appropriation is irreducible and ineluctable, there is no event worthy of its name except insofar as this appropriation *falters* at some *border or* frontier. (Borradori 90)

Here (intentionally or not) Derrida's remarks echo Benjamin's famous formulation that "articulating the past historically" means "appropriating a memory as it flashes up in a moment of danger." This danger for

Benjamin included "the danger of becoming a tool of the ruling classes" (Benjamin 4: 391).

For Derrida such a danger was not always avoided in the case of 9/11, as a terrorist attack on American soil was not unforeseeable (Borradori 91). Nor were the events unprecedented. The importance attributed to 9/11 implicitly belittles the catastrophes suffered by other populations in other parts of the world. The media apparatus, aligned with interests of dominant economic and political power, assigns significance to "events." The potentially traumatic disruption that defines the very possibility of what Derrida describes as an event is both doubled and negated by those "events" transmitted by the media apparatus. For Derrida the complex realities and historical processes from which the true event emerges and in turn transforms are illuminated insofar as the event presents itself initially as incomprehensible. The hegemonic discourses that define 9/11 as a "national trauma" thus articulate a failure to acknowledge its genuinely traumatic impact:

> What is a traumatic event? First of all, any event worthy of its name, even if it is a "happy" event, has within it something that is traumatizing. An event always inflicts a wound in the everyday course of history, in the ordinary repetition and anticipation of all experience. (Borradori 96)

For Derrida the traumatic event always opens a wound, not only in the past, but before the future, becoming a precursory sign of possibly worse things to come (such as chemical warfare or nuclear attack). Whereas commentaries tended to construct the trauma of 9/11 in terms of national identity and precedents of World War II and the Holocaust, Derrida argues that the so-called 'war on terror' falsely suggested a conflict based in national territory when the new forms of conflict that the phrase designates can no longer be located in these terms, but are globalized in new and pervasive ways (Borradori 101).

Derrida's deconstruction of 9/11 opens important avenues for critical reflection. His alternative conception of the events has been criticized by Slavoj Žižek, who sees Derrida as perpetually deferring the moment of action necessary to bring about actual social change. In his short essay "Welcome to Desert of the Real" written soon after 9/11, Žižek proposed that the devastation that resulted from the World Trade Center attacks presented an intrusion of the Real into the hyperreal bubble of everyday American life. 9/11 saw the collapse of a collective daydream, already prefigured in Hollywood fantasies such as *Independence Day*, into a traumatic reality. For Žižek the reality of what has happened "outside" the West in a long history of colonial barbarism, imperial conquest and global economic exploitation now "returned" in the manner of a traumatic memory ("Welcome" 133). Žižek's account of 9/11 recalls his earlier discussion of ideology in which both the attribution of trauma to an external cause or

event *and* insistence on the absolute unrepresentability of trauma are failures in that the subject must attempt to confront *both* the "concrete analysis of external, actual social conditions" *and* "the real of his or her desire" (*Mapping* 6). For Žižek the actual historical events that led up to the 9/11 attacks, the conditions that made them possible *and* the fantasies and anxieties they embodied, were all part of the reality of the event.

Žižek takes his concept of the Real from Lacan. The Real is a pre-, or non-linguistic reality, that cannot be encountered directly, but is always mediated by symbolization or representation. In a traumatic experience the Real intrudes into and disrupts the functioning of what Lacan calls the Symbolic Order, or language. According to the Freudian account, an event only becomes traumatic retrospectively, as a memory recalled in the context of later experiences. The concept of the Real explains this belatedness of trauma because the initial experience of an event resists symbolization and trauma only emerges later by breaking through into an entirely different linguistic context. Symbolization always remains incomplete with respect to the Real, which presents an excess that retains potential to further disrupt linguistic accounts of reality.

In his essay "The Spectre of Ideology," Žižek draws on the Lacanian conception of the Real to explain how symbolization always fails to "capture" the Real, thus leaving a non-symbolized remainder that *"returns in the guise of spectral apparitions"* (*Mapping* 21). The specter is not identical to symbolization but rather emerges in the gap that separates "reality" from the Real. "Reality" always has a structure that is to some degree socially or symbolically constructed. Žižek's example of the Real is the Marxist idea of class struggle. Class struggle is Real in the Lacanian sense because it constitutes a fundamental antagonism that all social structures and symbolic systems ultimately fail to contain (22). Žižek proposes that this "primordial" antagonism is what all ideologies attempt, but ultimately fail, to repress.

Because the Real is inaccessible, argues Žižek, ideology establishes itself through a *"spectral apparition that fills up the hole of the real"* (*Mapping* 21). I would argue that the published photograph of the Falling Man both filled and drew attention to this hole, this gap between symbolization and reality (a void that was quickly named "Ground Zero"). The photograph was unable to represent the physical motion of falling through space. Journalists, on the other hand, attempted to situate the Falling Man in a narrative about individual identity and about the events of 9/11. In doing so they drew further attention to the inadequacy of these narratives.

Žižek distinguishes his own understanding of the specter from Derrida's argument in *Specters of Marx*, claiming that Derrida resists any ontologization of the specter and therefore the translation of a spectral promise into a social project or state. According to Žižek, Lacan goes further by insisting on the moment of the act in which we experience the terror of freedom and the traumatic impact of the Real (*Mapping* 27). Here Žižek may be closer

to Benjamin's appropriation of "that image of the past which unexpectedly appears to the historical subject in a moment of danger" (Benjamin 391). For Žižek, as for Benjamin, there must be an act of appropriation that actualizes the antagonistic struggle that remains *real*. Derrida's resistance to any ontologizing of the specter would appear to hesitate before the possibility of this act and to indefinitely postpone it in the form of a promise.

In the documentary *The Falling Man*, different individuals comment on those who jumped from the burning towers as making a choice and acting on that choice. One family member comments that her father, as a Catholic who loved his family, could never have committed a public act of suicide. Another comments that the Falling Man "took his life in his hands." Author Tom Jerod feels compelled to ask, "What would I do in that situation?" Žižek's speculation on 9/11 provokes us to ask whether the jump constitutes an act as Žižek understands it—particularly as Žižek elsewhere quotes Lacan's maxim that the only true act is suicide.[6] But how can one ever evaluate such a situation, or such a choice to act, without reverting to a false empathy with the victim? The act retains its unknowable alterity. More disturbingly, Žižek's notion of the act could implicitly justify the suicide attack by the hijackers (not to mention countless other acts of suicide bombing). Ultimately Žižek's conception of the act could lead to the annihilation of both the self and any relation to the other in the pursuit of a moment of authentic experience.

Can Derrida's understanding of the event be aligned with Žižek's Lacanian notion of the Real? The difference, according to Žižek, is that the Real will always intrude directly into social discourse and the imaginary order creating a traumatic crisis. Žižek accuses Derrida of placing the event on a perpetual far side of meaning that will always be indefinitely deferred. But here we can align Derrida's conception of the event with his invocation of the specter who always returns and makes a demand on the subject. What Derrida calls the "democracy to come" (*Echographies* 21) is not a question of an infinite deferral of political decision, but instead an urgent imperative that intrudes into and disrupts the legitimacy of dominant discourses and power formations. Rather than infinitely postponing the moment of political intervention, Derrida's democracy to come can be understood in terms of a traumatic interruption of the social order that is always unpredictable and, in an important sense, unprecedented. This intervention cannot be prescribed by any political ideology. Rather, the nature of the event demands that it cannot be contained by, or assimilated into, any pre existing discursive frame: it must produce a new articulation of the political.[7]

What might those different theorizations of the event mean in the case of 9/11? In Žižek's response to 9/11 the Real becomes associated with the "outside" of the West and virtual capitalism. The outside threat is already envisioned in terms of established Hollywood film fantasies. The specter of 9/11 therefore represents a Real remainder of a global power struggle, intruding into a space between the reality of global capitalism and its symbolization

as architecture and/or media spectacle. For Žižek the trauma of the 9/11 attacks presents the possibility of a choice that would confront the violence that underlies and supports Western consumerist "reality." Derrida, on the other hand, speculates that if he had to make a choice between the West and the alternative presented by Bin Laden, he would have to support flawed Western liberal democracy that at least includes the possibility of democracy based in International Law (Borradori 113–114).

Which is the more real choice? At this historical moment those who enjoy the relative economic security and political freedoms to be had in Western democracies are not required to make the choice considered by Derrida: it is America that wields hegemonic power, not Bin Laden. Even this opposition is false, however, as Bin Laden can be seen as implicated in the same power structures by which America maintains global hegemony. Žižek, possibly proposes a more fundamental choice: between the structure of a mediated reality and the traumatic structure of the Real. We must ask however when and where such a choice may actually be possible. Perhaps the images of 9/11, including those of the Falling Man, remain best understood in terms of Benjamin's formulation of the true image of the past that "flashes up at a moment of danger." Only in that brief moment can the traumatic possibility, described by both Derrida's conception of the event and Žižek's conception of the act, be glimpsed.

IMAGE: THE HOODED MAN

Derrida's conception of the event and Žižek's conception of the act share an understanding of virtual trauma as a moment of both disturbance and potential. Both fit an understanding of historical trauma as a disruption of linear narratives and imaginary identifications *and* as an opportunity for more radical change. As a final case study, to demonstrate a multi-dimensional concept of historical trauma, I discuss the image of the Hooded Man from the Abu Ghraib prison in American occupied Iraq. The stakes of appropriating images in contemporary media culture are increasingly caught up in a violent struggle between hegemonic forms of power and resistance to that hegemony. In this virtual culture representation of the human body, particularly with regard to death and suffering, has a new dimension. The 'war on terror' includes a virtual war, as James Der Derian explains:

> Post Vietnam, post Cold War, postmodern, virtuous war emerged prior to 9/11, from the battle spaces of the Gulf War and the aerial campaigns of Bosnia and Kosovo in which killing was kept, as much as was technologically and ethically possible, virtual and virtuous. Virtuous war relies on computer simulation, media manipulation, global surveillance and networked warfare to deter, discipline and, if need be, destroy potential enemies. (Derian 105)

Media coverage of, and responses to, the 9/11 attacks participated in this virtual culture in which traumatic repetition of 'the moment of impact' provided the structure for a mediated event. The media operated as the technological apparatus of public perception and collective memory (Derian 106–107). Derrida also emphasized this role of media in his commentary on 9/11:

> More than the destruction of the Twin Towers, or the attack on the Pentagon, more than the killing of thousands of people, the real "terror" consisted of and, in fact, began by exposing and exploiting, having exposed and exploited, the image of this terror by the target itself. This target (the United States, let's say, and anyone who supports or is allied with them in the world, and this knows no limits today) had it in its own *interest* (the *same* interest it shares with its sworn enemies) to expose its vulnerability, to give the greatest possible coverage to the aggression against which it wishes to protect itself. (Borradori 108)

The traumatic impact of the images was almost instantaneously deployed by American and other Western corporate media to argue for specific political interpretations. Before this, the attacks themselves were planned in full awareness of their potential impact through the dissemination of media images. The traumatic image has thus been drawn into new tactical and strategic roles in so-called 'terrorist acts' and the 'war on terror.'

Media representation of the human body in the context of war has become a contentious issue. Andrew Hoskins and Ben O'Loughlin propose that media representation of the human body functions itself as weapon in the 'war on terror' (Hoskins and O'Loughlin 118). The absence of visual representations of victims of American bombings in media coverage of the 1991 Gulf War established an important precedent in the sanitizing of contemporary warfare. The Bush government also imposed a censorship of images of American casualties in Iraq. On the other hand, after 9/11 particular individuals deemed 'a terrorist threat' (including the sons of Saddam Hussein) were publicly exhibited showing evidence of violent retribution (125). W. J. T. Mitchell describes the 'war on terror' as a war of images whose aim is "to traumatize the collective nervous system via mass media" (Mitchell 185) by publishing images including the destruction of the World Trade Center, the humiliation of the captured Saddam Hussein, videos showing decapitation of American hostages and photographs of torture in Abu Ghraib prison. These images, writes Mitchell, "are not images *of* trauma, but images designed to traumatize the viewer, especially those who identify with the victim" (195). Mitchell comments that images of torture in Abu Ghraib "were no longer news within a month" (197). For this reason they provide a stark contrast with images of 9/11, which were commemorated in numerous documentaries and dramatizations over several years following the attacks.

The production and dissemination of images of tortured captives from Abu Ghraib prison in American occupied Iraq, created with digital cameras and camera phones and shown on the Internet, were was an integral part of the event itself. Degradation and torture of the prisoners was intended both to celebrate military power over their bodies and to demoralize their families and communities (Reinhardt 16–17). Susan Sontag discussed the images from Abu Ghraib as symptomatic of contemporary digital culture, home videos and pornography. She commented: "the photographs *are* us" (*At the Same Time* 131). Although this statement acknowledges political responsibility for torture and political violence, it runs the risk of appropriating the other in the name of national identity or Western culture.

The iconic image that emerged from Abu Ghraib has become known as the Hooded Man. This photograph, first published in 2004, shows a man draped in a black cloak with a black hood over his head, standing on a box, his hands connected to wires attached to a source of electric power. As with the image of the Falling Man, the suffering of the individual is strangely contradicted by a stillness and clarity of bodily posture. Like the Falling Man, the anonymity of the Hooded Man is a key feature of the iconic potency of the image.[8] Stephen F. Eisenmann has explained in his study of the images from Abu Ghraib that hooding of victims is designed to increase a sense of isolation and helplessness. The hooded person is completely at the mercy of his/her torturers. Hooding is a powerful means of dehumanization (Eisenmann 107). Whereas the exposure of American brutality in Iraq may not have provoked the outrage and indignation among the American public that many hoped it would, the image has instead become for many a symbol of resistance to American military occupation. The image has been reproduced in anti-American murals in the Middle East and used in anti-war protest, as well as reproduced on T-shirts, posters and in cartoons (Holloway 147–149).

In 2006 Ali Shalal Qassi claimed to be the Hooded Man. As with the Falling Man photograph, it was subsequently revealed that he was not the specific individual in the image. He had however been an inmate in Abu Ghraib and subject to the same methods of torture. Qassi went on to found the Association of Victims of American Occupation Prisons. He reproduced the image of the Hooded Man on his personal business card (Reinhardt 19). By identifying himself with the image and giving the anonymous figure a face and a voice, Qassi appropriated the image and engaged in a struggle over its significance in the public sphere and in the image spaces of contemporary urban society and technoculture. Qassi's claim to be the Hooded Man demonstrates that virtual specters can be actualized in unpredictable ways, transforming the meaning of images and events: in this case from helpless victimhood to active resistance. By inhabiting the identity of the Hooded Man, whether truthfully or not, or for whatever motivation, Qassi crossed the threshold, not from the virtual to the real, but from the virtual to the actual. The virtual trauma of torture in Abu Ghraib, enacted for the camera and reproduced by various visual media,

contained the potential for future events and acts and thereby the ongoing transformation of its meanings.

CONCLUSION

In this book I have argued against what I call the 'transmission model' of trauma, which understands visual media as able to directly convey a traumatic experience to a viewer, and thereby potentially to traumatize him/her. This 'transmission model' frequently supports the memorialization of specific events and thereby reinforces particular forms of collective identification. In the case of events such as World War II, the Holocaust and 9/11 these identifications are mostly with Western liberal democracy and capitalism. Claims to transmit trauma through media can form part of the politics of shock that in turn serves as a pretext for military force, or curtailment of civil liberties. I am skeptical about the possibility of media images literally transmitting trauma, in the sense of a subjective individual experience. However, images can certainly shock and disorient the public and for this reason they can have considerable political power.

In contrast to the 'transmission model' I argue in favor of an understanding of historical trauma in which the construction of specific events as traumatic is understood with reference to the politics of technological media and nation states, including their colonial ideologies and global impact. Historical trauma, then, responds to a crisis of identity as an opportunity for critical reflection on the structures of sovereign power and political violence. Such a critical theory of historical trauma engages with the conceptual blockages and disruptions to self identity that result from crisis situations and looks for ways to renew our concepts of both what it is to be human and to belong to a community.

From Michelangelo's statue of Moses to the embalmed corpse of Lenin, from King Kong to the World Trade Center, historical trauma is bound to images of collective identity and aspiration, as well as to fantasy and anxiety. I have argued that trauma theory is more closely related to what used to be called mass culture than is often acknowledged. The trauma victim, from Auschwitz to Abu Ghraib, has become visible as an image available to be appropriated and mobilized by specific communities. Trauma, one might say, functions as the code by which the living seek communion with the dead. The victim/survivor may be more usefully understood as embodying the biopolitical reduction of the human to disposable life. In biopolitical terms, trauma functions as a shock to the body of the social collective: a shock which is able to be employed for strategic political goals. A traumatized community is a disoriented and passive community open to manipulation and therefore able to be directed into violent acts of retribution. Yet thinkers from Benjamin and Adorno, to Derrida and Žižek, have shown that trauma is also a "moment of danger" that can become an opportunity for critical reflection and re-evaluation—as well as potentially for new forms of solidarity and struggle.

Notes

NOTES TO INTRODUCTION

1. See Luckhurst 5; Leys, *Guilt to Shame* 158–179; LaCapra, *History in Transit* 144–194.
2. Trauma culture can in turn be seen as part of a larger cultural formation that Frank Furedi has called "therapy culture" in which increasing numbers of people, including children, define themselves in terms of their emotional state. Trauma has become normalized in social life and an over-used term in new and entertainment media, leading to an over-dependence on therapeutic counselors and other professionals. See Furedi 1–4.
3. See Felman and Laub, *Testimony* 204–283; LaCapra, *History and Memory After Auschwitz* 95–138; Caruth, *Unclaimed Experience* 25–56.

NOTES TO CHAPTER 1

1. This tendency is developed further in Langer, ed. *Art from the Ashes* and Hartman, *The Longest Shadow*.
2. The publication of articles written by De Man in the 1930s, in which he apparently expressed anti-Semitic views, led to further waves of accusation against deconstructive criticism. Felman included a chapter on De Man's work of mourning for the past in *Testimony* 120–164.
3. See Friedrich, *War against War!*, which includes images of Armenian civilians massacred in Turkey during World War I.
4. Janet Walker's *Trauma Cinema: Documenting Incest and the Holocaust* follows the precedent of Kaplan's book insofar as Walker tends to make generalizations about events from the traumatic experience of particular individuals and communities, as she states "most people were horrified to experience, witness or learn about the assault on the United States" (xvi). In this statement the differences between victims and those who were informed about events by news media or word of mouth collapse into a global consensus. The logic of such statements may have more to do with the rhetorics of mass media and the speeds of information networks than any empirical reality. Moreover, Walker claims that film and video texts are intrinsically suited to represent "traumatic material" (xix) because they can "reproduce, mechanically or electronically, an actual profilmic or providseographic event" (xix). Here a reality which may be experienced as traumatic is potentially confused with a reality that can be experienced as an audiovisual representation. If the camera can "capture" reality it does not follow that a camera can capture a

particular experience of reality, although it may be employed in attempts to explain, analyze or simulate that experience in audiovisual language.

5. This logic can also be seen at work in the tendency of the post-war generation in West Germany to identify with the Jew as a victim. See Santner, *Stranded Objects* ix–x.

6. For a detailed discussion of Benjamin's and Adorno's construction of constellations, see Lewandowski, *Interpreting Culture: Rethinking Method and Truth in Social Theory* 38–67.

NOTES TO CHAPTER 2

1. Freud compares unconscious memory to a photographic negative that remains to be developed into conscious recognition in his early *Interpretation of Dreams* (5: 536) and his late work *Moses and Monotheism* (23: 126). The comparison is also made in "A Note on the Unconscious" (1912) (12: 264).

2. As Christopher Lane has shown, Foucault's relation with the psychoanalysis of Freud and Lacan was more complex and shifting than many of his followers have allowed. Foucault also made reference to the notion of an unconscious with respect to discourses and representations in the human sciences (Lane 316). My argument assumes that Foucault's perspectives on discourse and biopower can be integrated into a general theory of the optical unconscious. For example, the notion of a medical gaze is of central importance in *The Birth of the Clinic*. Agamben's discussion of Freud in *Homo Sacer* is limited to the question of the sacred in *Totem and Taboo* (*Homo Sacer* 75, 78). Agamben proposes that bare life constitutes a distinctly modern political problem that has not yet been fully acknowledged. I incorporate this proposal into my argument that images of bare life form a part of the optical unconscious in the writings of Freud and Benjamin.

3. Roberto Espisito argues that by complicating the identity of Moses as founding father of Judaism, Freud subverted Nazi racial ideology. However, my reading of *Moses and Monotheism* stresses that Freud cannot directly address modern forms of state terror because his understanding of historical trauma is based on an analogy with the psychic structure of the individual, who remains conceived in essentially ahistorical terms.

4. Freud also notes the inevitable inaccuracies of the photographic metaphor: "I see no necessity to apologize for the imperfections of this or any similar imagery. Analogies of this kind are only intended to assist us in our attempt to make the complications of mental functioning intelligible by dissecting the function and assigning its different constituents to different component parts of the apparatus" (5: 536).

5. For a discussion of some of these passages, see Kofman 21–28, Cadava 97–99 and Batchen 186–187.

6. On this point we can compare Cadava's reference to the photograph in such statements as "There has never been a time without the photograph, without the residue and writing of light" (5) to Derrida's use of the term "photological": "we would have to attempt a return to the metaphor of darkness and light (of self-revelation and self-concealment), the founding metaphor of Western philosophy as metaphysics. The founding metaphor not only because it is a photological one—and in this respect the entire history of our philosophy is a photology, the name given to a history of, a treatise on light—but because it is a metaphor" (*Writing and Difference* 31). Derrida's

term does not run the risk of conflating the metaphor of writing with light with the historical advent of photography as a technological medium.

7. The idea that photographs block memory comes not from Freud or Benjamin but from Barthes. Barthes writes: "Not only is the Photograph never, in essence, a memory . . . but it actually blocks memory, quickly becomes a counter-memory" (*Camera Lucida* 91). Baer cites this passage from Barthes in *Spectral Evidence* 5.

8. "Everything that can be an object of our internal perception is *virtual*, like the image produced in a telescope by the passage of light rays. But we are justified in assuming the existence of the systems (which are not in any way psychical entities themselves and can never be accessible to our psychical perception) like the lenses of a telescope, which cast the image. If we pursue this analogy, we may compare the censorship between two systems to the refraction which takes place when a ray of light passes into a new medium." (Freud 5: 611)

9. This theoretical turn in Freud's writing has earned him the ongoing enmity of those psychotherapists who wish to ground Post Traumatic Stress Disorder in external events. Leys has suggested that this hostility to Freud is itself implicated in the politico-juridical functions of PTSD. After all, it is too easy to seek to undermine the claims of traumatized individuals and groups by dismissing their distress as based on a fantasy of victimhood. Leys attempts to move beyond this debate by stressing that for Freud fantasy was an inescapable dimension on human identity and that this structural problem should not be evaded by seeking to place traumatic experience outside problems of language, representation and interpretation.

10. See Showalter, *Hystories* 40–42 for an account of this problem.

11. Foucault describes the clinical gaze "that envelopes, caresses, details, atomizes the most individual flesh and enumerates its secret bites is that that fixed, attentive, rather dilated gaze which, from the height of death, has already condemned life" (*Birth of the Clinic* 171).

12. Lilian R. Furst suggests that the lower-class origins of Charcot's patients precluded effective dialogue with the clinician, resulting in Charcot's authoritarian style and emphasis on visual evidence. She argues that Freud was able to establish a complex verbal relationship with his middle-class patients. See Furst, *Before Freud* 117.

13. For a detailed discussion of this notion, see Tate, *Modernism, History and the First World War* 64–95.

14. As Rainer Nagele comments, the *fort-da* scene in Freud was to receive an entirely new currency after Lacan's structural linguistic reading became so influential. But Nagele stresses that Benjamin's interpretation of the child's game forms part of his larger theory of historical materialism. See Nagele 59–60.

NOTES TO CHAPTER 3

1. Caruth's 1995 anthology *Trauma: Explorations in Memory* does include an important essay by Kevin Newmark on Benjamin and Baudelaire. Benjamin's theory of shock was the subject of substantial commentary in the early 1990s by cultural historians such as Wolfgang Schivelbusch, Susan Buck-Morss, Margaret Cohen, and film scholars Miriam Hansen, Tom Gunning and Anne Friedberg.

2. See Buck-Morss, *The Origins of Negative Dialectics* 17.

3. Benjamin's essay "The Work of Art in the Age of Mechanical Reproduction" is a widely cited text in film and media studies. Adorno has been more commonly cited in recent studies of cinematic representations of the Holocaust.

4. More recent writing about film oriented toward diasporic and exilic experience has offered new insights into the relations between cinema, social space and place. For example, see Naficy, *An Accented Cinema*.

5. As Arendt showed, the sovereignty of the people enshrined in the Rights of Man excluded non-citizens, later giving rise to the problem of stateless people, to which Jews became increasingly vulnerable. See Arendt, *Origins of Totalitarianism* 272.

6. For a more detailed discussion of the relation between colonial conquest and Nazism, see Enzo Traverso, *The Origins of Nazi Violence* 47–75.

7. Arendt emphasized the colonialist dimension of Nazi expansion into Eastern Europe (*Origins* 222–223) as well as the precedents for Nazi extermination and enslavement to be found in the colonization of the Americas, Australia and Africa (440). However, Arendt herself is not immune from massive gestures of historical erasure, such as when she writes: "Colonization took place in America and Australia, the two continents that, without a culture and a history of their own, had fallen into the hands of Europeans" (186).

8. See Ray, *A Certain Tendency in Hollywood Cinema* 59–66.

9. Buck-Morss explains that as early as 1926 Adorno had formulated a critique of certain theories of the unconscious as irrationalist responses to modern capitalism and as precursors of fascist ideology. Adorno saw an antidote to these tendencies in Freudian psychoanalysis as disenchantment. See *The Origin of Negative Dialectics* 18–19.

10. Benjamin's economic dependence on support from the Institute of Social Research meant that he was also subject to the changing political positions that held sway in the Institute. Adorno's responses to Benjamin's submissions reflected these changing positions. At this time Adorno and Horkheimer were particularly concerned that Benjamin's theory was compatible with a materialist critique of commodity fetishism. This meant that they were uneasy about Benjamin's preoccupation with writers such as Ludwig Klages, whose theory of the unconscious remained metaphysical. See Wiggerhaus 194–195, 197–200.

11. Dumas had himself been sent by the French government on a paid trip to Tunis for the purpose of publicizing the colonies. See Benjamin 4: 15.

12. Benjamin's interest in the image of the Mohican in French fiction may have been influenced by the Surrealist fascination with pulp fiction, including the legendary *Fantomas* who embodies a similar conjunction of mystery and boundless terror. For a detailed discussion of the Surrealist interest in popular culture, see Walz, *Pulp Surrealism*. It would appear that Benjamin owes the specific observation about the historical link between the detective story and the novels of Cooper to Roger Caillois, whom he cites in the section on the *flâneur* in the *Arcades Project*. See Benjamin, *Arcades Project* 439.

13. For a comprehensive discussion of Mohicans myth, see Barker and Sabin, *The Lasting of the Mohicans*.

14. For a comparison between Benjamin's dialectical images and Freudian psychoanalysis, see Lukacher, *Primal Scenes* 280–281.

15. Wolfgang Schivelbusch has developed these arguments in important ways in *The Railway Journey*.

16. For an account of Wagner's politics, see Cohen, "To the Dresden Barricades."

17. For visual examples and analysis of this question, see Schnapp, *Revolutionary Tides*.

NOTES TO CHAPTER 4

1. This interpretation was not accepted by all those on the left. For example, Robert C. Young has noted that the French Communist Party opposed Algerian independence. See Young, *Postcolonialism* 419.
2. For a discussion of the fist as political symbol, see Schnapp, *Revolutionary Tides* 46–52.
3. See Derrida, "Paul De Man's War"; Felman and Laub, *Testimony*, 120–164; Santner, *Stranded Objects*, 13–30; LaCapra, *History and Memory*, 74–77.

NOTES TO CHAPTER 5

1. 1961 was also the year in which Raul Hilberg's seminal study *The Destruction of the European Jews* first appeared. Sylvia Plath's famous use of Holocaust imagery in her poetry dates from 1962. For a detailed account of an emerging "myth" of the Holocaust, see Tim Cole, *Images of the Holocaust* 7–19.
2. James Young has provided a detailed analysis of the ways that video testimony constructs the survivors' experiences into specific textual forms. *Writing and Rewriting the Holocaust* 157–171.
3. Felman writes: "many of them attain, surprisingly, in the very structure of their occurrence, the dimension of discovery and of advent and the power and significance and impact of a true *event* of language—an event which can unwittingly resemble a poetic, or a literary act" (*Testimony* 41).
4. On this point, see also Santner, *Stranded Objects* 13–30.
5. See *Specters of Marx* 52–53 and also *Echographies of Television*.
6. Kali Tal has proposed that in this way Felman's and Laub's book initiates a new displacement of moral authority from the survivor to the witness and, implicitly, to the academic interpreter. See Tal 53.
7. According to Laub the Holocaust created a world in which "one *could not bear witness to oneself.* The Nazi system turned out to be foolproof, not only in the sense that there were in theory no outside witnesses but also in the sense that it convinced its victims, the potential witnesses from the inside, that what was affirmed about their 'otherness' and their inhumanity was correct and that their experiences were no longer communicable even to themselves, and therefore perhaps never took place" (Laub, *Testimony* 82).
8. On this problem, see also Leys, *Trauma*, Chapters 7 and 8.
9. Hirsch discusses the example of a film, shot by German naval sergeant Reinhard Wiener in 1941, of a massacre of Latvian Jews. He suggests that this unique footage of the Final Solution functions as a "traumatic relay, transmitting a shock from a specific scene of victimization . . . to other scenes, scenes of remote and mediated witnessing" (Hirsch 13–14). Didi-Huberman's example is his own study of four photographs produced by members of the *Sonderkommando* at Auschwitz—the inmates who disposed of bodies from the gas chambers—in August 1944 which show Hungarian Jewish prisoners being hoarded toward the gas chambers and their naked bodies subsequently being cremated in open pits.

NOTES TO CHAPTER 6

1. For useful discussions of these mediated events see Re:Public (ed), *Planet Diana: Cultural Studies and Global Mourning* and Douglas Kellner, *The Persian Gulf TV War.*

2. Geoffrey Hartman offers a similar view of the events. See "On That Day" 9.
3. Kali Tal has also written of the codification of Holocaust narratives. See *Worlds of Hurt* 6-7.
4. This did not prevent one mental health study in 2002 from estimating that "more than 500,000 people in the New York metropolitan area would have developed PTSD as a direct result of the attacks" (Furedi 13).
5. See Felman's essay on Camus's *The Fall* in *Testimony* 165-203, and Caruth, *Unclaimed Experience* 73-90.
6. Žižek cites Lacan's comment that "the only act which is not a failure, the only act *stricto sensu* is suicide" ("Rossellini" 22).
7. For a detailed discussion of Žižek's critique of Derrida with respect to the question of trauma see Andrea Hurst, *Derrida vis-a-vis Lacan* 78-90.
8. Mitchell discusses the resonances of the Hooded Man with Christian iconography of the martyr (200).

Bibliography

Ackermann, Ulrike. "Totalitarian Attempts, Anti-Totalitarian Networks: Thoughts on the Taboo of Comparison." *The Lesser Evil: Moral Approaches to Genocide Practices*. Eds. Helmut Dubiel and Gabriel Motzkin. London and New York: Routledge, 2004. 169–181.

Adorno, Theodor W. *Can One Live After Auschwitz? A Philosophical Reader*. Ed. Rolf Tiedmann. Trans. Rodney Livingston and Others. Stanford: Stanford UP, 2003.

———. *Critical Models: Interventions and Catchwords*. Trans. Henry W. Pickford. New York: Columbia UP, 1998.

———. *The Culture Industry: Selected Essays on Mass Culture*. Ed. J. M. Bernstein. London and New York: Routledge, 1991.

———. "Freudian Theory and the Pattern of Fascist Propaganda." *The Essential Frankfurt School Reader*. Eds. Andrew Arato and Eike Gebhardt. New York: Continuum, 1993. 118–137.

———. *In Search of Wagner*. Trans. Rodney Livingston. London and New York: Verso, 2005.

———. "Letters to Walter Benjamin." Bloch et al. *Aesthetics and Politics*. London and New York: Verso, 1977. 110–133.

———. *Minima Moralia: Reflections from Damaged Life*. Trans. E. F. N. Jephcott. London and New York: Verso, 1978.

———. *Negative Dialectics*. Trans. E. B. Ashton. New York: Continuum, 1973.

———. *Prisms*. Trans. Samuel and Shierry Weber. Cambridge, Massachusetts: MIT Press, 1981.

Adorno, Theodor W., and Walter Benjamin. *The Complete Correspondence, 1928–1940*. Ed. Henri Lonitz. Trans. Nicholas Walker. Cambridge: Polity Press, 1999.

Adorno, Theodor W., et al. *The Authoritarian Personality*. New York: Harper, 1950.

Agamben, Giorgio. *Homo Sacer: Sovereign Power and Bare Life*. Trans. Daniel Heller-Roazen. Stanford, California: Stanford UP, 1998.

———. *Means Without End: Notes on Politics*. Trans. Vincenzo Binetti and Cesare Casarino. Minneapolis: U of Minnesota P, 2000.

———. *State of Exception*. Trans. Kevin Attell. Chicago and London: U of Chicago P, 2005.

Alexander, Jeffrey C. "Toward a Theory of Cultural Trauma." *Cultural Trauma and Collective Identity*. Eds. Jeffrey C. Alexander et al. Berkeley, Los Angeles, London: U of California P, 2004. 1–30.

Allen, Richard W. "The Aesthetic Experience of Modernity: Benjamin, Adorno, and Contemporary Film Theory." *New German Critique* 40 (1987): 225–240.

Arendt, Hannah. *The Human Condition.* Chicago and London: U of Chicago P, 1998.

———. "Introduction." Walter Benjamin, *Illuminations.* Ed. Hannah Arendt. Trans. Harry Zohn. Glasgow: Fontana, 1973. 1–55.

———. *The Origins of Totalitarianism.* San Diego, New York and London: Harcourt Brace Jovanovich, 1979.

Baer, Ulrich. *Remnants of Song: Trauma and the Experience of Modernity in Charles Baudelaire and Paul Celan.* Stanford: Stanford UP, 2000.

———. *Spectral Evidence: The Photography of Trauma.* Cambridge, Massachusetts and London: MIT Press, 2002.

Ball, Karyn. "Ex/propriating Survivor Experience, or Auschwitz 'after' Lyotard." *Witness and Memory: The Discourse of Trauma.* Eds. Anna Douglas and Thomas A. Vogler. London and New York: Routledge, 2003. 249–273.

Barbrook, Richard. "HyperMedia Freedom." *Crypto Anarchy, Cyberstates, and Pirate Utopias.* Ed. Peter Ludlow. Cambridge, Massachusetts: MIT Press, 2001. 47–58.

Barker, Martin, and Roger Sabin. *The Lasting of the Mohicans: History of an American Myth.* Jackson: UP of Mississippi, 1995.

Barthes, Roland. *Camera Lucida: Reflections on Photography.* Trans. Richard Howard. New York: Noonday, 1981.

———. *Image Music Text.* Trans. Stephen Heath. New York: Noonday Press, 1977.

———. *Mythologies.* Trans. Annette Lavers. New York: Hill and Wang, 1972.

———. *Pleasure of the Text.* Trans. Richard Miller. New York: Hill and Wang, 1975.

———. *Writing Degree Zero.* Trans. Annette Lavers and Colin Smith. New York: Noonday Press, 1968.

Batchen, Geoffrey. *Burning with Desire: The Conception of Photography.* Cambridge, Massachusetts; London: MIT Press, 1997.

Baudrillard, Jean. *Paroxysm: Interviews with Philippe Petit.* Trans. Chris Turner. London and New York: Verso, 1998.

———. *Simulacra and Simulation.* Trans. Sheila Faria Glaser. Ann Arbor: U of Michigan P, 1994.

———. *The Spirit of Terrorism and Requiem for the Twin Towers.* Trans. Chris Turner. London and New York: Verso, 2002.

Bauman, Zygmunt. "A Century of Camps?" *The Bauman Reader.* Ed. Peter Beilharz. Oxford: Blackwell, 2001. 266–280.

Bazin, Andre. *What is Cinema?* Trans. Hugh Gray. Berkeley, Los Angeles and London: U of California P, 1967.

Benjamin, Walter. *The Arcades Project.* Trans. Howard Eiland and Kevin McLaughlin. Cambridge, Mass.: Harvard UP, 1999.

———. *Selected Writings Volumes 1–4.* Eds. Marcus Bullock, Michael W. Jennings, Howard Eiland and Gary Smith. Trans. Edmund Jephcott and Others. Cambridge, Massachusetts and London: Belknap Press, 1996–2003.

Berger, James. *After The End: Representations of Post-Apocalypse.* Minneapolis and London: U of Minnesota P, 1999.

Berger, John. *About Looking.* New York: Pantheon, 1980.

Bernard-Donalis, Michael, and Richard Glejzer. *Between Witness and Testimony: The Holocaust and the Limits of Representation.* State U of New York P, 2001.

Bhabha, Homi K. "Arrivals and Departures." *Home, Exile, Homeland: Film, Media and the Politics of Place.* Ed. Hamid Naficy. New York and London: Routledge, 1999. vii–xii.

Borradori, Giovanna. *Philosophy in a Time of Terror: Dialogues with Jurgen Habermas and Jacques Derrida.* Chicago and London: U of Chicago P, 2003.

Brantlinger, Patrick. "Forgetting Genocide: OR the Last of *The Last of the Mohicans.*" *Cultural Studies* 12.1 (1998): 15–30.

Breuer, Joseph, and Sigmund Freud. *Studies on Hysteria.* Trans. James Strachey. *Standard Edition of the Complete Psychological Works of Sigmund Freud. Volume II.*

Brill, Lesley. *Crowds, Power, and Transformation in Cinema.* Detroit: Wayne State UP, 2006.

Brown, Andrew. *Roland Barthes: The Figure of Writing.* Oxford: Clarendon Press, 1992.

Buck-Morss, Susan. *Dreamworld and Catastrophe: The Passing of Mass Utopia in East and West.* Cambridge, Massachusetts; London: MIT Press, 2000.

———. *The Origin of Negative Dialectics: Theodor W. Adorno, Walter Benjamin, and the Frankfurt Institute.* New York: Free Press, 1977.

Cadava, Eduardo. *Words of Light: Theses on the Photography of History.* Princeton, New Jersey: Princeton UP, 1997.

Camus, Albert. "A Letter to the Editor of *Les Temps Modernes.*" *Sartre and Camus: A Historic Confrontation.* Eds. David A. Spintzen and Adrian van den Hoven. New York: Humanity Books, 2004. 107–129.

Caroll, Noel. "*King Kong*: Ape and Essence." *Planks of Reason: Essays on the Horror Film.* Ed. Barry Keith Grant. Metuchen, New Jersey and London: Scarecrow Press, 1984. 215–244.

Caruth, Cathy. "Trauma and Experience: Introduction." *Trauma: Explorations in Memory.* Ed. Cathy Caruth. Baltimore and London: Johns Hopkins UP, 1995. 3–12.

———. *Unclaimed Experience: Trauma, Narrative, and History.* Baltimore and London: Johns Hopkins UP, 1996.

Cohen, Margaret. *Profane Illumination: Walter Benjamin and the Paris of Surrealist Revolution.* Berkeley, Los Angeles, London: U of California P, 1993.

Cohen, Mitchell. "To the Dresden Barricades: the Genesis of Wagner's Political Ideas." *The Cambridge Companion to Wagner.* Ed. Thomas S. Grey. Cambridge: Cambridge UP, 2008. 47–63.

Cole, Tim. *Images of the Holocaust: The Myth of the "Shoah Business."* London: Duckworth, 1999.

Creeber, Glen. *Serial Television: Big Drama on a Small Screen.* London: BFI, 2004.

Dean, Carolyn J. *The Fragility of Empathy after the Holocaust.* Ithaca and London: Cornell UP, 2004.

De Koven, Marianne. *Utopia Limited: The Sixties and the Emergence of the Postmodern.* Durham and London: Duke UP, 2004.

De Man, Paul. *The Resistance to Theory.* London and Minneapolis: U of Minnesota P, 1986.

Der Derian, James. "*In Terrorem*: Before and After 9/11." *Worlds in Collision: Terror and the Future of the Global Order.* Eds. Ken Booth and Tim Dunne. Hampshire, London: Palgrave, 2002. 101–117.

Derrida, Jacques. "Like the Sound of the Sea Deep within a Shell: Paul de Man's War." Trans. Peggy Kamuf. *Critical Inquiry* 3 (1988): 590–652.

———. *Specters of Marx: The State of the Debt, the Work of Mourning, and the New International.* Trans. Peggy Kamuf. New York and London: Routledge, 1994.

———. *The Work of Mourning.* Eds. Pascale-Anne Brault and Michael Naas. Chicago and London: U of Chicago P, 2001.

———. *Writing and Difference.* Trans. Alan Bass. Chicago: U of Chicago P, 1978.

Derrida, Jacques, and Elizabeth Roudinesco. *For What Tomorrow . . . A Dialogue.* Trans. Jeff Fort. Stanford: Stanford UP, 2004.

Derrida, Jacques, and Bernard Steigler. *Echographies of Television.* Trans. Jennifer Bajorek. Cambridge: Polity Press, 2002.

Des Pres, Terence. *The Survivor: An Anatomy of Life in the Death Camps.* New York: Oxford UP, 1976.

Didi-Huberman, Georges. *Images in Spite of All: Four Photographs from Auschwitz.* Trans. Shane B. Lillis. Chicago and London: U of Chicago P, 2008.

Donesan, Judith E. *The Holocaust in American Film.* New York: Syracuse UP, 2002.

Dorfman, Ariel. "The Last September 11." *Chile: The Other September 11. An Anthology of Reflections on the 1973 Coup.* Eds. Pilar Aguilera and Ricardo Fredes. Melbourne, New York: Ocean Press, 2006. 1–5.

Eaglestone, Robert. *The Holocaust and the Postmodern.* Oxford: Oxford UP, 2004.

Edkins, Jenny. *Trauma and the Memory of Politics.* Cambridge: Cambridge UP, 2003.

———. "Whatever Politics." *Giorgio Agamben: Sovereignty and Life.* Eds. Mathew Calarco and Steven DeCaroli. Stanford: Stanford UP, 2007. 70–91.

Eisenmann, Stephen F. *The Abu Ghraib Effect.* London: Reaktion Books, 2007.

Eisenstein, Sergei. *Film Form: Essays in Film Theory.* Ed. and Trans. Jay Leda. San Diego, New York, London: Harcourt Brace Janovich, 1949.

Ellis, John. *Seeing Things: Television in the Age of Uncertainty.* London: I. B. Tauris, 2000.

Elsaesser, Thomas. "Postmodernism as Mourning Work." *Screen* 42: 2 (2001): 193–201.

———. "Subject Positions, Speaking Positions: From *Holocaust, Our Hitler,* and *Heimat* to *Shoah* and *Schindler's List*." *The Persistence of History: Cinema, Television, and the Modern Event.* Ed. Vivian Sobchack. New York and London: Routledge, 1996. 145–183.

Erb, Cynthia. *Tracking King Kong: A Hollywood Icon in World Culture.* Detroit: Wayne State UP, 1998.

Esposito, Roberto. *Bios: Biopolitics and Philosophy.* Minneapolis and London: U of Minnesota P, 2008.

Felman, Shoshana. *The Juridical Unconscious: Trials and Traumas in the Twentieth Century.* Cambridge, Massachusetts and London: Harvard UP, 2002.

Felman, Shoshana, and Dori Laub, M.D. *Testimony: Crises of Witnessing in Literature, Psychoanalysis and History.* New York and London: Routledge, 1992.

Finkelstein, Norman G. *The Holocaust Industry: Reflections on the Exploitation of Jewish Suffering.* London and New York: Verso, 2000.

Foster, Hal. *The Return of the Real: The Avant-Garde at the End of the Century.* Cambridge, Massachusetts; London: MIT Press, 1996.

Foucault, Michel. *The Birth of the Clinic: An Archaeology of Medical Perception.* Trans. A. M. Sheridan Smith. New York: Pantheon Books, 1973.

———. *The History of Sexuality Volume 1.* Trans. Robert Hurley. London: Penguin, 2008.

Freud, Sigmund. *The Standard Edition of the Complete Psychological Works of Sigmund Freud, Volumes 1–24.* Ed. James Strachey. London: Hogarth Press and the Institute of Psychoanalysis, 1953–74.

Friedberg, Anne. *Window Shopping: Cinema and the Postmodern.* Berkeley, Los Angeles, Oxford: U of California P, 1993.

Friedlander, Saul. *Memory, History, and the Extermination of Jews in Europe.* Bloomington and Indianapolis: Indiana UP, 1993.

Fukuyama, Francis. "History and September 11." *Worlds in Collision: Terror and the Future of Global Order.* Eds. Ken Booth and Tim Dunne. London and New York: Palgrave MacMillan, 2002. 27–36.

Furedi, Frank. *Therapy Culture: Cultivating Vulnerability in an Uncertain Age.* London and New York: Routledge, 2004.

Furst, Lilian R. *Before Freud: Hysteria and Hypnosis in Late-Nineteenth Century Psychiatric Cases.* Lewisburg: Bucknell UP, 2008.

Gilman, Sander L. "The Image of the Hysteric." *Hysteria Beyond Freud.* Eds. Sander L. Gilman et al. Berkeley, Los Angeles, London: U of California P, 1993. 345–452.

Gilroy, Paul. *Postcolonial Melancholia.* New York: Columbia UP, 2005.

Ginsberg, Terri. *Holocaust Film: The Political Aesthetics of Ideology.* Newcastle: Cambridge Scholars Publishing, 2007.

Godard, Jean-Luc, and Youssef Ishaghpour. *Cinema: The Archaeology of Film and the Memory of a Century.* Trans. John Howe. Oxford, New York: Berg, 2005.

Griffiths, Alison. *Wondrous Difference: Cinema, Anthropology, and Turn-of-the-Century Visual Culture.* New York: Columbia UP, 2002.

Guerin, Frances, and Roger Hallas. "Introduction." *The Image and the Witness: Trauma, Memory and Visual Culture.* Eds. Guerin and Hallas. London and New York: Wallflower Press, 2007. 1–20.

Hansen, Miriam Bratu. "Benjamin, Cinema and Experience: 'The Blue Flower in the Land of Technology'." *New German Critique* 40 (1987): 179–225.

———. "Benjamin and Cinema: Not a One-Way Street." *Critical Inquiry* 25 (1999): 306–343.

———. "Mass Culture as Hieroglyphic Writing: Adorno, Derrida, Kracauer." *New German Critique* 56 (1992): 43–73.

———. "*Schindler's List* is not *Shoah*: The Second Commandment, Popular Modernism, and Public Memory." *Critical Inquiry* (1996): 292–312.

Hartman, Geoffrey H. *The Longest Shadow: In the Aftermath of the Holocaust.* Bloomington and Indianapolis: Indiana UP, 1996.

———. "On That Day." *Trauma at Home: After 9/11.* Ed. Judith Greenberg. Lincoln and London: U of Nebraska P, 2003. 5–10.

Herman, Judith Lewis, M.D. *Trauma and Recovery.* New York: Basic Books, 1997.

Hirsch, Joshua. *Afterimage: Film, Trauma, and the Holocaust.* Philadelphia: Temple UP, 2004.

Hirsch, Marianne. *Afterimage: Film, Trauma, and the Holocaust.* Philadelphia: Temple UP, 2004.

———. *Family Frames: Photography, Narrative and Postmemory.* Cambridge, Massachusetts and London: Harvard UP, 1997.

———. "I Took Pictures: September 2001 and Beyond." *Trauma at Home: After 9/11.* Ed. Judith Greenberg. Lincoln and London: U of Nebraska P, 2003. 69–86.

Hohendahl, Peter Uwe. *Prismatic Thought: Theodor W. Adorno.* Lincoln and London: U of Nebraska P, 1995.

Holloway, David. *Cultures of the War on Terror: Empire, Ideology, and the Remaking of 9/11.* Montreal and Kingston; Ithaca: McGill-Queens UP, 2008.

Horkheimer, Max, and Theodor W. Adorno. *Dialectic of Enlightenment.* Trans. John Cumming. New York: Continuum, 1993.

Hoskins, Andrew, and Ben O'Laughlin. *Television and Terror: Conflicting Times and the Crisis of News Discourse.* Hampshire, New York: Palgrave McMillan, 2007.

Hurst, Andrea. *Derrida vis-a-vis Lacan: Interweaving Deconstruction and Psychoanalysis.* New York: Fordham UP, 2008.

Huyssen, Andreas. "Adorno in Reverse: From Hollywood to Richard Wagner." *New German Critique* 29 (1983): 8–38.

———. *After the Great Divide: Modernism, Mass Culture, Postmodernism.* London: MacMillan, 1986.

———. *Present Pasts: Urban Palimpsests and the Politics of Memory.* Stanford: Stanford UP, 2003.

————. "Trauma and Memory: A New Imaginary of Temporality." *World Memory: Personal Trajectories in Global Time*. Eds. Jill Bennett and Rosanne Kennedy. Hampshire, New York: Palgrave, 2003. 16–29.

————. *Twilight Memories: Marking Time in a Culture of Amnesia*. New York and London: Routledge, 1995.

Jarvis, Simon. *Adorno: A Critical Introduction*. Cambridge: Polity Press, 1998.

Jay, Martin. *Downcast Eyes: The Denigration of Vision in Twentieth-Century French Thought*. Berkeley, Los Angeles, London: U of California P, 1993.

Jeanson, Francis. "Albert Camus, or The Soul in Revolt." *Sartre and Camus: A Historic Confrontation*. Eds. David A. Spintzen and Adrian van den Hoven. New York: Humanity Books, 2004. 79–105.

Jenemann, David. *Adorno in America*. Minneapolis and London: U of Minnesota P, 2007.

Jones, Ernest. *The Life and Work of Sigmund Freud*. Eds. Lionel Trilling and Steven Marcus. London: Hogarth Press, 1963.

Jonsson, Stefan. "The Invention of the Masses: The Crowd in French Culture from the Revolution to the Commune." *Crowds*. Eds. Jeffrey T. Schnapp and Mathew Tiews. Stanford: Stanford UP, 2006. 47–75.

Kaes, Anton. *From Hitler to Heimat: The Return of History as Film*. Cambridge, Massachusetts; London: Harvard UP, 1989.

————. "History and Film: Public Memory in the Age of Electronic Dissemination." *Framing the Past: The Historiography of German Cinema and Television*. Eds. Bruce A. Murray and Christopher J. Wickham. Carbondale and Edwardsville: Southern Illinois UP, 1992. 308–323.

Kansteiner, Wulf. "Genealogy of a Category Mistake: A Critical History of the Cultural Trauma Metaphor." *Rethinking History* 8.2 (2004): 193–221.

Kaplan, E. Ann. *Trauma Culture: The Politics of Terror and Loss in Media and Literature*. New Brunswick, New Jersey and London: Rutgers UP, 2005.

Kaplan, E. Ann, and Ban Wang. "Introduction: From Traumatic Paralysis to the Force Field of Modernity." *Trauma and Cinema: Cross-Cultural Explorations*. Eds. E. Ann Kaplan and Ban Wang. Hong Kong UP, 2004. 1–22.

Kellner, Douglas. *The Persian Gulf TV War*. Boulder, San Francisco, Oxford: Westview Press, 1992.

Khanna, Ranjana. *Dark Continents: Psychoanalysis and Colonialism*. Durham and London: Duke UP, 2003.

Kofman, Sarah. *Camera Obscura of Ideology*. Trans. Will Straw. London: Athlone Press, 1998.

Kracauer, Siegfried. *From Caligari to Hitler: A Psychological History of German Film*. Princeton and Oxford: Princeton UP, 1947.

Kristeva, Julia. *Powers of Horror: An Essay on Abjection*. Trans. Leon S. Roudiez. New York: Columbia UP, 1980.

————. *Strangers to Ourselves*. Trans. Leon S. Roudiez. New York: Columbia UP, 1991.

Krystal, Henry M.D. "Studies of Concentration Camp Survivors." *Massive Psychic Trauma*. Ed. Henry Krystal. New York: International Universities Press, 1968. 23–46.

LaCapra, Dominick. *History and Memory after Auschwitz*. Ithaca and London: Cornell UP, 1998.

————. *History in Transit: Experience, Identity, Critical Theory*. Ithaca and London: Cornell UP, 2004.

————. "Holocaust Testimonies: Attending to the Victim's Voice." *Catastrophe and Meaning: The Holocaust and the Twentieth Century*. Eds. Moishe Postone and Eric Santner. Chicago and London: U of Chicago P, 2003. 209–231.

———. *Representing the Holocaust: History, Theory, Trauma*. Ithaca and London: Cornell UP, 1994.

———. *Writing History, Writing Trauma*. Baltimore and London: Johns Hopkins UP, 2001.

Lane, Christopher. "The Experience of the Outside: Foucault and Psychoanalysis." *Lacan in America*. Ed. Jean-Michel Rabate. New York: Other Press, 2000. 309–347.

Langer, Lawrence L. *The Age of Atrocity: Death in Modern Literature*. Boston: Beacon Press, 1978.

———, ed. *Art from the Ashes: A Holocaust Anthology*. Oxford, New York: Oxford UP, 1995.

———. *Holocaust Memories: The Ruins of Memory*. New Haven and London: Yale UP, 1991.

Laplanche, Jean. *Life and Death in Psychoanalysis*. Trans. Jeffrey Mehlman. Baltimore and London: Johns Hopkins UP, 1976.

Laub, Dori, M.D. "An Event Without a Witness: Truth, Testimony and Survival." *Testimony: Crisis of Witnessing in Literature, Psychoanalysis, and History*. Eds. Shoshana Felman and Dori Laub. New York and London: Routledge, 1992. 75–92.

———. "September 11, 2001—An Event without a Voice." *Trauma at Home: After 9/11*. Ed. Judith Greenberg. Lincoln and London: U of Nebraska P, 2003. 204–215.

Le Bon, Gustave. *The Crowd: A Study of the Popular Mind*. Middlesex: Penguin, 1977.

Lee, Lisa Yun. *Dialectics of the Body: Corporeality in the Philosophy of T.W. Adorno*. New York and London: Routledge, 2005.

Lentin, Ronit. "Postmemory, Unsayability and the Return of the Auschwitz Code." *Re-Presenting the Shoah for the Twenty-First Century*. Ed. Ronit Lentin. New York, Oxford: Berghan, 2004. 1–24.

Levi, Primo. *The Black Hole of Auschwitz*. Ed. Marco Belpoliti. Trans. Sharon Wood. Cambridge: Polity, 2005.

Lewandowski, Joseph D. *Interpreting Culture: Rethinking Method and Truth in Social Theory*. Lincoln and London: U of Nebraska P, 2001.

Leys, Ruth. *From Guilt to Shame: Auschwitz and After*. Princeton and Oxford: Princeton UP, 2007.

———. *Trauma: A Genealogy*. Chicago and London: U of Chicago P, 2000.

Lifton, Robert Jay. "Preface." Alexander and Margarete Mitscherlich. *The Inability to Mourn: Principles of Collective Behavior*. Trans. Beverley R. Placzek. New York: Grove Press, 1975. vii–xiii.

Luckhurst, Roger. *The Trauma Question*. London and New York: Routledge, 2008.

Lukacher, Ned. *Primal Scenes: Literature, Philosophy, Psychoanalysis*. Ithaca and London: Cornell UP, 1986.

Lyotard, Jean-Francois. *The Differend: Phrases in Dispute*. Trans. Georges Van Der Abbeele. London and Minneapolis: U. Minnesota P, 1988.

———. *Heidegger and "the jews"*. Trans. Andreas Michel and Mark Roberts. London and Minneapolis: U of Minnesota P, 1990.

———. *The Inhuman: Reflections on Time*. Trans. Geoffrey Bennington and Rachel Bowlby. Stanford: Stanford UP, 1991.

Manovich, Lev. *The Language of New Media*. Cambridge, Massachusetts: MIT Press, 2001.

Metz, Christian. *The Imaginary Signifier*. Trans. Celia Briton, Annwyl Williams, Ben Brewster and Alfred Guzzetti. Bloomington: Indiana UP, 1982.

Micale, Mark S. "Jean-Martin Charcot and *les neuroses traumatiques*: From Medicine to Culture in French Trauma Theory of the Late Nineteenth Century."

Traumatic Pasts: History, Psychiatry, and Trauma in the Modern Age, 1870–1930. Eds. Mark S. Micale and Paul Lerner. Cambridge: Cambridge UP, 2001. 115–139.

Miller, Nancy K., and Jason Tougaw. "Introduction: Extremities." *Extremities: Trauma, Testimony, and Community.* Eds. Nancy K. Miller and Jason Tougaw. Urbana and Chicago: U of Illinois P, 2002. 1–21.

Mirzoeff, Nicholas. "Ghostwriting: Working out Visual Culture." *Journal of Visual Culture*, 1.2 (2002): 239–254.

Mitchell, W. J. T. "Cloning Terror: The War of Images 2001–2004." *The Life and Death of Images: Ethics and Aesthetics.* Eds. Diarmund Costello and Dominic Willsdon. Ithaca, New York: Cornell UP, 2008. 179–207.

Mitscherlich, Alexander and Margarete. *The Inability to Mourn: Principles of Collective Behaviour.* Trans. Beverley R. Placzek. New York: Grove Press, 1975.

Moore, Rachel O. *Savage Theory: Cinema as Modern Magic.* Durham and London: Duke UP, 2000.

Moscovi, Serge. *The Age of the Crowd: A Historical Treatise on Mass Psychology.* Trans. J. C. Whitehouse. Cambridge: Cambridge UP, 1985.

Muller-Doohm, Stefan. *Adorno: A Biography.* Trans. Rodney Livingston. Cambridge: Polity, 2005.

Naficy, Hamid. *An Accented Cinema: Exilic and Diasporic Filmmaking.* Princeton and Oxford: Princeton UP, 2001.

Nagele, Rainer. *Theater, Theory, Speculation: Walter Benjamin and the Scenes of Modernity.* Baltimore and London: Johns Hopkins UP, 1991.

Nye, Robert A. *Crime, Madness, and Politics in Modern France: The Medical Concept of National Decline.* Princeton and Oxford: Princeton UP, 1984.

Perloff, Marjorie. "'What has Occurred Only Once': Barthes's Winter Garden/Boltanski's Archives of the Dead." *Writing the Image After Roland Barthes.* Ed. Jean-Marie Rabate. U of Pennsylvania P, 1997. 32–58.

Radstone, Susannah. "Screening Trauma: *Forrest Gump*, Film and Memory." *Memory and Methodology.* Ed. Susannah Radstone. Oxford and New York: Berg, 2000. 79–107.

———. "Trauma Theory: Contexts, Politics, Ethics." *Paragraph* 30:1 (2007): 10.

———. "The War of the Fathers: Trauma, Fantasy, and September 11." *Trauma at Home: After 9/11.* Ed. Judith Greenberg. Lincoln and London: U of Nebraska P, 2003. 117–123.

Ray, Robert B. *A Certain Tendency of the Hollywood Cinema, 1930-1980.* Princeton: Princeton UP, 1985.

Reinhardt, Mark. "Picturing Violence: Aesthetics and the Anxiety of Critique." *Beautiful Suffering: Photography and the Traffic in Pain.* Eds. Mark Reinhardt, Holly Edwards and Erina Duganne. Williamstown, MA and Chicago: Williams College Museum of Art and U of Chicago P, 2006. 13–36.

Rentschler, Carrie A. "Witnessing: US Citizenship and the Vicarious Experience of Suffering." *Media, Culture and Society* 26.2 (2004): 296–304.

Re: Public, ed. *Planet Diana: Cultural Studies and Global Mourning.* Nepean: U of Western Sydney, 1997.

Roff, Sarah Ley. "Benjamin and Psychoanalysis." *The Cambridge Companion to Walter Benjamin.* Ed. David S. Ferris. Cambridge: Cambridge UP, 2004. 115–133.

Ross, Kristin. *Fast Cars, Clean Bodies: Decolonization and the Reordering of French Culture.* Cambridge, Massachusetts; London: MIT Press, 1996.

———. *May '68 and its Afterlives.* Chicago and London: U of Chicago P, 2002.

Rothberg, Michael. "'There is No Poetry in This': Writing, Trauma, and Home." *Trauma at Home: After 9/11.* Ed. Judith Greenberg. Lincoln and London: U of Nebraska P, 2003. 147–157.

————. *Traumatic Realism: The Demands of Holocaust Representation.* Minneapolis and London: U of Minnesota P, 2000.

Said, Edward. *Culture and Imperialism.* London: Chatto and Windus, 1993.

Santner, Eric L. *On Creaturely Life: Rilke / Benjamin / Sebald.* Chicago and London: U of Chicago P, 2006.

————. *Stranded Objects: Mourning, Memory, and Film in Postwar Germany.* Ithaca and London: Cornell UP, 1990.

Sarat, Austin, Nadav Davidovitch, and Michael Alberstein, eds. *Trauma and Memory: Reading, Healing and Making Law.* Stanford: Stanford UP, 2007.

Sartre, Jean-Paul. "Reply to Albert Camus." *Sartre and Camus": A Historic Confrontation.* Eds. David A. Spintzen and Adrian van den Hoven. New York: Humanity Books, 2004. 131–161.

Saxton, Libby. *Haunted Images: Film, Ethics, Testimony and the Holocaust.* London and New York: Wallflower Press, 2008.

Schivelbusch, Wolfgang. *The Culture of Defeat: On National Trauma, Mourning, and Recovery.* Trans. Jefferson Chase. New York: Metropolitan, 2003.

————. *The Railway Journey: The Industrialization of Time and Space in the 19th Century.* Lemington Spa, Hamburg, New York: Berg, 1986.

Schmitt, Carl. *The* Nomos *of the Earth in the International Law of the* Jus Publicum Europaeum. Trans. G. L. Ulmen. New York: Telos Press, 2003.

Schnapp, Jeffrey T. *Revolutionary Tides: The Art of the Political Poster 1914–1989.* Milan: Skira, 2005.

Schorske, Carl E. *Fin-de-Siecle Viena: Politics and Culture.* New York: Vintage Books, 1981.

Shandler, Jeffrey. "Schindler's Discourse: America Discusses the Holocaust and its Mediation, from NBC's Miniseries to Spielberg's Film." *Spielberg's Holocaust: Critical Perspectives on Schindler's List.* Ed. Jeffrey Shandler. Bloomington and Indianapolis: Indiana UP, 1997. 153–168.

Shohat, Ella, and Robert Stam. *Unthinking Eurocentrism: Multiculturalism and the Media.* London and New York: Routledge, 1994.

Showalter, Elaine. *Hystories: Hysterical Epidemics and Modern Media.* New York: Columbia UP, 1997.

Silverman, Kaja. *Male Subjectivity at the Margins.* New York and London: Routledge, 1992.

Simmel, Georg. "The Metropolis and Mental Life." *The Sociology of Georg Simmel.* Ed. Kurt H. Wolff. Trans. Kurt H. Wolff. London: Collier-MacMillan, 1950. 409–424.

Sontag, Susan. *At the Same Time: Essays and Speeches.* Eds. Paulo Dilonardo and Anne Jump. London: Hamish Hamilton, 2007.

————. *On Photography.* New York: Farrar, Straus and Giroux, 1977.

————. *Regarding the Pain of Others.* New York: Farrar, Straus and Giroux, 2003.

Spencer, Philip. "The Shoah and Marxism: Behind and Beyond Silence." *Re-Presenting the Shoah for the Twenty-First Century.* Ed. Ronit Lentin. New York and Oxford: Berghahn, 2004. 155–177.

Sreberny, Anabelle. "Trauma Talk: Reconfiguring the Inside and Outside." *Journalism after September 11.* Eds. Barbie Zelizer and Stuart Allan. London and New York: Routledge, 2002. 220–234.

Stafford, Andy. *Roland Barthes, Phenomenon and Myth: An Intellectual Biography.* Edinburgh: Edinburgh UP, 1998.

Starr, Peter. *Logics of Failed Revolt: French Theory after May '68.* Stanford: Stanford UP, 1995.

Stier, Oren Baruch. *Committed to Memory: Cultural Mediations of the Holocaust.* Amherst and Boston: U of Massachusetts P, 2003.

Tagg, John. *The Burden of Representation: Essays on Photographies and Histories*. London and Minneapolis: U of Minnesota P, 1988.

Tal, Kali. *Worlds of Hurt: Reading the Literatures of Trauma*. Cambridge: Cambridge UP, 1996.

Tate, Trudi. *Modernism, History and the First World War*. Manchester: Manchester UP, 1998.

Taylor, John. *Body Horror: Photojournalism, Catastrophe and War*. Manchester: Manchester UP, 1998.

Thody, Philip. *Roland Barthes: A Conservative Estimate*. London: MacMillan, 1977.

Torgovnick, Marianna. *The War Complex: World War II in Our Time*. Chicago and London: U of Chicago P, 2005.

Traverso, Enzo. *The Origins of Nazi Violence*. Trans. Janet Lloyd. New York and London: New Press, 2003.

Trimarco, James, and Molly Hurley Depret. "Wounded Nation, Broken Time." *The Selling of 9/11: How a National Tragedy Became a Commodity*. Ed. D. Heller. New York: Palgrave MacMillan, 2005. 27–53.

Van der Kolk, Bessel A., and Onno Van der Hart. "The Intrusive Past: The Flexibility of Memory and the Engraving of Trauma." *Trauma: Explorations in Memory*. Ed. Cathy Caruth. Baltimore and London: Johns Hopkins UP, 1995. 158–182.

Virilio, Paul. *Ground Zero*. Trans. Chris Turner. London and New York: Verso, 2002.

Wagner, Richard. "On State and Religion." *Richard Wagner's Prose Works Volume IV: Art and Philosophy*. Trans. William Ashton Ellis. New York: Broude Brothers, 1966. 3–34.

Walker, Janet. *Trauma Cinema: Documenting Incest and the Holocaust*. Berkeley, Los Angeles, London: U of California P, 2005.

Walz, Robin. *Pulp Surrealism: Insolent Popular Culture in Early Twentieth Century Paris*. Berkeley, Los Angeles, London: U of California P, 2000.

Weigel, Sigrid. *Body-and-Image-Space: Re-reading Walter Benjamin*. Trans. Georgina Paul with Rachel McNicoll and Jeremy Gaines. London and New York: Routledge, 1996.

Wellmer, Albrecht. "Adorno, Modernity, and the Sublime." *The Actuality of Adorno: Critical Essays on Adorno and the Postmodern*. Ed. Max Pensky. New York: State U of New York P, 1997. 112–134.

Whitehead, Anne. "Introduction." *Theories of Memory: A Reader*. Eds. Michael Rossington and Anne Whitehead. Baltimore: Johns Hopkins UP, 2007. 186–191.

Wiggerhaus, Rolf. *The Frankfurt School: Its History, Theories and Political Significance*. Trans. Michael Roberston. Cambridge: Polity Press, 1994.

Williams, Rosalind. "The Dream World of Mass Consumption." *Rethinking Popular Culture*. Eds. Chandra Mukerji and Michael Schudson. Los Angeles: U of California P, 1991. 198–235.

Wood, Nancy. *Vectors of Memory: Legacies of Trauma in Postwar Europe*. Oxford and New York: Berg, 1999.

Young, Allan. *The Harmony of Illusions: Inventing Post-Traumatic Stress Disorder*. Princeton, New Jersey: Princeton UP, 1995.

———. "Posttraumatic Stress Disorder of the Virtual Kind: Trauma and Resilience in Post-9/11 America." *Trauma and Memory: Reading, Healing, and Making Law*. Eds. Austin Sarat, Nadd Davidovitch and Michael Alberstein. Stanford: Stanford UP, 2007. 21–48.

Young, James E. *Writing and Rewriting the Holocaust: Narrative and the Consequences of Interpretation*. Bloomington and Indianapolis: Indiana UP, 1990.

Young, Robert C. *Postcolonialism: An Historical Introduction.* Oxford: Blackwell, 2001.

Zelizer, Barbie. "Photography, Journalism and Trauma." *Journalism after September 11.* Eds. Barbie Zelizer and Stuart Allan. London and New York: Routledge, 2002. 48–68.

———. *Remembering to Forget: Holocaust Memory through the Camera's Eye.* Chicago and London: U of Chicago P, 1998.

Žižek, Slavoj. "Introduction: The Spectre of Ideology." *Mapping Ideology.* Ed. Slavoj Žižek. London and New York: Verso, 1994. 1–33.

———. *Iraq: The Borrowed Kettle.* London and New York: Verso, 2004.

———. "Rossellini: Woman as Symptom of Man." *October* 53 (1990): 19–44.

———. "Welcome to the Desert of the Real!" *Dissent from the Homeland: Essays after September 11.* Eds. Stanley Hauerwas and Frank Lentricchia. Durham and London: Duke UP, 2003. 131–135.

Index

A

Abu Ghraib prison, 17, 172, 192–195.
 See also war on terror
Adorno, Theodor W., 13, 21, 25–26,
 106, 107, 110, 111, 131, 134,
 185, 195; on Auschwitz, 2, 3,
 15–16, 18, 32, 45–46, 76–77,
 129, 133, 135–136, 143,
 144–150, 151, 153, 166, 176;
 on compulsive repetition, 97,
 99, 105; critique of Benjamin,
 73, 75, 85–87, 92, 94, 97; on
 crowds, 74, 79–80; on film, 2,
 40, 76, 78–79, 81, 102–104,
 165, 167, 200n3; use of Freud,
 14, 18, 23, 26, 36, 39–40, 47,
 73, 75–76, 77, 79, 86, 97–98,
 100–102, 105–106, 145–148,
 150, 200n9; on group identity,
 75, 76, 100–101, 145–146, 151,
 154; on historical trauma, 2, 9,
 14–15, 18–19, 24, 30, 32, 39–41,
 45–46, 73–74, 80–81, 99, 103,
 105–106, 164, 167, 176, 179;
 on *King Kong*, 15, 74, 76, 80,
 101–105; on mimesis, 36, 79,
 102; and Mitscherlichs, 149–150,
 151; on television drama, 152;
 Authoritarian Personality, 135;
 "Cultural Criticism and Society,"
 146–147; *Dialectic of Enlight-
 enment*, 25; "Education after
 Auschwitz," 148–149; "Freudian
 Theory and the Pattern of Fascist
 Propaganda," 98, 100; *Group
 Experiment*, 148; "The Meaning
 of Working Through the Past,"
 148; *In Search of Wagner*, 14, 18,
 24, 41, 74, 77, 97, 98–100, 101;

Minima Moralia, 3, 14, 73, 97,
 102–106; *Negative Dialectics*, 15,
 45, 135, 145, 148–149, 167
Agamben, Giorgio: on bare life, 3, 13,
 48, 134, 138, 142–143, 167,
 198n2; on biopolitics, 25, 48,
 56, 67, 141–142; on the term
 "Holocaust," 138–139; on
 political community, 29; on
 sovereignty, 2, 3, 25–26, 28,
 62, 130, 134, 139, 168; and
 trauma theory, 2; *Homo Sacer*,
 3, 25, 62, 83, 129, 168, 198n2;
 Remnants of Auschwitz, 134,
 139–140, 143–144
Alexander, Jeffrey C., 31
Algeria, 110, 113
Allende, Salvador, 186
Althusser, Louis, 81, 119
anti-Semitism,90, 91; and Adorno, 87;
 and Benjamin, 86–87; and De
 Man, 131; and Freud, 59–60,
 64, 66; and Wagner, 98. *See also*
 Jewish identity
Apaches, 90–91
Arendt, Hannah: on denationalization,
 29, 60–62, 67, 82, 200n5; and
 Eichmann trial, 133; on imperi-
 alism, 74, 141, 200n7; on optics,
 53, 56
aura, 9, 40, 69, 70, 81, 93, 128, 139
Auschwitz, 30, 195; Adorno on, 2, 3,
 15–16, 18, 32, 45–46, 76–77,
 133, 135–136, 143, 144–150,
 151, 153, 166, 176; Agamben
 on, 134–135, 139–140, 143–
 144, 168–169; representations
 of, 16, 46, 63, 133–137, 164,
 166–170

B

Baer, Ulrich, 19, 22–23, 29, 32, 37, 42, 47, 49, 51–52, 96, 159, 199n7

Barbrook, Richard, 84

bare life, 3, 13, 25–26, 48, 76, 105, 134–135, 138; and colonialism, 29; and denationalization, 29, 59–63; and film, 167; and identity politics, 49; the *Muselmann* as instance of, 140, 142–143; and photography, 24; and psychoanalysis, 59–63; and September 11, 185–186; and the sovereign, 168–169

Barthes, Roland, 21, 133, 134, 173; and colonialism, 113, 115, 129; on film stills, 117–119; and the Holocaust, 113, 129–130, 131–132; use of Lacan, 121; and Marxism, 110–112, 118–120; on photography, 2, 8–9, 15, 40, 107–132, 159, 183, 188, 199n7; *punctum*, 108, 120–125, 126–127, 128, 130; *studium*, 108, 120, 122, 126–127; and trauma theory, 125–128; *Camera Lucida*, 15, 108–109, 110, 116–117, 120–130; *Mythologies*, 107, 113, 124; "The Photographic Message," 107–108, 114–116; "The Rhetoric of the Image," 107, 116–117; "The Third Meaning," 15, 117–118, 120, 129–130; *Writing Degree Zero*, 110–112, 128

Battleship Potemkin, 70, 118

Baudelaire, Charles: Adorno's comments on, 73, 97–98; Benjamin's writings on, 12, 14, 18, 24, 73–75, 77–79, 83, 88–89, 91–98, 102, 105, 109; compared to Celan, 96

Baudrillard, Jean: on *Holocaust*, 152–153; on representations of the Holocaust, 134, 156–157; on September 11, 4, 33, 174–175

Bauman, Zygmunt, 43

Bazin, Andre, 36, 71

Benjamin, Walter, 21, 107, 110, 111, 131, 147, 159; on aura, 9, 40, 69, 70, 81, 93, 128; on Baudelaire, 12, 14, 18, 24, 73–75, 77–79, 83, 88–89, 91–98, 102, 105, 109; and the dialectical image, 1, 30, 40, 85–87, 94, 98, 146, 165, 168; and film, 2, 40, 76, 78, 80–82, 89, 200n3; use of Freud, 2, 13, 14, 24, 26, 36, 39, 67–74, 76–77, 86, 92–95, 105–106; and historical trauma, 2, 14, 16, 18, 19, 24, 32, 39–46, 73, 80–81, 92, 93, 105-106, 144-145; on Lenin, 70–72; on the Mohican, 14–15, 78, 87–91, 200n12; on optical unconscious, 14, 23, 32, 40, 47, 49–52, 63–65, 68–70, 71, 73–74, 78, 80–84, 89, 91–93, 105, 122; on photography, 6, 8, 9, 22, 40, 47, 49–52, 69–72, 77, 93–94, 173, 183, 184; and popular sovereignty, 76, 79; and shock, 2, 6–7, 8, 10, 40, 44, 73, 75, 78, 80, 87, 88, 92–96, 105–106, 137, 144, 159, 173, 184, 199n1; *Arcades Project*, 40, 51, 69, 75, 84, 86, 98, 105, 165; "Little History of Photography," 47, 49, 69; "On the Concept of History," 2, 5, 17, 18, 23, 32, 41, 43–44, 71, 135, 144–145, 150, 166, 188–189, 191, 192, 195; "On Some Motifs in Baudelaire," 24, 67, 77, 81, 92–95; "Paris of the Second Empire in Baudelaire," 14, 86–91; "The Storyteller," 58–59, 81; "Toys and Play," 68; "The Work of Art," 68, 81

Berger, James, 129

Berger, John, 33, 183

Bergson, Henri, 67, 92

Bhabha, Homi, 74, 82, 83, 88, 103

Bin Laden, Osama, 26, 192

biopolitics, 2, 3, 13, 25–26; and Auschwitz, 134–135, 139–140, 169; and colonialism, 141; and Freud, 49, 55, 62; and the optical unconscious, 48–49; and shock, 195; in the Soviet Union, 71–72

Blanqui, August, 87, 91

Boer War, 59

Brecht, Bertolt, 40, 44, 81, 96, 151, 163

Breuer, Joseph, 24, 54, 60

Buck-Morss, Susan, 31, 72, 103

Burroughs, Edar Rice, 103

Bush, George W., 174, 178, 193

C

Cadava, Eduardo, 22–23, 32, 47, 49, 51, 159, 198n5
Camus, Albert, 20; debate with Sartre, 112, 120, 129, 131; Barthes's criticism of, 114–115; Said's criticism of, 114
Caroll, Noel, 103
Caruth, Cathy, 2, 5, 8, 18, 74, 96, 111, 135, 160, 173; influence on Baer, 37, 52; influence of DeMan, 158–159; on falling, 183–184; and Freud, 23, 48, 66–67; influence on Hirsch, 163; on historical trauma, 25–26, 49, 42; Leys's critique of, 35–37, 125–126; and the media image, 9,11, 19, 29; *Trauma: Explorations in Memory*, 7, 22; *Unclaimed Experience*, 25
Cayrol, Jean, 163
Celan, Paul, 20, 96
Charcot, Jean Martin: influence on Freud, 47–48, 53–57, 63, 100; influence on Le Bon, 80; use of photography, 6, 23–24, 47–48, 53–57, 70
Chile, 177, 186
cinema. *See* film
Cohen, Margaret, 85–86
Cold War, 110, 112–113, 131–133, 139, 177, 192
collective unconscious, 75, 77, 85–86, 97–98
colonialism: and bare life, 29; and Barthes, 113, 115, 129; and Camus, 114–115; and Freud, 61; and genocide, 141; as historical trauma, 32, 81,92, 107; *King Kong* as an image of, 15, 76, 103, 105; and the Mohican, 14, 76, 78, 88–91; and the origins of concentration camps, 59; and unconscious optics, 51, 82–84; and understandings of class, 74, 83, 90; victims of, 28. *See also* imperialism
Combat, 112
Communist Party: French, 110, 114, 119, 201n1; Russian, 70–72
community of witness, 2, 19, 38; and Holocaust testimony, 154–158; and September 11, 172, 175, 183

concentration camps, 59; Adorno on the significance of, 3, 4, 5, 176–177; Agamben on significance of, 3, 138–140, 142–144; and bare life, 29, 48; representations of, 58, 163, 166–169, 173, 179–181; survivors of, 157–159
Cooper, James Fenimore, 14, 78–79, 84, 87–91
Copernicus, Nicholas, 52–53, 110
cosmopolitanism, 61–62
Creeber, Glen, 153–154
crowds: Adorno's conception of, 74, 79–80; Benjamin's conception of, 14, 78, 82, 88, 94–95; Freud's conception of, 24, 57, 64–65; Le Bon's theory of, 57; symbols of, 118
cyberspace, 82, 137

D

Darwin, Charles, 52–53, 66, 103
Dean, Carolyn J., 43
Debord, Guy,113
deconstruction, 7, 157; and Cadava, 51; and Caruth; and DeMan, 20; and Derrida, 111; and Felman, 20–21, 44–45, 138; and trauma theory, 20–23, 26, 44, 46–117. *See also* Derrida, Jacques
deep memory, 9, 93, 96, 106, 122, 158
Delbo, Charlotte, 158
De Man, Paul, 20, 45, 131, 133, 158–159, 197n2
denationalization, 26, 29, 200n5; Agamben on the significance of, 62; Arendt on the history of, 29, 60–62; Benjamin's experience of, 82, 87, 92; Freud's experience of, 14, 48, 60–61, 66–67
Der Derian, James, 192
Derrida Jacques, 119, 187, 198n5; on Barthes, 15, 126–128; on De Man, 131; response to September 11 attacks, 4–5, 16–17, 172, 175, 177–178, 188–192, 193, 195; *Specters of Marx*, 110–111, 177, 187
Des Pres, Terence, 20, 157
dialectical images, 1, 30, 40, 85–87, 94, 98, 146, 165, 168
Diary of Ann Frank, 134
Didi-Huberman, Georges, 136, 164–165, 169, 201n9
digital media, 10, 11, 136, 137, 194

Donesan, Judith E., 152
Dorfman, Ariel, 186
Dostoevsky, Fyodor, 20
Doyle, Arthur Conan, 103
Dr Mabuse, 167–168
Drew, Richard, 182, 185
Dumas, Alexandre, 88

E

Eaglestone, Robert, 141
Edison, Thomas, 104
Edkins, Jenny, 28–29, 185–186
Eichmann, Adolf, 133
Eisenmann, Stephen F., 194
Eisenstein, Sergei, 69–70, 89, 117–118, 120
Ellis, John, 31, 33
Elsaesser, Thomas, 7, 10–11, 12–13, 39, 134, 160
empathy, 1, 3, 5, 6, 21, 25, 27, 28, 154–155; in Agamben's criticism, 140; in Baudrillard's criticism, 153; in Barthes's criticism, 122, 130–131; Benjamin's critique of, 43–44; Des Pres on, 157; LaCapra's account of, 19, 42–43, 134, 143; Mitscherlichs emphasis on, 135, 150–151; and victims of September 11 attacks, 178–180, 182, 191; Zelizer's emphasis on, 179–180
Erb, Cynthia, 104
Erikson, Erik, 148
exilic optic, 82–83

F

Falling Man, 16, 172, 181–186, 190–191, 194
Fantomas, 103, 200n12
Fassbinder, Rainer Werner, 168
Felman, Shoshana, 5, 6, 18, 19, 23, 29, 36, 111, 142, 171, 179, 183; on Benjamin, 44–45; on De Man, 131, 158; on historical trauma, 138; on *Shoah*, 135–136, 139, 143, 161–162; *Testimony*, 3–4, 20–22, 39, 137–138
film, 5, 6, 10, 11, 13, 19, 23; Adorno on, 2, 40, 76, 78–79, 81, 102–104, 165, 167, 200n3; Barthes on, 117–118; Benjamin on, 2, 40, 76, 78, 80,-82, 89, 200n3; and Freud, 64; and historical trauma, 73–74; and

the Holocaust, 160–170; and imperialism, 84; and September 11, 4, 173, 181–182; and testimony, 4, 20–22, 131, 133. *See also* Hollywood
film theory, 7, 71, 84
Final Solution, 16, 20, 25, 63, 135, 138–141, 149, 154, 156, 161, 168, 176. *See also* Holocaust
flâneur, 78, 81–82, 84, 86
Foucault, Michel, 25, 48, 55–56, 119, 198n2
Fortunoff Video Archives, 20, 134, 154
Frank, Ann, 134
Frankfurt School, 18, 67, 84, 91, 97, 147–148, 200n10
French Revolution, 79, 169
Freud, Sigmund: Adorno's use of, 14, 18, 23, 26, 36, 39–40, 47, 73, 75–76, 77, 79, 86, 97–98, 100–102, 105–106, 145–148, 150, 200n9; Benjamin's use of, 2, 13, 14, 24, 26, 36, 39, 67–71, 73–74, 76–77, 86, 92–95, 105–106; and Charcot, 47–48, 53–57; on dissociation, 23; on fantasy, 4, 27, 31–32, 35–36, 174; on group identity, 3, 9, 26, 83, 148, 150, 154; and Jewish identity, 48, 59–67; and historical trauma, 1, 13, 24, 39, 47; and photography, 14, 23–24, 47, 49–59, 63–65, 73, 198n1, 198n4; on representation, 126; seduction theory, 24, 27, 54, 86, 121; theory of shock, 92–93, 116–117; temporality of trauma, 42, 190; the unconscious, 10, 40, 89, 176, 198n1; war trauma, 24, 57–58, 75; *Beyond the Pleasure Principle*, 2, 66, 68, 77, 92–93, 128; "A Difficulty in the Path of Psychoanalysis," 52; *Group Psychology and the Analysis of the Ego*, 100; *Interpretation of Dreams*, 53; "Moses of Michelangelo," 49, 63–65, 71; *Moses and Monotheism*, 2, 18, 24, 25, 48, 63, 65–67, 198n3; *Psychopathology of Everyday Life*, 68; "Resistances to Psychoanalysis," 52; *Studies on Hysteria*, 24, 54; "Thoughts for the Times of War and Death,"

61; *Totem and Taboo*, 2, 65. *See also* psychoanalysis
Friedberg, Anne, 84
Friedlander, Saul, 158
Friedrich, Ernst, 58
Fromm, Eric, 97
Fukuyama, Francis, 111, 176–177

G

Galileo, Galilei, 53
genocide, 17, 18, 28, 29, 169, 177; colonial, 14, 74, 76, 141–142; Derrida on, 111; as historical trauma, 32, 76, 91; suffered by Jews, 133, 139, 150, 151, 153, 157–58; suffered by Native Americans, 83, 91, 161; photographic documentation of, 48, 58, 179–180. *See also* Final Solution, Holocaust
Gilman, Sander L., 55–56, 62–63
Gilroy, Paul, 74, 141–142
Godard, Jean-Luc, 16, 136–137, 163–170
Godzilla, 104–105
Goering, Hermann, 118, 167
Guerin, Frances, 30
Gulf War, 174, 192–193

H

Hallas, Roger, 30
Hansen, Miriam, 41, 81–82, 161, 165
Hartman, Geoffrey, 21, 45, 74, 135, 154–156, 171, 178
Hegel, G. W. F., 112
Heidegger, Martin, 158
Heinle, Fritz, 45
Hemingway, Ernest, 112
Herman, Judith, 27, 35
Hernandez, Norberto, 181
Hiroshima, 105, 128
Hiroshima, mon Amour 8, 163–164
Hirsch, Joshua, 9, 19, 37, 159, 163–164, 166, 169–171, 201n9
Hirsch, Marianne, 183
Histoire(s) du Cinema, 16, 136–137, 163–170
historical trauma, 13–17, 19, 142; and Adorno, 2, 9, 14–15, 18–19, 24, 30, 32, 39–41, 45–46, 73–74, 80–81, 99, 103, 105–106, 164, 167, 176, 179; and Agamben, 25, 143, 167; and Barthes, 15, 107–111, 118–120, 124, 127,

129–132; and Benjamin, 2, 14, 16, 18, 19, 24, 32, 39–46, 73, 80–81, 92, 93, 105–106, 144–145, 164; Caruth on, 25; definitions of, 1, 32, 38–39; and Derrida, 110–112, 177, 187–189; and Freud, 2, 14, 19, 24, 47, 57, 63, 66–67, 73; Holocaust understood as, 15–16, 25, 108, 129, 131–132, 138, 140, 164, 170; Kaplan and Wang on, 12; LaCapra on, 24–25; and Marxism, 110–112, 118–120; September 11 understood as, 16–17, 175–178, 187–192; and Žižek, 16, 189–192
Hitler, Adolf, 15, 65, 80–81, 101, 103, 135, 139, 146, 148–149, 167–168, 174,
Hohendahl, Peter, 147
Hollywood, 4, 16, 38, 78–79, 113, 135, 150, 170, 173–175, 180, 191
Holocaust, 2, 28, 31, 38, 58, 98, 120, 195; Adorno on, 15–16, 18, 45–46, 76, 77, 133, 135, 145–150, 176; Agamben on, 25, 134, 138–140, 142–144; and Barthes, 113, 129–130, 131–132; Baudrillard on, 134, 152–153, 156–157; and Celan's poetry, 96; code, 26, 178–181; and deconstruction, 133, 136, 158–160; film, 6, 9, 16, 21–22, 36–137, 160–170; Hartman on, 74–75; as historical trauma, 39, 108, 138; Huyssen on, 138–139; LaCapra on, 42–43, 128, 134, 140–141, 143; photography, 33, 133, 179–180; representation of, 3, 134, 171; and September 11, 4, 33, 172, 174–175, 178–181, 189; survivors, 8, 12, 27; testimony, 4, 20–21, 26, 76, 106, 133, 139, 150, 154–156, 157–158; video testimony, 20, 21–22, 135–136, 153–157, 162. *See also* Auschwitz, Final Solution
Holocaust, 21, 133, 135, 150–153, 156, 160
homo sacer, 2, 25, 83, 91, 129, 139–140, 168, 182
Hooded Man, 17, 172, 192–195
Horkheimer, Arnold, 25–26, 144
Hoskins, Andrew, 193

Hugo, Victor, 79
Huyssen, Andreas, 7, 10, 46, 77, 134, 137, 139, 142, 151–152
Hussein, Saddam, 26, 193
hyperreality, 33
hypnosis, 57
hysteria, 23–24, 29, 48–49, 54–56, 70

I

ideology, 141; Adorno's account of, 146–147, 150, 165; Barthes's account of, 107–110, 112–114, 118, 131–132, 133, 173; and mourning, 182; and realism, 163; Žižek's account of, 189–192
imperialism, 14, 28, 62, 69, 74, 76, 78, 83–84, 91, 114, 141. *See also* colonialism
Independence Day, 189
Institute of Social Research, 84, 91, 97, 147–148. *See also* Frankfurt School
Internet, 4, 5, 173–174, 181, 183, 187, 194
Ishaghpour, Youssef, 165

J

Jay, Martin, 117
Jeanson, Francis, 112, 114
Jerod, Tom, 181–182, 191
Jewish identity, 200n5; of Adorno, 145, 147; Agamben on, 62, 139; of Benjamin, 87; of Freud, 2, 59–60, 64–67; and the Holocaust, 136, 152
Jung, Carl, 77
Jurassic Park, 103

K

Kant, Immanuel, 184
Kapan, E. Ann, 6, 11, 23, 29, 34, 178–179
Kennedy, John F., 12, 65, 160, 171, 181
Kertesz, Andre, 122
Khanna, Ranjana, 141
Khmer Rouge, 119
King Kong, 14–15, 72, 74, 76, 80, 101–105, 146, 195
Klein, Naomi, 177
Kofman, Sarah, 50
Kracauer, Siegfried, 167
Kristeva, Julie, 59–60
Krystal, Henry, 157

L

Lacan, Jacques, 39, 119, 120, 132, 199n14; influence on Barthes, 121; influence on film theory, 7, 36, 81; concept of the Real, 15, 109, 121, 128, 169, 190–191
LaCapra, Dominick, 19; on Agamben, 143–144; on Barthes, 128; use of Benjamin, 74, 95–96; on empathy, 19, 42–43, 143, 134; on historical trauma, 24–25, 39, 42–43, 131–132; on the sacralization of trauma, 8, 12, 23, 96, 128, 136, 162; on Shoah, 136, 162; on trauma and identity, 140–141; on video testimony, 155
Lang, Fritz, 167
Langer, Lawrence, 20, 155, 157–158
Lanzmann, Claude, 8, 16, 20–22, 109, 134–136, 138, 160–162, 164–166
Laplanche, Jean, 55
Laub, Dori, 179; on September 11, 178; *Testimony*, 4, 19–22, 39, 137–138, 159–160, 201n7
Le Bon, Gustave, 57, 74, 80
Lenin, Vladimir Ilyich, 65, 69–72, 112, 195
Les Temps Modernes, 112, 114
Levi, Primo, 139, 143, 150
Leys, Ruth, 27, 199n9; critique of Agamben, 142–143; critique of Caruth, 35–37, 125–126; on Freud, 56–57, 62; on mimetic and anti-mimetic accounts of trauma, 35–38, 42
liberalism: Adorno on, 99–100; conception of subject, 19, 25, 26, 43, 57, 83, 105, 130; Derrida on, 177, 192; Freud and, 57, 59, 62, 64–65; Fukuyama on, 176–177; politics of, 27, 28, 111, 195
Lifton, Robert J., 140
Lili Marlene, 168
literal trace, 1; Adorno's critique of film image as, 165, 171; Barthes's conception of photography as, 40, 112, 114–117, 121, 128–129, 131; Caruth's conception of traumatic memory as, 9, 19, 22, 52, 135–136, 159–160; and Freudian theory, 55; and Leys's critique of Caruth, 27, 35, 42,

125–126; media image under-
stood as, 13, 36, 133, 159; pho-
tograph understood as, 23–24,
37, 40, 50, 52, 112, 114–117,
128–129, 131
"live" transmission, 10–11, 172, 181
Luckhust, Roger, 140

M

McLuhan, Marshall, 152–153
Manovich, Lev, 84
Marcuse, Herbert, 148
Marxism: Adorno's engagement with,
18, 99, 111; Barthes's engage-
ment with, 110–112, 118–120;
Benjamin's engagement with,
18, 30, 45, 77, 83, 89, 95, 111;
Camus's engagement with, 112;
and class struggle, 16, 83, 190;
Derrida on legacies of, 110–111,
177, 187; influence on Eisen-
stein, 89; Frankfurt School, 67;
Sartre's engagement with, 112;
historical relation to structural-
ism, 119; Žižek's engagement
with, 190
mass culture: Adorno's critique of, 2,
14, 73–74, 76–80, 105; Barthes's
critique of, 15; Benjamin's cri-
tique of, 14, 69, 73–74, 76–80,
105; and the Holocaust, 21,
151–153; Godard on, 169–170;
and Lenin, 71; and trauma
theory, 195
mass media, 9; Barthes's critique of, 18,
107–109, 113–116, 131; Ben-
jamin's critique of, 92; and the
Holocaust, 4, 21; and Lenin, 71
mass politics, 83; Adorno on, 14, 73,
76–80, 103; Barthes on, 109;
Benjamin on, 14, 76–80; and
King Kong, 72, 103; and Lenin,
72; and September 11, 174
mass psychology, 24, 101
Matrix, The, 175
May '68, 110, 117, 119
media: and trauma, 6–13. *See also*
cyberspace, internet, film, mass
media, photography, television,
video
Mengele, Dr, 63
Metropolis, 168
Metz, Christian, 36
Michelangelo, 49, 63–65, 71, 195

mimesis: Adorno on, 36, 40–41, 79,
102; Benjamin on, 36, 40–41;
Leys on, 35–36, 56; and post-
traumatic cinema, 38
Mirzoeff, Nicholas, 91
Mitchell, W.J.T., 193
Mitscherlich, Alexander and Margarete,
135, 140, 148–151
Mohican, 14, 76, 80, 84, 87–91,
103–104
montage 30, 32, 36, 89, 164–165
mourning: Barthes on, 109, 120,
124–125, 130; Derrida on, 127,
187; and mass media, 171; poli-
tics of, 160; and September 11,
174, 182–185
Moses, 24–25, 48–49, 63–67, 70–71,
195
Muselmann, 134, 139–140, 143, 169

N

Nagasaki, 105
Napoleon III, 87
Native American, 14, 74, 83–91, 104,
141, 156, 161
Neoliberalism, 111, 177
Newton, Isaac, 184
Nicaragua, 120, 122
Nibelungen, Die, 167
Niederland, William, 157
Nietzsche, Friedrich, 112
Night and Fog, 134, 163–164
noble savage, 90

O

O'Laughlin, Ben, 193
optical unconscious, 198n2; Baer on,
22–23, 47, 51–52; Benjamin
on, 14, 23, 32, 40, 47, 49–52,
63–65, 68–70, 71, 73–74, 78,
80–84, 89, 91–93, 105, 122;
Bhabha on, 74; Cadava on,
32, 47, 51; and Freud, 14, 47,
49–52, 63–65, 73
optics, 6, 43, 53, 69,70

P

Perloff, Marjorie,125
photography 13; Baer on, 22–23, 37,
47, 49, 51–52; Barthes on 2,
8–9, 15, 40, 107–132, 159,
183, 188, 199n7; Bazin on, 36;
Benjamin on, 6, 8, 9, 22, 40,
47, 49–52, 69–72, 77, 93–94,

173, 183, 184; Cadava on, 22,
47, 49, 51; and Caruth's trauma
theory, 159; Charcot's use of,
6, 23–24, 47–48, 53–57; Freud
and, 14, 23–24, 47–48, 49–59,
63–65, 73, 198n1, 198n4; and
indigenous peoples, 104; and the
Holocaust, 33, 133, 179–180;
and September 11, 181–186,
187, 188, 190; Zelizer on,
179–181, 182
photojournalism, 6, 179
physiologies, 87–88
Poe, Edgar Allan, 99
Post Traumatic Stress Disorder, 2, 5, 7,
16, 22–23, 27, 35–36, 140, 163,
173, 199n9
postmodernism, 7, 10, 13, 39, 77–78
poststructuralism, 10, 15, 110, 119,
129, 133, 163, 183
posttraumatic cinema, 163–164
primal scenes, 91
Proust, Marcel, 67, 92–93, 154
psychic numbing, 5
psychoanalysis, 6, 35, 49, 59, 123, 134,
174; influence on Adorno, 2,
32, 36, 39, 67, 97–98, 100–101,
131, 146; influence on Benjamin,
2, 8, 32, 36, 39, 42, 47, 50, 67,
79, 85–86, 91, 131; and social
class, 56–57; and photography,
14, 47, 50; and trauma theory,
5, 36. *See also* Freud, Lacan
Pudovkin, Vsevolod, 69

Q

Quassi, Ali Shalal, 194

R

Radstone, Susannah, 27, 174
real, 134, 166; in Barthes's criticism,
109, 159; Lacan's conception
of, 15, 109, 121, 128, 169,
190–191; Žižek's conception of,
175, 189–192
real time, 10
realism, 110, 162–63
Resnais, Alain, 8, 134, 163–164
revolution, 17, 28, 82, 112; and Ador-
no's criticism, 2, 14, 39, 77, 97;
and Benjamin's criticism, 2, 14,
39, 78, 85, 105; and Barthes's
criticism, 15, 107, 109–112,
117–120, 122–123, 129; of

1848, 18, 87, 92, 99, 110; and
historical trauma, 32, 39, 92;
and Wagner, 98–100
Roff, Sarah Ley, 67
Romm, Mikhail, 118
Ross, Kristin, 118–120
Rothberg, Michael, 46, 134, 162, 178
Rousseau, Emile, 90
Russian Revolution, 15, 117–118

S

sacralization, 109; of Holocaust, 25,
136, 140, 162–163; LaCapra's
critique of, 8, 96, 128, 136, 162
sacrifice, 109, 129, 139
Said, Edward, 114
Sander, August, 69
Santner, Eric, 131, 198n5
Sartre, Jean-Paul: Barthes's relation to,
113–114; debate with Camus,
112, 120, 129, 131
Saussure, Ferdinand de, 107
Saxton, Libby, 136, 164–165
Schindler's List, 2, 134, 136, 160–162
Schmitt, Carl, 83, 88–89, 145
Schorske, Carl E., 59–60, 64
Screen, 81
semiotics, 7, 113–115, 124, 132
September 11, 3, 31, 34; Baudrillard's
commentary on, 4, 174–175;
Derrida's response to, 4–5,
16–17, 172, 175, 177–178,
188–192, 193, 195; Fukuyama's
response to, 176–177; compared
to the Holocaust, 26, 38, 46,
178–181; media representations
of, 4, 6, 12, 16, 19, 27, 28, 30,
33, 160, 171–175, 179–192;
Zizek's commentary on, 16–17,
172, 175, 186, 189–192
shell shock, 24, 57
Shoah, 8, 20, 109, 134–136, 138,
160–162, 164–166, 179
shock, 33, 41, 88, 166, 195; Adorno's
conception of, 81, 97, 106,
149; Barthes's conception of,
108–110, 112, 121–123, 159,
173–174; Benjamin's conception
of, 2, 6–7, 8, 10, 40, 44, 73, 75,
78, 80, 87, 88, 92–96, 105–106,
137, 144, 159, 173, 184, 199n1;
Freud's conception of, 2, 57, 75,
78, 92–93,116–117; in Godard's
use of montage, 164–165; Klein

on, 177; and September 11,
178–180, 182–183
Shohat, Ella, 84
Silverman, Kaja, 38–39
Simmel, Georges, 67, 95, 149
Singer, Henry, 16
Solzhenitsyn, Alexander, 119
Sontag, Susan, 31–32, 44, 194
Sorel, Georges, 90
sovereignty: Agamben's account of,
2, 3, 25–26, 28, 62, 130, 134,
139, 168; individual, 185; pop-
ular, 14, 31, 79–80; Schmitt's
theory of, 145; state, 91, 130,
176, 178
Soviet Union, 70–72, 83, 91, 111–112,
119–120, 129–131,170
Spanish Civil War, 58
Spencer, Lady Diana, 6, 12, 160, 174,
180
Spielberg, Steven, 2, 16, 134, 136,
160–162
Srebnik, Simon, 161
Stalin, Joseph, 70–71, 81, 110–112,
119
Stam, Robert, 84
Starr, Peter, 119–120
stateless. *See* denationalization.
Stevens, George, 134, 168
Stier, Oren Baruch, 155
structural trauma, 13–14, 35–38, 82,
107, 116–120, 123, 127, 129,
130, 131; Baer's account of, 29,
37; in Barthes, 15; in Caruth,
36–37; definition of, 31–32;
LaCapra's account of, 24–25
structuralism, 7, 108, 110, 113, 119,
131–132
Soviet Union 70–72, 83, 91, 111–112,
119–120, 129–131, 170
sublime, 143
Surrealism, 30, 67, 79, 103, 200n12
survivors: of Holocaust, 8, 12, 18, 46,
76, 139, 163, 166–170, 171;
identification with, 6, 12, 49, 75;
testimony of, 4, 133, 153–159

T
Taylor, Elizabeth, 136
telescope, 53, 199n8
television, 5, 6, 10, 84, 180; cover-
age of September 11 attacks,
4, 172–174, 181, 187; and
Holocaust, 21, 133, 150–154,

160; and *Histoire(s) du Cinema*,
136; "live" transmission, 11,
172, 181
terror, 2, 15, 17, 75, 82, 102, 103, 185–
186; and the Second Empire, 75,
87–89, 91; Stalinist, 110, 112,
129
terrorism, 3, 4, 16, 171–178, 182, 186
testimony, 1, 6, 8, 12, 19, 22; and
deconstruction, 157–160; of
Holocaust survivors, 4, 26, 76,
133, 135, 139, 150, 154–156;
and the image, 164, 166, 188;
and September 11, 182, 187
Third Reich, 18, 48, 72, 99, 135, 141,
150
torture, 193–194
totalitarianism, 112–113, 118, 130–
131, 152, 187
transmission model, 1, 19, 42, 133,
167, 195
trauma: Caruth's theory of, 5, 7–8, 9,
22–23; Charcot's theory of, 54;
collective experience of, 1, 4,6;
Derrida's conception of, 16–17,
189; and media, 6–13; neuro-
biological research into, 7, 27;
philosophical, 145, 148–149;
psychological theories of, 5;
psychotherapeutic studies of,
8; sacralization of, 8, 25, 96; sec-
ondary experience of, 42; Sep-
tember 11 attacks understood as,
3–5, 171–175, 178–181; trans-
mission of, 1, 19, 42, 133, 167,
195; vicarious experience of, 6;
Žižek's conception of, 16–17,
189–192. *See also* historical
trauma, structural trauma, war
trauma
trauma theory, 1, 2, 3, 7–8, 10, 16,
19–23, 125–128, 137–144
traumatic image, 8, 13, 31, 32–35, 82,
107, 115–116, 118, 129
traumatic realism, 134, 162–163
Traverso, Enzo, 59, 74, 90

U
unconscious optics. *See* optical uncon-
scious

V
Van der Kolk, Bessel, 22–23, 125–126
Verne, Jules, 103

victims, 40, 171, 194, 195; of child
 abuse, 27, 35; culture of, 27–28;
 empathy with, 43, 178–180; of
 Holocaust, 139, 176; identifica-
 tion with, 75–76, 131, 162
video, 4, 19–20, 22–23, 133, 165, 181,
 183, 194
video testimony, 20, 21–22, 135–136,
 153–157, 162
Vietnam War, 6, 8, 12, 27–30, 119,
 136, 140, 152, 156, 160–161,
 171, 173, 175, 181, 192
violence, 2, 109, 177; images of, 110,
 116, 131, 188; and history, 144,
 187; political, 3, 108, 120, 188,
 193–195
Virilio, Paul, 4 174
virtual capitalism, 175
virtual trauma 172–175, 181, 186–194
Vorontsov, Alexander, 167

W

Wagner, Richard, 2, 14, 18, 24, 41, 74,
 77, 97–102, 167
Walker, Janet, 37–38, 163, 197n4
Wang, Ban, 6, 11, 23, 29
war on terror, 31, 189, 192–194
war trauma, 24, 57–58, 75
Weigel, Sigrid, 144–145
Wiesel. Elie, 150

witness, 1, 2,6, 8, 12, 35, 40, 42–43,
 109, 123, 143; to the Holocaust,
 20–21, 134, 159–160, 67, 170,
 179; images and, 30, 33–38,
 131, 138–139, 167, 173, 179–
 180, 182–183; to September 11
 attacks, 4, 175, 179, 182–183
Woolf, Virginia, 41
World Trade Center, 16, 173, 175, 181,
 183, 185, 189, 193, 195
World War I, 6, 24, 26, 29–30, 45,
 57–60, 68–69, 81, 100, 113
World War II, 6, 24, 26, 29–30, 45,
 57–60, 68–69, 81, 100, 113,
 138–139, 152, 163–164, 168,
 175–176, 178–179, 181, 189,
 195

Y

Yale University, 20
Young, Allan, 173

Z

Zelizer, Barbie, 31, 33–34, 179–182
Zionism, 59
Žižek, Slavoj, 195; on ideology, 190–
 191; commentary on September
 11, 4, 16–17, 172, 175, 186,
 189–192
Zuckermann, Moshe, 178